# The Union of Youth

For Albina

# The Union of Youth

## An artists' society of the Russian avant-garde

Jeremy Howard

MANCHESTER UNIVERSITY PRESS

Manchester and New York

*distributed exclusively in the USA and Canada by St. Martin's Press*

Copyright © Jeremy C. Howard 1992

*Published by* Manchester University Press
Oxford Road, Manchester M13 9PL, UK
*and* Room 400, 175 Fifth Avenue, New York, NY 10010, USA

*Distributed exclusively in the USA and Canada*
*by* St. Martin's Press, Inc., 175 Fifth Avenue, New York,
NY 10010, USA

*British Library Cataloguing-in-Publication Data*
A catalogue record for this book is available from the British
Library

*Library of Congress cataloging in publication data*
Howard, Jeremy.
  The Union of Youth : a society of artists in St. Petersburg, 1910-14 / Jeremy Howard.
   p.  c.m.
  Includes bibliographical references and index.
  ISBN 0-7190-3731-X
  1. Soiuz molodezhi (Saint Petersburg, Russia) 2. Avant-garde (Aesthetics)—Russian
S.F.S.R.—Leningrad—History—20th century. 3. Arts—Russian S.F.S.R.— Leningrad.
I. Title.
  NX556.L46H69  1992
  709'.47'45309041—dc20  92-8989

ISBN 0-7190-3731-X *hardback*

Printed in Great Britain
by Biddles Ltd, Guildford and King's Lynn

# Contents

# Plates

These plates, many of which illustrate works long lost and unreproduced since the 1910s, are almost exclusively taken from archival sources in Russia and Latvia. Most were published in Petersburg magazines between 1910 and 1915, several appearing as illustrations to the journal *The Union of Youth*. (All measurements are given in centimetres)

# List of plates

# Acknowledgements

It was in 1983 when I first thought of writing a book on the origins of modernism in St Petersburg, and in particular the art of Nikolai Kul'bin and the Union of Youth. I had come to sense a gap in the history books, although at the time I had little grasp of its scale or significance. Under the guidance of my first tutor in Russian art history, the uniquely inspirational Boris Kalaushin, I gradually began to explore this gap and soon arrived at the belief that it was a gaping hole that needed to be filled. Having decided that I was the one to do the filling I set to on a task that was to involve many years work and the help of many people and institutions. This book is the culmination of that work.

While it is not possible to record here the names of all those whose assistance I received I should like to thank the following: Boris Kalaushin, who started the whole process; Christina Lodder, who guided the work through its many stages as a PhD thesis; Anthony Parton, who provided much support as the writing got under way; Georgii and Janna Kovenchuk, who introduced me to Kul'bin's paintings; Sergei Kuznetsov, who helped me in my searches in the Russian Museum, taught me of Leningrad/St Petersburg and filled my head with many other projects; Elena Stolbova and other members of staff at the Russian Museum who showed me the collections; the staff of the Petersburg Theatrical Museum; Irena Buzinskis; Peteris Savickis for his warm encouragement, and all the staff at the Latvian Museum of Art, Riga; all the other libraries, academies and museums in which I worked in Russia and Latvia; Martin Kemp for facilitating my passage at St Andrews; the British Council and University of St Petersburg for their funding and realisation of my research in the Soviet Union; the Academy of Science library staff in St Petersburg for their willing supply of much material; my family for their patience; and my wife, Albina Ozieva, for the love and belief.

J. H .

# Introduction

This book represents the first attempt to analyse the development of the St Petersburg avant-garde between 1910 and 1914, with special reference to the art society 'The Union of Youth'. This group of artists played a fundamental role in the establishment of an artistic ambience particular to Petersburg. This ambience is shown to involve an approach that was characterised by its retention of 'idealistic' and 'realistic' symbolism within a variety of modern styles.

The Union of Youth was born out of the short-lived art society 'Triangle', led by the unorthodox figure of Dr Nikolai Kul'bin. For this reason much attention is given to Kul'bin's aesthetics in the early part of the book. His panpsychic ideas and their relation to the art of Triangle are introduced in the attempt to demonstrate their place and transmission within the context of the local Russian avant-garde, and the Union of Youth in particular. This, in turn, establishes their symbolist and scientific heritage and their Neo-Primitivist potential.

An important and unprecedented feature of both Triangle and the Union of Youth was that neither was limited by parochialism or dogma. It can be argued that their breadth of outlook primarily stemmed from Kul'bin's position as an untrained artist and 'outsider' to the art establishment. Their diversity hints at a certain synthesism, which became apparent in their attempts to unite the visual, musical and literary arts. They welcomed contact with all artists concerned with renewal in the arts and frequently took steps to broaden their spheres of activity – both creatively and geographically. Thus the Union of Youth held talks with German and Nordic artists and took its exhibitions to Riga and Moscow and planned to take them further afield (to Baku, Berlin and Helsinki). It also planned a museum of modern art, an idea circulated by Kul'bin, and sent Matvejs abroad to purchase works, organise exhibitions and get acquainted with European movements.

It could be argued that it was the initial lack of parochialism and dogma that led to the swift collapse of the Union of Youth, and that naive immaturity and lack of confidence hindered its creative development. Certainly, its all-embracing qualities, together with the call for modernisation, led to the participation of many amateur artists and students who subsequently gave up painting, as well as to many divergent views. Yet ultimately, the brevity of its existence was primarily the result of the call

1

for continual self-appraisal and change. Moreover, it was this very openness to ideas that stimulated the development of certain individuals, such as Baudouin de Courtenay, Rozanova, Shkol'nik, Dydyshko and Matvejs.

Western scholarship has tended to underestimate the contribution of the Petersburg avant-garde between 1910 and 1914, and has concentrated more on the Moscow developments such as 'The Blue Rose' and 'Golden Fleece' salons, as well as major figures such as Malevich and Tatlin. When Triangle is mentioned it is generally dismissed as 'decadent' or 'neo-symbolist', while the Union of Youth is mistakenly labelled 'Cubo-Futurist' on the basis of its production of *Victory over the Sun*. Such evaluations have inevitably obscured the significance and diversity of the Petersburg avant-garde.

In order to elucidate the development of the Union of Youth, this study seeks to establish an accurate chronology. In this way the relationship to symbolism can be clarified. The extent of the symbolist heritage in the group is seen through discussion of its aesthetics and ideas in relation to Russian and Western symbolist literature and painting. This leads on to an examination of the emergence of Neo-Primitivism in Russia, and the relationship of this new trend to Western developments, such as Fauvism. Within the Russian context, developments in Moscow, especially the art and ideas of Mikhail Larionov and Natal'ya Goncharova, and the interchange of ideas between Petersburg and Moscow, are studied.

The aesthetic liberalism of the Union of Youth showed a continuity, via Triangle, with the approach of the World of Art. In the late 1900s and early 1910s this created the circumstances for new experimentation: young artists were able to exhibit their work for the first time and to discuss their ideas in a totally new environment. The concentration on technique led to the development of new artistic principles which moved away from figurative art. Yet, neither Kul'bin nor the Union of Youth were concerned to establish a school. Triangle was simultaneously interested in symbolism, science and the subjective expression of the artist's relation to the world. While stressing the importance of the artist's individuality and expressive freedom that allowed him to distort reality, Kul'bin regarded the result as an objective truth. For him, the artist could choose to show the essence or meaning of a thing rather than the concrete object, or he could rely entirely on visual appearances. Either way he could produce genuine art. Although Kul'bin still believed in the objective world, his art was essentially perceptual and synthetic. Such was his 'impressionism', which owed more to Russian symbolism, the Austrian literary impressionism of Altenberg and Schnitzler, and Post-Impressionism, than to French Impressionism.

Kul'bin's influence on the Union of Youth was paramount. Even the group's name implies that the most important factor unifying them was their age as artists, not any stylistic trend or established worldview. This

book attempts to show that although they were influenced by Neo-Primitivism, they cannot be identified with a single trend. It also argues that their 'ecletic' nature was not strictly detrimental but, as an inherent part of their *raison d'être*, provided them with the means to experiment and develop.

This study examines the art and theory of various prominent individuals from the group, as well as its development as a whole. Its exhibitions are used as a primary source of information, since they were the most regular and clear demonstrations of members' work. These are backed up by relevant details from minutes of group meetings, members' letters, unpublished essays and reports. Other valuable sources are found in their publications, lectures and stage productions.

In the first chapter the nature of Triangle's 'impressionism', mixed as it is with *Art Nouveau*, symbolism, realism, Post-Impressionism and synaesthesia is analysed. The symbolist heritage and relationship with Ryabushinskii's Moscow journal *The Golden Fleece* [*Zolotoe runo*] is studied, together with the collaboration with the Moscow group Wreath. The intention is to show how the *fin de siècle* roots developed into a basis for the re-examination of the formal principles of painting and how this stimulated the founding of the Union of Youth. Thus, though many old formulae for symbolism and impressionism were repeated, innovation was felt in the 'impressionistic' and psychological relationship with nature seen in Kul'bin's, Matyushin's and Guro's work. These artists realised that the modern artist had to alter his or her consciousness in order to feel and express a universal truth. This involved a belief in experiment and knowledge derived from experience through the senses. It also led to a new concentration on technique and included the use of Fauvist principles, known to the Russians through *The Golden Fleece* journal and art salons in 1909.

Kul'bin's theories are compared to those of Matvejs in Chapter 2, and as representatives of Triangle and the Union of Youth respectively, the ideas of these artists are particularly revealing about the shift in values that took place in Russian art at this time. Matvejs' articles highlight the move from, and overlap between, symbolist impressionism to Neo-Primitivism. Common to both trends is a continuing emphasis on spiritual content, as well as a call for a new social and cultural awareness, not only among artists but also the public at large. To a large extent, this was a reaction against the dehumanising effects of the late-nineteenth and early-twentieth-century industrialisation of Russian society. Rapid technological progress had destroyed much of man's communication with nature and introduced a new poverty of spirit. This was particularly felt by Matvejs, who rejected the 'constructive' principles introduced to European art by the Greeks. He called instead for a return to an individual and cultural response to beauty, devoid of external pre-conditions and evocative of the creator's own 'tun-

ing fork'. His interest in abstracting from nature and his empathy with nature suggest parallels with the ideas of Kandinsky, Marc and Worringer, supporting the notion that there was much in common between the Munich and Petersburg avant-garde.

The reasons for the founding of the Union of Youth are shown to include the desire for renewal in the arts and the lack of a place in existing societies for young artists. The statutes of the group called for the 'mutual rapprochement of people interested in the arts' and stated that it sought self-appraisal and continual reassessment of aims through the communal study of art. This was to be attained through the establishment of a group studio, the organisation of exhibitions, discussions, dramatic productions, and the founding of an art library.

The Union of Youth's first exhibition was a relatively modest study in the transition from impressionism to Neo-Primitivism, although the latter was only represented by Larionov's and Goncharova's independently se-lected work. The formal experiments of Matvejs, Filonov and Shkol'nik were still burdened with metaphysical content. Its second show marks a far more emphatic break with academic art and, indeed, lived up to its name of 'The Russian Secession'. It attracted many non-members as exhibitors and displayed a broad variety of modern trends, from Naumov's decorative symbolism and Shitov's non-objective colour-music to Nagubnikov's Cézannism and Larionov's use of stone *baba* in his sculptures. Overt synthetism was found in Petrov-Vodkin's and Matvejs' work.

The 1910–11 art season was remarkable for the new definition of direction that occurred, specifically with regard to the group's performance of *Khoromnyya Deistva* (and *Tsar Maksem'yan* in particular). The multiple references in this event to the distinctions between 'high' and 'low', and 'European' and 'Russian' art indicate a pervasive commitment to the debasement of the static formulae, not only of urban theatre, but of the arts in general. Thus it was not simply a case of replacing 'chairs with barrels' but it consisted of a far more vital transference of '*lubok*' motif and technique. Non-sequential shifts in space and time, the mixing of the mythological and the realistic, the use of the absurd and the emphasis on native forms created a dramatic and provocative new dynamism that re-flects many aspects of the Union of Youth's future development, not least those present in *Victory over the Sun* and *Vladimir Mayakovsky: A Trag-edy*, staged by the Union of Youth at the end of 1913.

Examining the relationship of the Union of Youth with the Moscow group, The Donkey's Tail, it is found that, despite much antagonism, they did share considerable common ground. This is pertinently demonstrated by comparing Bobrov's theory of 'Purism' with Markov's (Matvejs') 'The Principles of the New Art'. Differences arose because of the new factionalising spirit within the Russian avant-garde from 1912 onwards.

Thus artists drawn to Larionov's more radical Neo-Primitivism left the Union of Youth and set up in opposition. Even Markov, the leading figure in the Union of Youth, was associated with Larionov's Donkey's Tail and Target groups. Henceforth, although the Petersburg group is seen to be less of a unifying society than previously, it retained its ability to attract young artists of various persuasions.

The increasing presence of Rozanova and Malevich is highlighted in the discussion of 1912 and 1913. An analysis of their contributions to the final Union of Youth exhibitions establishes that they continued to paint in a Neo-Primitivist manner until very late 1912 or early 1913. Only in 1913 did they adopt a Cubist idiom for their examination of creative principles and then they imbued it with a Futurist denial of a static object. Simultaneously, they began to perceive reality in an 'alogical' way, in collaboration with Kruchenykh and Matyushin, and this freed objects from their generally accepted functions and meanings, giving them a new identity.

This book sets out to show the profound relevance of both the Neo-Primitivist concentration on material and *faktura*, as expressed in Markov's theories, and the introduction of a new level of consciousness in Kul'bin's and Matyushin's ideas concerning the creation of art, to the subsequent move to *zaum* art and Cubo-Futurism. The retention of a 'spiritual' content in the work of these artists derives from the pervasive atmosphere of science, spiritualism, and occultism in the intellectual circles of St Petersburg. It is this that distinguishes the Russian avant-garde from their European counterparts (although the latter were very influential for the form of the Russians' work).

However, it is also shown that it would be a mistake to consider the better known artists who participated with the Union of Youth (such as Malevich, Rozanova, Filonov, Matyushin and Markov), as the sole arbiters of its direction. Indeed, there were many other artists for whom both a 'spiritual' and a 'Russian' content was either irrelevant or subdued. The Union of Youth was a heterogeneous organisation where the study of the formal aspects of art, devoid of extraneous influences, was not only justified but promoted. This is observed in Zel'manova's and Shkol'nik's imitations of Matisse's decorative period, in Shleifer's pastoral-primitivism, Dydyshko's impressionism, Nagubnikov's still-life compositions and Spandikov's Steinlenian references to the low-life of Paris. Nor was this study of form a straightforward reiteration of the Cubists' concern with volume and pictorial construction, or the Futurists' desire to evoke dynamism and simultaneity, as is shown by the discussion of the introduction of Cubist, Futurist and Rayist principles in 1912 and 1913.

The nature of the Union of Youth's public appearances is also examined. An orientation towards modern trends in Europe as well as ancient Eastern art, is revealed in the very first publications of the group – Matvejs'

'The Russian Secession' and the first two numbers of *The Union of Youth* [*Soyuz molodezhi*]. Later, the debates on the new painting and literature are seen to promote the Futurist ideas of Malevich, David Burlyuk, Aleksei Kruchenykh, Olga Rozanova and Vladimir Mayakovsky. The association of these five artists and poets with the Union of Youth is analysed in order to establish the extent of their influence on the identity of the group. The pace of their experimentation outstrips that of most Union of Youth members and their accommodation within the group, or within 'Hylaea', its 'autonomous' literary counterpart, comprises a considerable part of the ensuing enquiry.

The new pitch of the factionalising tendencies within the avant-garde is examined with reference to the breakdown of the Union of Youth's relations with Larionov. The contents of the third *Union of Youth* journal and the group's *Credo* reveal a break with the earlier liberal, unifying outlook, and a new aggressive attitude which calls for a reappraisal of artistic values. The responses of Avgust Baller, Burlyuk, Matyushin, Shkol'nik and Rozanova to European developments affirm the group's new orientation towards a Futurist stance for revitalising the arts, while also indicating the continuation of an underlying metaphysical approach.

Although Zheverzheev and Shkol'nik tried to revive the Union of Youth in 1917, its force, and even *raison d'être*, was spent after the performance of *Victory over the Sun*, so the attempt failed. This essay regards the Futurist performances staged by the Union of Youth at the end of 1913, while not integral to the group itself, as a promotion of a new worldview that they had encouraged. To this effect they called upon themselves to abandon past associations and disperse. The Union of Youth's unifying tenets had been usurped by a factionalising tendency. Its purpose had been served. Artists now sought new allegiances and doctrines.

The development of the 'transrational' aesthetic in the Union of Youth's final period (late 1913 to early 1914) is first examined by reference to the group's last exhibition. The combination of Neo-Primitivist, Cubist and Futurist techniques with a spiritual content seen here is complemented by the analysis of *Victory over the Sun* and *Vladimir Mayakovsky: A Tragedy*. It is argued that *Khoromnyya Deistva* set an important precedent for the content and form of these stage productions. The Union of Youth's publication of Markov's essays is also discussed with a view to establishing the relation of Markov's 'primitivist' ideas concerning the interpretation of art of other cultures with the development of the Union of Youth's aesthetic.

One of the important aspects to emerge from this examination of the Union of Youth is its particular means of renewal in the arts, within the symbolist ambience of St Petersburg. The frequent retention of a mystical content and assimilation of Neo-Primitivist principles is revealed not to be a narrowly based attempt to establish a definite movement or school, but

rather a vaguely formulated desire to rediscover the principles of beauty. Only the essays of Markov and, to a lesser extent, Rozanova strove to encapsulate the influences and, ultimately, the purpose of their art. The investigation undertaken here indicates the importance of Matyushin's and Markov's (and Kul'bin's) ideas in determining the Petersburg avant-garde's move into abstraction and transrationalism. It also shows that the Union of Youth, as a whole, lagged behind them in their enquiry into artistic principles and content.

By analysing the sequence of events concerning the Union of Youth, the transformation of painterly styles in Russia between 1910 and 1914 is more clearly identified. This period is shown to mark the transition from *fin-de-siècle* symbolism via Neo-Primitivism to Cubo-Futurism, with the reception of Fauvist and Cubist principles and Futurist ideas playing a fundamental role. Members of the Union of Youth were not predominantly innovative in their formal solutions, but the establishment of the group brought together several artists capable not only of abandoning Russian art's reliance on post-Renaissance classical principles, but also of bringing Russian art to the forefront of the European avant-garde.

Unless otherwise stated, all translations from Russian are by the author. Titles of groups, exhibitions, works of art, lectures and stage productions have been translated into English (where an appropriate translation exists). Within the text, titles of books and important journals, such as *The Golden Fleece* and *The Union of Youth*, are given in English, the first entry being followed by the transliteration of the Russian original. A capital letter is used for Impressionism, Cubism and so on, when it signifies the specific artistic movements; lower-case letters denote practices divorced from the original movement (e.g. 'Kul'bin's impressionism'). Russian dates are given in the old style.

Abbreviations: TsGALI – The Central State Archive for Literature and Art, Moscow; cat. – Number of exhibit in exhibition catalogue. The British Standard system of transliteration is used throughout. Exceptions include proper names of European origin, such as Benois, Baudouin de Courtenay, or of artists who are generally known by other versions, such as Chagall and Kandinsky.

# 1                                    The prologue

Without Dr Nikolai Ivanovich Kul'bin and his art group 'Triangle' there
would have been no Union of Youth, and hence no Petersburg forum for
the early art of Malevich, Matyushin, Filonov, Tatlin or Rozanova.
Kul'bin's influence not only changed exhibiting practice in the Russian
capital but it also profoundly affected the ideas and art of the Russian
avant-garde. He introduced non-professionals and young artists to the
public, and from his own position as an untrained 'outsider', adopted a
stance which allowed both anti-establishment art and anti-high art. This, in
turn, contributed to the evolution of Neo-Primitivist styles.

By recognising the right to existence and freedom of expression of all
art groups and tendencies in his 'Modern Trends in Art' exhibition (St
Petersburg, 26 April to 20 May 1908), Kul'bin acknowledged the new,
multifarious state of Russian art in the 1900s. His was perhaps the first
attempt to show the full range of creativity and diffusion of talent that
epitomized the period generally known as the Russian 'Silver Age' - an age
when a vital cultural rebirth was taking place.

St Petersburg had been the centre for western influences entering Russia
for almost two centuries and it was here that *The World of Art* [Mir
iskusstva] was organised by Diaghilev and Benois in 1898. The founding
of this journal and art society was one of the first concrete steps in the
development of Russian modernism. Its philosophy was based on aestheti-
cism, anti-academicism and dislike for the social realism of the Wanderers.

The journal paid particular attention to the development of European *Art
Nouveau* and reproduced works by Beardsley, Burne-Jones, Van de Velde
and Denis. Only in 1904, shortly before the journal's closure, was attention
given to Post-Impressionists, such as Gauguin and Van Gogh. One of its
aims had been to acquaint the Russian public with recent developments in
the 'world of art'. Acting as an important stimulus for artists in particular, it
presaged Kul'bin's stance by combining a generally tolerant attitude to-
wards the aesthetic views of its young contemporaries with a predomi-
nantly symbolist orientation.

*The World of Art* closed in 1905, during the early months of the Revolu-
tion. The quality of aristocratism and reserve, typical of St Petersburg, and
particularly expressed in the group's interest in antiquity and the publica-
tion of mystical-symbolist poetry, meant that its 'progressive' qualities
were severely limited by a certain decadence. By January 1906 the inaugu-

ral issue of *The Golden Fleece*, a new journal aspiring to encompass art and literature, appeared in Moscow. Owned by Nikolai Ryabushinskii, the son of one of Moscow's *nouveau riche* merchant-industrialists, it emphasised, and, indeed symbolised, the sometimes contradictory shifts of values after the Revolution.

Members of the new entrepreneurial class in Moscow had followed Pavel Tretyakov's lead in collecting art and opening their collections to the public. Collectors and patrons with more cosmopolitan and 'modern' tastes than either Tretyakov or the founder of Abramtsevo, Savva Mamontov, emerged. Ivan and Mikhail Morozov built up large collections of French art. Sergei Shchukin began collecting works by Denis, Redon, Cézanne, Gauguin, Matisse and Picasso, and, by opening his home on Sundays to those interested, introduced, together with *The Golden Fleece*, the Post-Impressionists to Russia. Mikhail Ryabushinskii, the brother of Nikolai, purchased works by Degas, Pissarro, Renoir and Vrubel.

The importance of *The Golden Fleece* in establishing the modernist movement in Russia cannot be overestimated. The first issue was devoted primarily to Vrubel, the second to Somov, the third to Borisov-Musatov, and the fourth to Bakst. All four artists personified *The Golden Fleece*'s quest for universal relevance and rejection of contemporary society in art, while Vrubel's and Borisov-Musatov's prominence recognised them as the spiritual forebears of the avant-garde.

*The Golden Fleece* had a synthetic, fin-de-siècle approach to culture that was expressed in the argument for realistic symbolism (symbolism grounded in nature) as opposed to idealistic symbolism (symbolism grounded in the 'supernatural'), as well as in the correspondence between illustration and text and a number of early theoretical articles, e.g. Blok's 'Colours and Words'[1] and Imgardt's 'Painting and Revolution'.[2] Significantly, Blok considered poetry not as an art of sounds alone but as a combination of 'colour and line' and called for the preservation of a childlike susceptibility to nature through the use of pure and distinct colour. Anticipating Kul'bin, and with him, Čiurlionis, Skryabin and Kandinsky, Imgardt conceived 'visual music and sound painting', that is, a non-figurative and synthetic art, as a consequence of the artist's intuitive impulse.

Ryabushinskii patronised the new Russian avant-garde of Pavel Kuznetsov, Petr Utkin, Mikhail Larionov, Natal'ya Goncharova, Nikolai Sapunov, Sergei Sudeikin, Artur Fon Vizin, Nikolai and Vasilii Milioti and Martiros Sar'yan, and exposed their work to the public, either through reproduction in his journal or through display in the exhibitions he organised. Only in mid-1908, after the first Golden Fleece salon, was modern French art reproduced for the first time. As a result of this policy, by the time of 'Modern Trends', the Petersburg artists had had considerable opportunity to assimilate the art of the 'Blue Rose' painters, which

Stupples has conveniently divided into 'organic symbolism' where 'colour is primary, the intention mythopoetic' (e.g. Kuznetsov, Milioti, Sapunov, Utkin) and 'romantic pantomime' which 'treats life as theatre' with figures that are 'detached, condescending, playful and coquettish'[3] (e.g. Fon Vizin, Sudeikin). Furthermore, 'Blue Rose' artists showed in Petersburg even before Ryabushinskii had financed the 1907 Blue Rose exhibition in Moscow: at the twelfth exhibition of the Moscow Association of Artists, which opened on 15 January 1905 (Kuznetsov's exhibits included *Evening, Morning, Ecstasy, Melancholy*); and at the World of Art, which opened on 27 February 1906 (Nikolai Milioti's exhibits included *Motif from Verlaine, The Ringing*).

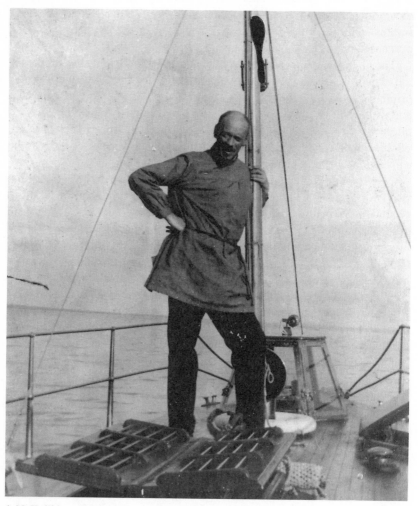

1 N. Kul'bin, *c.* 1912

Between 1908 and 1910 Kul'bin organised four art exhibitions, delivered many lectures and published several articles on his theory of artistic experience. His ideas were essentially those of a psychologist looking at art as a language of symbols that signify the relationship between man and the world. This enabled him to call for a free art, reflecting the 'three aspects of the psyche... consciousness, feeling and will'.[4] His triadic conception of experience has much in common with Andrei Bely's three-term formula for the symbol as image, idea and their vital connection. Like Bely, his attempt to embody this in his art did not contradict realism but rather sought to establish a methodology of conceptually grasping reality. He called his group 'Triangle-The Impressionists', his notion of impressionism being close to Bely's:

> Kul'bin dwelt in detail on the essence of impressionism. This is a new direction in art, reproducing the first spontaneous impression, it does not recognise the separate existence of music, literature and the plastic arts – the studio of impressionist artists does not involve mutual obligations, but is united by a general artistic direction which they call the pyschological *impressio*. They reflect their intimate experiences in psychological art, avoid everything that is preconceived, forced or deliberate, and love a single, free art and the new, because art is always new. 'They are not decadents, and have not come to destroy but to construct' said Kul'bin.[5]

This compares with Bely's symbolist interpretation and thereby encompasses not only the French Impressionists' concern with optical reality but also a metaphysical reality:

> Realism is only an aspect of impressionism. But impressionism, i.e. a view of life through the prism of experience, is already a creative view of life. My experience transforms the world; by going deeper into experience, I delve more deeply into creativity; creativity is, at the same time, the creativity of experiences and the creativity of images. The laws of creativity are the only aesthetics of impressionism. But these are the aesthetics of Symbolism.[6]

From this study it will become clear that while much of Triangle's and the Union of Youth's art bore the distinctive marks of a symbolist and *Art Nouveau* heritage, a new creative spirit had emerged among the young artists, and this spirit was to become the driving force behind the break with the art establishment and the creation of a vital, and essentially new, modern art. The Union of Youth grew out of Triangle and in opposition to it. The overlap of ideas, together with the conflict in personalities and practice, is essential to an understanding of the development of the Union of Youth. Kul'bin searched for new aesthetic possibilities, discarded all rules and conventions and was stimulated by recent discoveries in science and psychology. The Union of Youth was the first and most important group to be inspired by Kul'bin's ideas and developed his call for a synthetic and psychological art into a vital and modern approach.

On 26 April 1908 Kul'bin's first exhibition, 'Modern Trends in Art', opened in 'The Passage' salon on Nevskii Prospekt. For the Petersburg public this was something quite new, for not only were totally unknown artists exhibiting for the first time, but they were exhibiting with established painters. Also, artists from avant-garde and conservative tendencies were drawn together. David Burlyuk's Wreath group, champions of the current modernist trends, were to be found alongside artists, such as Nikolai Bogdanov-Belskii and Genrikh Manizer, who exhibited with realist groups such as the Wanderers and the Petersburg Society of Artists. Notable by their absence were the young Moscow symbolists and impressionists, such as Kuznetsov, the Miliotis, Larionov and Goncharova.

The aim of the exhibition was subsequently outlined by Kul'bin in a review of Sergei Makovskii's 'Salon 1909'.[7] The vast majority of exhibitors at Makovskii's show belonged to the famous Union of Russian Artists, while young and unestablished artists were excluded. Kul'bin complained that the Union was not so much a unifying organisation as simply a society whose members had similar approaches to art, and to whom the 'idea of the joint existence of several artistic directions' had not occurred. He attributed this to the generally low level of culture in Russia and the failure of artists to develop their social consciousness, valuing only themselves or their party and not recognising all other artists' rights to independence. He outlined his idea of a salon, stating that it should be an exhibition of independent artists as in Paris, where there is no jury, where there is freedom of expression for each group and where the concern was not commercial but social. He regarded 'Modern Trends in Art' as an attempt to achieve this: it had embraced seven totally independent groups and allowed unbiassed information about the aims of modern art and the ideas of the artists to be read to visitors.

Kul'bin also considered that exhibitions should be organised by representatives of the artistic community rather than by businessmen. Hence the organising committee of 'Modern Trends' included Lev Bakst, Nikolai Kalmakov and the sculptor Vasilii Kuznetsov. Initially the show was scheduled for the start of 1908, but due to the unavailability of venues, it was postponed until 26 April.[8] The groups consisted of Wreath, Triangle: The Art and Psychology Group, The Union, The Neo-Realists, Academic Trends and The Architectural Group, as well as the 'Majolica Group' (which consisted solely of the ceramicist Petr Vaulin). In addition two non-aligned artists, Boris Ferdinandov and the blind Vasilii Nechaev took part.[9]

Some groups were undeniably under-represented, many members of the Moscow-based Wreath, for instance, were missing – essentially those who were showing at the first Golden Fleece salon in Moscow and the independent 'Wreath' show in Petersburg. The Union of Russian Artists was

also lacking many who had been involved in its show the previous month. Other groups, such as the Neo-Realists, the Academic Trends and the Architectural group, though newly formed for the show, contained artists with well-established reputations.

Reviews were varied. Metsenat called it 'some kind of farrago, a blend of representatives of the most opposing directions in painting, from the so-called 'far left', who paint with mops, to the market rubbish which it is possible to see in shop windows'.[10] Dubl'-ve found the ensemble comprehensible – 'Starting from the entrance the paintings of the "extreme left" revolutionaries in art, who recognise no form and deny the necessity to copy nature, are distributed consistently',[11] and ending with the Neo-Realists and Group of Academic Trends so that 'overall the exhibition creates a pleasant impression.'[12] Most critics found the idea of bringing together the various directions that had sprung up in Russian art new and worthwhile. Thus Simonovich was able to write

> this exhibition, while falling far short of its grand title, is highly remarkable. Especially striking is that it sets out in special relief the co-existence here in Russia of the most varied of artistic groups and individual artists.[13]

Yanchevetskii hoped 'that this experiment at rapprochement between artists of various trends develops into something more sound and permanent'.[14] However, Kul'bin never again attempted to organise such an exhibition and for the next two years focused instead on his own group and the development of his own ideas. Such a process of definition led to differences of opinion and approach among the group's members, a factor which contributed to the formation of the Union of Youth.

At the time of 'Modern Trends' 'Triangle: The Art and Psychology Group', led and dominated by Kul'bin, consisted of fourteen painters and a sculptor, of whom only Kalmakov and Lidiya Meister had previously exhibited.[15] Kul'bin's ideas are crucial to understanding the group's art (and hence that of the Union of Youth which followed it) and it is significant that in his publications he employed the symbol of the triangle rather than using the written word. One of the earliest mystical symbols, it was commonly used by the theosophists, then popular in Russia.[16] Kul'bin's triangle consisted of the three primary colours, yellow, blue and red. These colours, the three sides of the triangle, represented 'idea, feeling and will, which comprise in their complex, the human soul'.[17] His illustrated lectures and proclamations were powerful and complete personal expressions, which included the important aspects of visual and aural impressions.[18] 'The Theory of Artistic Creation', read at the Society of Architects and Artists in November 1909, was the first to attract critical attention:

> Kul'bin himself confessed the lecture had an incoherent and fragmentary nature. Frankly, this lecture occasionally resembled a fast gallop through jum-

bled up piles of all possible ideas from the fields of aesthetics, the psychology of artistic creation, the theory of technique, painting etc., with short explanations of ideas, unexpected excursions into various fields and still more unexpected and original examples, like the cook who knocks seven times on the bed with her heel in order to get up at seven o'clock.[19]

In fact, Kul'bin deliberately adopted an odd form of delivery, replacing logical argument by non-sequential statements and aphorisms. This was compounded by his military uniform and high-pitched voice. His conception of a work of art was described in short, fragmentary phrases – the form of his speeches being as significant as the content. His disregard for logic and his concern for the latest scientific and philosophical discoveries, was to have repercussions in the art of the Russian avant-garde. It can be argued that it stimulated the eventual development of *zaum* (i.e. transrationalism) by Velimir Khlebnikov, Aleksei Kruchenykh, Kazimir Malevich and Mikhail Matyushin, as well as the theatrical productions of the Union of Youth.

Kul'bin presented art as a psychological action, neither wholly rational nor wholly intuitive, but a mixture of the two. He regarded art as an attempt to represent man's perception of nature and his place within it. He presented his precepts in typically aphoristic form:

In order to acquire a suitable mood the artist must disregard everything. The only important thing is that the disregard must be of a conscious character. Deliberate weakness of drawing often produces brilliant results. Mood is also created by severity of style, by the striving for novelty etc. In art what is important is not that which is represented but how it is represented. Art is not a copy, but a convention, a symbol. The work of art must, before all else, affect a creative itch in the imagination of the viewer. Art is a play and the artist is an actor. He must pretend: half- open the secret and veil the known. Incompleteness is primary. The viewer must embellish the picture.[20]

Kul'bin emphasised psychological cause and effect as fundamental to the nature of art. For him, art is born of man's inner self and as a response to the world, but is created by the viewer as well as the artist. They are united in their task, and without one another the artistic process is incomplete.

Kul'bin never dismissed the art of earlier epochs but considered it relevant because it manifests aspects of the creative unconscious. For him, 'art is revelation… the unmasking of invisible things' and 'only a few loving hearts have a gift for reading the ideas of art in the great works of art of the past.'[21] Yet, always the artist and viewer are only the purveyors and perceivers of 'the great art that exists in nature, natural art'.[22] This closely relates to Ivanov's conception of realistic symbolism, where art, as a representation of the phenomenal world, and having its roots there, reveals the essential nature of things and their place in the divine scheme.[23] Furthermore, Kul'bin's psychological and symbological approach to art was soon to find most striking parallels in Kandinsky's work.[24]

Kul'bin called for scientific analysis and experiment in art: 'The self can know nothing but its own sensations and through the processing of these sensations creates its own world... No one can jump out of themselves... The only method for truth... is experiment, observation and generalisation and this is all based on the impressions of the researcher.'[25] Believing that art originated from the natural world, that is itself a work of natural art, Kul'bin considered an observational approach essential. His aim resembles Bely's desire to describe phenomenologies of behaviour through open-ended research rather than create a conceptual worldview that sought to explain purpose and meaning.

How far were Kul'bin's ideas realised in his art? Almost inevitably his exhibits reflected a knowledge of Post-Impressionism and, to a lesser extent, an espousal of symbolist motifs. The critic Yanchevetskii, reviewing the exhibition, noted that: 'Kul'bin does not recognise the brush or the blending of colours; he puts balls of pure colour on the end of a knife in the hope that the eye receives the desired impression at a distance.'[26] He added that the result sometimes restricted the spectator's ability to comprehend the painting. Dubl'-Ve complemented this description of Kul'bin's technique: 'Without recognising the mixture of colours and by smearing them, he attains a variety of tones by placing several dabs of various colours next to one another.'[27] Despite some reservations that Kul'bin was being over-ambitious in attempting to express the ineffable, he found that he approached 'nature from a completely new angle', and with greatest success, in *Avenue* and the *Crimean studies*.[28] Kravchenko criticised the Pointillism he employed in some works as naive: 'he does not understand colour harmony as he should, and in his studies presents brightly coloured images of the human body, which even from afar do not lose their false speckled appearance.'[29] On the other hand, Simonovich noted that 'Kul'bin... excels in a prismatic medley, remarkably softened, which is evidence of a certain strength of colour.'[30] These comments by critics are reinforced by the artist Petrov-Vodkin, who also left a note about Kul'bin's technique:

> One of the first people I met after my arrival in Petersburg [early November 1908] was Kul'bin... he was studying mosaic painting. He would pick the paste off a crayon and with a small knife daub it on the canvas – I must confess this was a rather confused, but original Pointillism and these exercises ... were not at all lost on the 'exhibitions of the youth'.[31]

Kul'bin's art is dominated by a varied approach. He painted realistic landscapes and portraits, Pointillist studies and, later, simplified, geometricised Cubist and Futurist compositions.[32] Often his early works depict bright coastal scenes (e.g. *Coast at Kuokkala* (Cat. 110?, Private Collection, St Petersburg). Only occasionally does his 'impressionism' appear to have resorted to mythology for its symbols. Indeed, *Siren*, together with *The Monk and the Diva*, are the only works in the 'Modern

Trends' catalogue that are not listed as landscape or portrait studies. Vasilii Kamenskii appears to have described the former, supplementing his description with a revealing note about Kul'bin's proclamation of his ideas:

> Looking at the paintings, Chukovskii was absolutely beside himself and cried out in his thin tenor 'Brilliant! Ravishing! A naked green girl with a violet navel – who is she? From which primitive island? Can I be introduced?...'
>
> 'But why is she green? Couldn't she just as well have been made violet and her navel green? That could be even more elegant,' said Breshko-Breshkovskii.
>
> 'She's a drowned woman,' 'tenored' Chukovskii. Next to the 'Green Woman' stood an unsmiling and scholarly looking doctor in a military frock coat. This middle-aged gentleman with prominent cheekbones and fiery eyes explained: 'We are impressionist artists. On the canvas we give our impression, that is impressio. We reflect things on the canvas as we see them without taking into consideration the banal notions of others about the colour of the body. Everything in the world is relative. Even the sun is seen by some as gold, by others as silver, others as pink and still others as colourless. The artist has the right to see things as they appear to him – that is his absolute right....'
>
> Chukovskii announced loudly: 'That's the artist himself, part-time lecturer at the Military Medical Academy, Doctor Nikolai Ivanovich Kul'bin.'
>
> 'Mad doctor' someone shouted from the crowd...
>
> 'Well what an exhibition! What an Homeric success!' cried Breshko-Breshkovskii...'[33]

Throughout the two years of Triangle's existence Kul'bin acted as its inspiration, spokesman and leader. From the catalogue titles and contemporary reviews it appears that in 1908 many members combined impressionism and symbolism in a similar way to Kul'bin. However, the emphasis was switched to a concentration on mythological motifs and fantasy in the work of two artists, Kalmakov and Shmit-Ryzhova.[34] Indeed, Kornei Chukovskii had already noted the former's *Art Nouveau* tendency at the 1907 'Autumn' exhibition where he had contributed, among other things, some *Salome* sketches: 'a certain Mr Kalmakov has stirred Stück, Klinger, Sasha Schneider and Beardsley into one ugly mixture and added his own complete graphic inability, poverty of imagination, utter disharmony of line, and all the colours of the rainbow....'[35]

Kalmakov's symbolism is based in the imagination and exotic rather than in direct and detailed observation of nature. He depicts swan princesses and Eastern princesses with snakes with a morbid sensuality. Simonovich described some of his watercolours at 'Modern Trends':

> There are beautiful colour combinations in his *Tropical* where the artist has succeeded in catching in colour and line an original exotic motif... His *Evening* is more successful: on a background shot with copper trees is a green bench and, as if wilting in the evening melancholy, a statue. This is a most candid work, flowing from a momentary impression – something which cannot be said of his major canvases, *Moloch* and *Centaur*, where one feels the strong influence of

Stück without the temperament of Stück; or more precisely his paraphrasing of an already well used stereotyped symbol, that has come into fashion from the ball which Belkin and Stück began rolling.[36]

Yanchevetskii also noted Kalmakov's fantastic symbolism: 'His *Eros,* drawn in imitation of medieval frescoes, in hazy tones, is beautiful: a huge centaur rushes across the glade under the light of the rising moon. The exotic picture *Tropical* has a quite original fantasia with the ornamentation of the Polynesian islands.'[37]

Elaborate 'Secessionist' imagery and treatment was rare in Triangle, Ludmila Shmit-Ryzhova apparently being the only other artist to exploit it in her four works, *The Dance of Salome*, *Salome*, *Eastern Fantasy* and *The Worship of Gold*. The critic L'dov considered the works 'pure imitations of Vrubel' while Simonovich felt the fantastic imagery executed 'with much taste, even too much taste'– to the extent that the prettiness of the *Salome* paintings prevented them from conveying the terrifying emotions of the Biblical tale.

Other Triangle artists included three who, through their participation in the Union of Youth, were to play significant roles in the development of the Petersburg avant-garde. The first was Eduard Karlovich Spandikov (1875–1929), a co-founder in 1909 of the Union of Youth, who had arrived in Petersburg from Poland in order to continue his career in medicine. Simultaneously he began to study at a private Petersburg art school.

Spandikov's work fits in with the general *fin-de-siècle* tendency of Triangle. He exhibited seventeen works, the majority of which appear to have been sketches in the manner of Toulouse-Lautrec or Steinlen. The only works with titles were *Thoughts*, *Dance* and *Masks*. Simonovich noticed a dilettantism, 'a superficiality of knowledge and absence of form'. He did not deny their effectiveness or the artist's talent, but felt that Spandikov had 'locked himself in the narrow field of painterly sketches and stands at an impasse before the more important problems'.

In 1908 and subsequent years Spandikov's work appears eclectic – ranging from an Ensor-like interest in masks, death and sleep-walkers to a Redon-like study of nature and the psyche. From autumn 1908 his illustrations were often reproduced in the first issues of *Spring*, a new journal 'of independent writers and artists', edited by Kamenskii. This work was highly diverse: Toulouse-Lautrec is recalled in a big black and white sketch of a can-can dancer; a debt to Degas' depictions of women from unusual viewpoints is evident in a trapezist swinging high above the crowd; Beardsley's eroticism has inspired the delicate rhythmic decoration in some black and white drawings of prostitute figures and women in hats; and finally, in an abstract swirl of moving form there is an echo of Van de Velde's *Ornament of Fruit* (1892) as the linear rhythms used to express movement leave nature unrecognisable.

**17**

Zoya Yakovlevna Mostova (1884–1972) had moved to Petersburg after graduating from the Kiev Art College in 1905. Although she went on to develop a style of bright colours and simplified form closely related to that of Petrov-Vodkin and other World of Art artists, this was not apparent in 1908. Her exhibits included *The Kiss*, *In the Tavrian Garden*, *On the Islands* and *Hollyhocks*, suggestive of diverse subject matter, if not style. L'dov noted the symbolism of two other paintings:

> *Premonition* [cat. 182] depicts a carefree young girl, walking through a green glade; in the foreground are dark apparitions that personify the future cares of humdrum life. In *The Poet* [cat. 185] a 'disfigured' decadent, around whom crowd admiring, bewildered and derisive female listeners is humorously portrayed. The painting has been considered and executed very interestingly.[38]

Any suggestion of a debt to the 'Blue Rose' artists in Mostova's work, and, indeed in that of any Triangle exhibitor, is difficult to substantiate fully since the Petersburg critics, who were aware of the work of Kuznetsov, Milioti, Utkin and Sar'yan through the virtually simultaneous 'Wreath' show, made no comparison.[39] Still, the titles of work by Meri Anders and Iosif Solomonovich Shkol'nik (1883–1926),[40] the future secretary of the Union of Youth, such as the latter's *Bright Night*, *Autumn*, *Boredom*, *Sadness* and *The End of the Day*, suggest a pervasive interest in the evocation of emotional mood and atmosphere through the study of nature. This concern with melancholy and transience was probably inspired by similar sources – Vrubel, Borisov-Musatov, von Hofmann, Munch and the literary symbolism of Maeterlinck and Verhaeren.

It would seem then that in 1908 the art of Triangle was predominantly symbolist and symbolist-impressionist. Both styles retain a fundamental concern with the nature of reality, be it metaphysical, optical or both. While symbolism sought the expression of the psyche's relation to nature, impressionism was concerned with conveying intrinsic characteristics of the external world. In Triangle, and in Kul'bin's ideas, these approaches became mixed, perhaps unsurprisingly since they both infer a rejection of the illusory elements of establishment realism, in art that is at once intuitive, analytical and fantastic. However, in 1908 the problems seem only beginning to be tackled and the results of little note.

It is worth briefly mentioning the contribution of 'Wreath' to 'Modern Trends', since this radical group was highly significant in terms of the future development of the Petersburg avant-garde. It also maintained closest contact with Triangle. Artists often appeared in both groups, or changed between the groups, in various exhibitions. Moreover, Wreath artists also subsequently joined the Union of Youth. Wreath, free from Triangle's symbolism, and evidently concentrating on the study of form to a greater extent, was, nevertheless, characterised by a heterogeneous identity.

Wreath was dominated by the Burlyuk family at 'Modern Trends'.

Many of the participants in its first exhibition, 'Wreath-Stefanos' (Moscow, January 1908)[41] were absent, as were all those from the March 'Wreath' show in Petersburg. In fact, the latter was an exhibition of a different 'Wreath' group which consisted of ten artists, only one of whom, Anisfel'd, had previously exhibited.[42] However, this March 'Wreath' exhibition, did attract as exhibitors four artists from the 'Wreath-Stefanos' show (Larionov, Utkin, Fon-Vizin and Bromirskii), as well as Pavel Kuznetsov, Nikolai Milioti and Feofilaktov.[43] The reasons why the Burlyuks and Lentulov did not participate in the Petersburg 'Wreath' are unclear, but their absence hints at new experiments with form, that the sponsor, Makovskii, could not accommodate. While he welcomed the 'dreamprint' art of the Blue Rose he also expressed the belief that art could have no future through the further dematerialisation of nature and abstraction common to primitivism.[44]

On 8 April 1908 David Burlyuk wrote to Larionov with the following request: 'In Peter[sburg] our Wreath will be at the 'Exhibition of Free Groups'... Send your works and those of Natalya Sergeevna Goncharova... Invite others... Get Fon-Vizin... Yakulov would be good.'[45] However, perhaps due to their participation in the first Golden Fleece salon in Moscow, with the cream of the new French artists,[46] these artists did not appear, and their collaboration with Burlyuk was left until November at the Kiev show, 'The Link'. Thus the Wreath section at 'Modern Trends' comprised just six artists: Ludmila, David and Vladimir Burlyuk (each of whom contributed over twenty works), the sculptor Vasilii Kuznetsov, Aristarkh Lentulov and Aleksandra Ekster.[47] Many exhibits had been at 'Wreath-Stefanos' and for this reason it is worth quoting at length, Muratov's characterisation of that show:

> It was said somewhere that this exhibition is a continuation of last year's 'Blue Rose', but actually this is absolutely incorrect... There is no fundamental similarity between these exhibitions. In fact at 'Wreath' there is a whole group of searchers for new techniques which would scarcely find itself at home in the 'Blue Rose'. This group is highly noticeable at the exhibition and it is mainly responsible for the heavy, and oppressive impression that 'Wreath' produces. Nowhere else in Russian painting has such a dead, cold and meaningless concentration on technique appeared so openly as in the works of the Burlyuk family. Everything is abandoned here – soul, nature, the eternal aims of art. Here everything is sacrificed to new brush technique, new forms and grouping of daubs. However, in David and Ludmila Burlyuk this is not new - this is simply an echo of that which the Paris *Salon des Indépendants* went crazy about three or four years ago... Mr. Lentulov joins the Burlyuk family with his artisan painting.'[48]

At 'Modern Trends' Wreath was regarded as 'revolutionary'[49] and as 'artists who recognise the abstract form of nature, but who treat it with complete originality.'[50] The critics, however, differed on the merits of the

'simplification of form... taken to absolute naivety'.[51] Vladimir Davidovich Burlyuk (1886–1917), who exhibited twenty-five untitled studies and paintings, attracted most attention. He had started exhibiting in Moscow a year earlier but, unlike his elder brother and sister, had never before shown in St Petersburg. Muratov described his approach as seen at 'Wreath-Stefanos'

> he [Vladimir Burlyuk] has invented his own technique, at least, we have never before seen such right-angled strokes with dots in the middle... It is easy to laugh at this 'patch' technique, but... what exactly did the artist want with all his squares and dots? Apparently he wanted to represent, almost to draw, the air.[52]

Burlyuk's works at 'Modern Trends' were also in this 'coloured cobble-stone' style. Dubl'-Ve complained that his '*Hunter* is simply ugly daubs reminiscent of a signboard clumsily painted by a house-decorator'. Simonovich was more explicit:

> He displays confused attempts to find new methods for the expression of new painterly ideas in the covering of the human body, faces and background of the paintings with little squares, circles and other geometrical and non-geometrical figures. This is all the more vexing here because some works, e.g. *Woman in Blue*, show a fine artistic taste.[53]

For Burlyuk the artist was able to abdicate much of his responsibility for the work, leaving it to the viewer to find his own meaning. In short, by empathising with the barbaric energy, integrity and immediacy of the signboard painter, but without his obvious functional aims, he challenged the meaning and public conception of a work of art. Compositions become asymmetrical; one point perspective abandoned, viewpoints ambiguous and forms defined by crude *cloisonné* technique, bold brushstrokes and unmixed colour. In other words painting now responded first to the principles of Russian folk arts, and especially to the signboard and *lubok*, where simplified figures often appear represented in two-dimensional space against a flat ground.

Unlike his brother, David Davidovich Burlyuk (1882–1967) was regarded positively by the critics of 'Modern Trends' for his Post-Impressionism, even though he had found little sympathy for his earlier appearances in Petersburg.[54] Indeed, the observation of nature in his work was even acclaimed as: 'striking in its airiness and soft tonal harmonies. The triptych [*Views of an Estate in the Tavria Guberniya*] is one of the strongest works. The artist has expressed the space and true nature of the hilly landscape.'[55] Furthermore, Simonovich noted that:

> Burlyuk has developed his technique, combining discrete Pointillism with broad decorative strokes. Tonally gentle and delicate, his landscapes are profoundly poetic and the striving for original technique has not killed a sincere and deep love of nature. His *Garden in Flower* is one of the most beautiful paintings at the exhibition.[56]

Despite recent claims that Aristarkh Vasil'evich Lentulov (1882–1943) was employing a style close to the atmospheric symbolism of Borisov-Musatov and Kuznetsov at this time,[57] no evidence of this can be found in what is known of his 'Modern Trends' exhibits. In fact, his appearance here, rather than at the March 'Wreath' show or the Golden Fleece salon, could be seen to contradict this. But for two new studies and a portrait, Lentulov's contributions to 'Modern Trends' were the same as the 'artisan painting' he had shown at Wreath-Stefanos. Even so his work found critical approval. L'dov, for instance, found the traditional viewpoint and construction of form in his portraits was not out of keeping with the simplifications employed: 'His *Portrait of E.P. Kul'bina* consists of just a few tones, but in them you feel the observation of life and a striving to express the truth.'[58] Simonovich, who regarded the artist as the 'most mature' of the group, added: '[He] intelligently and delicately interprets the influence of French Neo-Impressionism and in his decorative works has found those gentle outlines which are most aptly suited to this technique.'[59]

Overall Wreath showed a greater focus on formal problems and technique than the predominant realist symbolism in Triangle. Indeed, the Wreath artists, bound together by their rejection of academicism and desire for a more socially active, revitalised art, were the more innovative and daring in their borrowing from Post-Impressionism. To this end they were willing to shock and defy, to ignore all metaphysical symbolism and firmly plant their feet in the conscious, spatio-temporal world.

In the two years following 'Modern Trends' Kul'bin organised three exhibitions for Triangle (two in St Petersburg and one in Vilna) which supplemented the selection of those artists he had introduced to the Petersburg public in 1908 with several other young painters. While a few slipped into obscurity, many, such as Sophia Baudouin de Courtenay, Boris Grigor'ev, Vladimir Kozlinskii, Evgenii Pskovitinov and Elena Guro, went on to make significant contributions to Russian art in the following decade. At least twelve of the artists discovered by Kul'bin were to be involved in founding the Union of Youth.

Through its four exhibitions, Triangle's position in relation to other artistic groups gradually became defined. Although the group had a tolerant attitude towards the aesthetic attitudes of its members, some artists felt that there was a general lack of skill and potential for innovation, and they began to leave the group in 1909. It was no coincidence that by mid-1910 the Union of Youth Society of Artists had been officially registered with the City Governor's office and Triangle had ceased to be active.

On 9 March 1909, simultaneous with his course on 'Free Art as the Basis of Life' at the Peoples' University, Kul'bin's second exhibition, 'The Impressionists-Triangle', opened in St Petersburg. In contrast with the

halls of The Passage used in 1908, the Triangle show of 1909 was held in the vaulted premises of an old fruit shop 'under the furnished rooms of the "Bristol"'.[60] Furthermore

> the exhibition has been organised with some kind of special artistic cosiness, like that of Parisian Bohemianism. The public come straight from the street in their overcoats and furs and into the exhibition.... A stove, covered with the pictures of Bystrenin, burns all day. Alongside are antique armchairs, the sort you find in the manor-houses of country estates. There is the desire to sit down with a book and read by the sound of the brightly blazing logs...[61]

The three-coloured triangle was to be seen: 'everywhere – on the signboard, on the catalogues, on the coat-hanger tags, on the ceiling of the exhibition premises'.[62] The 'furnishing and architectural sections' were described as 'the latest word in modernism'.[63] In addition, Kul'bin sought to make the link between the arts more tangible for the spectators and provided a musical accompaniment to the paintings.[64] This was intended to be the aural expression of what was expressed visually on the canvases, in order to provide a more holistic experience of art. Indeed, of all Kul'bin's exhibitions, that of 1909 most vividly embodied his concern with the psyche's role in hearing and vision. In his article 'Colour Music' he discussed the interrelation of colour and sound, concluding that colour could be perceived 'from the influence of sounds on the optical apparatus of the eye and brain' and likewise that sounds could be perceived due to the action of colours.[65]

The considerable interest in Russia in the synaesthesia of colour and music no doubt encouraged – and was encouraged by – the inherent, and sometimes overt, musicality of the symbolists' paintings (Ïiurlionis, Kuznetsov and Mikhail Shitov were attempting to 'paint' music). Ïiurlionis, who was first a composer and then a painter, had moved temporarily to Petersburg in the autumn of 1908. Within a few months he exhibited six works with musical titles (four 'sonatas' and two 'fugues') at Makovskii's 'Salon' in January 1909. In addition, Skryabin and Tcherepnin had given recitals and Greek dances had been performed at the Blue Rose exhibition, although then critical attention had been drawn 'to the lack of any co-ordinating theme between the paintings and the literary and musical recitals, which had the effect of weakening rather than enhancing the potential collective impact'.[66] Still, Rimskii-Korsakov's study of his own colour hearing was published in 1908[67] and his ideas linking notes and colours were taken up by Skryabin in 1907. Skryabin planned a *gesamtkunstwerk* and began by developing a colour organ for his 'Prometheus' symphony in 1908. His music is patently sensuous and has a languorous, harmonic feeling strongly suggestive of slowly shifting colours and clearly in keeping with the symbolist aesthetic.

Kul'bin sought to establish the association of pyschological vision and psychological hearing as a basis for his colour-music theory:

Every sensation has a peculiarity, a quality which in psychology is called coloration, qualitative colouring or qualitative tones. Green colour, the note 'fa', a sour taste, the smell of grass etc., are all pecularities which comprise a common area in the psyche, i.e. in the world. All these are qualities, the materials from which the subjective aesthetic experience is composed, like a picture is composed of colours.[68]

To be more representative of our experience of the world, Kul'bin called for microtonal music.[69] He contrasted the comparatively weak association between colour and sound in Schumann with the strongly associative 'colour' music of Skryabin and Drozdov, and used the latter to illustrate the musicality of his group's works of art.

'The Impressionists' of 1909 contained more than 200 works by a total of thirty-six artists, a considerable expansion on the Triangle section of 'Modern Trends'.[70] The fluid quality of the affiliations among the Russian avant-garde at the time is underlined by the composition of Triangle. Just ten artists from 1908 remained, though these were joined by Nechaev and Vaulin who had then appeared independently. Of the twenty-two new exhibitors, at least seventeen (including Matyushin, Guro, Grigor'ev and Savelli Shleifer) showed for the first time. In addition, the future Futurist poets Kamenskii and Aleksei Kruchenykh, both of whom worked with Kul'bin after the Union of Youth split from Triangle, showed one work each.

It could be argued that Kul'bin lacked discrimination in his choice of artists, or, alternatively, that he was one of the most innovatory and visionary exhibition organisers in Russia. Certainly several Triangle artists were Kul'bin's pupils, others were total beginners and some were already well established. Still others, art students and graduates, some newly arrived in the capital from the provinces, were probably persuaded to exhibit more by Kul'bin's enthusiasm and the unexpected chance to show their work to the public, than by his ideas.

Continuing the tendencies seen in Triangle in 1908, the group retained a predilection for realistic and idealistic symbolism. For Breshko-Breshkovskii the overall impression was positive: 'This is a group of likeable people and artists... They are fanatics, enthuasists, searchers and, at times, grown-up children. Anything you like, but not charlatans. Their emblem is the mystical triangle, as if they are some kind of mysterious corporation or caste.'[71] He went on to explain Kul'bin's apparently objectless canvases:

in every inch of the canvas you see the thinker, searching for some new expression by means of colour. One study, for example, constitutes a simple combination of colours. There is no need to look in the catalogue because the last thing the artist sought to represent is some object. He has given himself exclusively coloristic concerns and the form has not even entered into his head.[72]

Kul'bin's *The Crimea* (cat. 76?, Russian Museum), which is almost identical to a work seen in the group exhibition photograph (Plate 2), is an effective study of colour and light. Spatial recession is described by a curving line of conifers. The high viewpoint enables the artist almost to fill the entire canvas with the mountains, constructed from a medley of small and densely worked, asymmetrical, blue and red blocks of colour. At the top, soft greens and tans in a broad diagonal brushstroke indicate the sky. In the middle distance a twin-towered church stands on an outgrowth of rock, while in the foreground flat-roofed houses and a crouched figure with two large bowls are visible. More small, white buildings follow the line of the coast in the centre of the work. These representational elements are incidental. Here Kul'bin's study of nature concentrates on the momentary impressions of light and colour.

The painting on the far left of Plate 2 could be Shmit-Ryzhova's *The Song of the Indian Guest from 'Sadko'* (cat. 174). The figure of the half-naked young woman surrounded by the decorative patterning of the carpet and wall, together with a swirling transparent veil, are clear enough for the scene to be recognisable. Kul'bin recommended the painting of Rimskii-Korsakov's 'Song of the Indian Guest' as a manifestation of true colour music: '"He who hears this song, forgets everything,"' and the bird covers the blue sea with its wings, and brightly coloured precious stones are dreamed up. This is real colour music.'[73]

The critics agreed that Kalmakov, who was now beginning to establish a reputation as an artist of some originality, was one of the most talented artists of Triangle. He showed two works with musical associations, *Prelude* and *The Musician*; a series of costume and set designs for Leonid Andreev's *Black Masks*; and a sketch for the backdrop of a censored production of *Salome* (ex-catalogue). Breshko-Breshkovskii supplied a vivid description of the latter:

> A nightmarish monster, begotten of disturbed, feverish dreams, turns black, like a titanic deity, like an obelisk it towers up among blood-stained wreathes… while below, with a myriad of sharp-clawed paws the monster tramples on a whole hetacomb of human skulls. They are pierced and penetrated to the brain by the talons. And the convulsively twisted masks of the skulls are distorted by some excruciating and crazy, voluptuous ecstasy.[74]

Clearly, the grotesque and exotic elements of Andreev's and Wilde's plays were sympathetic to Kalmakov's morbid imagination. Indeed, despite the 'psychological' aspect of his work, Kalmakov never again exhibited with Triangle, preferring to concentrate on his theatrical work.

N. M. Sinyagin, who contributed to all four of Kul'bin's shows, received praise from Yanchevetskii for his *fin-de-siècle* interests: 'Sinyagin is very interesting in his *Tambourine* [cat. 133a], where he seeks to express the impression of the rhythmical sounds, and in his *Cyclops* [cat. 133b]

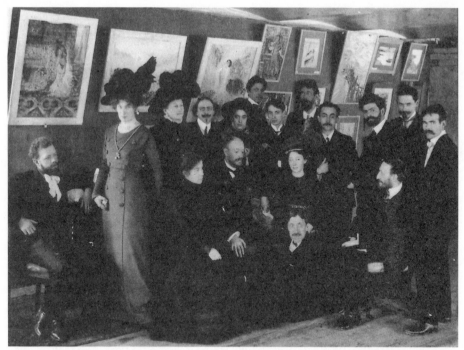

**2** Photo of The Impressionists/Triangle Group at their Exhibition, St Petersburg, March 1909

where the large eye sombrely looks around in the midst of a stylised Japanese (after Hokusai) background.'[75] Later, he also showed *The Singer has Fallen Silent, The Count has been Completed, Haunting Thought, Morning Prayer* and *The Optimistic Woman*, indicative of a prevailing Maeterlinckian desire to depict contemplative, rather than active, moments.

An interest in symbolism and the representation of sound was also apparent in the exhibits of Boris Grigor'ev (e.g. *Forest Shadows, Nightmare, Saturday Peal,* and *In a Strange Forest*), Aleksandr Nikolaev (*Balalaika Player* and *The Green Girl (from Kalmuck mythology)* and Sophia Ivanovna Baudouin de Courtenay (1889-1967) (*Sketch to Mirbeau, Night* and *In the Copse*).[76] According to Breshko-Breshkovskii, Kul'bin taught his students to represent impressions of sound by using concentric spirals – a technique described by the critic as 'successful' in Baudouin de Courtenay's case:

> Baudouin de Courtenay illustrates one of the most terrifying moments from Octave Mirbeau's *Garden of Tortures* (the whole of this novel is unbroken terror). The one doomed to perish is tortured and made to suffer under the continuous ringing of a large bell. The ring torments and shakes the nervous system, driving one mad... And when you look at the blood-brick red gamut of colour and guess that among this orgy of malicious pigments is the impression **25**

of a bell, then you begin to believe in Miss Baudouin de Courtenay. Indeed, from these shaking and vibrating sounds, which so murderously fill the air, it is possible to go mad, to turn into an idiot for the rest of your life, to be shaken to death....[77]

This interpretation of Mirbeau[78] suggests that Baudouin de Courtenay, an artist who was subsequently to join the Union of Youth, was attracted to Kul'bin's symbolist impressionism. She has synthesised a grotesque, aural motif with an apparently polyphonic play of colour. Breshko-Breshkovskii implied that the result is representative of the synaesthetic ideas promulgated by Kul'bin. Yet colour is given an expressive, emotional force that is far more psychologically intense than Kul'bin's own work, and, perhaps closer to Munch in *The Scream* (1893), seems to cross the boundary between being visualisations of sound waves and externalisations of *Angst*.

The Bessarabian Avgust Ivanovich Baller (1879–1962)[79] and his wife Lidiya Arionesko-Baller[80] also crossed from Triangle to the Union of Youth, Baller being the only contributor to both Kul'bin's *The Studio of Impressionists* and the *Union of Youth* journal.[81] His early work seems to have been a mixture of the grotesque and the lyrical – two aspects which were reflected in the works shown at 'The Impressionists', as well as in the earlier 'Autumn' exhibition of September 1907.

At the 'Autumn' exhibition, Baller showed several Petersburg 'nocturnes' and interiors that recalled the uneffusive style of Benois. With these he exhibited three curious works (*The Halo*, *Furioso* and *Astronomer*), the first two of which were from a series he called '*Cycle Macabre*'. They had an overtly allegorical content, quite possibly derived from the Dutch and Belgian symbolists, such as Ensor, Toorop and Delville, who Baller would have been able to see during his years in Holland. *Furioso*, with its musical connotations, was depicted by a skeleton running across a field with a gun on its back, and *The Halo* had little underwater air-bubbles in the form of a halo above a skull. In 1909 this dual tendency of the macabre and the poetic, recalling the thematic dichotomy seen in the Blue Rose, and particularly Kuznetsov's work of 1907–8, was embodied in three pastel 'nocturnes' of Holland, and in the 'drawing of disfigurement'[82] (again suggestive of Ensor) expressed in *Indian Puppet Theatre*.

Symbolist inclinations were also apparent in Leonid Yakovlevich Mitel'man. He, together with Evgenii Yakovlevich Sagadaichnyi and Savelii Yakovlevich Shleifer,[83] who likewise exhibited with Triangle for the first and last time at 'The Impressionists', went on to make a significant contribution to the Union of Youth. All three were students at the Petersburg Academy. Mitel'man showed fourteen works, including three with musical references (*Melody*, *Violin*, *Adagio*), and three which caught different moments of evening, (*Towards Evening*, *Evening* and *Late Evening*). Breshko-Breshkovskii noted: 'Mitel'man is a rather refined draughtsman.

His little works are interesting, although he has yet to break free from imitating Somov. In the affected delicacy of the firmly marked lines there is something Somov-like, that is sickly-refined and at times exotic.'[84]

It is interesting to compare this account with that given by Varvara Bubnova, who shared a studio at the Academy with Mitel'man and was taught by the same professor, the landscapist Nikolai Dubovskoi.[85] Bubnova remembered her colleague as a gifted artist who had an original method of composing a painting: 'he drew random spots on little pieces of cardboard and then used his imagination to either extract or insert grandiose landscapes in miniature.' This method could account for the exaggeratedly precious quality of the works noted by Breshko-Breshkovskii as well as the need for bold outlines.

Besides the aforementioned artists, Mostova (six flower and landscape studies), Spandikov (twenty-two works on the theme of men and women) and Shkol'nik (fifteen paintings with symbolist-impressionist subjects, e.g.: *Melody of Spring, From Memory, Anguish, Silence* and several that related to the passing of evening into night), there were two others in the show, Mikhail Vasil'evich Matyushin (1861–1934), his wife Elena Genrikovna Guro (1877–1913) who were to play important roles in the Union of Youth. Guro showed five drawings from *Hurdy-Gurdy* [*Sharmanka*] (St Petersburg, 1909). This was her first book and it contained a series of small prose pieces, poems and plays accompanied by some little illustrations. The stream-of-consciousness literary style was matched by the drawings in which a childlike, deliberately naive quality was also apparent: little stars, tiny leaves, trees and circles among the text; lanterns and curtains; a thin part of a faflade with a window, a drainpipe, an arched door and the cobbles of the street; pine trees (a recurring motif); stairs; and a bucket. Guro concentrated on the small, often unnoticed objects in life. She discarded one-point perspective, modelling, conventional viewpoints and subject matter and sought to capture the fleeting moment.

Matyushin, who exhibited three studies of the southern Caucasian Coast, was influenced by a similar attitude towards subject matter. Central to his approach, and possibly stimulated by Kul'bin's theories concerning perception, was an expanded awareness of man's relation with nature. Certainly, his musical training and his painterly experiments led to panpsychism. In 1912 he was to argue that through observing physical reality the artists experienced a higher order of reality, generally equated with new spatial dimensions and the supernatural: 'the branches of trees are like bronchial tubes – the basic element of respiration… The sacred earth breathes through them, the earth breathes through the sky. The result is a complete circle of earthly and celestial metabolism. They are the signs of an ulterior life.'[86] He considered that humans were physiologically capable of expanding their vision in order to attain this new perception.[87] By focusing atten-

tion on the organic, universal rhythms of nature, through both intuitive and conscious study, such an expanded vision could be attained.

This notion, expressed in different ways by both Matyushin and Kul'bin, appears to stem from the latter's world of medical psychology and its recent impact on art. Since the late 1870s, the psychologist Jean-Martin Charcot's study of neurological systems had given the French *Art Nouveau* movement a basis for its organic creations. He defined the human being as suspended between stimulus and response: the external world, like that of Matyushin and Kul'bin, acted directly on the internal world of the nerves. Kul'bin described the process: 'The artist, studying nature, arouses within himself a flair for intuition. Penetrating into the ideas of his great teacher, he acquires the ability to create something unprecedented yet beautiful... Form is seen as a kind of energy.'[88]

The correspondence of Kul'bin's and Charcot's ideas may have been coincidental, but it is, nonetheless, striking and tells of a similar cultural ambience. Similarly, a debt to the Goncourt brothers may be posited, since they regarded the neurasthenic state reached by continual mental effort unrelieved by physical action as 'the ground of existence for the modern artist'.[89] They considered overdeveloping the nervous sensibilities to be the means by which the clinical analysis of impressions and sensations could be invested with artistic form. Only then could truth about the self and the nature of reality be revealed: 'I have come to the... conclusion that observation, instead of blunting my sensibilities, has extended them, developed them; left me laid bare.'[90] It is tempting to suggest that the frenetic activity of both Matyushin and Kul'bin at this time, their prodigious creative output and extreme irritability and sensitivity, were the results of just such a state of neurasthenia.

Kul'bin allowed the artist to depict freely whatever he chose in order to create a picture without any fixed interpretation. Matyushin, on the other hand, like Guro, concentrated more on the representation of carefully selected, unexceptional, objects in the local environment. Matyushin, however, was far more restricted in his selection, concentrating almost exclusively on landscape and portraiture.[91]

Matyushin's surviving pre-1910 work consists of several landscape studies based on 'expanded colour impressionism'[92] where dematerialised, flowing forms represent his sense of organic movement in nature. There is an echo of Kul'bin's ideas, and pictorial solutions, concerning the unity of matter. Yet Matyushin concentrated on the representation of a particular visual and spatial perception, while Kul'bin introduced a greater degree of symbolism into his work. In this Kul'bin is probably closer to Guro, for she could also divorce her art from nature, while examining the intimate relationship between the consciousness of the artist and the object depicted.

'The Impressionists' 1909 exhibition in St Petersburg closed on 12

April. On the invitation of the Vilna Art Society, a new Triangle show opened in Vilna, Lithuania on 26 December 1909.[93] Again it continued the symbolist-impressionist tendency already seen, even though artists such as Guro, Matyushin, Shkol'nik, Shleifer, Spandikov, Mitel'man and Kalmakov had now disappeared, and of the twenty-three contributors, six had never before participated with the group (Evseev, Shmit, Rybakov, Kozlinskii, Krukovskaya and Vashchenko). Most significant of these was Konstantin Ivanovich Evseev (1879–1944),[94] who became a co-founder of the Union of Youth. One of the few artists who supported both groups in 1909 and 1910, his works shown with Triangle were dominated by landscapes and still-lifes. At Vilna he showed several *Haystacks*, and, of all the exhibitors, he alone seems attracted to an orthodox interpretation of French Impressionism, and Monet in particular.[95]

The exhibition ran until 20 January 1910 and was complemented by Kul'bin's talks in which he further elaborated his psycho-symbolist approach.[96] The first two of these, 'New Paths in Art: literature, music and the plastic arts' and 'Impressionism (literature, the plastic arts and music)', were similar. Both were accompanied by various declamations as well as visual and musical illustrations, e.g. Grieg's 'Procession of the Gnomes', the prelude and nocturne to Skryabin's Opus No.9, a Bach aria, an aria from Grétry's opera 'Richard the Lionheart' and 'Lilac' by Rachmaninov; slides and photographs of works by Böcklin, von Stück and Wyspiański,[97] as well as of classical buildings; and paintings by the Burlyuks and others, showing the new freeing of colour from form: 'violet cows, a chocolate view, iridescent trees growing with roots upwards… orange horses'.[98]

One reviewer noted that Kul'bin concentrated on the psychological basis of art and claimed that art is to express the intimate experiences of the artist spontaneously, without preconception, stylisation or deliberation.[99] He attacked traditional distinctions of the arts and called for a unified art in which music joined with the plastic arts, the plastic arts with literature, and literature with music. He felt that a common creative spirit united the arts and the essence of this should be conveyed in the artwork. He reiterated his fundamental tenet: 'The world – this is our sensations.' The artist, with a peculiar sensibility, was to express perception of nature and provoke a definite sensation in the viewer. For this purpose dissonance, as well as harmony, could be employed – Kul'bin used Skryabin's music to demonstrate that the listener associates certain disharmonic sounds with previously experienced impressions.

Kul'bin grounded his theory in a mechanistic worldview, asserting, as in 'Colour Music', that sensations of light are provoked by aural phenomena – in other words, sounds in the ears may simultaneously stimulate a perception of light in the eyes (closed or open). He emphasised that it was important to communicate the basic traits of objects and phenomena, but to

**29**

omit details – the work of art being supplemented by man's inner experiences. These ideas have implications for Larionov's subsequent development of Rayism, which claimed to depict the immaterial matter between objects, and Malevich's and Kruchenykh's art of *zaum*, which expressed the perception of the world according to an altered state of consciousness. For all these artists, the work of art was no longer to be merely a representation of the visual world, but of the broader, psychical world.

The last Triangle show (19 March to 14 April 1910), while apparently not indicating any radical departures from the trends already noted, extended Kul'bin's notion of a synthesis of the arts by including a joint exhibition of drawings and autographs of writers (both famous and non-famous).[100] It also included a Wreath section, folk sculptures, signboards, examples of modern Japanese drawing and French and Dutch posters. It opened at the same time as the Union of Youth's first show, the Union of Russian Artists and the tour of Izdebskii's Salon.[101] There were thirteen new exhibitors, some of whom were already established artists.[102] Guro, Matyushin and Kamenskii were present as non-member exhibitors of Wreath. Allegiances were further confused by the appearance of Kul'bin, David Burlyuk and Konstantin Dydyshko in both Wreath and Triangle.

At the opening of the exhibition Kul'bin gave a short report. He examined the denial of academic rules; anatomy and symmetry; and the depiction of dissonance – referring in particular to the Wreath group. These artists, he said, cultivated the absence of harmony and the absence of the beautiful – they denied the whole history of painting. This did not mean they sought to turn the beautiful into the ugly or to paint scandalously. Kul'bin cited Vrubel's violation of rules in his *Demon* paintings as an important precedent, at least for himself. Vrubel had not sought to fight the beautiful, but had attempted to embody it with new methods: this allowed Kul'bin to search for new forms of beauty through an intuitive, free art.

Interestingly suggestive of the relevance of Kul'bin's symbolism to later developments, his desciption of the creative process included the following: 'It is possible to violate all academic rules, trying to cross to the so-called "fourth dimension", trying to convey one's inner spiritual world – thus the artist sincerely represents on the canvas how his environment appears to him.'[103] Such an early reference to the fourth dimension, albeit vague and reminiscent of his psychological-impressionism, was the first by a Russian artist and it presages the importance that this philosophical and spatial idea was to have on Russian avant-garde artists, not least the Union of Youth members Malevich and Matyushin.

Apparently, Kul'bin's notion of the fourth dimension did not involve the visualisation of hyperspace by means of time and motion in time as in the Promethean philosophy of Uspenskii.[104] Even so, his writing, full of references to 'intuition', 'feeling, will and consciousness' and the need to

represent not things, but their sensation, echoes the vocabulary employed in Uspenskii's first essay on the subject, *The Fourth Dimension*, published a few months earlier.[105] Furthermore, Kul'bin, with his notion of art as revelation, would almost certainly have agreed with Uspenskii's subsequently expressed view that the seeming three-dimensionality of the world is a property not of that world, but of 'psychic apparatus'[106] and that 'art in its highest manifestations is a path to cosmic consciousness'.[107]

In 1910, Kul'bin acknowledged the desirability of depicting motion, but without reference to time:

> My path in art is to represent not only the existing world but also the existing signs of an object. In painting I am not limited by colour and form, but also depict the psyche, sound, motion etc., as far as this is necessary for the reflection of poetic experiences. The world of the artist is the reflection of his feeling, will and consciousness.[108]

His exhibits bore a wide variety of titles and consisted of oils, a series of engravings and wall majolica.[109] Most revealing with regard to his concentration on transitory nature and mood is *Trilogy* (cat. 107). This consisted of three illustrations to Nikolai Evreinov's monodrama 'Performance of Love': *Stylisation of Banality*, *Night of Love* and *Despair*.[110] All three depict a beach somewhere on the Gulf of Finland, where the play is set. Evreinov gives Kul'bin the chance to continue his interest in coastal scenes and to supplement his earlier work with an anthropomorphic element of imagined, rather than actual, mood. This allows the crude stylisation in the pictures.

Evreinov's literary approach is highly pertinent and revealing in the attempt at characterisation of Triangle and Kul'bin. It was also an important precedent for the Union of Youth's theatrical ventures. In his 'Foreword to "Performance of Love"' [Predislovie k "Predstavleniyu lyubvi"'] he wrote that the play was conceived prior to his theory of monodrama, and was the basis for that theory.[111] Monodrama was essentially a reflection of the inner experiences of the subject and their effect on how his surroundings are perceived. Everything is presented as it appears to the single subject. Thus all nature becomes animated and the world described is subordinated to a subjective process of metamorphosis. As the outer world changes with the subject's mood so the viewer is drawn into the experience of the subject. The result is a dynamic, psychological theatricality that coincides with Kul'bin's symbolist beliefs concerning the 'impressionistic' nature of reality. In Evreinov's drama, fantasy and reality are deliberately ambiguous. The identity of the subject, the 'I', appears to shift from the first to the second to the third person, leaving the reader unable to discern which character is its true embodiment. Ultimately, many of the characters reflect an aspect of the subject's being. And as the moods of that being change so does the environment – the sea, pine trees, wind, colours, smells, sounds. In searching for a 'complete drama', as Kul'bin searched

for a unified art, Evreinov employed movement, speech, music and pictorial art in order to express mood.

Evreinov's play describes much that is analogous with Kul'bin's own world. The place is equivalent to Kuokkala where Kul'bin had his dacha, and the actions of the characters on the beach are played out against a typical background of distant music, silence, wind, the sound of the sea and gossiping of passers-by. At first the impressions of two old, ill men are presented, together with the local environment, tainted by their characters and perceptions; then there is the fantasy of a young man about a beautiful princess and his own fated love for 'She' (Klara, a baker's girl); and finally the rejection of the young man, the meeting of the old men with Klara and her new young man, and their banal chatter. The young man is a poet and painter, while the baker's girl is flighty, according to the old men: 'yesterday it was some artist or poet,... today an officer... tomorrow... a Full State Councillor'.[112] Only those knowing Kul'bin could realise that these three personalities were encapsulated in one individual.

Kul'bin's *Stylisation of Banality* depicts the opening scene, described by Evreinov as: 'Spring on the seashore. Nothing special; a kind of banal oleograph.' Two old men, who are named after their physical dispositions (The Catarrhal Subject and the Haemorrhoidal Type), are represented as silhouettes sitting on a bench in the featureless foreground. In contrast, but in keeping with the change of mood in the Second Act, Kul'bin's *Night of Love* is full of swirls of dynamic, bright colour. The sea, shore and sky, together with the squatting, semi-erotic figures and the moonlight on the left, combine in their unmixed tones to create a pantheistic, flowing sense of nature. Kul'bin's fusion of the intuitive and decorative is convincingly evident in this work which depicts the moment when 'I' reaches the climax of his love-making with 'She': when the whole world around him changed.

Finally, *Despair* shows the young man sitting alone on the sand dunes, reading a letter of rejection from his love. In the distance stand other figures. The whole scene is surrounded, unlike the previous pictures, by a proscenium, as if emphasising the play of fantasy with reality. The inscription below reads: '... it begins to tell of the strength of the cup of my anguish. The trees droop, it becomes darker, the pale sunset colours begin to turn purple with a sickly flush, the sea takes on a lead-yellow tinge... The letter... slightly crumpled, many times read, tear-stained....' The mood has changed since the old men, now younger and more cheerful, have left, and 'I' has entered. His despair has dramatic effect on the surroundings: 'There is an impression of interminable grief, desolation and cold....' Kul'bin conveys this through the rhythmic, anxious curves of abstract form. The world becomes unstable and threatening and Kul'bin uses the colours of Evreinov's description, endowing nature and the work with a psychological intensity. Thus the stretch of shoreline, three times transformed due to

the mood of its perceivers, is depicted by Kul'bin in three distinct styles.

Shmit-Ryzhova's contributions also included illustrations to Evreinov's monodrama where nature is again imbued with animate qualities and intimately connected with the response of the individual. Yanchevetskii even found her works the best in the exhibition and their fantastic symbolism (rather than any psychological intensity) evocative of Kul'bin's newly discovered fourth dimension in art:

> All Shmit-Ryzhova's paintings, it seems to me, are that other world of the 'fourth dimension'; she depicts fabulous women, slim with narrow, oblong eyes and bronze bodies; her paintings are full of a special bewitching charm and are so distinctively original that it is impossible to say she imitates someone. She depicts her own special world. For her it is unnecessary to create dissonance and wage war on symmetry. The fairy tales on which her imagination lives are so beautiful, and so talented is she in portraying them that she carries the spectators into the world of their spirit. Her white peacocks and woman, interweaving with lianas, called *Dreams* is especially beautiful.[113]

Lastly, the appearance of Konstantin Vinkent'evich Dydyshko (1876–1932) is worth mentioning as he was to be an important figure in the Union of Youth. Having studied with von Stück and Ažbé in Munich, in 1910 he was a student of Kardovskii's at the Petersburg Academy. His exhibits included a number of studies and sketches in which Yanchevetskii found a sharp distinction: 'As an example of a strange conception of art it is possible to point to the work of Dydyshko. As much as his pencil drawings are conveyed with a light, enchanting melody of lines, his oil paintings are capable of rousing indignation. Moreover, he is finishing the Higher Art School.'[114]

Dydyshko contributed to both the Triangle and Wreath sections, highlighting an overlap in styles between the groups. However, while Kul'bin's pantheist ideas and the introspective intensity of the Triangle exhibits acted as an adequate counterpart to the divisions within the literary symbolist school, by March 1910, when both the symbolist journal *Libra* [Vesy] and *The Golden Fleece* had ceased publication, they were beginning to look passé. Fauve works by Matisse, Vlaminck, Marquet, Derain, Van Dongen, Braque and Friesz were now known to the Russians, largely through their being exhibited in 1909 at the second Golden Fleece Salon[115] and the Izdebskii Salon. In the season of 1909–10, really only in the Neo-Primitivist work of Larionov, Goncharova and the Burlyuks, was a way forward for Russian modernism found that in any way echoed or exploited the Fauves' pictorial solutions (including the use of saturated colour as space and the proto-Cubist experiments of Braque). Thus avoiding the symbolists' notion of transcendentalism they allowed colour to play the part of a subjective and emotional equivalent of space.

Triangle's art and aesthetics showed many of the concerns and motifs of the Russian symbolist writers. The 'impressionism' of Kul'bin and his

group was imbued with the feeling that the visible world is a feeble reflection of the real world. Like both Blok and Bely, the artists considered musical forms to be the most suitable means to recapture the child's moment of intuition – that spontaneous, unencumbered and innocent condition in which the human soul and perception are at their purest.

The belief in experiment and knowledge derived from experience through the senses was reflected most clearly in the art and ideas of Kul'bin and Matyushin. 'Realistic' symbolism dominated Triangle, but the boundaries between 'realistic' and 'idealistic' symbolism were blurred in the psychological approach, and it encompassed numerous styles: a naturalistic, momentary approach to the physical derived from French Impressionism, seen in the work of Evseev and David Burlyuk; decorative *Art Nouveau* in Kalmakov and Shmit-Ryzhova; a Divisionist use of brushstrokes of pure colour seen in Kul'bin and Leonid Baranov; an expressive use of colour as the equivalent of emotion in Baudouin de Courtenay; a synaesthetic use of colour as sound in Nikolaev and Sinyagin. Ultimately, it is this diversity that defines Kul'bin's notion of impressionism, based as it is on his idea of 'free art' and 'the world as a projection of the artist's psyche'.[116]

## References

1 A. Blok, 'Kraski i slova', *Zolotoe runo*, No. 1, 1906, pp. 98–103.

2 D. Imgardt, 'Zhivopis' i revolyutsiya', *Zolotoe runo*, No. 5, 1906, pp. 56–9.

3 P. Stupples, *Pavel Kuznetsov: His Life and Art*, Cambridge, 1989, pp. 86–7.

4 N. Kul'bin, 'Svobodnoe iskusstvo, kak osnova zhizni', *Studiya impressionistov*, St Petersburg, 1910, p. 12.

5 I. Z., 'Lektsiya priv.-dots. N.I. Kul'bina', *Vilenskii kur'er*, 13 January 1910, p. 3.

6 A. Bely, 'Symbolism and Contemporary Art', Vesy, No. 10, 1908, cited from R. E. Peterson (ed. and trans.), *The Russian Symbolists: An Anthology of Critical and Theoretical Writings*, Ann Arbor, 1986, p. 102.

7 N. Kul'bin, 'Salon 1909', *Luch sveta*, 15 January 1909, p. 3.

8 O. B-r. [Bazankur], *Sankt-Peterburgskiya vedomosti*, 26 April 1908, p. 3.

9 The Neo-Realists consisted, except for Bogdanov-Belskii and K. I. Filkovich, of young, unknown artists. Filkovich (1865–1908), who had studied at Petersburg Academy of Arts and in Munich under Ažbé, displayed 'coloured photographs... modernised with a brightly spotted background' (M. S. [Simonovich], 'Sovremennyya napravleniya v iskusstve', *Rech'*, 9 May 1908, pp. 2–3).

The Group of Academic Trends included artists who contributed to Petersburg Society of Artists and the Academy Spring shows. Most significant, however, was the debut of the young sculptor Matvei Genrikhovich Manizer (1891–1966), who subsequently became a leading Soviet sculptor.

The Architectural Group comprised several established architects, including Aleksei Shchusev, Vladimir Shchuko, Aleksandr Tamanov and Nikolai Lansere. Their works ranged from sketches of ecclesiastical buildings to project designs for houses, cafés and an exhibition pavilion.

The Union of Russian Artists, whose Petersburg exhibition had only closed on 30 March, was represented by Bakst (eight sketches), Benois (a stage design for 'Boris Godunov'),

Bilibin (several graphic works) and Ostroumova-Lebedeva (some architectural motifs).

Petr Kuz'mich Vaulin (1870– ?), the majolica 'group', showed over twenty works, including caché-pots, vases, metal tiles and a Yaroslav tiled stove. Having worked at Abramtsevo and Mamontov's Butyrskii ceramics factory in Moscow (where he instructed Vrubel, Matveev and Kuznetsov, among others) from 1890, he moved to Kikerino, not far from St Petersburg, in 1904, in order to open ceramic studios with O. Geldvein. He was responsible for a revival of ancient Greek, Scythian, Indian and Russian motifs in decorative art and was commissioned for the decoration of many buildings throughout Russia (including the Metropol Hotel, Moscow and the Emir of Bukhara's Palace at Zheleznovodsk).

Ferdinandov showed nine works, divided into two groups: 'Subjective Experiences' and 'Problems of Objective Existence', suggesting a relationship with the new introspective trend in Russian painting and Kul'bin's pyschological approach to art. In both groups he appears to have abandoned figurative form in favour of an abstracted representation of reality: 'Ferdinandov's works... depict absolutely nothing. This is just like a dirty painted mosaic where form and idea are totally forgotten. Titles like *Merriment through Dark Shadows* and *Joys of Grey: Dull Boredom* have nothing in common with the absurdities exhibited under glass, which really only give cause for concern about the artist's sanity.' (N. Kravchenko, 'Vystavka sovremennykh techenii v iskusstve', *Novoe vremya*, 30 April 1908, p. 5).

Nechaev, who contributed to all the Triangle exhibitions, showed eight works, dominated by 'views' of hills, e.g. 'the crimson peaks of *Great Mountain*, *The Alps* and the pinkish-reds of *The Day Dies* (K. L'dov. [V-K. N. Rozenblyum] 'Khudozhniki-revolyutsionery', *Birzhevye vedomosti*, No. 10478, 30 April 1908, pp. 3–4). Although the effect was one of 'splodges' (*ibid.*), overall the critics were impressed by the works of a blind artist. As representations of visual imagination and memory, they coincided with Kul'bin's notion of impressionism: 'A blind artist is not simply an astonishing thing, it is full of symbolic meaning and serves as a forewarning that the ensuing pictures at the show, especially those of Triangle: the Art and Psychology Group, are to be perceived not with external vision, but with what may be called an inner, spiritual sight' (*ibid.*). Perhaps significantly, the perception of the blind had been studied by Maeterlinck in his death dramas *L'Intruse* (The Intruder) and *Les Aveugles* (The Blind), both of which had been translated into Russian and put on by Stanislavskii at the Moscow Arts Theatre in 1904.

10 Metsenat, 'Vystavka 'Sovremennykh techenii' v iskusstve', *Peterburgskaya gazeta*, 26 April 1908, p. 2.

11 Dubl'-Ve, 'Vystavka sovremennykh techenii v iskusstve', *Peterburgskii listok*, 26 April 1908, p. 2.

12 *Ibid.*

13 M. S., 'Sovremennyya napravleniya'.

14 V. Yan [Yanchevetskii], 'Vystavka sovremennykh techenii v iskusstve', *Rossiya*, 27 April 1908, pp. 3–4.

15 The sculptor was Natalya Gippius, a student at the Academy and sister of the poet Zinaida Gippius. She showed six symbolist-inspired wooden sculptures (including *Soothing Rapture*, *Slug*, *Entrants to Heaven* and *Crawlers on Earth*), which Simonovich described as 'The only works... in which there is an original imagination... Gippius... has managed to capture the beauty of the ugly and to discover an organic link in fabled beings.' A pencilled note in a copy of the exhibition catalogue (*Katalog 1908 Vystavka 'Sovremennykh techenii v iskusstve'*, Petersburg Academy of Arts, mentions that Gippius' other sister, Tatyana (1877–1957), also a student at the Academy, also contributed. Meister was a regular exhibitor with the New Society of Artists from 1906. At 'Modern Trends' she showed nine pastels, including *The Barn*, *Sunset*, *Wild Rosemary* and *Petersburg*.

16 The notion of the triangle was popular among various groups of Russian intellectuals in

35

the 1900s, see J. Bowlt and R. Washton Long (ed.), *The Life of Vasilii Kandinsky in Russian Art: A Study of the Spiritual in Art*, Newtonville, 1980, pp. 113–14.

17 K. L'dov. 'Khudozhniki-revolyutsionery'. To *The Studio of Impressionists* [*Studiya impressionistov*] (1910), a Triangle publication which he edited, he contributed: 'Free art as the basis of life' ['Svobodnoe iskusstvo, kak osnova zhizni']; 'Free music' ['Svobodnaya muzyka']; 'Colour music' ['Svetnaya Muzyka]; and 'Ending' ['Kontsovka'].

18 Kul'bin ran a course at the Society of Peoples' Universities (15 February to 26 April 1909) entitled 'Free Art as the Basis of Life (Past, Present and New Trends)', see *Nasha gazeta*, 13 February 1909, p. 5. This cycle of nine lectures was accompanied by slides, prints, original paintings, musical illustrations and declamations. Practical sessions concerning techniques were included as well as excursions to museums and art-salons. The first lecture, 'Free Art: As the Basis of Life', was divided into two parts: 'I The Ideology of Art' and 'II Artistic Creation'. Participants included Rigler-Voronkova, the mathematician and cellist Andrei Alekseevich Borisyak (1885–1962), and the pianist Lev Pyshnov (1891– ?).

19 A. Rostislavov, 'Lektsiya N.I. Kul'bina', *Apollon*, December 1909, p. 17.

20 N. Kul'bin as quoted in [anon] 'Teoriya khudozhestvennogo tvorchestva', *Rech'*, 30 November 1909, p. 4.

21 Kul'bin, 'Svobodnoe iskusstvo', pp. 9–12.

22 *Ibid.*

23 See V. Ivanov, 'Dve stikhii v soveremennom simvolizme', *Zolotoe runo*, No. 3-4-5, 1908, pp. 86–94.

24 Kandinsky published part of the Neue Kunstlervereinigung's manifesto in *Apollon*, January 1910, p. 30. It argued that art is a combination of the artist's inner experiences and external impressions. The resulting forms, free from inessentials, are a synthesised expression of these two elements. They therefore vary from one artist to the next. On 24 June 1910, sensing common ground, Kandinsky introduced himself to Kul'bin in a letter from Munich (see E. Kovtun, 'Pis'ma V.V. Kandinskogo k N.I. Kul'binu', *Pamyatniki kultury. Novye otkrytiya 1980*, Leningrad, 1981, p. 399).

25 Kul'bin, 'Svobodnoe iskusstvo', p. 12.

26 V. Yan., 'Vystavka'.

27 Dubl'-Ve, 'Vystavka'.

28 *Ibid.*

29 N. Kravchenko, 'Vystavka'.

30 M. S., 'Sovremennyya napravleniya'.

31 K. Petrov-Vodkin, *Khlynovsk. Prostransto Evklida. Samarkandiya*, Leningrad, 1982, p. 640.

32 Much of Kul'bin's surviving work is in the Russian Museum, St Petersburg. Although Kul'bin did not receive formal art training, he had studied anatomical illustration and some of his medical texts contain his highly detailed and precise drawings of human organs, e.g. his doctorate dissertation: *Alcoholism* [*Alkogolizm*], St Petersburg, 1895. This contains the following note (p. 175) on Kul'bin: 'From 1888 has specialized in the study of microscopic drawing, and from 1894 in microphotography.'

33 V. Kamenskii, *Put' entuziasta*, Perm, 1968, pp. 84–5. Vasilii Vasil'evich Kamenskii (1884–1961), moved from Perm to Petersburg in 1906 to study agriculture. Also worked as an icon-restorer. Began to write poetry and edit the journal *Spring* [*Vesna*], 1908.

34 Nikolai Konstantinovich Kalmakov (1873–1955) was a lawyer who took up painting as a career in 1906, first exhibiting at the Petersburg 'Autumn' shows (1906 and 1907). He became a regular exhibitor with the World of Art and an established theatrical artist. In 1917 he emigrated to France.

35 K. Chukovskii, 'Vtoraya osennyaya vystavka v Passazhe', *Rech'*, 21 September 1907, p. 2.

36 M. S., 'Sovremennyya napravleniya'.

37 V. Yan., 'Vystavka'.

38 L'dov 'Khudozhniki-revolutsionery'.

39 The 'Wreath' exhibition, Count Stroganov's House, 23 Nevskii Prospekt, Petersburg, opened 21 March 1908. Organised by Aleksandr Gaush and Sergei Makovskii. Exhibitors included Bromirskii, Gaush, Matveev, Larionov, Pavel Kuznetsov, Karev, Naumov, N. Milioti, Feofilaktov, Sar'yan, Jawlensky, Shitov, Chekhonin, Utkin, Anisfel'd, Fon-Vizin.

The only 'Blue Rose' exhibition had taken place a year earlier (Moscow, 15 March to 29 April 1907). Exhibitors were Arapov, Bromirskii, Krymov, Drittenpreis, P. Kuznetsov, Knabe, V. Milioti, N. Milioti, Matveev, Ryabushinskii, Sapunov, Saryan, Sudeikin, Utkin, Feofilaktov and Fon-Vizin. Most of these artists were from Moscow or the Russian south. Nearly all had studied at the Moscow Institute of Painting, Sculpture and Architecture. Influences included Borisov-Musatov, Vrubel, Denis and Beardsley. The decorative tendencies of many of the artists combined with a new element of disturbing fantasy.

40 Anders' work at 'Modern Trends' included: *The Soul, Shadows, Branches, Combination of Red and Blue*. The following year she exhibited *Melancholy, Delirium* and *At Twilight*.

41 'Wreath-Stefanos', Stroganov Institute, Moscow, 27 December 1907 to 15 January 1908. Exhibitors included the Burlyuks, Larionov, Goncharova, Fon Vizin, Yakulov, Lentulov, Utkin, Baranov, Ulyanov, Knabe, Sapunov, Sudeikin.

42 See M. Voloshin, 'Venok', *Rus'*, 29 March 1908, p. 3.

43 See *Venok* [Exhibition catalogue], St Petersburg, 1908.

44 See S. Makovskii, 'Golubaya roza', *Zolotoe runo*, No. 5, 1907, p. 26.

45 N. Khardzhiev, *K istorii russkogo avangarda*, Stockholm, 1976, p. 29. 'Exhibition of Free Groups' clearly refers to 'Modern Trends'.

46 The Golden Fleece Salon, Moscow 4 April–11 May 1908. Exhibitors included Goncharova, Pavel Kuznetsov, Larionov, Matveev, Knabe, Fon-Vizin, Utkin, Denis, Van Gogh, Gauguin, Vuillard, Signac, Gleizes, Metzinger, Matisse, Le Fauconnier, Rouault.

47 Aleksandra Aleksandrovna Ekster (1882–1949) had earlier shown with the New Society of Artists (February 1908), where her four exhibits included a French study, *Cancale*. Her one work at 'Modern Trends', also suggestive of an earlier trip to Western Europe, was admired by Kravchenko: 'In Wreath there is only one beautiful work, Ekster's *Switzerland* [cat.101], which is painted as a panel. There is much light, air, space and but for some artificiality in the colours, the panel would have been even better.'

48 Pavel Muratov, 'Vystavka kartin 'Stefanos'', *Russkoe slovo*, 4 January 1908, p. 4.

49 L'dov, 'Khudozhniki-revolyutsionery'.

50 Dubl'-Ve, 'Vystavka'.

51 *Ibid*.

52 Muratov, 'Vystavka kartin 'Stefanos''.

53 M. S., 'Sovremennya napravleniya'.

54 Early in 1908 Burlyuk had contributed to the Wanderers show: 'Burlyuk's study undoubtedly breaks the record with regard to the curious: a ramshackle building against a background of irregular arabesques, the stylisation of which, is supposed, apparently, to represent a garden in full bloom.' (M. S. [Simonovich], 'XXXVI peredvizhnaya vystavka', *Rech'*, 14 March 1908, p. 3).

55 Dubl'-Ve, 'Vystavka'.

56 M. S., 'Sovremennyya napravleniya'. The descriptions recall two delicately worked 1908 canvases in the Russian Museum, *Steppe* and *Houses on the Steppe*.

57 See G. Pospelow, *Moderne russische Malerei: Die Kunstlergruppe Karo-Bube*, Dresden, 1985, p. 169; E. B. Murina, S. G. Ddzhafarova *Aristarkh Lentulov*, Moscow 1990, p. 17.

58 L'dov, 'Khudozhniki-revolyutsionery'.

59 M. S., 'Sovrenennya napravleniya'.

60 *Novaya rus'*, 4 March 1909, p. 5. The exhibition took place on the corner of Morskaya and Vosnesenskaya Streets.

61 N. Breshko-Breshkovskii 'Pod misticheskim treugol'nikom (Vystavka impressionistov)', *Birzhevye vedomosti*, No. 11002, 11 March 1909, p. 5. This article was continued in *Birzhevye vedomosti*, No. 11004, 12 March 1909, p. 6.

62 *Ibid.*

63 *Novaya rus'*, 4 March 1909, p. 5.

64 'Khudozhestvennyya vesti', *Rech'*, 5 March 1909, p. 5.

65 N. Kul'bin, 'Svetnaya muzyka', p. 25.

66 P. Stupples, *Pavel Kuznetsov*, Cambridge, 1989, p. 82.

67 V. Yastrebtsov, *Russkaya muzykalnaya gazeta*, No.39–40, 1908, cited in Kul'bin 'Svetnaya muzyka', pp. 21–2.

68 Kul'bin, 'Svetnaya muzyka', p. 25.

69 See N. Kul'bin, *Svobodnoe muzyka. Primenenie novoi teorii khudozhestvennago tvorchestva k muzyke*, St Petersburg, 1910.

70 Contradicting press notices only days before the opening (*Novaya Rus'*, 4 March 1909, p. 5; 'Khudozhestvennyya vesti', *Rech'*, 5 March 1909, p. 5), Wreath did not contibute to 'The Impressionists' and instead opened its own exhibition: Wreath-Stefanos, 18 March– 12 April 1909. The six exhibitors, who contributed seventy-eight works in all, were: Vladimir and David Burlyuk, Baranov, Gaush, Ekster and Lentulov.

71 Breshko-Breshkovskii, 'Pod misticheskim'.

72 *Ibid.*

73 Kul'bin, 'Svetnaya muzyka', p. 26.

74 Breshko-Breshkovskii, 'Pod misticheskim'.

75 Yanchevetskii, 'Vystavka impressionistov'.

76 The daughter of the famous Polish-Russian professor of philology Ivan Baudouin de Courtenay. After the revolution she left Russia with her family and settled in Poland.

77 Breshko-Breshkovskii, 'Pod misticheskim'.

78 Mirbeau's complete works were published in Moscow (1908–11). *Le Jardin des supplices*, a bitter social satire, was written in 1899. Voloshin had reviewed it in 'Novaya kniga Oktava Mirbo', (*Kur'er*, 8 September 1901, p. 3).

79 Concerning Baller, see biographical notes.

80 At the 1909 'Impressionists' Lidiya Arionesko-Baller showed a predilection for Dutch themes (seven *Sketches of Volendam*). In 1910 she exhibited a 'self-portrait… some kind of nightmare with an improbably ugly twisted face' (N. Breshko-Breshkovskii, 'U impressionistov' II, *Birzhevye vedomosti*, No.11632, 26 March 1910, p. 5).

81 See A. Baller, 'Wajang. Yavaiskii kukol'nyi teatr'', *Studiya impressionistov* pp. 28-30; 'Apollon budnichnyi i Apollon chernyavyi', and 'O khromoterapii uzhe ispol'zovannoi', *Soyuz molodezhi*, No.3, 1913, pp. 11–3 and pp. 23–4.

82 Breshko-Breshkovskii, 'Pod misticheskim'. This compares with his illustrations of dis-figured and distorted Javanese puppets in *Studiya impressionistov*, pp. 28–30.

83 Shleifer showed two works (*Sunny Day* and *Overcast Day*) and Sagaidachnyi one study, none of which were noted by the critics.

84 Breshko-Breshkovskii, 'Pod misticheskim'.

85 V. Bubnova, 'Moi vospominaniya o V.I. Matvee (Vladimir Markove)', October 1960, Archive of the Academy of Arts, Riga.

86 'Sensation of the Fourth Dimension' (p. 1), 1912–13. Cited by Povelikhina, 'Matyushin's Spatial System', *The Structurist*, 1975–6, p. 67.

87 For Matyushin's later 'See-Know' theories of expanded vision see, for example, L. Dalrymple-Henderson, *The Fourth Dimension and Non-Euclidean Geometry in Modern Art*, Princeton, 1983.

88 N. Kul'bin, 'Garmoniya, dissonans i tesnyya sochetaniya v iskusstve i zhizni', *Trudy vserossiksogo s'ezda khudozhnikov*, I, p. 39.

89 Debora L. Silverman, 'The Brothers de Goncourts' Maison d'un Artiste', *Arts Magazine*, May 1985, p. 126.

90 *Ibid.* Cited from 'Souvenirs des Goncourts', *La Revue Encyclopédique*, 8 Augustt 1896, pp. 550–1.

91 In 1910 Guro wrote *Nebesnye Verblyuzhata* (St Petersburg, 1914) and *Bednyi rytsar*, both of which are full of symbolism and flights of fancy.

92 Povelikhina, 'Matyushin's Spatial System', p. 70. Most of Matyushin's works are in the Matyushin Museum and Russian Museum, St Petersburg.

93 The exhibition was held in the former building of the State Bank, 6 Ostrovorotnaya Street.

94 Evseev had studied at the Munich Academy of Arts and in private Parisian studios. He had previously contributed to the Union of Russian Artists (1907) and Makovskii's 'Salon 1909'. In 1909 he was engaged as a designer at the Kommissarzhevskii Theatre.

95 See [anon.] 'S vystavki impressionistov', *Severo-zapadnyi golos*, 8 January 1910, p. 3.

96 'New Paths in Art: The Word, Music and the Plastic Arts', Hall of the Gentry Club, 9 January 1910; 'Impressionism (The Word, Plastic Arts and Music)', Vilna City Club, 30 January 1910; Lecture, 'Zula' Lithuanian Club, 31 January 1910. Little is known about the third other than it was an outline of the role of the human subconscious in life. For the programme of 'New Paths', see [anon.] 'Lektsiya', *Vilenskii vestnik*, 8 January 1910, p. 3.

97 The Kraków artist, dramatist and poet Stanislaw Wyspiański (1869–1907) was the leader of the 'Young Poland' modernist movement. Well known for his *Art Nouveau* pastels and stained glass, his theatrical activity embodied many of Kul'bin's ideas concerning a unified art: he utilised ancient Greek theatre and Wagner as his models, and folk arts, local customs, ceremonies, processions and Christmas puppet shows to create a total theatre that is all image – shapes, colours and sounds.

98 N. R., 'V bedlam u dekadentov', *Vilenskii kur'er*, 1 February 1910, p. 3.

99 [anon.] 'Lektsiya ob impressionizme', *Severo-zapadnyi golos*, 3 February 1910, pp. 3–4.

100 The 'First Exhibition of Drawings and Autographs of Russian Writers' contained paintings and drawings by an extensive selection of Russian writers (including Pushkin, Tolstoy, Chekhov and the symbolists), as well as their letters and signatures. These were seen as 'reflections of the personalities of the artists of the word... The writer, creating a picture from words, experiences an impression (impressio), comparable to that of a painter. He only reflects his experience in words not paint. We are not concerned with the basic difference between the literary and plastic arts.' (Kul'bin, 'Treugol'nik' [Exhibition Catalogue]).

101 The 'International Salon' of Vladimir Alekseevich Izdebskii (1882–1965) toured Odessa (4 December 1909 to 25 January 1910), Kiev (13 February to 14 March 1910), Petersburg (20 April to 25 May 1910) and Riga (12 June to 7 July 1910). His second salon was held in Odessa (March 1911).

102 For example the Lithuanian sculptor Petras Rimša (1881–1961), the founder of the first Lithuanian Art Society (1907), who exhibited symbolist sculptures (e.g. *Golgotha*, *Moonlit Night*); the Latvian Erna Deters (1876–?), a regular contributor to the New Society of Artists; and Andrei Romanovich Diderikhs (1884–1942), a student of Ažbé, van Dongen and husband of the artist Valentina Khodasevich.

103 V. Yanchevetskii, 'Vystavka impressionistov 'Treugol'nik'', *Rossiya*, 24 March 1910, p. 4.

104 For a discussion of the subsequent impact of Uspenskii's theory of the fourth dimension on Russian modern art, see L. D. Henderson, *The Fourth Dimension*.

105 P. Uspenkii, *Chetvertoe izmerenie, opyt izsledovaniya oblasti neizmerimago*, St Petersburg, November 1909.

106 P. Uspenskii, *Tertium Organum*, St Petersburg, 1911, p. 110.

107 *Ibid*, p. 331.

108 'Triangle', *Salon 2*, Odessa, 1910–11, p. 19.

109 Titles included *Tales: I About Construction, II Blue on White, III By the Pond (Once*

*upon a time)*, *IV The Conversation*; *By the Green Table*, *A Pea*, *White on Green*, *On the Shore* and *Spring*.

110 N. Evreinov, 'Predstavlenie lyubvi', *Studiya impressionistov*, pp. 49–127. Kul'bin's illustrations accompanied the text. Nikolai Nikolaevich Evreinov (1879–1953) was a director, playwright, critic, composer, artist and close friend of Kul'bin. In the Triangle section of the 1910 exhibition he showed sketches for various recent productions at his Drama Studio and The Intimate Theatre (e.g. *The Death of Ase* from Peer Gynt, d'Annunzio's *Dream of an Autumn Sunset* and *Prologue of a Harlequinade*).

111 *Ibid*, p. 51.

112 Evreinov, 'Predstavlenie lyubvi', p. 109.

113 Yanchevetskii, 'Vystavka impressionistov'.

114 *Ibid*.

115 Following its first salon in 1908, *The Golden Fleece* journal, devoted considerable space to articles concerned with modern French art, especially Gauguin, Van Gogh and Matisse (see, for example, the issue devoted to French art, *Zolotoe runo* No.7-9, 1908). Forty-four works from the second salon (11 January to 15 February 1909) were reproduced in *Zolotoe runo* (No. 2-3, 1909), including Braque's proto-Cubist *Le Grand Nu* and *Still-Life*). Furthermore, from 1908 Shchukin added many Matisses to his collection (e.g. *The Game of Bowls* and *Harmony in Blue*), making Matisse the most popular French avant-garde artist in Russia.

116 N. I. Kul'bin, 'Novyya techeniya v iskusstve', p. 40.

# 2     Act I Scene i, The triangle breaks: the founding of the Union of Youth

By 1910 the plastic arts in Russia had moved away from the elegant retrospections of the World of Art: Vrubel and the Saratov artists (for example Borisov-Musatov, Kuznetsov, Utkin) had stimulated a new perception of the formal aspects of art. Symbolism combined with impressionism as art, still representational, became more introspective and subjective. Metaphysical implication, morbidity and deformation became regular attributes of painting. The rejection of external appearances, inspired by the conditions of political and social unrest, as well as the rapid industrialisation of Russia, fused with the search for novelty and a modern aesthetic. Other cultures were scrutinised for new artistic values. A mood of confrontation swept the young artists arriving in Moscow and Petersburg from the provinces.

With this process art was freed from the need to represent physical nature or observe academic convention. The Neo-Primitivists, led by Larionov, Goncharova and the Burlyuks, disillusioned with symbolism, sought more vigorous and immediate sources of inspiration, and they found them in primitive art forms, including Russian folk arts and crafts. Developments in France and Germany were crucial. Many younger Russian artists, including the Burlyuks, Larionov, Dydyshko and Shleifer, had studied in Paris and Munich. Others had readily absorbed the works of Cézanne, Gauguin, Rousseau, the Fauves and finally Picasso and Le Fauconnier, brought to Russia by Morozov, Shchukin, Ryabushinskii and Izdebskii.[1]

Fauvist techniques, especially the bright colour, abandonment of linear perspective and emphasis on expressive brushstrokes, were quickly adopted by Moscow artists. These Fauvist borrowings first appeared at the 1909 Wreath-Stefanos exhibition and the third Golden Fleece salon (January 1910). Larionov, after copying the expressive impasto brushwork of Van Gogh and Post-Impressionism, as well as Gauguin's use of colour and composition, now began to concentrate on domestic arts as stimuli for his work. He, together with Goncharova and the Burlyuks, exploited the unconventional stylistic devices found in the *lubok*, the hand-painted tray, provincial toys and whistles, the signboard and the icon. From these they borrowed vivid colour, emphatic lines, flat figures, inverted perspective, use of script, and stylised and schematic decorative elements.

In Petersburg, symbolist and psychological-impressionist styles, seen in the work of Kul'bin, Kalmakov, Baller, Čiurlionis and Petrov-Vodkin at the shows of Triangle, the Union of Russian Artists and the New Society of artists, were the dominant avant-garde trends until 1910. Kul'bin's appearance on the Petersburg art scene in 1908, together with the Wreath exhibitions, had been the first sign of changes to come. Kul'bin encouraged 'free art' and at his exhibitions signboards and autographs were shown alongside Vaulin's Abramstevo-inspired use of folk motifs, Kalmakov's *Art Nouveau*, Kul'bin's Pointillism, Spandikov's 'decadence' and Guro's 'naive' impressionism. Against this background the Union of Youth was founded.

A small article, published on 8 January 1910, was the first to appear about the Union of Youth. It succinctly described the impulses behind its formation and the environment in which it developed:

> 'The Union of Youth'
> This is the name for an enterprise of a group of artists that deserves sympathetic attention. Taking into consideration the difficult contemporary situation for artists, especially the artistic youth, due to undoubted over-production, an abundance of exhibitions, the closed nature of societies, the detachment and solitude of artists, all of which make it difficult for new artists to show their skill, the 'Union' aims to organise its own centre. This will be something like a museum-club, where links can be established, artists can become acquainted, and where most importantly, they can get to know each other's work, can listen attentively and freely to arguments and thus new talents can be revealed.
> Here the main aim is not the organisation of exhibitions, which will occur later as a result of the group's essence becoming clear. Rather, it is to allow the possibility of self-examination, free searching, and the elucidation of new paths. What is actually desirable here is a certain crystallisation that is more or less clearly promoted, a new sense of individuality or a new common movement. The idea is new and interesting. As a rule, exhibiting societies and groups are phenomena which are often independent of inner necessity, become burdened by their productivity, and sometimes by a dilletanti character.[2]

In fact, the group had been in existence, at least loosely, for some eight months and their first exhibition was already being planned by this time. Even so, the text is highly revealing, for over the next four years the 'crystallisation' was to be felt not only in the exhibitions of the group, but also in its publications, theatrical productions and public debates, as well as in the individuals who emerged as leaders. The first public evidence of such a crystallisation was the organisation of exhibitions in 1910 and the 'manifesto' written by Voldemārs Matvejs.[3]

Rostislavov provides several important hints about the identity of the Union of Youth and the initial feelings that had provoked the artists to form the group. The lack of preconceived direction, other than an interest in the new and essential, was highly influential upon the way the group devel-

oped over the next four years. However, sources considered below reveal that a direction was already emerging and the crystallisation of ideas was already under way by January 1910: arguments led to the resignation of some artists; paintings were selected for exhibition; regulations, including a statement of aims, were prepared for presentation to the city governor.

Rostislavov emphasises that members felt that their aim was to search freely for the new; looking within (to the psyche and emotions – the personal and group experiences), rather than only outside (to visual reality and the public). This aspiration coincides with Kul'bin's idea that the new art was to be based upon inner experience and experiment. But whereas Kul'bin sought to free form, colour and content without restriction, the Union of Youth sought a specific replacement for old methods. This led to dissensions within the group about the nature of the new art. Although a tolerant attitude towards style was generally maintained, an evolution took place which allowed distinctive characteristics to emerge. The very process of gradually determining identity was something new in Russian art: for the first time a group had been set up which had no fixed aim, no apparent identity. The organisation of the group came first, the aims were established step-by-step and open to change: discussion, the exchange of ideas and growth were fundamental.

A draft letter of application, presumably to the city governor's office, requesting permission to form the 'Union of Youth', survives.[4] Headed by the names of Spandikov, Matyushin and Voinov,[5] it states that the 'aim of the society is to study the problems of modern art and organise exhibitions'. This application was probably written around the same time as the minutes of a committee meeting on 8 November 1909. The latter is concerned with the organisation of an exhibition and lists as members: Matyushin, Guro, Spandikov, Voinov, Shkol'nik, Bystrenin, Shleifer, Gaush and Evseev.

Many meetings followed in quick succession during November 1909. Levkii Ivanovich Zheverzheev was invited to participate in the group's activities; an art and music evening was planned to raise funds; a studio was sought – Matyushin and Voinov were to ask Mostova for premises, while Shkol'nik was to approach the artist Konstantin Veshchilov.

However, by 2 January 1910 tension had arisen between the founders and an argument ensued between Shkol'nik, Voinov and Matyushin concerning the membership rules that had been drawn up. There was a definite rift in the committee, even before the group had been officially registered. The minutes of the meeting on 6 January 1910 note that Matyushin and Voinov refused to sign the draft regulations: 'Both expressed the idea that they saw a different direction ahead to the one proposed by the current work, and that they felt ideologically at variance with the group.' Thus Spandikov, Zheverzheev and Bystrenin became the signatories and within **43**

two days Matyushin and Voinov had resigned from the committee and, together with Guro, soon ceased all participation in the group's activities. On 29 January 1910 the draft regulations were sent to the city governor and by 16 February they had been authorised and the 'Union of Youth' placed on the register of Petersburg societies (No.503).[6]

The minutes of the meeting on 8 January 1910, the same day as Rostislavov's article appeared, note that 'In view of several fundamental differences of opinion the committee considered it necessary to make their programme more definite.' This suggests that while diversity was possible, the group also recognised the need for a certain control and sense of direction. With the withdrawal of Guro, Matyushin and Voinov it was Matvejs' presence that proved one of the most decisive influences. Although Matvejs' name does not appear in the list of members on 8 January (L'vov, Verkhovskii, Zheverzheev, Mostova and Baudouin de Courtenay were the new names) he must have joined the society around this time. A Latvian student at the Petersburg Academy, Matvejs brought with him a lot of fresh ideas and enthusiasm that were to penetrate the group extremely quickly and to lead to a more defined programme.

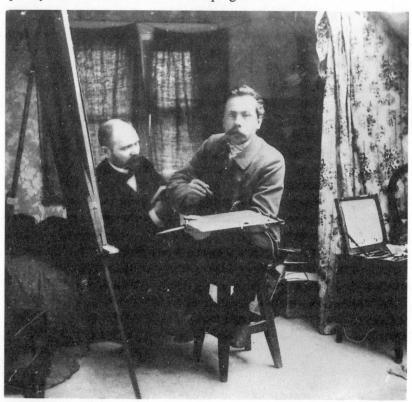

3 V. Matvejs, *c.* 1910

A series of letters from Matyushin to Shkol'nik, written in January and February 1910, confirm the tension in the group with regard to an argument with Mostova over the use of her studio, and a demand by Matyushin for expenses. Whatever the causes of the unease, on 19 January Matyushin requested that membership fees paid by himself and Guro, be returned. The wrangling over money and the dispute over Mostova's studio continued. On 5 February Matyushin, feeling insulted by the group generally, expressed his disappointment, and asserted that 'nobody did as much for the Union of Youth as me'. He added that henceforth he distanced himself from its activities.

In his last letter, amongst his pernickety calculations for financial repayment, Matyushin gave the founding of the group as April 1909. This is the only documentary evidence of the date of original inception of the Union of Youth. Significantly, it coincides with 'The Impressionists' second exhibition to which Guro, Matyushin, Mostova, Spandikov, Bystrenin, Gaush, Shleifer and Shkol'nik – that is, the initiators of the Union of Youth – contributed. Furthermore, early Union of Youth associates such as Baudouin de Courtenay, Mitel'man, the Ballers, Vaulin, Sagaidachnyi were also represented at the show. Almost certainly Kul'bin introduced these artists to one another and they then split from Triangle, gradually dropping out of its exhibitions, in order to establish their own group with independent aims.

The primary reasons for the break with Triangle cannot be conclusively established as precise differences in aesthetic ideology or personality are not documented. Indeed, the original conception of the Union of Youth is totally unrecorded, although Matyushin later claimed that he and Guro rejected Triangle because they were irritated by the prevailing and feeble imitations of Vrubel.[7] This, however, fails to suggest any positive alternative programme.

The membership rules drawn up by the Union of Youth in early 1910 included the following points: prospective members were to show examples of their work in the group's studio for one week, provided that at least one member agreed to it. After the week, the work would be assessed by all members of the Union of Youth and if more than half voted in favour, the artist would be accepted as a member. Artists whom the committee members wanted to be members could simply be invited to join and as long as they sent some work to the committee and paid the fee they would be accepted. In this way, the group could control the general direction it took, without placing impossible barriers in the way of new artists seeking to join. There was no demand for individual artists to adopt a particular approach.

A supportive article in the conservative newspaper *Petersburgskaya Gazeta* appeared precisely at this time. It highlighted the plight and complaints of young artists: 'Nowhere in the world do so many barriers stand in

the path to fame for young artists, as they do here.'[8] The article emphasised the difficulties of joining an art society (whatever the quality of the artist's paintings) and of participating in society exhibitions, where members could exhibit as much 'rubbish' as they liked without it going before a panel of judges; and how full societies are of well-known artists who dislike anyone following a different line. The article seems to be a cloaked demand for the setting up of the Union of Youth or a similar group. The Union of Youth's rules imply a direct response to this situation and, in practice, as many non-members as members took part in their exhibitions.

The success of the Union of Youth's approach is reflected in the novelty and diversity of its exhibitions and innovative stage events. Furthermore, following hard upon its footsteps, a number of other, usually short-lived, art groups emerged in the Russian capitals. Thus the whole dynamic of the art situation was changed. Kul'bin's Triangle disappeared, but was re-placed by societies such as the Petersburg Association of Independents, the Non-Aligned Society of Artists, the Arts Association and the revitalised World of Art.[9] These, together with the Dobychina Art Bureau,[10] which opened in 1912, offered new opportunities to young, inexperienced artists in Petersburg. They were complemented in Moscow by the emergence, from 1910 onwards, of such groups as the Moscow Salon, Free Art, Free Creativity, the Knave of Diamonds and Donkey's Tail.[11] Links between these groups and the Union of Youth, both direct and indirect, are examined below.

The first phrase in the Union of Youth's official Regulations implies a revisionary, rather than revolutionary, approach to art:

> The Society of Artists 'The Union of Youth' has the aim of familiarising its members with modern trends in art; of developing their aesthetic tastes by means of drawing and painting workshops, as well as discussions on questions of art; and of furthering the mutual rapprochement of people interested in art.

There is no insistence that members must follow modern trends in art – simply that they should become aware of them. The use of art workshops for learning emphasises the open outlook of the group. Indeed, the emphasis is on the integration of attitudes. While this may have been a precautionary step, since the regulations required official approval, it appears that the 'avant-garde' ambition of the group was muted at this stage. Still, the regulations go on to list a whole range of activities from evenings of communal drawing and discussion in the studio to exhibitions, musical evenings, dramatic productions, auctions, public debates, competitions, publications, and talks with museum workers. Evidently, the Union of Youth was intended to be much more than an exhibiting society and no field of art was to be ignored.

46     Despite the breadth of activities envisaged by the Union of Youth,

exhibitions played an essential role in defining its identity. A draft copy of the regulations gave members the right to 'exhibit their works at the society's exhibitions without having them judged by a jury, and in any quantity'. Furthermore, any artists sympathetic to the group could be invited to participate and others could send their work to be judged by a jury. All these points were omitted in the published regulations which, perhaps bearing in mind the ideas expressed earlier in the *Petersburgskaya Gazeta*, makes no mention at all of a panel of judges or the quantity of works permitted. It seems that a rather informal attitude prevailed, making it possible for a large number of 'sympathetic' non-member exhibitors to take part, and this had a significant impact on the character of the group's exhibitions.

An article about the Union of Youth, published just ten days after the regulations had been approved, stated:

> the circle of young artists has actively set to work. It has taken a studio (Zamyatin Lane No. 3 flat 8) where twice a week, on Wednesdays and Saturdays, the artists meet, study drawing and discuss their work. Although this circle, which at the moment consists of fifteen artists, has only recently started to function, by means of highly serious communal discussion of their works and the unity of direction, for which they are being organised, it appears that the 'union' could come forward and open their exhibition in the first week of Lent. This exhibition will allow the circle to plan its future activities.[12]

Although the stress is again on communal discussion dictating direction, exhibitions are given a definite place in helping to establish this direction. This idea was more clearly developed in another article a week later:

> By means of the communal discussions the individual aspects of each artist will be identified and the artistic aims that they will pursue will be planned. But true success in the fulfilment of their aims is unthinkable without criticism, and taking this into consideration the Union has decided to exhibit its work.[13]

Here for the first time the individuality of artists finds its place – as a goal for definition through the group's common activities. The desire to react to criticism positively – to be open to influence in order to learn and create – meant that the group could change and develop. Rostislavov was right when he pointed out, after the exhibition had opened, that 'the original idea of this Union was different: exhibitions were to be the result of mutual achievement and communal discussions... Nevertheless this appearance now seems legitimate.'[14]

As early as mid-February Matvejs was involved in the organisation of the exhibition and was dispatched to Moscow to collect works from various artists, as shown by his undated letter to the group leaders:

> I'm running all around Moscow. I called about five times at Zel'manova's – there was nothing. Still, I took two small things from her. I was at Mashkov's. Took one work. Larionov isn't giving what I'd like, but is imposing his own

**47**

choice. If I do take any of these, I take no responsibility for them. But as regards his wooden sculpture – I've selected two small but interesting works. The most interesting work that I've so far come across is Goncharova's. She has still not exhibited in Petersburg. I'm taking two paintings and two triptychs – eight works in all. At Sar'yan's there was nothing. The same at Utkin's... The Golden Fleece has ceased to exist. Ryabushinskii has gone bankrupt. So I won't go there for works, although I'll ask Larionov. Let me have Burlyuk's address....[15]

This letter, giving Matvejs and Larionov much of the responsibility, accounts for the selection of works by the Moscow contributors to the exhibition. Indeed, Matvejs appears to be invested with the power to invite those artists he deemed suitable and bring those works he found appropriate.

By 27 February 1910 Matvejs wrote to Shkol'nik saying that the packing of works was under way, although it was being delayed because of the holiday. He had some 'very beautiful works' but they would only arrive in Petersburg early in the morning on Sunday or Monday. This presumably means the following week (i.e. 7/8 March) as any earlier and Shkol'nik would not have received the card in time. Indeed Matvejs added: 'I shall take the works straight to the exhibition. Give the order that they let me in when I arrive with the box. Forewarn the porter.' The exhibition opened on 8 March, leaving little time for the works to be judged. Matvejs' selection, therefore, was crucial in determining the composition of the show.

It is not known what criteria Matvejs used to make his choice in Moscow, but it is interesting that while he was away the following appeared concerning the Union of Youth exhibition:

Each member has the right to show all the works he finds it necessary to exhibit. As regards exhibitors, those represented will have their works determined by selection. A large number of paintings of the latter have been offered to the society and (a small number) of these, works close in ideas to the aims of the 'Union' have been accepted. The vast majority of members exhibit their works for the first time.[16]

This sounds very like the methods of societies criticised earlier in the *Peterburgskaya Gazeta*. The resemblance, however, is spurious for in actuality the selection procedure was lenient with the rules, and the non-member artists, who numbered ten out of a total of twenty-five exhibitors, contributed well over a third of the 228 works shown.

The first Union of Youth exhibition opened in an empty apartment on the corner of Morskaya and Gorokhovaya Streets. Besides the five Moscow exhibitors, the other non-members were probably Afanas'ev-Kokel, Ukhanova (both students at the Academy), Nalepinskaya, Mitrokhin and Vaulin. None of these seem to have had any connection with the Union of Youth after its summer show in Riga, and, with the exception of Vaulin, none exhibited more than four works. This leaves the members of the group as: Bystrenin, Baudouin de Courtenay, Verkhovskii, Gaush, Zhever-

zheev, L'vov, Matvejs, Nagubnikov, Spandikov, Severin, Evseev, Filonov, Sagaidachnyi, Shkol'nik and Shleifer. Of these, at least nine had studied or were studying at the Petersburg Academy. Their exhibiting experience was slight. Although only nine artists were making their debut, the majority had appeared in just one or two shows with Triangle or another group. The only 'established' artists were Gaush, Bystrenin and Larionov.[17]

The vast majority of works in the exhibition consisted of paintings and sketches, although there were some etchings by Bystrenin, theatrical designs by Evseev, embroidery by Zheverzheev, Persian and Indian-style tiles, vases and a caché-pot by Vaulin, and two sculptures by Larionov.[18] Many critics recognised an aesthetic distinction between the Moscow and Petersburg contributions. The *Golden Fleece* correspondent favoured the work by his local Moscow artists, but found the exhibition 'slipshod' and 'a sticky bog of baseless daubs and feeble lines, a dirty celebration of the canvas and colour over and above the intentions of the artists'.[19] Dubl'-ve, while focusing on the Muscovites, was even more scathing: 'There are no pictures in the exhibition…. The works on the wall are so disgustingly ugly and pitifully weak that even those with perverted taste and a sick idea of beauty turn away with a bitter grimace.'[20] Breshko-Breshkovskii supported the Petersburg artists but his attention was primarily caught by the Muscovites: 'If you like a quick change of impressions, so that happy, impetuous laughter changes to curious attention and vice versa, then go to this exhibition…[in] the very last room… are the Muscovites… the remains, or… scraps of the lost *Golden Fleece*.'[21] Yanchevetskii had similar reservations and only excepted Shkol'nik, Filonov and Spandikov from his judgement that 'The Union of Youth say nothing with their heart or head, and only arouse a feeling of protest.'[22]

Both Simonovich and Rostislavov found the Union of Youth's exhibition similar to that of Triangle. However, they reached widely varying conclusions about the shows. Simonovich wrote:

> Here, in the majority of cases, there is only unbridled dilletantism. And it is difficult to distinguish where inability mascarading as primitivism ends and where a real fatigue with the aesthetic connoisseurship of recent times, a striving through the guts of primitivism to new, solid and monumental, if also coarse, form, begins.[23]

Rostislavov was more optimistic. Of the critics, he alone sensed the Union of Youth's potential to usher in a new era. While recognising that it was 'difficult to see firm foundations leading to a new canon' in the exhibits, he noted that 'successes exist' and that 'the attractive freshness of new currents is felt'.[24] He found the 'majority of artists of both of our left exhibitions – unquestionably gifted painters', indebted to the colour syntheses created by Cézanne, Gauguin and, more recently, Matisse. At the same

**49**

time, he felt that 'the synthesis goes deeper, to a new psychology, expressed in new forms'.

As the critics noted, the Moscow and Petersburg contributions to the exhibition were marked by different approaches. In many respects this distinction was similar to that seen between Triangle and Wreath; the Muscovites having assimilated and exploited recent developments in French art to a far greater extent, while the Petersburgers continued with a mixture of idealistic and realistic symbolism, akin to the literary movements, and based on the experiments of Vrubel, Borisov-Musatov and Kuznetsov. So while mythology was present in Bystrenin's *Pandora*, Filonov's *Samson*, Baudouin de Courtenay's *Piéta*, Ukhanova's *Christ and the Sinner* and Matvejs' *Golgotha*, Maeterlinckian motifs and atmospheric, poetical images were also represented in Evseev's *Mélisande's Tomb*,[25] Shleifer's *Peacocks*, Spandikov's *Souls of the Dead* and Shkol'nik's *Twilight*, Gaush showed impressionistic work and L'vov, Nagubnikov and Severin their independent 'Post-Impressionist' styles.[26]

Shkol'nik studied nature in an attempt to express mood. His titles, which included various atmospheric times of day and Finnish landscapes (e.g. *Twilight, Evening, Night, Saiima Lake, After the Rain*), differed little from those he had chosen for Triangle. Breshko-Breshkovskii noted his lyrical symbolism:

> There is a soft, mystical poetry in Shkol'nik's landscapes. Something delicate in his transparent and faded tones. These are fantastic valleys, with thick twilight and bright spots of gigantic flowers. These are fragile little trees drooping under the rain. This is the dreamy-sullen Finnish nature. All of which expresses a modest and meditative searching.

In addition, Yanchevetskii found that 'Shkol'nik's landscapes have beautiful, airy colours' and Rostislavov suggested an impressionistic approach to nature, if a lack of spontaneity: 'There seem to be echoes of Levitan in Shkol'nik's slightly affected melancholy, e.g. in *Grey Day, Saiima Lake, Autumn Study* and *After the Rain*.'

Bystrenin, at thirty-eight the most senior and distinguished artist of the group, imitated classical Egyptian themes and forms in his graphic art. In 1898 he had joined Vasilii Mate's engraving studio at the Petersburg Academy and from that time on his principal interest lay in etching. Five of his six exhibits were etchings. After graduating from the Academy in 1902 Bystrenin created picturesque and lyrical engraved landscapes, as well as developing an experimental use of aluminium (a technique he called 'algraphy').[27] Breshko-Breshkovskii found his interpretatation of classical mythology very strong:

> The gems of the exhibition belong to the etcher-graphic artist Bystrenin – an artist about whom nothing is heard and yet what a great artist! Those like him,

that is graphic artists with such a fine conception of form, number no more than five or six in Russia…. Pencil, charcoal, watercolour brushes, needles – all are equally subservient to the skill of his golden fingers. Here is someone capable of penetrating to ancient epochs of ancient worlds. If you need a complex drawing reproducing a religious procession in ancient Egypt, Bystrenin will go to an academic library, glance through fine art publications and sketch female headgear, pleats of drapes and corners of temples. And when all the drawings are ready one can only exclaim in astonishment. Life, epochs, types and figures all gush forth from every line. As if the man spent ten years of his life studying ancient Egypt. At the exhibition one should note *The Little Head*, the wonderful drawing *Palladium* and the sketch *Pandora*, so powerful in colour that they compete with Vrubel's best.

Despite such glowing praise, Bystrenin's use of motifs extracted from the ancient world, while in keeping with the resurgence of interest in other cultures, is apparently an attempt to echo and recreate the aura of those cultures, rather than to transpose, exploit and transform them for specific pictorial purposes.

The debt to Vrubel, indeed his legacy in the work of this younger generation of artists, did not go unnoticed by the artists themselves. While their exhibition was in progress, Vrubel's death was announced.[28] The Union of Youth artists felt strong enough about this to write a communal letter to the press:

M. A. Vrubel is dead. As an artist and creator Vrubel died long ago, but his significance for art will never die. Not knowing any better means by which, at the moment, his memory may be immortalised, we offer the enclosed, with all the strength of a mite, for the organisation of an exhibition of the work of this artistic genius, in the hope that society will respond to this call. Enclosed is twenty-five roubles. *The Society of Artists 'The Union of Youth'*.[29]

Clearly, in early 1910, respect for Vrubel's innovations was high in the Union of Youth. In expressing the value it placed on his art, the group suggested the debt it owed him as one of the great initiators of the modern movement in Russian art. The potential of Vrubel's influence was most strikingly felt in Pavel Nikolaevich Filonov (1883–1941), one of those taking part in his first exhibition. Four out of five of his works were simply recorded as drawings and sketches in the catalogue. Contemporary descriptions alone give important indications of their form: 'Filonov has shown himself to be an undeniably original and talented artist. In his small drawings and the painting *Samson* [cat.186] there is an interesting, beautifully melodic line and a strange purely Eastern sense of the fantastic, reminiscent of the vision of a stupefied opium-smoker.'[30] Further: 'thoroughly exquisite works like the small, almost jewel-like works of Filonov have such taste in the brightly painted, rather Vrubelesque tones….'[31] This allows that Filonov's work contained the germs of his analytical art, with its unique concentration and facetting of form, as early as 1910, when he

was still a student at the Academy.

With titles such as *Lakshmi the Hindu Goddess of Beauty* and *Piéta*, Baudouin de Courtenay, one of only three artists to appear at both this exhibition and the simultaneous 'Impressionists,'[32] also showed a concern for mythology and the East. Like Filonov and Bystrenin, Baudouin de Courtenay incorporated her artistic worldview in that of archaic cultures:

> You might not agree with her technique, but one divines undoubted penetration in reconstructing forgotten cultures and forgotten peoples from the depths of the ages. These are the brown, stretched figures, both naive and schematic, in the *Sketch of a Freize* [cat.18]. In order that the viewer 'believes' in them he must be able to think and he must be able to create. But you do 'believe' in them.[33]

From this it is clear that Baudouin de Courtenay had turned to a concern with primitive forms. However, by 'reconstructing forgotten cultures', the artist retained both the semantic and representational value deliberately abandoned by Larionov in his Neo-Primitivist extrapolation of stylistic device for its own sake.

This cultural searching for expressive form was present, to varying degrees, in the work of several other Union of Youth artists. Sagaidachnyi's exhibits, *Happiness in Crime, Medallion, Venice* and *At Dawn*, were described as 'beautiful, decorative works'[34] deeply influenced by a study of ancient icons. Similarly Matvejs' exhibits reflected his study of the Italian primitives (he had travelled through Italy the previous summer). Unlike Bystrenin or Baudouin de Courtenay, Matvejs was not concerned with the recreation of epochs. This he was to make clear in his writings. Instead he sought to utilise motifs and techniques for his own pictorial purposes – be they primarily symbolist (e.g. *Golgotha, Peace*); or non-specified formal and colorist concerns (e.g. *Yellow on Yellow, Evening, Servant Girl, Siena*). In at least one instance his experimentation using a religious subject was regarded as too excessive:

> Matvejs' foggy composition, *The Torture of the Saviour*, was censored. A group of people and horsemen. The tormented Christ has fallen. Blows are struck upon him. A theme, so to speak, for a museum. Paintings with such subject matter have been created by Rubens (Kushelev Gallery), and our own Egorov (The Russian Museum). All the same, they took Matvejs' painting away.[35]

Spandikov avoided the interest in mythology and the East common to many of his colleagues (his titles included *Laughter and Sorrow, In the Morning, Motif from Colours, The Dancers, The Greenhouse* and *Portrait of I. S. Sh[kol'nik]*). However, he still persisted with a sketch-like quality and Rostislavov noted a 'refined decadence, not without an affectedness'. Yanchevetskii found a visionary symbolism: 'Spandikov's sketches are fantastic and not devoid of a certain gracefulness of colour. They are

4 P. L'vov, *Tobolsk*

original, especially his *Souls of the Dead*, which are mysteriously represented in the forms of fabulous birds.'

Remaining exhibitors from Petersburg (for example Gaush, L'vov, Nagubnikov and Verkhovskii) appear more conservative in their pictorial solutions and on the whole they gained critical respect for less adventurous but talented work. One of the founders of the Union of Youth, Aleksandr Fedorovich Gaush (1873–1947) had studied at the Petersburg Academy from 1893 to 1899. His landscapes are essentially impressionistic. Although he showed just one work (*Autumn*) at the first show, at the group's Riga exhibition three months later, he displayed ten paintings. *Landscape with Poplars* (1909–10, Russian Museum), which is inscribed on the back 'Stage Design', may have been shown in Riga (cat. 36). The symmetry of the row of trees, bright colours, the movement and high viewpoint recall Monet's *Poplar* series. A decorative naturalism dominates much of Gaush's surviving work and it is therefore not surprising that he found the World of Art, with whom he began to show later in the year, a more suitable exhibiting platform.

Another founder-member of the Union of Youth, the Siberian Petr Ivanovich L'vov (1882–1944) had briefly studied at the Moscow School of Painting, Sculpture and Architecture (1900–2) before entering the Petersburg Academy. Bubnova described this friend of Matvejs' as 'talented and disor-      **53**

derly'.[36] He contributed to the group's first five exhibitions, the critic Vrangel' finding 'two or three very dexterous pencil drawings'[37] at the first show.

L'vov preferred to draw Siberian scenes, landscapes, interiors and portraits, often using a free and bold line, as in his depiction of an old wooden bridge over the River Irtish (Plate 4). With the Tobolsk kremlin, its ancient cathedral and prison, in the distance, here foreground and background are generalised with a rough line while the sky is reduced to a few diagonal strokes.

Although L'vov appears more dismissive of metaphysical content than many of his fellow Union of Youth colleagues, his concerns with graphic form were paralleled by Nagubnikov's concentration on painterly composition. Svyatoslav Aleksandrovich Nagubnikov (1886–1914?), a still-life and portrait painter, studied with Rubo and Samokish at the Petersburg Academy. Bubnova described him as 'the taciturn Nagubnikov who worked in dark prussian blue and black'. He participated in every Union of

5 S. Nagubnikov, *Still-Life with Oranges*

Youth exhibition but the last. Although early works were described as 'strong and original,'[38] those that survive show little evidence of this. *Still-life with Oranges* (Plate 5), for instance, recalls Cézanne's *Fruit* (1880), which had been in the Shchukin collection since 1903. Although Nagubnikov lacks Cézanne's emphasis on volume building up colour, he employs a similar range of warm oranges and cool grey-blues. Here he replaces Cézanne's jug and decanter with two bottles, depicted with six oranges and crumpled drapery. Nagubnikov often attained a massive, static quality, while retaining a lack of finish and emphasis on pictorial structure, and it is therefore unsurprising that in 1912 he was considered close in style to Aleksandr Kuprin.[39] Indeed, had he lived in Moscow, he could well have found an appropriate place in the Knave of Diamonds.

The Muscovites, shown in a separate room, offered a different vision. Their inclusion (especially that of Larionov and Goncharova) in the Union of Youth exhibitions is problematic for they were never members of the society, nor did they share in the group's attempts at finding a common purpose and movement. Still, their art, while obviously distinct from that of the Petersburg artists, was inevitably related to it, and their inclusion in the exhibitions is legitimate considering the Union of Youth sought a 'rapprochement of people interested in the arts'. Thus, while Larionov and Goncharova cannot be considered integral to the Union of Youth, their presence, in all exhibitions but the last, is highly significant.

At the first exhibition the five Moscow artists were dominated by Larionov and Goncharova whose bold distortions of form and bright colour were closer to the Burlyuks shown in the Wreath section of 'The Impressionists', than to the Union of Youth artists. Many of the exhibits from Moscow had previously been seen at the last Golden Fleece salon, which had closed five weeks earlier, on 31 January 1910. There Larionov and Goncharova had asserted their leadership of the young Moscow avant-garde and launched their Neo-Primitivism. The Petersburg public, however, was not ready to comprehend their vulgarisation of form and its new non-representational aspect.

Many works by the Muscovites have survived, but because of the ambiguity of the catalogue titles, it is impossible always to make precise identifications. One work certainly shown was Goncharova's *Planting Potatoes* (cat. 29, Tretyakov Gallery), also displayed at the Golden Fleece. It depicts a rural scene of women working in the fields. The figures are simplified, flattened and separated by Gauguin's *cloisonné* technique. Indeed, the simplified delineation of form, stylisation of plants and trees and relative restraint in colour, is, in the first place, indebted to Gauguin, e.g. *Picking Fruit* (1899, Pushkin Museum, Moscow), then in the Shchukin collection. Yet it also relates to the Russian *lubok* and icon which employed similar techniques. The positioning of two disproportionately small

figures in the centre of the canvas, denying spatial recession, is a device adopted from the *lubok*. Quite possibly Goncharova studied the freeing of painting from its pervasive narrative meaning in Gauguin's work and then applied a local context and improvised local techniques in order to make her work essentially Russian. Thus the composition is separated into three broad, horizontal layers of colour, divided by the verticals of the figures and trees that stretch out beyond the frame, yet the landscape, with its broad river in the background, and the figures, dressed in their peasant clothes, is quite Russian. The linear rhythm in the work, combined with the decorative sense and hints of brilliant colour, as in the spades, headscarves and trousers, can also be associated with her study of icon-painting.

One of the works contributed by Goncharova that has since disappeared was *Portrait of Zel'manova* (cat. 34). Here the form appears to have been further simplified: 'What has she done with the young artist Zel'manova? Instead of a beautiful, blooming young lady God knows what looks out from the canvas! Some kind of flat head, without any age, and an extremely distorted face. This is not a portrait, not even a bad portrait. This is either deliberate, shocking affectation or madness.'[40]

Despite such indignation there was, perhaps surprisingly, an equivalent amount of cautious praise for the Moscow artists. Vrangel', for instance, was able to admire the triptychs by Goncharova, and Zel'manova's *Portrait of O. L.*. Others, such as Rostislavov and the *Golden Fleece* critic, aware that the deliberate naivety underlined a genuine and valid search for new artistic values, were openly supportive.

Breshko-Breshkovskii, in his negative criticism, mentioned a source of inspiration for Larionov:

Larionov's exercises have neither line nor depth of colour. All of them are ugly figures cruelly and coarsely covered with paint. Take his *Hairdresser*, twenty years ago in remote south-western Jewish *mestechkos* the signboards of the local barbers were distinguished by more skill and expression. And these women of Larionov and Mashkov, with their malignant abesses and loosely hanging stomachs and breasts are close to a joke.

Larionov exhibited two still-lifes, two *Bathers*, *The Water-Seller*, *The Strolling Woman* as well as *The Hairdresser*. The critic was right in isolating the provincial sources for the works. This was exactly what Larionov had been studying – as he sought to bring to his art the language and world of the Russian people. The transference of the unconventional stylistic devices of the *lubok* is highly apparent in his *Hairdresser* paintings. The figures are simplified and anatomically distorted, their heads either in profile or full-face; the perspective of the dressing table is inverted and a scrolled leg reminiscent of the stylized foliage in *lubki* is added; form is flattened and the space very limited; the bright colouring of the figures' clothes contrasts with the flat, pale ground.

Larionov's still-lifes exploited the signboard art of his native region as he concentrated his attention on elementary contrasts in mass and copied the signboard painters' neglect of modelling and perspective. Paint could be thickly applied, the texture could vary – signboard painters were interested in a direct, static evocation of the objects for sale, rather than imbuing their work with literary or associative meaning. Through employing their techniques, Larionov could simultaneously concentrate on compositional structure and colour combinations, and question the salient conventions of academicism and symbolism.

The Neo-Primitivist experiments of Larionov and Goncharova were very different from the explorations of the Petersburg artists (with the possible exceptions of Matvejs and Baudouin de Courtenay). To reinforce this distinction between the two cities, the Moscow artists did not participate in the group's meetings or discussions, and sought to remain apart from the other Union of Youth contributors, throughout the period of their co-operation. Nevertheless, the novelty of Larionov's and Goncharova's artistic approach influenced the Union of Youth and by 1911 this was beginning to be apparent. In a letter to Larionov, written shortly after the closure of the first exhibition, Matvejs reinforces the notion of the Union of Youth's debt to the Moscow contributors, as well as emphasising that its achievements hitherto had been modest:

> You have pushed forward our cause very effectively by supporting us and this itself moves the new art forward... Thanks to you we have quite confidently taken the path shown us by the Muscovites. We are not fanatics and we are not maestroes but we are somehow making use of the beauties of others....[41]

Two months after the first Union of Youth exhibition closed in Petersburg, the second opened in Riga. It ran from 13 June to 8 August 1910, in the Keninš Secondary School, 15 Terbatas Street. Although works by the group's members did not differ greatly from the first show, there were many new additions, including the Burlyuks, Ekster, Dydyshko, Petrov-Vodkin, Naumov and Zaretskii. The Moscow artists increased the number of their exhibits. In all there were 222 works by thirty-four artists. In addition photographs of exhibits at the first Golden Fleece salon (for example works by Van Gogh, Matisse, Gauguin and Cézanne's *Portrait of the Artist's Wife*), as well as thirteenth-century Italian primitives, such as Nerrocio di Bartolomeo, were shown.

The show opened the day after the Izdebskii Salon's vernissage at the premises of the Riga Society for the Encouragement of the Arts. By the time it reached Riga, the final stage of its tour, the Salon's exhibits had been reduced from 776 at Kiev to 617.[42] Important French works by Braque, Bonnard, Vuillard, Valloton, Guérin, Gleizes, Denis, and Van Dongen were absent. In addition, some Russians (i.e. the Burlyuks, Petrov-

Vodkin and Goncharova) preferred to exhibit only with the Union of Youth. On the other hand, Triangle associates such as Kul'bin, Shmit-Ryzhova, Rimša, Lentulov and, significantly, Matyushin, contributed to the Salon rather than the Union of Youth. The only artists represented at both were Larionov, Gaush, Ekster and Mashkov. Thus the overlap between these two exhibitions of modernist trends was minimal.

The simultaneous showing of these two exhibitions in Riga gave the Latvian public the chance to see a spectrum of Russian avant-garde art. It was the Union of Youth's show, however, that provoked the most discussion and argument among the local population and art critics. While the Salon presented a rather confused medley of international trends, the Union of Youth produced a more cohesive picture of Russian modernism. In subtitling its exhibition 'The Russian Secession', the group emphasised not only its links with developments in Europe, Munich and Berlin in particular, but also the fact that the contributions were to be considered a break with the prevailing Russian academic tradition. The new trends shown, while not fully representative of the recent changes in Russian painting, drew, in the first place, upon work by the Golden Fleece, Wreath and, of course, the Union of Youth exhibitors. Only the psychological tendency of Triangle was not represented.

It is worth focusing on Matvejs, the inspiration behind the exhibition, and indeed behind many of the Union of Youth's activities. He only exhibited three times with the group (and only once in Petersburg): at the two 1910 shows and at the Donkey's Tail in March 1912. This, however, belies his activity within the group and was perhaps a cautious step against provoking the wrath of the Petersburg Academy (which he had entered in 1906), and in particular his professor Dubovskoi. In the summer of 1910 Matvejs himself noted that the Academy, together with the Moscow art schools, had expelled more than fifty students in the academic year 'because they worked in the spirit of the "Golden Fleece" exhibitions'.[43] He implied that the student contingent of the Union of Youth was also working in this spirit, having studied Shchukin's and Morozov's collections of French Symbolists, Impressionists and Post-Impressionists and, more recently, 'the colour problems posed by the newest French artists – Matisse, Braque, Van Dongen and Picasso'. This study combined with an 'examination of the Pre-Raphaelites and Russian folk art' to create the various modern styles of the Union of Youth.

Matvejs was uninterested in the recreation of epochs. This he was to make clear in his writings. Instead, concerned with the expression of the artist's experience of the world and himself, he sought to utilise motifs and techniques for his own pictorial purposes. Thus he could make equal use of mythological subjects, universal themes or abstract principles. For Matvejs, art could be mimetic only of the idea, not of nature. It could

exploit the art of other cultures and ages, but not use them as models or attempt to reproduce their *faktura*. In this sense, Matvejs echoes Worringer's call for abstraction as opposed to empathy.

Matvejs showed only ten works at the second Union of Youth exhibition, compared with twenty-one at the first, perhaps because he was simultaneously participating in the first 'Exhibition of Latvian Artists' (Riga, 15 June – 16 July 1910). Treilev noted that he was 'an original artist... unafraid of combining styles and not setting any limits to his imagination'.[44] Like Borisov-Musatov and Petrov-Vodkin, he attempted to join idea and form, and to this end used colour combinations based both on harmony and dissonance. But his art differed from both of these artists not only because he used a greater variety of sources, but also because form for him was something active, more expressive and, ultimately, more sacred. Form itself was an expression of inner characteristics – be it national, folk or simply individual. Here his ideas were closer to the Neo-Primitivists.

For Matvejs, beauty was expressed when art perfectly accorded to the time and place. The artist's concern was to feel the atmosphere. This could be done by looking at the historical traditions that have shaped the modern situation. But an artist should also be free to indulge his fantasy, to express universal themes and emotions. In this Matvejs fully belongs to the symbolist aesthetic. His triptych *Morning, Noon and Evening* (cat. 97) depicted: 'childish, hopeless figures; one canvas is in grey-lilac tones, the second in yellow and red spots and the third is violet'.[45] Treilev considered the same work:

> *Morning* and *Noon* are not so much morning or noon but rather stylish illustrations of Slavic scenes from those times when they were still like 'wild animals'. His *Evening* really resembles evening, but it is the evening of human life, the evening of stormy, proud, refactory and disturbed life, finally broken and submitting to the supreme power. Thus we understand his figure standing on crutches before the church.

Similarly, he regarded *Golgotha* (cat. 94), which may well have been the *Torture of Our Saviour* censored at the Petersburg exhibition, as 'more a symbolic representation of the procession of mankind to something dismal, shameful and generally rotten, than the treatment of the title theme'. Thus Golgotha, that is, mythology, as well as times of the day, places, sculpture and nature, were taken as starting points and turned into something of universal relevance. Art was to be primeval, to evoke the suffering and the beauty of the world.

The symbolist attempt to impart universal relevance to the subject was repeated in *Seven Princesses* (cat. 102, Art Museum, Riga), (Plate 6) where the ethereal figures in long purple and green robes stare out to sea, watching a distant ship. The tall group of figures filling the picture space are like monumental, sculptured figures, their poses taut and static, their features

**59**

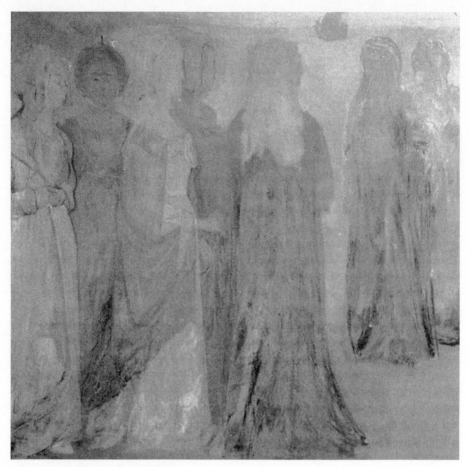

**6** V. Matvejs, *The Seven Princesses*

rubbed away by the processes of time. The almost timeless dresses, the melancholic mood, the subdued tones and the generalisation of form recall Borisov-Musatov. This is especially evident in the other-worldly expression of the figure to the far left. Indeed, the subtle tonality, flat space and frieze-like composition, all appear in keeping with the Saratov artist's techniques.

If a period were to be attached to the subject, the shape of the headdresses and the ship suggest the medieval. The use of suggestion generally is appropriate, for the work appears to relate rather loosely to Maeterlinck's *Seven Princesses* (1891), the last of the author's trilogy of death. There is no specific correlation with a scene. The ship in the distance can be taken as the man-of-war that has brought a prince to marry, only to find that of the seven awaiting princesses, his chosen one has died. Matvejs' interpretation is free: if the ship is arriving the princesses should be lying asleep, or if

it is departing only six should be on their feet. Maeterlinck's play has been described as

> a tableau recalling the albums of the Pre-Raphaelite Walter Crane, rather than a drama proper... The princely lover who returns to find his beloved dead is a figure of legend, but this is no fairy tale. Rather is it the allegory of Love seeking after the Ideal. This Ideal may be attained only by penetrating Death itself, and yet, once Man approaches, the Ideal itself dies and the barrier remains between the two.[46]

Matvejs' wan, misty images, an early characteristic of his work, appropriately recall Maeterlinck's 'Pre-Raphaelitism'.

Idealistic symbolism, with a debt to the Pre-Raphaelites, was most evident in the works of Naumov, Tsarevskaya and Petrov-Vodkin,[47] none of whom appeared with the Union of Youth on any other occasion. From April 1906 to October 1908 Kuz'ma Sergeevich Petrov-Vodkin (1878–1939) studied in Paris where he was influenced by Puvis de Chavannes and the Nabis. Upon his return to Russia he settled in St Petersburg and in 1909 began to exhibit. *The Dream*, shown at the Union of Russian Artists in March 1910, caused a sensation and the diversity of interpretations stimulated the break-up of the Union. It was shown again at the Union of Youth's exhibition where his twenty-six pictures, the vast majority of which were documentary-type sketches and studies from his trip to North Africa in 1907 (for example *Kasbah in Algiers*, *The Sahara* and *Carthagenian Woman*), filled a separate room.

With an increased concentration on artistic device, Petrov-Vodkin strove to convey a partially-symbolist worldview in three other exhibits, *Portrait of Maria Fedorovna Petrova-Vodkina, Wife of the Artist*, *The Shore* and *The Dream* – major paintings, from 1907, 1908 and 1910.[48] In the first, the artist's wife, dressed in dark bottle-green, sits in a slightly hunched pose with arms folded. In the background is an unfinished painting or tapestry on which three simplified female figures are set in repose against the simplified yellow-green curves of a landscape. This play of the concrete and idealised – with the wan colours and abstract features of the backdrop serving to emphasise the illuminated face and eyes, as well as the olive dress of the model – recalls Borisov-Musatov. Even the wistful, melancholic look of Maria Fedorovna has that other-worldliness of Borisov-Musatov's young women.

*The Dream* (1910, cat. 154) is full of ambiguity in its symbolism. The scene seems simple enough – three naked young figures on the picture surface and behind them a blue sky, rolling landscape and erupting volcano. The women, looking intently at the boy, are the visions of his dream. The foremost female represents the spiritual side of woman to which he is attracted, while the other is woman's physical aspect. However, the symbolism may be taken a step further and the sleeping youth interpreted as the

poetic consciousness of man, while the women, one pink and weak look-ing, the other darker-skinned, more muscular and healthy, represent beauty and ugliness. The subject, as Rusakov has indicated, is suggestive of Ferdinand Hodler's *The Chosen One*.[49] Both Petrov-Vodkin and Hodler projected the conflicting tendencies of naturalism, idealism and Symbol-ism and both arrived at formulae for their art derived from pre-Renaissance painting. They used stylised but precisely modelled figures isolated against a neutral background. In *The Dream* the emptiness of the land behind the figures is emphasised by the dissonance of its bluish-green tones with the black, pink and browns of the foreground and figures. The figures are isolated from one another, and the spectator, in a spiritual solitude.

In *The Dream* Petrov-Vodkin achieved a powerful combination of coloristic and plastic means. For example, the bodies are over-modelled anatomical studies and the colour scales dissonant, contributing to a delib-erate formal and stylistic incongruity. While the content remains ambigu-ous it is clear that he sought to embody universal notions in concrete forms, and to this end turned to the plastic language of a variety of times and cultures. This retention of figurative painting and historical precedents belies the experimentation that penetrated the trend of Russian synthetism to which Petrov-Vodkin, like Kul'bin and Matvejs, belonged.

Besides Petrov-Vodkin, five other artists (Matvejs, L'vov, Larionov, Goncharova and Mitrokhin) were given individual rooms in Riga.[50] Larionov and Goncharova supplemented those works they had shown at the Petersburg exhibition with Neo-Primitivist paintings they had exhibited at the Izdebskii Salon in Petersburg and at the Golden Fleece. Despite the use of different expressive means there is a similar complexity of motif in the work of the two Moscow-based artists to that of Petrov-Vodkin. All three artists simplified form, explored the dissonance of bright colours, exaggerated features and introduced unexpected objects. For example, Goncharova, in her *Portrait of Verlaine*, represented the deeply set eyes and face of the Symbolist poet 'in completely putrid colours;[51] Larionov's *Walk in a Provincial Town* (cat. 77), included a pig (the most dignified of all the figures) in the foreground; and Petrov-Vodkin's *The Dream* has two heaps of meteor-like black stone in prominent positions. Such features exaggerate the distortions inherent in two-dimensional representational painting rather than trying to hide them. Rejecting the objective observa-tion of nature, all three studied and employed Russian icon painting tech-niques, as well as the brightened palettes, colour combinations and defini-tion of space of Matisse and Gauguin. However, Petrov-Vodkin used the language of neo-classicism, while Larionov and Goncharova used that of the *lubok* and Russian folk art. In addition, Petrov-Vodkin alone main-tained a direct link between the subject matter, means of expression and the concrete idea. For Larionov and Goncharova these aspects could be

divorced as painting became more a display of device, an exercise in colour and line that exploited indigenous motifs and techniques for anti-establishment purposes.

Matvejs attempted to propagate his and the Union of Youth's ideas and aims by being almost permanently at the exhibition, explaining to the public and arguing with artists about the merits and values of the works on display. In addition, he published his thoughts in an article entitled 'The Russian Secession',[52] in essence one of the earliest apologies for Russian modernism. In the attempt to identify divergences and similarities in aesthetic outlook between the Union of Youth and Triangle, and hence understand their mutual development, comparison of Matvejs' theory with Kul'bin's proves revealing.

As if speaking for the Union of Youth as a whole, Matvejs described the modern artist's relation to nature. He traced this to the art of various cultures and individuals, and concentrated on colour as the foremost medium of expression. He argued that the subject matter was not that depicted – which acted merely as a source – but the manner of its depiction:

> We do not express nature itself but only our relation to it. We take from nature only that which may be called its radium. Thus nature is not the object but the departure point for our creative work. It brings to our fantasy some melody of colours and lines which when conveyed on the canvas in all fullness have nothing in common with nature.[53]

For Matvejs, like Kul'bin, art was a search for universal beauty and this involved exploring the individual's relation to nature and rejecting academic realism. However, Matvejs' freedom from visual appearances led in different directions to Kul'bin's. The latter's 'free art' was limited by an omnipresent relativity and the pantheistic conception of reality. The same sun could be painted 'gold... silver... pink... colourless'[54] by different artists but they would still be painting their relation to the sun, i.e. there would still be an empirical object.

Matvejs' relations to the object as a starting point left the way open for a more intrinsic and non-objective art. As if echoing the argument between realistic and idealistic symbolism, Kul'bin's 'hints' of the object were absent in Matvejs' 'radium', which was purely metaphysical. Matvejs wrote:

> If music is musical then why can't painting be painterly. Only when colours are free, when they are independent from some concrete notion, can one colour cling to another and that which is sweetest to it. Only then can colour ideas come into being and open a new, strange and forbidden profane world... That which man creates nature never does... Zola's formula that art is nature passing through a prism of temperament is unsuitable for us. For nature is unnecessary to us.

**63**

In other words, man is distinct from the rest of nature and his creations should reflect that distinction. The very essence of art is that it is not nature: 'In nature everything is subordinate to laws. In art everything must be permissable.' This justified, for example, Larionov's irreverant and unassociated images in his *Soldiers* series of 1908–11. However, for Kul'bin, the pantheist, all was one: man and nature were too intimately united to be separated. Art therefore was an expression of nature be it a reflection of man's psyche, sound or movement.

Ultimately both Matvejs and Kul'bin regarded art as an expression of the self, Matvejs writing:

> When a colour appears as an expression of temperament it can be pure, inno-
> cent, sinful, dirty, wild, naive, sweet, loud, childish, national, mystical. Is this
> not a rich world? And any person who has the ability to perceive all this delights
> in it. But the existence of this world of colour is possible only when colour is
> reproduced absolutely free, when it is not in the service of materially-relative
> phenomena and ideas.

Matvejs freed colour from conceptual associations so that it was intuitive. Kul'bin also sought an intuitive art, yet his notion of intuition was not of an isolated metaphysical action but of a physical response. He therefore did not allow art to be free from an interpretation of 'materially-relative phenomena'. His psychologist's outlook saw man's conscious and subconscious as physiological: even colours when spontaneously chosen are identifiable with certain strict subconscious laws which, in turn, are governed by the laws of nature. The use of colour as an expression of temperament, backed by scientific rules which determine its action on the spectator, was central for Kul'bin: his theory of 'close combinations'[55] states that the parallel positioning of colours of minimum tonal divergence produces powerful effects on the psyche – in this way man was able to create an effect like that of nature which had no boundaries in colour or form.

Matvejs, on the other hand, sought to distance colour from nature. In nature colour is never free from form and material. In the new art it must be free. Thus:

> In nature the colours of the spectrum exist not by themselves, independently,
> but relative to all possible organically-necessary and sensible phenomena. Here
> light, water, air etc. are endlessly related. Every colour in nature unites abso-
> lutely with a notion of something material, provokes an image of some object.
> All colour combinations in nature appear at the same time as some material
> phenomena.
> Thus colours act as slaves. In nature there are no unnecessary colours just as
> there are no unnecessary colour combinations. Everything in it has been subor-
> dinated from the start to monotonous and dull laws.
> The world of colour must be another world. When colour frees itself from its
> slaves' duties it opens up new worlds with new poetics and new secrets.[56]

This contrasts with Kul'bin's far more dynamic and vital vision of natural laws that are open to continual re-examination and revision. For Kul'bin the identity of nature was forever being challenged and changed. In his notion of 'impressionism' art could be free, full of harmony and dissonance, visually representative or an expression of fantasy, but it was always subordinate to nature. What it should not be is subordinate to the inadequate ideas about the nature of reality habitually taught in the academies. His stance is both conceptual and perceptual. New discoveries in science (X-rays, microbiology, for example) were to change established theories about the nature of reality, and Kul'bin felt it essential for art to reflect these developments. His works are studded with references to art as natural products and reality as a natural work of art: 'The world is a work of natural art – a play of dissonance with consonance... Art is the basis of life, a form of natural religion... Works of art are the flowers of culture.'[57]

This monistic worldview (the identification of art, science, man and nature) was far from being accepted by Matvejs. Although he used the analogy of the newly discovered element of radium in association with the content of art, he appears to have rejected science altogether. Art was to be grounded in art (and culture) alone. Artistic reality was, and always had been, distinct from natural reality. He developed the theory of chance[58] as essential for art, rather than law. Still, he agreed with Kul'bin's dismissal of academic notions of nature:

> We hate the copying of nature, this bankruptcy of thought and feeling, we hate studies of light and shade, studies of air and light, studies of sun and rain – all of this has nothing in common with the study of the world of colour. Giving the texture of visible objects is not the aim of art but of the crafts. It cannot give pleasure either to the public or the author; it is just grammatical exercises for children.[59]

Besides colour, Matvejs also recognised the freedom of line and acknowledged their potential: 'Lines free from anatomical laws and conventions are rich in surprises.' However, having studied Cézanne's work, Matvejs was more in favour of simple geometric figures and forms, noting their great versatility:

> The square, cone, cylinder and sphere have infinite variations in architecture. It is only a shame that the pyramid, with its inclined planes and large base has been so little developed and rare in architecture. Greece forced out this grandiose, monumental and mystical form. Not a single palace or temple or house is now built using this form.
> In the Gothic style the lines extend to infinity; here it is cold and serious; in the East it is passionate and with infinite variations. India, China, Assyria, Byzantium – every country and every nation break lines according to their taste and manner. Each has its own ornamentation. And not only nations but every great artist has his own calligraphy.[60]

Matvejs has most in common with Kul'bin when it came to the meaning and significance of beauty. For both it was to have a revelatory nature, being concerned with the 'unmasking of invisible things'.[61] As seen in Chapter 1, perception of these invisible things relied on a heightened 'consciousness, feeling and will' and entailed the artist obtaining a special 'poetic' state of consciousness. Then the artist would be able to sense the beautiful. The beautiful, the expression of the poetic experiences of man, remained the aim of art – for both Kul'bin and Matvejs. Furthermore, both sought to modernise art by discarding the public demands for a pleasant impression, rejecting 'all sugariness in art' (Kul'bin)[62] and the abandoning 'deft brushstrokes of Zorn or Sorolla [which] are no more than *salto mortale*, cheap effects' (Matvejs).

Matvejs felt that the twentieth century had lost the principles of beauty discovered by the artists of 'Egypt, Heliopolis, Samarra, Japan, Byzantium, the frescoes of the catacombs, mosaics, Islamic fantasies and Russian art'. Whatever shortcomings such artists may have had in regard to technical ability they were extremely skilled in using 'invisible means to express beauty, to fix individual and national fantasies'. Modern art needed to rediscover those invisible means, to replace technique and the crafts which had become too prominent, with beauty: 'Art and the crafts never get on with one another. Beauty usually functions and manifests itself especially strongly where the crafts are in a rudimentary state and where they ostensibly do not exist.' Beauty was to be found, therefore, not only in the art of the past but also in the primitive arts of the present: 'in caricatures, children's drawings, in folk art, and even in signboards which sometimes present and resolve colour problems unbeknown to their authors'. But 'beauty...is so capricious' and it needs (as Kul'bin also argued) a sharpening of the consciousness in order to be perceptible.

In fact, both artists turned to Buddhist belief to elucidate their aesthetic ideas. Kul'bin's psychological pantheism (often couched in Buddhist terms) is very close to Buddhist thought. Matvejs talked directly about Buddhism and the lessons that the modern artist could derive from its teachings. First of all, the artist must be able to penetrate, like the peoples of the ancient worlds, into a new state of existence, 'the circle of the spirit, of unreal nature'. To attain this 'One must possess refined and keenly ordered thoughts and feelings in order to forget the ordinary and commonplace.' Having achieved this altered state of consciousness, one would be able to perceive 'a completely different character of desires, different beauties, different secrets and different motives'. This perception of the 'poetic' could then be expressed in art. Matvejs cited the painting of the Tibetan Buddhist artists of Hara-Hoto as an example:

> Its colour combinations were so unexpected and so logical, and everything in it was arranged with such demonical richness and mystery that one comes to

realise that these people were unspoiled, that their feelings had not been distracted by dirty realism, that they were able to catch beauty, able to feel, to believe, to love and to reason.[63]

Beauty then, for Matvejs, was something individual and universal, something commencing from within, rather than being revealed from outside. Labelling the persuasions of Kul'bin and Matvejs, as with many of the Union of Youth contributors, proves complex and full of pitfalls. Calling Kul'bin a 'realistic symbolist' and Matvejs an 'idealistic symbolist' is insufficient. However, Kul'bin could be seen as a 'psychological-impressionist' and Matvejs as a 'symbolist-expressionist'. In other words, for Kul'bin art was a conceptualised symbol of the world as perceived by man and in which he participated, while for Matvejs it was a symbol of human temperament, independent of exterior phenomena.

Impressionism and Expressionism were never clearly defined as distinct schools in Russian modernism, which was often overlaid by symbolism, and it is for this reason that it is so hard to establish direct parallels with any one European trend. Jensen, although concerned primarily with literature, has identified the problem: 'Impressionism in Russia existed as a stylistic tendency that influenced realists, symbolists and futurists, yet impressionism never became an exclusive feature of any school... Impressionism is a meeting ground for various schools and movements, realistic and modernistic.'[64]

For Matvejs, beauty was physically expressed, before all else, in the combination of colours, although the distortion of form was also capable of 'much distinctive and even conventional beauty'. This explained the attraction, for the Union of Youth artists, of primitive art, the naivety of which they considered rich in poetry. There was no need to 'be overmodest with colour'. Bright or grey tones could be just as effective as one another and sharp contrasts (which he incidentally noted were found in church stained-glass windows) by themselves did not necessarily create solutions but were more likely to convey new problems.

Matvejs wrote as if for the Union of Youth as a whole and his ideas are applicable to many in the group, not only its Neo-Primitivist associates. He traced such ideas to the appearance in Russia of the art of Puvis de Chavannes, Monet, the Pointillists, Cézanne, Gauguin, Matisse, Braque, Van Dongen and Picasso; while also acknowledging the influence of the Pre-Raphaelites and Russian folk art. But he regarded his group's fundamental freeing of colour and form from concrete notions as indebted primarily to Van Gogh, Gauguin and Cézanne.

Still, the Union of Youth artists retained certain academic principles of composition and none, as yet, had challenged two-dimensional representation itself. Rather they challenged various established compositional elements and techniques; their 1910 exhibitions, with the Fauve-like primitiv-

ism of the Muscovites and the convoluted combination of symbolism, impressionism and neo-classicism, justifying the title of 'The Russian Secession'.

## References

1 Links with Munich were also considerable. The Russian emigrés Kandinsky and Jawlensky were co-founders of the Neue Künstlervereinigung [New Artists' Association] in 1909. The work of this group shows clear correlations with that of Triangle and the Union of Youth. Kandinsky contributed over fifty works to Izdebskii's first salon and expressed a symbolist aesthetic based on subjective truth not dissimilar to that of the Petersburg avant-garde from the World of Art onwards.

2 A. Rostislavov, 'Soyuz Molodezhi', *Rech'*, 8 January 1910, p. 5

3 Matvejs' full name was Hans Voldemars Yanov Matvejs (Matvei in Russian). From 1912 he published articles under the pseudonym Vladimir Markov.

4 This and all other original documents cited below, unless otherwise noted, are in the Union of Youth archive, Manuscript Department, Russian Museum, St Petersburg, fond 121, op. 1.

5 Rostislav Vladimirovich Voinov (1881–1919), who had his own wooden-toy workshop, had studied at the School of Drawing at the Society for the Encouragement of the Arts and in L. E. Dmitriev-Kavkazskii's studio. He worked as a sculptor and ex-librist, and later contributed to the Union of Youth's fifth and last exhibitions. He had a one-man show in Petersburg (1907).

6 See published *Ustav obshchestva khudozhnikov 'Soyuz Molodezhi'*.

7 M. Matyushin, 'Russkie kubo-futuristy' in N. Khardzhiev, *K istorii*, p. 141.

8 [anon.] *Peterburgskaya gazeta*, 6 January 1910, p. 4.

9 The Association of Independents was registered as a society on 27 April 1910. Its founders were A. Vakhrameev, I. Bespalov, I. Grabovskii and others. It held exhibitions of painting, graphic art and applied art (1911–16). In its regulations the Association stated its aim 'to encourage the clarification of the individuality of the artist and to help him in his endeavours to self-determination' (cited in V. Lapshin, 'Razvitie traditsii russkoi zhivopisi XIX veka', *Russkaya khudozhestvennaya kul'tura kontsa XIX-nachala XX veka (1908–17) kniga 4*, Moscow, 1980, p. 57).

The Non-Aligned Society of Artists was founded by Pskovitinov. On 30 October 1912 it was registered as a society and published its regulations. The aim of the group was to unite artists 'regardless of their approach to art' (*Ustav vnepartiinago obshchestva khudozhnikov*, St Petersburg, 1912) and to give members the chance to acquaint the public with their work. Exhibitions were held without a panel of judges. By December 1912 the number of members was 150, including artists from all over Russia. In their initial *Credo* the Non-Aligned Society noted that it had been founded 'For the creation of the conditions by which the work of artists, that freely express their creators' experiences and moods, would not meet any obstacles and would be determined only by the moments of personal creativity... We appeal to all of those for whom art is dear, who are interested in its absorption into life, who may take the new society seriously, to abandon isolation for free cooperation and unrestricted searching' (*Russkaya molva*, 23 December 1912, p. 6). In the catalogue of its first exhibition were 'Credos' of more than ten artists, some of which were openly antagonistic.

The Arts Association was registered as a society on 27 April 1910. It described its aim as the 'unification of young artists from all branches of art on the grounds of service to true art and mutual aid in the broad sense of the phrase' (see *Ustav khudozhestvenno-Artsisticheskoi Assotsiatii*, St Petersburg, 27 April 1910). Initiator of the group was the artist Komarov. The Association organised one exhibition (November 1912) and several debates.

The World of Art recommenced its activities after a schism occurred in the Union of Russian Artists in 1910. Its first new exhibition opened in Petersburg on 30 December 1910.

10 The 'Art Bureau' of Nadezhda Evseevna Dobychina (1884–1949) opened in Petersburg on 28 October 1912. It was the venue for many types of exhibitions, though it favoured the avant-garde, until it closed in 1918. As a commercial enterprise, the bureau aimed to help young artists overcome financial difficulties as well as avoid exploitation by unscrupulous dealers. It also aimed to disseminate the ideas and art of contemporary artists to a far broader cross-section of the public than had hitherto been reached.

11 The 'Moscow Salon' was founded in 1910. Its first exhibition opened on 10 February 1911. The aim of the 'Salon' was 'Tolerance of all beliefs in art... The unification of various directions in painting in one exhibition. This systematic grouping will clarify the principles and ideas that inspire them' (From the catalogue of the first exhibition, Moscow 1911, cited in Lapshin, 'Razvitiye traditsii', p. 58). It continued to organise exhibitions until 1918.

The 'Free Art' society began to organise annual exhibitions with the title 'Modern Painting' from 1912, while the 'Free Creativity' association held annual exhibitions from 1911 to 1918.

12 [anon.] 'Soyuz molodezhi', *Rech'*, 26 February 1910, p. 5.

13 [anon.] *Novaya Rus'*, 4 March 1910, p. 4.

14 A. Rostislavov, 'Levoe khudozhestvo', *Rech'*, 28 March 1910, p. 2.

15 This letter is clearly predated by that of 19 February (Kharzhiev, *K istorii*, p. 31) in which Matvejs invited Larionov to participate with a '*carte blanche*'.

16 [anon.] Rech', 5 March 1910, p. 5.

17 Mashkov and Goncharova, although already established artists in Moscow, made their Petersburg debuts at the Union of Youth show.

18 Larionov's *Wooden Sculpture* (cat. 80) was a stone *baba* image, a primitive sculptural form from the Steppes (see Vsev. Ch-in. [Cheshikhin], 'Vystavka Soyuza molodezhi II', *Rizhskaya mysl'*, 28 June 1910, p. 3). Three works by Matvejs entitled *Wooden Sculpture* (cat. 123–5) were paintings of sculptural forms (now in Tukumas Museum, Latvia).

19 [anon.] 'Soyuz molodezhi', *Zolotoe runo*, Nos 11–12, 1909, p. 101.

20 Dubl'-ve, *Peterburgskii listok*, 10 March 1910, p. 2.

21 Breshko-Breshkovskii, 'Soyuz Molodezhi', *Birzhevye vedomosti*, No.11612, 13 March 1910, p. 6.

22 V. Yanch. [Yanchevetskii], 'Khudozhestvennaya khronika', *Rossiya*, 12 March 1910, p. 3.

23 M.S. [Simonovich], 'Khudozhestvennaya zhizn' Peterburga', *Moskovskii ezhenedel'nik*, 8 May 1910, p. 55.

24 A. Rostislavov, 'Svezhie buri', *Teatr i iskusstvo*, No. 14, 1910, pp. 297–9.

25 Evseev exhibited twenty-six works, many being stage designs for symbolist plays (Sologub's *Vanka Klyuchnik and Pazh Zhean*, Rachilde's *Mistress Death* and Osip Dymov's *Nyu*). He also showed *The Blue Room*, Greek costume sketches for a concert by M. A. Verdinskaya, still-lifes and studies of flowers. One critic noted: 'such areas of colour as he creates, you [the older generation] do not have' (G.M. [Magula], 'Tri pokoleniya (Vystavki peredvizhnaya, Soyuz russkikh khudozhnikov i Soyuz molodezhi)', *Zemshchina*, 25 March 1910, pp. 3–4).

26 Ivan Mitrofanovich Severin (1881–1964) contributed to the first two Union of Youth exhibitions. Born in the Poltava gubernia, he received his art education at the Krak"w Academy from the landscapist Jan Stanislawski, graduating in 1907. Having studied briefly in Paris and Rome, he settled temporarily in the Bukovina region of the Ukraine. There he made many studies of Huzul life. The work of his early period reflects a debt to Stanislawski, in the use of expressive, broad brushstrokes in decorative landscapes. His Union of Youth exhibits included *From Rome, From the Carpathians, The Cemetery in the Evening, Haystacks, Poltavshchina*, and *Chrysanthemums*.

27 Concerning Bystrenin's algraphy see J.F. Kowtun, *Die Wieder geburt der Kunstlerischen Druckgraphik*, Dresden, 1984, pp. 33–4. Bystrenin first exhibited his algraphy works at the New Society of Artists (1905).

28 Vrubel died in a Petersburg mental asylum on 1 April 1910.

29 'Pis'ma v redaktsiyu', *Rech'*, 3 April 1910, p. 6.

30 V. Yanch., 'Khudozhestvennaya khronika'.

31 A. Rostislavov, 'Levoe khudozhestvo'.

32 The other two artists were Evseev and Vaulin.

33 Breshko-Breshkovskii, 'Soyuz molodezhi'.

34 Rostislavov, 'Levoe khudozhestvo'.

35 Breshko-Breshkovskii, 'Soyuz molodezhi'. The Rubens in the Kushelev Gallery (Count Kushelev-Bezborodko's rich collection of west European art bequeathed to the Petersburg Academy) was almost certainly *Ecce homo* (*c.* 1606). *Torture of the Saviour* (1814) by the academician Aleksei Egorovich Egorov (1776–1851) remains in the Russian Museum.

36 V. Bubnova, 'Moi vospominaniya' (unpaginated).

37 N. V. [Vrangel'], 'Vystavka 'Soyuza molodezhi'', *Apollon*, No. 6, 1910, p. 38.

38 Rostislavov, 'Levoe khudozhestvo'.

39 Rostislavov, 'Vystavka Soyuza molodezhi', *Rech'*, 24 January 1912, p. 3.

40 Breshko-Breshkovskii, 'Soyuz molodezhi'. Anna Mikhailovna Zel'manova(-Chudovskaya) first exhibited at this show. She was to become a member of the Union of Youth and regular contributor to their exhibitions. She also participated in World of Art shows.

41 Cited in Khardzhiev, *K istorii*, p. 30.

42 See *Salon Izdebskago* [exhibition catalogue], Kiev, 1910 and *Salon Izdebskago* [exhibition catalogue], St Petersburg, 1910. The Riga catalogue with 617 entries was printed in Petersburg at the Printing House of F. N. von Al'tshuler. The catalogue for the Petersburg show, with 656 entries, was also printed by Al'tshuler, but as seen from the reviews (e.g. A. R-v. [Rostislavov], 'Otkrytie vystavki 'Salon'', *Rech'*, 21 April 1910, p. 4 and 'Salon', *Rech'*, 1 May 1910, p. 6) this catalogue alone relates to the Petersburg leg of the Salon tour. The quick selling of works in Petersburg (including those of Van Dongen and Beltrand) was noted a week after the opening: [anon.] 'Salon', *Novaya rus'*, 28 April 1910, p. 5.

43 This quotation is taken from the Russian version of Matvejs' article 'Russkii Setsession (po povodu vystavki 'Soyuza molodezhi' v Rige)', *Rizhskaya mysl'*, 11 and 12 August 1910, p. 3. The article had earlier appeared in German in *Rigasche Neueste Nachrichten*, 10 July 1910 and in Latvian in *Jauna Dienas Lapa*, 20 July 1910; *Latvija*, 24 July 1910; and *Dzimtenes Vestnesis*, 29 July 1910. See I. Buzhinska (ed.), *Chteniya Matveya*, Riga, 1991, p. 184.

44 K. Treilev, 'Russkii Setsession', *Rizhskii vestnik*, 13 July 1910, p. 3.

45 V. Ch-in. [V. Cheshikin], 'Vystavka Soyuza molodezhi II', *Rizhskaya mysl'*, 28 June 1910, p. 3.

46 W. D. Halls, *Maurice Maeterlinck: A Study of his Life and Thought*, Oxford, 1960, pp. 31-32.

47 Pavel Semenovich Naumov (1884–1942), a student at the Academy and friend of Rerikh's, often painted medieval scenes with generalised forms that are evocative of a romantic vision of a beautiful past. Vera Kirillovna Tsarevskaya(-Naumova) (1882–1956) showed *Fairy-Tale* which, according to Cheshikhin's note, compare with Petrov-Vodkin's *The Dream*: 'Here is a knight, who sleeps... while slim and melancholic Pre-Raphaelite virgins look on.'

48 See Vsev. Ch-in. [Cheshikhin], 'Vystavka Soyuza molodezhi', *Prilozhenie k Rizhskoi mysli*, 26 June 1910, p. 1. Petrov-Vodkin's portrait of his wife was previously considered unexhibited until his retrospective show in 1936-1937. However, Ch-in has identified it and its 'olive tone with the very lively eyes'.

49 See I. Rusakov, *Kuz'ma Petrov-Vodkin*, Leningrad, 1986, p. 38.

50 The exhibits of Dmitrii Isidorovich Mitrokhin (1883–1973) included *The Courtesan*, *The Jester*, *The Alphabet* as well as vignettes and heraldic motifs. Attracted by the work of Lansere and Ostroumova-Lebedeva, Mitrokhin concentrated on graphic art with literary and retrospective motifs, finding, henceforth, the World of Art a more suitable exhibiting forum. Notable among the other exhibitors were Dydyshko (*The Dead*, *Evening* and *The Lake*), who began an association with the group that was to last until its final exhibition; Spandikov (whose *Women*, according to Cheshikhin, represented: '... unprecedented Papuan mugs in Australian dress'; Mikhail Aleksandrovich Shitov (his titles indicating a tendency towards the symbolism of Verlaine and Maeterlinck, e.g. *Bluebirds*, *In the Chambers of Sorrow*, *Music*, *Light Symphony* and *Autumn Sounds*); and Matvejs' friends Bubnova, Nikolai Vasil'evich Zaretskii (1876–1959, whose graphic work resembled Beardsley and Dobuzhinskii) and Anastasiya Vasil'evna Ukhanova (1885–1973). The inclusion of these artists considerably increased the percentage of Academy students represented in the Union of Youth.

51 Vsev. Ch-in., 'Vystavka Soyuza'.

52 See note 43. Although the Russian version only gave 'M' as the author, stating that it was one of the participants in the exhibition, the Latvian version gave both Matvejs' name and the address of the exhibition (15 Terbatas Street, Riga).

53 Matvejs, 'Russkii setsession'. Matvejs' use of a 'radium' analogy may have associations with Larionov's subsequent style of Rayism. It is worth remembering that radium was the first natural radioactive element to be discovered – by the Curies as recently as 1898. Matvejs apparently had in mind radium's property of spontaneous disintegration which involves the emission of alpha and beta particles and gamma rays.

54 V. Kamenskii, *Put entuziasta*, p. 85.

55 Kul'bin lectured on 'Harmony, Dissonance and Close Combinations in Art and Life' at the All-Russian Congress of Artists, 30 December 1911.

56 Matvejs, 'Russkii setsession'.

57 Kul'bin, 'Treugol'nik'.

58 See Chapter 4 concerning Matvejs' (Markov's) 'Principles of the New Art' (*Soyuz Molodezhi* No.1 and 2, 1912).

59 Matvejs, 'Russkii setsession'.

60 *Ibid.*

61 Kul'bin, 'Svobodnoe iskusstvo', p. 12.

62 V. Yanch., 'Vystavka impressionistov Treugol'nik'.

63 Matvejs refers to an exhibition of Buddhist painting and sculpture from the ancient Tibetan city of Hara-Hoto, that took place in Petersburg in spring 1910. Hara-Hoto had been discovered in 1908 by the Russian explorer Petr Kuz'mich Kozlov (1863–1935), leader of a Mongolian-Szechwan expedition in the Gobi desert. Much unique material relating to the Tangut culture was found, including painting of Buddhist figures on cloth and books with unusual heiroglyphic writing.

64 K. Jensen, *Russian Futurism, Urbanism and Elena Guro*, Aarhus, 1977, p. 188.

# Act I Scene ii, 1911

Between the closing date of the Union of Youth's Riga exhibition (8 August 1910) and the opening of its next show in Petersburg (11 April 1911) there were many significant events in the history of the Russian avant-garde. The World of Art had resumed its activities and invited members of the younger generation (e.g. Goncharova, Sar'yan and Sapunov) to participate in its exhibitions.[1] An exhibition known as 'The Knave of Diamonds' (Moscow, December 1910 to January 1911) heralded the founding of a society of the same name. The newly founded 'Moscow Salon' had held its first exhibition (February to March 1911) and the second Izdebskii Salon had opened in Odessa in February.

As far as the Union of Youth was concerned, some of its members (Filonov, Shkol'nik, Spandikov and Shleifer) had visited Helsingfors (Helsinki) in late November with the aim of forming a union with young Finnish artists and organising a joint exhibition with them.[2] In addition, Zheverzheev's patronage of the group increased and his home, as the Union of Youth's official premises, became the venue for most of its meetings. His influence came not only from his ability to provide facilities and financial resources but also from his ideas. For instance, in early 1911 he was instrumental in the innovative conception of the Union of Youth's first theatrical venture, *Khoromnyya Deistva*.[3]

After graduating from a Petersburg college of commerce in 1899, Zheverzheev began to supervise the art work at his father's brocade and religious artefacts workshop. The products of this workshop were sold in the prosperous family shop on Nevskii Prospekt. However, Zheverzheev was interested in helping the cause of modern art and he devoted much of his time, money and organisational talent to the Union of Youth. His patronage was deemed indispensable. Soon after being invited to join the group, he was elected president, a position he held until the Union of Youth closed. His own conception of the essence of the society was broadly in line with that expressed by its founding members:

> He [Zheverzheev] saw it as a creative union, the doors of which were opened wide for all new artists, as long as they were not traditionalists and were talented. Free from any sectarian narrowness and not afraid of reproofs for eclecticness, it was to give the youth that which was insufficient in their generation – an atmosphere of benevolent cohesion and a co-ordination of

effort. It was to be an experimental laboratory of modern art; a large camp, well-fortified against any enemy attacks.[4]

Zheverzheev also contributed examples of applied art (brocaded cloths, screens and cushions) to the first two Union of Youth exhibitions. Made 'according to original Tibetan and ancient French designs'[5] his brocade had 'wonderful colours and design… making us remember the magnificent garments of Catherine's metropolitans that decorate the museum of the Aleksandr Nevskii monastery. The combination of gold and silver, with cherry, green and blue is remarkable in its consistency.'[6] Thus, using the study of brocade design essential for his profession, Zheverzheev was able to combine rich colour and traditional folk design, as if in keeping with the plastic searches of the easel painters.

However, Zheverzheev's input into the Union of Youth was not primarily through his own art but through his promotion of painting and theatre. In early 1911 he directed the group's attention towards the latter, where he sought, as elsewhere, innovation based on ancient forms. The first theatrical venture staged by the group, *Khoromnyya Deistva*, opened on 27 January 1911 in the Suvorin Theatrical School. This location was ideal for the evening because various entertainments took place simultaneously in separate halls. The evening proved so successful that public demand meant it was soon repeated and later on in the year taken to Moscow by its director Mikhail Mikhailovich Bonch-Tomashevskii (1884–*c*.1920).

Through Zheverzheev's initiative, theatrical design entered the consciousness of many Union of Youth artists. While some members (especially Academy students, such as Matvejs, Dydyshko, L'vov and Nagubnikov), preferred not to become involved, many saw theatrical work as an integral branch of painting and one where their experiments could be taken in new directions, away from the two-dimensional limitations of easel painting. Thus the occasion served as an introduction of the new generation of 'left' artists to dramatic design and ideas.

Modern historians[7] have been quick to point out, on the evidence of one critic, that the evening involved the use of a new, deliberately crude, theatrical style: 'bad taste in costumes, absence of footlights, free passage of actors from stage to audience, walls decorated with posters, and barrels instead of chairs in the buffet'.[8] There has, however, been no attempt to assess the content of *Khoromnyya Deistva* or its contribution towards the development of the Union of Youth.

The performance of *Khoromnyya Deistva*, with its tinges of nationalism and archaism, can be seen as a legitimate and integral part of the Neo-Primitivist movement that was then beginning to dominate Russian modernism. The evening brought new ideas to the fore that were to affect not only the nature of future (and Futurist) theatrical production in Russia, but also the nature of painting. It was one of the first steps in the fusion of

modern visual and literary art forms in Russia called for by Kul'bin and started in his performance-type lectures. The cover of Kul'bin's *Studio of Impressionists* had the letters of 'Studiya' created out of *skòmorokhi*-type figures (minstrels, actors, jugglers and dancers) in clear imitation of four-teenth-century Novgorodian or Pskovian psalter and liturgicon initials, and represented his call for a unified art. Even though these travelling entertain-ers were essentially pagan, often leaders of cult ceremonies, they became so popular in North Russia by the fourteenth century that they were depicted as illuminations in Christian books.

The *skomorokhi* were symbols for much of what Kul'bin sought in art. Originating as Eastern Slavs in the pre-Christian era of Kievan Rus' they were both indigenous to Russian lands and made essential contributions to native art forms. Such forms were often fused in cylical festivals and rites but it is worth identifying them separately. Their songs, sung to the accom-paniment of stringed, wind and percussion instruments (predominantly the gusli, horns and tambourine respectively), were often of a ritualistic and worshipping nature. They were closely related to the seasons and cycles of nature and were characterised by free rhythms, simple melodies, basically diatonic and often repeated. As far as dance was concerned, the *skomorokhi* often led the *khorovod*, or circle dance, which communities performed as a ritual to invoke the spirits for a good harvest. In other words they acted as a means of communication between man and nature. Their contribution to drama (besides their trained bear acts and later use of puppet theatre) is less clear, although it is known that they took a leading part in the seasonal festivals and wedding rites – which took the form of a community folk drama – often wearing animal masks or playing the jester. Their improvisa-tion of comic dialogue eventually developed into folk comedies. These, 'in the seventeenth and eighteenth centuries... came under considerable influ-ence from scholastic and court drama, which result ultimately in the crea-tion of such legitimate folk plays as *Tsar Maksimilian*'.[9]

The flamboyant and brightly coloured costumes of the *skomorokhi*, and the versatility of their repertoire, had offered medieval Old Slavonic illu-minators a broad range of artistic possibilities for initials in religious texts. Equally, Kul'bin and more significantly the Union of Youth, were to use them as source material for even more diverse forms of art. Judging by the dating of some of the costume designs for *Khoromnyya Deistva*, the idea occurred first in 1910 (designs by Mikhail Mizernyuk, Zheverzheev and Baudouin de Courtenay dated 1910 survive).[10] This then coincides with the dissemination of Kul'bin's ideas and Evreinov's theory of monodrama, where the literary tradition of high drama had been broached by an increase in the significance of body language, correlatory shifts in the nature of the surroundings and the spectator being turned into an illusionary performer, going through the same experiences as the actor.

In 1909 Evreinov had become chief producer at The Crooked Mirror and put on a series of burlesques, pantomimes and satires, parodying the extreme realism of Stanislavskii.[11] Furthermore, 1910 had also seen the opening of The House of Interludes in St Petersburg, one of its founders being Bonch-Tomashevskii. Here Meierkhol'd and Pronin experimented with interludes performed amidst the public, the applying of make-up in the auditorium and the 'casting' of the audience, as in the production of Znosko-Borovskii's play 'The Converted Prince' where they became visitors to a Spanish bar. Thus the reaction against the stagnant naturalism and the symbolism of the Russian theatre had already been made public.

This reaction had, however, really begun at the end of 1906 when Meierkhol'd staged Blok's *Balaganchik* ['Little Fairground Booth']. Blok's play was a parody of symbolist theatre, but it also initiated the move to a Neo-Primitivist theatre based on native forms. *Khoromnyya Deistva* employed similar sources, although it searched deeper into Russian history for its content and form. Indeed, Blok, while retaining the *Balaganchik* title of his play[12] focused attention on foreign 'low' theatre – primarily on Italian *commedia dell'arte*. He not only resorted to old motifs (for example buffoonery) but also revived old techniques (a play within a play, the use of masks, improvisation and pantomime, actors addressing the audience directly, the author represented in the play, moving scenery in view of the audience).

Blok, like Evreinov at the Theatre of Antiquity (where he worked in 1908) and The Crooked Mirror, really found no native historical precedent for his ideas of theatricality. Although the symbolists (such as Remizov in his *Devil Play* of 1907),[13] had searched Russian folklore for sources for their own dramas, on the whole they, like Blok, Meierkhol'd and Evreinov, sought to modernise the Russian theatre using European models. Leonid Andreev's medievalism also epitomised this preference (for example *Black Masks*, 1908, is set in Italy). The House of Interludes, which had opened under Meierkhol'd's direction on 9 October 1910, continued this persuasion, with a cabaret theatre of farce and pantomime (including works by Schnitzler, Cervantes and Kuzmin).

It was at the House of Interludes that *Tsar Maksem'yan*, a central part to the Union of Youth's *Khoromnyya Deistva*, was first intended to be revived. A notice was published stating that a performance of the Russian folk play was to be given, together with *Don'Juan*, during the Christmas holiday period and, significantly, that the action would be 'performed on stages amidst the public'.[14] As part of the programme various artists of the House of Interludes were to perform solo numbers among the public and on the stage. No details were given and no reports of such a performance of *Tsar Maksem'yan* have survived.

The search for, and use of, indigenous forms, is indicative of the artistic

youth's newly acquired aspiration for independence from Europe. Certain Abramtsevo artists such as Elena Polenova and Viktor Vasnetsov had, towards the end of the nineteenth century, begun to use motifs from Russian folklore, but they restricted themselves to the pictorial representation of myth and fairy tales. *Khoromnyya Deistva*, although not overtly nationalistic, helped establish the new nationalist-inspired Neo-Primitivist movement in Russia. This subsequently, as shown later, made possible a dramatic new spatial dynamism, having far-reaching effects on the development of stage design and on the very essence of painting.

The formal revolution that the Union of Youth began with *Tsar Maksem'yan* was heavily reliant – like the World of Art had been in its retrospectivism and like Larionov and Goncharova were in their Neo-Primitivist canvases – on the careful study of historical precedent. The text was important but the formal qualities of the set, costumes and music were more significant.

*Tsar Maksem'yan and his Disobedient Son Adolf* is by no means a conventional play: although it has a plot, it is not a single unified drama but a collection of scenes. These do not necessarily develop from one another, but focus around a central theme: namely the religious conflict between the Tsar and his son. The story is not complex. Many variants of the play are known but the Union of Youth used a specially written text by the 'young author V. Spektorskii'.[15] This accorded with known variants of the *Tsar Maksem'yan*,[16] although the violence after Adolf's martyrdom (traditionally there was a series of duels involving Anika the Warrior and much unexplained beating and quarrelling) appears diminished.

The fabled Tsar, under the spell of passion for the pagan Venus (Venera) decides to give up his faith and worship his bride's idols (only if he does so will Venus consent to marry him). Maksem'yan's son from his first marriage, Prince Adolf, retains his belief in the Orthodox church, to the outrage of his father. The Tsar has Adolf put in chains by a blacksmith, thrown in a dungeon and then executed by the sword of the aged knight Brambeus. This happens despite the entreaties of the Mohammedan envoy and the threats of the 'noble' Roman ambassador, who, indignant at the injustice, approached the Tsar only to be driven away by mighty Anika the Warrior (only Death can defeat Anika – a popular figure in Russian folk mythology). Inevitably, Death appears and throws the apostate Tsar Maksem'yan into the abyss, even though he begs to live – at first for three years, then a year, then three months and finally one minute. A colourful cock, as a vagrant, poet and emblem of the dawning of life, clambers up on to the throne and welcomes with a loud cock-a-doodle-do the rebirth of dawn, the sunrise and a new life. And thus the tragedy ends.

While this sequence of events appears straightforward enough, it is interrupted by a series of unexpected 'interludes'. These include the arrival

of the *skorokhod*-marshal (apparently summoned by Maksem'yan and thrashed for some unknown crime), the games and dances of the *skomorokhi*, the recalcitrant and grumbling old gravedigger and his wife Matrena, and the music of the fife player. These served as comic and serious relief from the main story of the play. Some interludes were tenuously linked with the plot while others appear independent of it. Remizov has described their function:

> With the appearance of the eccentrics the interludes start. ... the eccentrics are irrepressible... and worm their way into the action. And apparently break up the structure of the play. But in fact it is the converse of this: with their disorder they construct a new special tune – the tune of tiresome presences and jest-making. Moreover, the appearance of the eccentrics in the action, like the reiterations and the repetitiveness of the *Skorokhod*, introduces its own measure of time – their appearances and words are like the movement of the hand of a watch or the strike of the clock....[17]

Essentially, the morality of the play remains the same in all known variants of the play – two opposing elements, embodied in Maksem'yan and Adolf, mark the struggle between Christian humility and evil power; virtue and vice. Virtue, the meek Adolf, martyred for his beliefs, emerges as the hero while vice is punished by death and damnation. Remizov noted: 'The basis of *Tsar Maksimilian* is the Passion of the disobedient Tsarevich, tormented for his beliefs by his own father, the pagan and impious Tsar... Tsar Maksimilian – this is Tsar Ivan and Tsar Peter. The disobedient and recalcitrant Adolf – this is Tsarevich Aleksei and the whole Russian nation.'[18]

The formal elements of the Union of Youth's production were the most important aspects of the spectacle. The folk costumes, decorations, audience involvement, music and acting techniques all contributed to create a piece of dramatic performance unprecedented in Russian high theatre. It was to have important consequences, not least for the Union of Youth's artists and their future dramatic projects. Thus the absurd cock announcing the 'rise of the usual sun' i.e. the return to decent, normal life and values, at the end of *Tsar Maksem'yan* cohesively links the performance with the Futurist opera *Victory over the Sun* of 1913, where an Aviator appears at the end, replacing the cock but at the same time contradicting its call for a return to normality. The cock is also present in *Vladimir Mayakovsky: A Tragedy* produced by the Union of Youth at the same time as *Victory over the Sun* which, like the latter and *Khoromnyya Deistva*, generally denied the conventions of high theatre.

The decorations were principally designed by Sagaidachnyi, who was in overall charge of the artistic work. The costumes were designed by Mikhail Vasil'evich Le-Dantyu (1891–1917), assisted by other Union of Youth artists. The music was written by a certain, possibly pseudonymous, M. P. Rechkunov.

The play began with the sounds of a horn, a drum and the song of a cock. Simultaneously there appeared from among the public a festive procession which made its way to the 'specially constructed *balagan* stage'[19] (a stepped wooden platform) for the actors. At one end of these boards was the fantastic throne of Tsar Maksem'yan and at the other that of Venus. On the surrounding walls of the hall were, the critic and cartoonist P'er-O noted, 'Byzantine frescoes "in the Russian manner"'. He added that 'Everything was so new and so original and at the same time familiar because of its Suzdal-*lubok*-like Byzantinism.'[20] Rostislavov found the novelty lay not only in the production itself but also in the unity of the 'Byzantinism with the chivalrous romanticism, the Shakespearean conciseness and beauty with the scenic naivety (almost all of the participants are 'summoned') and the originality of the Russian speech'.[21]

As the play had been performed in a variety of ways at different times (it had even been part of the *vertep*, the Russian puppet theatre), the director, Bonch-Tomashevskii, had to choose the most appropriate manner for the given circumstances. One of the most significant decisions concerned the public's involvement. In contrast with earlier times, the Petersburg public of 1911 was alienated from the action, not only because performances of such plays and the *skomorokhi* had all but ceased but also because theatre had become a more strictly defined, sophisticated and urban phenomenon. So Bonch-Tomashevskii decided to 'convert' the public, as far as possible, into the original spectator folk, to make them a part of the historical scene. According to Kamyshnikov he succeeded in doing this 'almost irreproachably'.[22]

The raised boards in the centre of the hall, dominated by the brightly illuminated arch and the throne of Tsar Maksem'yan, at the top of a broad staircase on which the action took place, attracted much attention. A sketch by Sagaidachnyi, depicts the Tsar seated on a centrally positioned throne that surmounts a flight of five green and pink stairs. On either side of Maksem'yan stand two courtiers with pikes, below are more servants, two dancers and a lady sprawled at the Tsar's feet. The left-hand wall is covered by a plant-like form and two medieval windows, while the right side has an ornate door, above which is a strangely speckled picture of a dog. Frieze-type decorations frame the left and right sides of the sketch. The colours are muted – green, red, turquoise and grey. The reviewer Malishevskaya noted the wall-designs:

Before the spectators appeared the epoch of sixteenth- and seventeenth-century Russian theatre, with its primitive, yet artistically true, requirements... The decor was in complete harmony with this epoch... to which *Khoromnyya Deistva* belonged... Everything was finished in the Slavonic style. Simple, but odd, decorations had colourful original inscriptions, like 'Love is a Delightful Pursuit'.[23]

The brightly coloured primitivism of the walls attracted the eye and praise of other critics who were impressed and intrigued by its originality. Gita noted 'The hall had a completely unusual look, covered with curious scenes and a panel by the artist Sagaidachnyi. This panel immediately carries one to to some special fabulous and fantastical age; the furniture was elegantly set out in semi-circles so that the performers could make their appearance'; and Rostislavov found 'The artists reached creative heights in the costumes and decorated walls designed according to old *lubok* images. They carried in them the freshness of folk art.' Furthermore, P'er-O added that the naivety of the images, and the bright colours of the 'calico and coloured paper, created with size paint in a few hours of energetic work' recreated the 'distinctive style of the Russian *lubok*'.

However, Kamyshnikov felt the folk tragedy required more 'tinselness' and gold colour. Such criticism was almost certainly directed more at the costume designs and props than the wall paintings which seem to represent a very early, direct use of the Russian *lubok* by modern artists (perhaps only presaged by Larionov's and Goncharova's painterly exploration of the folk images). Descriptions of the materials and colours of props and costumes, dating from original performances of the play in the eighteenth and nineteenth centuries, make it clear that the Union of Youth observed tradition: 'anything that came to hand, was used in the construction of costumes... odd pieces of wood for swords; cardboard... scraps of coloured materials, oddments of sheepskin or fur for beards... straw... coloured paper'.[24] Gold and silver tinsel was undoubtedly also used, for example, in the Tsar's sceptre and orb, but not to the extent Kamyshnikov maintained.

Generally, the costumes also were admired by the critics for their imagination, innovation and truth, although to talk about historical accuracy can be misleading since the play is 'a confusing jumble of elements traceable to a wide variety of sources'.[25] P'er-O noted that the participants were made interesting through 'their original make-up and *caricature* costumes'. The figure of Tsar Maksem'yan, at once a sympathetic lover and a murderous tyrant, was 'large, with a huge, wavy beard, and in bright robes'.[26] He held two symbolic objects – 'in one hand there was something in the form of a golden Easter cake with a cock on top, and in the other, in the form of a sceptre, a simple staff with a cock. Obviously this "*symbole de la vigilance*" was the most significant figure in the curious kingdom.'[27] Sagaidachnyi was apparently responsible for the Tsar's appearance. In one sketch the Tsar sits on his throne with his crown and orb, wearing brightly coloured clothes – a fine red jacket and blue breeches. But there is no real sense of the military uniform that the Tsar wore in many traditional variants. Similarly the attributes of crown (mitre-like in this case), orb and sceptre have features distinguishing them from the traditional forms. The

**79**

repetition of the provocative cock symbol on both the orb and sceptre appears to be a creation of the Union of Youth artists as descriptions of such royal regalia refer to them being topped by stars rather than a cock.

Deeply entrenched in folklore, the cock, a favourite image of the *lubok*, had been representative not only of the vigilant but also of the persecuted and the dawn.[28] Its unexpected appearance in the Union of Youth's *Tsar Maksem'yan* has this threefold significance simultaneously. In the first place it represented the Tsar's guard against his enemies. In addition, as the life-size image rising up at the end of the play over the dead Tsar to herald the return to normal life, it fulfilled the dual function of symbolising the future victory of the persecuted and the dawning of the new day and new life.

There is an element of the absurd about the Union of Youth's cock, which was played by Sagaidachnyi.[29] Its appearance was described as 'magnificent' and one of 'quite charming unexpectedness'.[30] Two costume sketches, by Sagaidachnyi and Spandikov, give the cock yellow spurs, red legs and claws, green wings, a blue breast, a beak that resembles a hooked nose and a large red plumed hat. There does not seem to be a historical source for these, although they do have a naive simplicity reminiscent of the *lubok* or fairy-tale illustrations. Presaging the *Victory over the Sun* three years later, the lasting impression created by the appearance of the flamboyantly and absurdly dressed cock at the end of the tragedy, is that of the artists presenting a new vision to the world. The cock, as in Rimskii-Korsakov's *Golden Cockerel*, will not serve a corrupt master and, however weak, will always try to overcome evil with good.

The appearance of Anika the Warrior and Death was based on the medieval tale 'The Contest between Life and Death'. Indeed, Anika was the frequent subject of medieval folk tales and legends, songs and poems as well as *lubki*. However, here too there is an unusual element in the Union of Youth's version. Usually Anika, the brave and boastful warrior, is met by the white-robed female figure of Death who kills hims with her scythe despite his cries for mercy and pleas for moments to live. The Union of Youth avoid this conflict. Instead it is the Tsar who succumbs to Death despite pleas for mercy and time to live. In this instance, unlike the cock symbols and scene, the action is not the invention of the group, but is taken from one of 'the few versions of Tsar Maksimilian in which it is the tsar himself who is killed by Death rather than Anika'.[31] These versions had taken this scene from an analogous scene in the *vertep* theatre 'where Herod is felled by a mocking Death for all his wickedness'.[32]

The costume sketches of the two characters are by G. E. Verkhovskii. There are two variants of 'Anika'. In one the bearded warrior holds a pike, wears a round blue hat, a red jacket with blue buckle, green breeches and pink and blue stripped stockings. The other is a much more dynamic

depiction of a warrior with shield and sword. His hat is long and curving with a jagged edge and he wears high boots and a red jacket with green borders. These images were probably inspired by a *lubok*, as was the case for 'Death'. Rather than depicting a woman in white robes carrying a scythe, Verkhovskii's figure is male, small and naked. He has a very long tongue and on his back is an oblong bag with a crossweave pattern. In this bag are spears, saws and arrows. The grotesque little figure is remarkably close in outward appearance to the figure of Death in the *lubok Anika the Warrior and Death* (History Museum, Moscow). Even the distorted profile and the flattened space of the drawing are similar and reveal the artist's preference for the folk print over the traditional dramatic form. Again the Union of Youth's free interpretation of historical precedent and concern with the *lubok* appears essentially Neo-Primitivist.

Other surviving designs include Gaush's sketches of courtiers in brightly decorative dress; Baller's turbaned guard, relation of Venus, and pipe player; Bystrenin's pencil sketches of the pagan throne of Venus, depicting a palace in the city of 'Anton' with trees and solid, round clouds; and Shleifer's pencil sketches of the *skorokhod*-marshal and medieval musicians, some of which include grotesque primitive elements, such as over-large lozenge-shaped eyes staring out from flat, profiled heads.

The more important sketches belong to Le-Dantyu, Sagaidachnyi and Spandikov and show a free interpretation of their subject. Of the sixteen pencil and watercolour sketches attributed to Le-Dantyu there are various dynamic dancers, drawn with an Eastern exoticism and subdued colour. They vary in style from rough pencilled images to academic watercolours. Le-Dantyu also depicted the gravedigger and his wife, the bearded old man wearing patched brown clothes and a yellow pointed hat and holding a spade. While this foolish-peasant image in part coincides with that described in early texts he lacks the hunchback traditionally ascribed him. In addition he drew sketches of a violin player in a red jacket with blue breeches and white stockings and Venus wearing a blue robe, red breeches and a crown.

Le-Dantyu's sketches give little indication of his artistic persuasions. Yet, his position in charge of costume design, shows that in early 1911 he was working closely with Union of Youth members. Furthermore, possibly influenced by his experience of *Khoromnyya Deistva*, Le-Dantyu wrote an essay the following year on 'Active Performance' in which he proposed a new synthetic theatre, not dissimilar to Evreinov's monodrama.[33] His idea was that the movements of the actor should coincide with the painted stage designs, the music and words, to actively, rather than passively, influence the spectator. Similar ideas were expressed by Larionov, who Le-Dantyu was to join at the end of 1911, concerning his 'Futu' theatre in 1913 (see Chapter 7).

The majority of Spandikov's sketches were for dancers' costumes. There is, for instance, a seated dancer wearing green stockings, short red boots, a hitched-up skirt and a huge red and black headdress; and the headgear of a dancer, depicted with a triangular-shaped head and huge Vrubelesque eyes with very heavy, sad eyelids. In addition, Spandikov depicted a menacing Death with a ribbed smock-like dress, a red tassle hat and a cloak; a sinister witch-like figure in a vast green and red hat, purple cloak and yellow socks; and a sketch of Venus where she is shown on a pedestaled throne in a red tent. Of especial interest is the watercolour sketch of three costumes where three women are linked in a triangular ring by their oustretched arms. They wear long triangular skirts that are green, mauve and blue respectively. The simplicity of colour and geometricism of form bear a striking, if chance, resemblance to Malevich's costume designs for *Victory over the Sun*.

Sagaidachnyi's costume sketches (for example the cock, Death, a fox, the gravedigger's wife, soldiers, courtiers, drummers, *skomorokhi*, boy-soldiers, the Tsar, Venus and the *skorokhod*-marshal), are marked by a spontaneity and freedom from historical precedent. Almost all are roughly drawn in pencil and only rarely is watercolour added (for example the *skomorokh* musician with a *domra*, a predecessor of the balalaika). Samples of the cloth to be used for the costume have been stuck on the sketch and the name 'Spandikov' written by the side, coinciding with the casting of Spandikov as a *skomorokh*. Other sketches also have the players names beside them, including a bright pink, green and blue '*poteshnyi*' costume for Shleifer.[34] The only sketch that approximates to descriptions of the play is that of Brambeus who wears a red-hooded mask and black cape. That of a handsome young male figure in a bright jacket and peaked hat may well be Adolf, but if so again tradition is flaunted because he is not in military dress. This, however, relates to a certain 'demilitarisation' of the play that the Union of Youth appear to have consciously undertaken.

Yet some contemporary critics complimented the correlation of the costumes with tradition. Gita, for example, singled out the Italian ambassador, blacksmith, Anika and Death for their effectiveness and accuracy as regards fitting in with the overall picture the play presented. Moreover, the photograph of the actors (Plate 7) does show a number of characters in military uniform and with their distinguishing props. Ultimately, it appears that the artists occasionally observed certain costumer traditions while at the same time freely indulging their imagination in primitive, *lubok*-inspired forms and colours. The absence of a really developed plot and any profound characterisation increased the significance of the characters' appearance. Visual form was emphasised for audience recognition, in contrast with the more recent practices of the 'high' theatre where the developed, literary plot and characterisation relied heavily on the spoken effect.

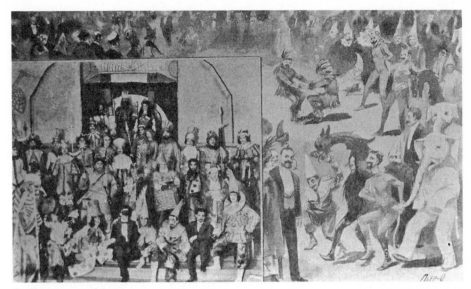

7 *Khoromnyya deistva*

Overall, the sketches produce an impression of disregard for strict adherence to a particular historical period. This in itself was a valid approach because *Tsar Maksem'yan* is essentially a framework for a variety of fictional and folkloric characters that combines a mixture of influences. Warner substantiates this view: 'One of the most striking features... is the diversity of types and methods of costuming to be found... within... a single text' and she cites 'the mixture of military influences, symbolism, attempts at historical accuracy and remnants of ritual masking to be found all together in *Tsar Maksimilian*.'[35]

In the original folk productions of *Tsar Maksem'yan*, as in the Union of Youth's version, costumes had been used that failed to reflect either the period to which the action belonged or that of contemporary society. Even so attention would have been paid to individual details of costume in order that they comply with some model. The Union of Youth's production, with all its idiosyncracies, followed this pattern of sporadic historical accuracy, spontaneity and flights of imagination. In this, the group embraced the characteristics of the folk theatre which could abandon logic and realism for recognition and identification. Distinctions were thus sharply and visually drawn rather than subtly and intellectually as in 'high' theatre. This necessarily altered the reaction of the public who felt drawn to participate in the recognisable scenes with characters whose role they knew and outcomes they could predict. Yet, at the same time the Union of Youth retained exaggeration and distortion, as well as those conventions (such as the balagan stage), that clearly delineated the audience from the players.

*Tsar Maksem'yan*, as the *Khoromnyya Deistva* evening as a whole,     **83**

reflected the shifts in time and space that were inherent in folk dramas more than any other production at the time. It also rejected the rational plot and audience-actor distinctions of the contemporary theatre.[36] This was further seen in the subsidiary parts, the 'Folk Dance Whims', the 'Champagne' hall and the 'Beer-Cellar of Mr Gambrinus', which comprised a conglomeration of German, Russian, Siberian, Spanish and French elements; the combination of the absurd, mythological and realistic; and the mixture of the medieval and the nineteenth century.

The second half of the evening was a medley of traditional Russian folk dances and games, and a parody of European high and low culture. As with the *Khoromnyya deistva* title, the Union of Youth utilised obsolete, colloquial words (*pivnitsa* for beer-cellar and *shampaneya* for 'champagne') for these activities, thereby stressing their rejection of current values in favour of older, local norms. The public took part in all the events, having first been invited to the specially decorated (by Shleifer and Baudouin de Courtenay) 'make-up' room to receive their domino costumes and masks. The Union of Youth insisted that everyone who did not don costumes and masks leave the hall and not 'interfere with the general merry-making'.[37]

A great variety of events took place simultaneously. Loud cannons fired showers of confetti. One critic found this overwhelming: 'the main role in the whims, in all fairness must be ascribed to the calico and coloured paper'.[38] The merry-making was led by 'lovable devils, the masters-of-ceremonies'.[39] These evil spirits and dancers consisted of 'masked boyars, town dwellers, wood goblins, water-sprites, skomorokhi, gravediggers, warriors, courtiers, drummers… envoys… and… chanticleers'.[40] There were 'elephants… closed capuchin-hoods'[41] and 'our own Russian devils with ludicrous tails'.[42] All took part in the round dances. Shaman dances and the dance of 'the fantastic little people'[43] were performed by specially invited anonymous ballet dancers. 'The Success of the Poteshny Regiment' and the 'Promenade of Joy'[44] were also enacted amidst the dancing public. In place of a stage was an elevated area with a brightly lit arch. In the 'Champagne' hall, decorated by Gaush and Shkol'nik, a vocal quartet sang; ballet dancers danced minuets; and, 'gripping the public', were 'Vortexes of the Green Dragons' and 'White Elephants together with Red Devils'; 'Cupid and Amourica'; and 'The Couriers of Love'. The music for the dances, written by the young composer Adrian Shaposhnikov, 'produced a most fascinating impression'.[45]

The 'Beer-Cellar of Mr Gambrinus' apparently derided the Parisian brasserie Gambrinus which had been the meeting place for young bohemians committed to radical social reform, if with a sense of detachment and intellectual snobbery, in the early 1880s. Here, besides the drinking, the 'remarkable Spaniard Ridaldi Ramacleros' sang standing on a barrel and 'Spanish and Italian Villain-Temptresses' sang folk songs.

Verkovskii's decoration designs are frieze-like sketches with primitive, simplified *lubok*-like figures in dramatic poses. In the first a man rides a pig, a woman holds a fan, another man clothed in a red cape holds up a chalice-like cup. Next to the latter is a pot, presumably containing beer, and then, by another pig, a male figure wearing black tights and in a blue hat. To his right is an older man, also holding a beer-pot and beyond him a woman holds a pot from which the drink is poured. Above these figures is an emblem with a partly illegible inscription in German. The second sketch also contains figures with goblets and pigs: a woman holds a stick, a youth arches his back, an old man with a white beard and broad black hat sits cross-legged. Above the latter is the inscription 'AQVA VITAE' (the water of life: i.e. alcohol). The figures appear obliviously independent of one another despite their mutual activity.

Gambrinus (1251–94) was the duke of Brabant and is reputed to be the inventor of lager. The choice of Gambrinus's beer-cellar as the scene for various amusements at first seems curious, especially as it was so obviously European and not Russian. But the bawdy entertainment that occurred in the bar complemented the medley of primitive and decadent activities of the evening and particularly the Russian and main part of the evening, *Tsar Maksem'yan*. In such a context the Russian folk play was seen as a relatively sophisticated and sincere counterpart to the more frivolous, debauched European entertainments. The secularity of the scenes, the emphasis on baser human instincts, however vulgar or refined (i.e. pigs, beer and standing on barrels in the beer-cellar, elegant ladies, champagne and graceful seventeenth century French dances in the 'Champagne' hall), contrasts with the moral and religious issues raised by *Tsar Maksemyan*.

It is not clear, however, whether the Union of Youth's main aim was to contrast these aspects of historical European culture with an example of indigenous Russian culture. Indeed, any nationalist tendencies in the evening were implicit rather than explicit. Certainly the variety of acts in the latter part of the evening was conceived as a creative whole, and the inclusion of shamanism and *skomorokhi* belies any concern with the moral superiority of the Russian people. What seems to have been of essential importance to the organisers was the integrity of the cultural activities of various nations and the desire to present this as a bright, joyful medley of folk entertainments. The absence of a stage, and the costuming of the public added to that colourful whole and 'created an atmosphere of unity, of sincere-communal creativity'.[46] The novelty of *Khoromnyya Deistva* essentially comprised a rejection of contemporary theatre and technique. The return to traditional folk methods and acts served to highlight the desire for change and formal innovation and to act as a highly significant precedent for *Victory over the Sun*. The limitations of 'high' theatre and its

'professionalism' were attacked in all respects, not least by the use of amateur players.

Finally it is worth noting that the success of the Union of Youth's first production of *Khoromnyya Deistva* brought calls from critics and the public for it to be repeated. On 2 February the group announced that because of its 'great artistic success'[47] it would be performed again, though no precise details were given as to when and where. Simultaneously, Bonch-Tomashevskii, wrote to the press in a mood of exaltation, thanking those who took part for their 'most passionate participation' and 'the touching attitude to the success of the evening'.[48] By 6 February it was announced that the second production would occur on 17 February at the House of Interludes, although on this occasion the 'Folk Dance Whims with the Public' was to be dropped and Cervantes' interlude 'The Jealous Old Man', with a prologue written by Bonch-Tomashevskii and designs by Verkhovskii and Gaush, was to be staged instead.[49] The production was repeated on 18, 19 and 20 February. The addition of the Cervantes interlude (written in 1615), although it altered the form of the *Khoromnyya Deistva*, fitted well with *Tsar Maksem'yan*: the absence of deep characterisation and a rational plot in 'The Jealous Old Man' coincides with that of the Russian play, as does the portrayal of vice. Furthermore, the apparent simplicity is deceptive, and the realism is ambiguous and combined with absurdity. The only mention in the press noted that the effect produced by *Tsar Maksem'yan* echoed that of the first occasion: 'As before, the entrance of individual players was greeted by applause, so distinctive and interesting were these figures.'[50]

### The Union of Youth's Third Exhibition

After the Union of Youth delegation returned to Petersburg from their trip to Finland and Sweden during the autumn of 1910, the press published reports that the group had invited Finnish, Swedish and Norwegian artists to participate in its next exhibition.[51] The idea was to present a picture of the latest trends in Northern art generally. The show was due to open at the beginning of February. However, the Scandinavian and Finnish artists apparently failed to send their works and the exhibition was postponed until April. This allowed the group to search for other artists with whom to collaborate. As in 1910, the Union of Youth turned to Moscow. Exhibitors at the first Knave of Diamonds and Moscow Salon shows were found ready to contribute works and as a result the third Union of Youth exhibition represented a broad section of the new Russian avant-garde.

Significant changes, both in participants and style, set this exhibition apart from the two in 1910. Many artists who had contributed to the earlier exhibitions, including the founder members Bystrenin and Gaush, were

now absent. Also missing, if only temporarily, were the Academy students Bubnova, Dydyshko, Matvejs and Mitel'man, all of whom had been assigned to the studio of professor Aleksandr Kiselev. However, Kiselev had died at the start of the year. Indirectly, his death had a profound effect on the future appearance of the Union of Youth's exhibitions. Nikolai Dubovskoi was subsequently appointed the students' professor and although a 'quiet and kind' man he stipulated that his students should work 'only for the Academy'.[52] This accounts for the 'muted' contributions of these four to the Union of Youth's shows thereafter.

The disappearance of Matvejs indicates the compromise he felt worth making in order to finish his studies at the Academy. Both he and Bubnova placed a value on their Academy places, if only for the access they provided to studios and materials, stipends, and the chance to meet fellow students. Indeed, Matvejs continued to be openly provocative in his art classes, but outside the Academy he felt it apposite to be more cautious. Thus, both his and Bubnova's future publications were written pseudonymously (Bubnova as D. Varvarova) and he subsequently displayed just three paintings, at the Donkey's Tail exhibition in Moscow.

In fact, of the Petersburgers, only Shkol'nik, Spandikov, Shleifer, L'vov, Sagaidachnyi, Baudouin de Courtenay and Verkhovskii remained from the Riga show. Of these, Verkhovskii (who withdrew all his catalogue entries except one wooden sculpture),[55] Sagaidachnyi (who soon 'defected' to the Moscow avant-garde) and Baudouin de Courtenay exhibited for the last time with the Union of Youth. However, Filonov recommenced his co-operation with the group and Le-Dantyu (for this occasion only) continued his association by exhibiting five landscapes and two sketches ex-catalogue.[56] The group's state of flux was also evidenced by the fact that there were twelve new Petersburg-based exhibitors, including the Ballers, Belkin, Rozanova and Chagall. New Moscow exhibitors included Malevich, Tatlin, Morgunov and Konchalovskii.

The exhibition opened at 10 Admiralteiskii Prospekt, the house of Princess Baryatinskaya, on 11 April 1911.[57] A respect for and debt to French Post-Impressionists and Fauves was underlined by the sale of photographs of paintings by Matisse, Van Dongen, Gauguin, Cézanne, Van Gogh and others.[58] Bazankur noted two catagories of participants: 'those who painted that which does not exist in nature (Baller, Filonov) and those who, although they depict that which exists in nature, do so from a naive, quasi-childish point of view (Burlyuk, Mashkov, Goncharova, Malevich and many others)'.[59]

It was a highly significant show, not least because it introduced several new names (e.g. Rozanova, Le-Dantyu, Tatlin and Chagall)[60] to the Petersburg public, artists who were to play prominent roles in the development of the Russian avant-garde. While Chagall's contribution was de-

layed by his departure for Paris in early 1911, for Tatlin and Rozanova, the 1911 exhibition marked the beginning of an important association with the Union of Youth that lasted nearly three years. In that time they, as much as almost anyone else, helped define the group's artistic direction. Le-Dantyu, on the other hand, rapidly aligned himself with the Moscow avant-garde. Both he and Sagaidachnyi were introduced to Larionov by their friend at the Academy, Viktor Sergeevich Bart (1887–1954). Together with another Academy student, Kirill Zdanevich,[61] these young artists began to associate with Larionov's newly formed 'Donkey's Tail' group in 1911.[62] Thus Le-Dantyu and Sagaidachnyi, the main designers of *Khoromnyya Deistva* just a few weeks earlier, dropped out of the Union of Youth, finding that 'the core of the group [are] imitators of Munich modernism'[63] and claiming that 'the coloured academicism of the imitators in the Union of Youth is not even copying, but parasitism'.[64]

While such words are generalised and probably over-strong they do point to a lack of independence that persisted in 1911. Still, particular approaches are worth highlighting in the attempt to define the Union of Youth's overall persuasions. Both Nagubnikov and L'vov contributed a number of works to the show which Rostislavov felt displayed a 'continuity and link with the painting of the recent past' that was absent in the Moscow artists.[65] However, contradicting Le-Dantyu, he singled out L'vov for being 'so original' and 'having found his own style in his drawings'. Such a duality of response to L'vov is reiterated by Milashevskii:

> Lev Bruni continued: 'L'vov is the single pleasing phenomenon in our painting… L'vov is integrity… to himself, to art and to nature! No 'affectation' and no 'marquis''… I found… dull painting… dry officialese, 'class drawing'. Some kind of drum major of the Life Guards of the Pavlovsk Regiment. Samokish got such models for his studio… with an absence of charm and fascination.[66]

Nagubnikov made one change to the works published in the catalogue, replacing a still-life with *Woman and Child* (cat. 79). This was also the title of a work contributed by L'vov, and added to the proliferation of female figures at the exhibition noted by Breshko-Breshkovskii: 'At no exhibition this season has there been so many female bodies. In every room there are virtually dozens of studies of female models.'[67] Milashevskii described Nagubnikov's work thus:

> An exhibition of his work was organised in the hall of Isakov's flat. Outwardly it looked like Matisse's early work of 1902–3. These female models with some angular forms. Their sharp edges made them similar to Cubist 'toys'. The colour was pleasant and resonant, if a little disconnected i.e. not perceived as with the French, but contrived. Yet taken as a purely decorative tendency rather than as a study of nature in heightened colour, they produce a conventional but nice impression… Of course all this was imitation, a second-hand copy and 'the vocabulary of the popular unabridged lexicon'.[68]

Rostislavov perceived an academic note in Zel'manova's work: 'Zel'manova is very able and gifted. She has contributed a very beautiful *Still Life with Carnations*, a series of landscapes and keen, distinctive portraits where a great 'realistic' capability is felt.' But according to Breshko-Breshkovskii such 'realistic' capability as Zel'manova possessed was being undermined by her recent attraction to other methods of expression:

> She draws, and draws not badly. Previously she had charcoal studies of female models, created, not without talent, in a broad and sketchy manner. But now Zel'manova appears drawn to Le Fauconnier... and in 'Le Fauconnier style' she has painted the *Portrait* of a young man. It turns out that this is a real person for his initials are noted. But Ms Zel'manova has taken fierce revenge on the young man who so trustfully, suspecting no treachery, posed for her. And although, by all appearances, this is a 'pale-faced' European (he is tall and waxen white) his cheeks and hands are blacker than boots. Indeed the entire model is a flat, leather dummy.[69]

Zel'manova's interest in Le Fauconnier was almost certainly real. The Frenchman, who had a Russian wife, had exhibited works from his Fauve period in Russia on various occasions since the first Golden Fleece salon in 1908. Furthermore, his article 'The Work of Art', originally published in the second *Neue Künstlervereinigung* catalogue in the autumn 1910, was translated in *The Union of Youth*, testifying to the group's respect for his ideas at this time.[70]

Spandikov's work was described by Breshko-Breshkovskii as the 'furthest right'. Almost certainly this was because he lacked the geometricisation and primitivisation of form of others. In addition, his subject matter, including the lawless apaches and harems, with its concern for urbane society, could be considered already out of vogue with its references to Steinlen and Van Dongen. Indeed, the *Ogonek* critic noticed: 'Spandikov possesses taste and talent, he searches for interesting features and in the *Apaches* (cat. 95) sketches successfully catches movement.'[71] He had twelve entries in the catalogue, including a *Sketch for Venus' throne* (from *Tsar Maksem'yan*), *Flowers*, *Doves*, *A Church*, *On the Sofa*, *The Mask*, *The Harem* and *Skating*. Breshko-Breshkovskii's review helps identify his interests further:

> Where there's a will one can find that which is good and that which is typical in his drawings of *Apaches*. All the filth and depravity of the Paris slums is relished in these heads, so perversely-bestial, so repulsive. All this is in charcoal. But Spandikov also has oil paintings. And there are times when you find pleasant tones and a feeling for colour that compensate for the excessiveness of generalisation. Finally, the psychological self-portrait may inspire one with the 'confidence', in other words one can agree, that here at least Spandikov realises his own self precisely.[72]

Spandikov's *Self-Portrait* (cat. 104, Plate 8) uses colour combinations, generalised form, and cuts off the composition in a way that also recalls Van Dongen, whose atypical Fauve work was well known to Spandikov through the Golden Fleece and Izdebskii salons.[73] Amongst his colleagues Spandikov was undoubtedly the closest in both subject matter and compositional treatment to Van Dongen. Both artists favoured impasted colours, heightened and improvised colour relationships and forceful arabesques. Spandikov's tempera *Self Portrait* shows a middle-aged man with a long, pointed face. The blue eyes below the yellowish hair look mournfully out of the picture; the dark blue coat covers almost half the picture surface; the loose modelling and unreal pale green background compare with Van Dongen's *The Red Dancer* (1907), owned by Ryabushinskii and shown at the second Golden Fleece salon.

Shleifer displayed eight works that showed elements of a lyrical primitivism. These included two *Sketches for a Theatrical Panel* (presumably for *Khoromnyya Deistva*), *Shepherd Boy*, *Love*, *Stockholm Study*, *Still-Life* and *Portrait*. His *Shepherd Boy* (cat. 120, Plate 9) depicts a stylised southern scene with a pipe-playing young boy sitting on a rock surrounded by grazing sheep and his dog. In the background is an undulating landscape which ends in some low hills. This is separated from the foreground by a tall tree and two sheep. The effect is of a generalised, decorative composition. Despite the use of perspective the figures remain flattened on the picture surface. Wisps of foliage to the right add a compositional balance that is reminiscent of a medieval fresco. Similar attributes are found, for instance, in Giotto's *St Francis Preaching to the Birds* in the Basilica of St Francis, Assisi, where the figures are also flattened, trees divide the foreground and background and a rural lyricism pervades the simplified scene. However, Shleifer employs *cloisonné* technique and an artificial naive style and crude brushwork that suggests a study of Gauguin.

In contrast, Filonov presented a far more compressed image of the desolation of life in his work of the period. His name did not appear in the catalogue, yet in the Russian Museum copies he is twice pencilled in with a work. In one, *Nightmare* is added while in the other the title *Fantasy* has been deleted and replaced by *Sketch*. Whatever the title,[74] there is no doubt that the image presented was identically disturbing to viewers as that of *Heads*. Filonov's sister, Glebova recalled the creation of the latter, its exhibition at the Union of Youth, and that her brother later considered it his first 'made' painting:

My brother left Petersburg for the village of Vokhanovo... He lived in a small, dark and squalid peasant's hut, with a tiny window. It was autumn – damp and cold... How could he work?.. In the darkness and with a paraffin lamp. I know two works which he created... One, a small oil, was acquired by the Russian Museum. In it, to the right, is a red-bearded king sitting on an strikingly drawn white horse. To the lower left my brother depicted himself. The resemblance is

clear, though I never saw my brother with such an exhausted, mournful face. This painting was exhibited without a title at the Union of Youth's spring 1911 exhibition. Other oils, regarded by the selectors as too far to the left, were not accepted.[75]

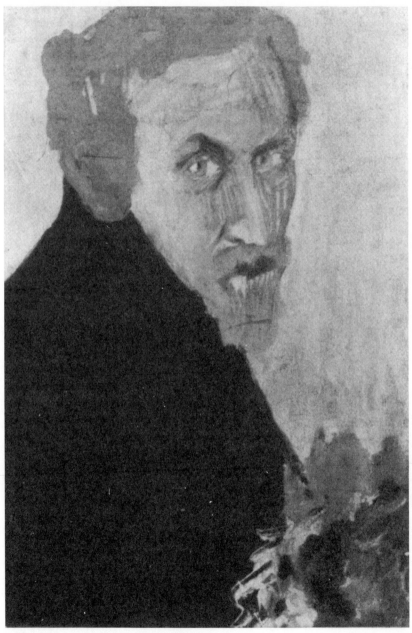

**8** E. Spandikov, *Self-Portrait (My Self)*

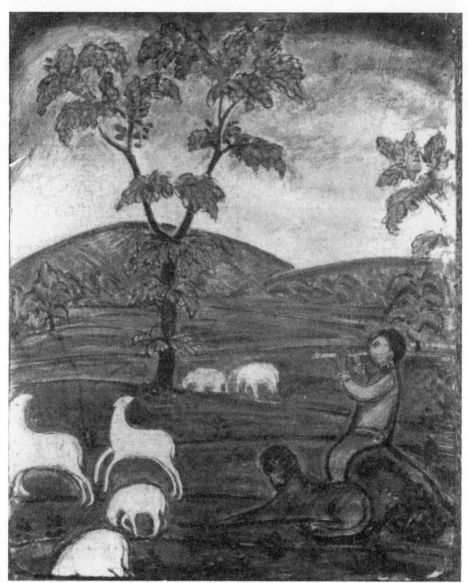

9 S. Shleifer, *The Shepherd Boy*

The painting depicts a dense mass of dark faces, sinews and hands. Separated from this darkness by a curving line, the white horse, lit brightly, as if by fire, rears up below the gleaming images of an Egyptian goddess and the king. Behind the king, in a tiny space in the very top right hand corner, appears the staring, sad face of a negro slave. The other heads, in the dark left side of the canvas, are impregnated with suffering and resignation. Besides the putrid crimson, apparently decomposing, face of the

infant and the light shining on the forehead of the artist's self-portait, the faces are united by the pervasive dark red-brown tones. Only the infant's head is attached to a body (the up-raised arms stretch out of a dress of sinew and body tissue). None of the persons, not even the two in the upper left corner who stare eyeball to eyeball, relate to one another, though they are united in their despair and loss of feeling. Sinewy blue-grey hands, with bent fingers, appear from nowhere. Ugliness and beauty, age and youth, male and female (though predominantly male), are squeezed together in this dark crowd. Madness, cruelty and wisdom are all expressed in the faces.

The disparate influences, symbols and meanings of *Heads*, combined in an intense formal examination of visual art, assert the analytical attitude to art that was to dominate Filonov's work during the next three years. In declaring this canvas his first 'made' painting Filonov indicated that it adhered to the principle where 'the research initiative is linked with the maximum professional data'.[76] Diverse objects are integrated to form one subject matter, created with an almost clinical attention to detail, that distorts traditional conceptions of both narrative and composition.

Filonov had left the Academy without graduating in 1910, considering himself better able to further his creative work alone. His drawing and painting skills, combined with his wealth of imagination, reach their first artistic climax in *Heads*. He borrowed from Bruegel the Elder and Bosch, was attracted to the symbolism of Vrubel and, as other Russian modernists, had an interest in the grotesque that appeared to derive, in part at least, from Ensor (for example *Portrait of the Artist surrounded by Masks*, 1899). His appreciation of academic anatomical accuracy did not blunt his search for originality. The brilliant painterly quality of *Heads* was highly praised by the critics, who found it hard to correlate with the nightmarish vision.

Idealistic and realistic symbolism seem to co-exist in Filonov's work. On the one hand, his vision denied reality, being a product of rampant fantasy, on the other it depicted realities that were both cerebral and biological. Thus he was able to impart life to the painting: 'These colours, as in nature, are not dead: they quiver and flow: they are not motionless.'[77] To have this painting described as a living object was exactly in accordance with his soon to be pronounced ideas about the metamorphic and tensile qualities of art.

Despite a common re-evaluation of artistic values evident in the exhibits, Breshko-Breshkovskii realised correctly that Filonov 'stands completely by himself'. Yet other artists were considered to have a similar passionate feeling for the creative process and to be able to breath life into their use of colour. Bazankur noted such qualities in Kuns' *Little Head 'en plein air'*, Chagall's *Portrait in White* and *Portrait in Red*, Kevorkova's *Portraits of Two Boys* and L'vov's *Siberian landscapes*.[78] She also related

Baller to Filonov, not stylistically, but because they both painted 'that which does not exist in nature'. Baller's previous interest in the grotesque and the lyrical now gave way to certain primitivist distortions, mentioned by Breshko-Breshkovskii:

> You can't recognise Baller. You look in the catalogue because you don't believe your eyes... Where have his poetic nocturnes, such finely executed pastels, disappeared? Gone are the nice ghosts... Isaac [St Isaac's Cathedral] appearing dimly through the foggy haze of a Petersburg night, the mysterious little lights of the embankment, the sleepy Dutch canals – none of these, not even a hint of them, remain. They have all conceded their place to some schematic abstract emptiness. And those who loved the earlier Baller feel empty inside.
>
> This sudden change, a break so drastic, in the artist's creative work is unaccompanied by any stirrings. Silently, without fanfares, he searches for new ways. Whether he gets lost, whether he feels solid ground under his feet – that's his own concern. But had Baller been in another group, his burning of the old gods would have had his friends loudly proclaiming the whole event and crowning him with the martyr's wreath of a pioneer and searcher.[79]

Such a change, from the vague forms of symbolism to depicting Bessarabian peasants with a sense of 'schematic, abstract emptiness', hints at an adoption of certain Neo-Primitivist values by Baller. Yet, as Bazankur noted, this move, which was evident in several Union of Youth artists, was still only modestly proclaimed, the group recognising that they were studying and searching, open to making mistakes and learning from criticism.

Baudouin de Courtenay's twelve exhibits, which included *Scene in a Tavern*, *Part of a Frieze*, *White Deer*, *Angelica*, *Alms* and, ex-catalogue, *Horses*, employed a broad variety of style and subject matter.[80] Almost certainly, it is *Horses* which was described by the *Ogonek* critic: 'the imitation of old Italian and Dutch masters sometimes attains good results. Such is the case with Baudouin de Courtenay's composition of horsemen with a peasant woman, which is precisely copied from Gozzoli.'[81] Copying and studying early Renaissance Italian art, whatever the formal purposes, was clearly not unique to Baudouin de Courtenay (see, for example, Filonov and Matvejs). She, like her colleagues, was not interested in the narrative content of the subject but in using it to explore stylistic possibilities. However, the precise adherence to earlier styles noted above, and with reference to her miniatures ('echoes of Byzantinism'),[82] does not convey the sense of Neo-Primitivism that was present in her other works (*Angelica*, for instance, was parodied in one journal for its child-like distortions).[83]

Baudouin de Courtenay's *Scene in a Tavern* (Plate 10) mocks the vocabulary of academic convention. The figures are flattened and monolithic, spatial recession and proportion are ambiguous, detail and one-point

perspective are abandoned. Thus the dancing couple, the woman sleeping on the floor, the musician and the man behind the table are flatly and crudely rendered; the incline of the table hides too much of the man's body and legs; the oval plate of fish is seen from above, but the decanter and glass are seen from the side. Where spatial recession does occur, such as in the wooden bench, it is countered by the absence of two of the benches legs and the abrupt appearance of the door, too low and too near to coincide with the articulated space of the bench. The decorative twist of the schematic branch in the lower right corner contrives to upset the bold clumsiness of the other forms. The sense of absurdity that is achieved, together with the different devices and various viewpoints, coincides with Larionov's and Malevich's experiments. Representational aims are diminished and suppressed by the study of primitive technique.

It would seem then that, while no single way forward was envisaged, a primitivism of sorts – at times grotesque and at times pastoral – was beginning to prevail in the multifarious modern identity of the Union of Youth. This was encouraged by the assimilation of recent developments in France, not least Fauvism. Still the group refrained from making any generalised polemical statements, and did not seek to present a united

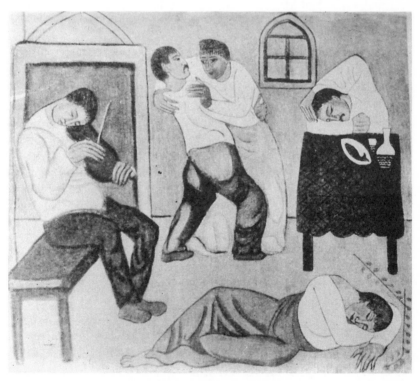

**10** S. Baudouin de Courtenay, *Scene in a Tavern*, 1911

front. Such stealth could largely have been responsible for the defection to the Moscow faction of the ebullient talents of Le-Dantyu and Sagaidachnyi, who felt the need for more pronounced expression and search. For this reason it is worth briefly outlining the trends evident in the work of the Moscow artists, in order that their interaction with the Union of Youth can be better understood.

In fact, there was little radical departure from the styles seen the previous year: Larionov and Goncharova continued developing their Neo-Primitivism, the Burlyuks their eclectic simplifications, and Mashkov and Konchalovskii their 'Cézannism'. As usual, most of the Moscow artists exhibited their work separately from the Union of Youth. However, as if presaging the split between the Knave of Diamonds and Donkey's Tail, Mashkov's and Konchalovskii's work was mixed with that of the Petersburg artists. The others occupied two entire rooms and were entered separately in the catalogue. They had selected their own exhibits without any control by the Union of Youth. This autonomy led to a more coherent selection than that Matvejs had achieved in 1910.

From the two Moscow 'factions' only Tatlin had failed to exhibit works in the recent Knave of Diamonds and Moscow Salon shows. Almost all the Konchalovskiis and Mashkovs had been at these Moscow shows. At the Union of Youth, the former showed part of his Spanish series, the central piece being his *Matador (Manuel Garta)* (cat. 47, Russian Museum) whose blackened face, hat and hair led Breshko-Breshkovskii to accuse the artist of being, in part, 'a dirty coal miner'. The generalised form, against an unelaborated background, was typical of much of Konchalovskii's work of the period. There is little attempt at psychological penetration as it is the concentration on the effects of colour that is of primary importance. This led, in the majority of Konchalovskii's 1910 works, to the use of brilliant, saturated tones and radical simplifications. The use of colour to order the composition, slight modelling, crude brushwork, and even the frontality and exaggerated shade on the face of his *Matador*, can be traced to Matisse, who Konchalovskii greatly admired and had met in 1908, while studying in Paris.

Konchalovskii's friend Mashkov, heavily influenced by the Cézannist Fauvism of 1907 to 1908 (he had also been in France in 1908), showed two studies of female models, two still-lifes and a portrait. His *Portrait of a Young Man in an Embroidered Shirt* (1909, Russian Museum) exemplifies his use of the model as a subject for a painterly exercise. The whole of the picture surface is treated as an ornate pattern and saturated with brilliant, unnaturalistic colour. The brushwork is crude and the form thickly delineated. The huge red roses of the background are juxtapositioned against the small crimson floral designs on the man's shirt, as if indebted to Matisse's *Harmony in Red* (1908), recently bought by Shchukin. However, Mashkov

restricted his experimentation and style, retaining an interest in modelling and the description of space through light rather than colour.

The scorn of most critics was reserved for Malevich, Larionov, Goncharova and the Burlyuks. Their work was primarily Neo-Primitivist, drawing on domestic Russian stimuli. David Burlyuk exhibited eleven works, essentially landscapes and still-lifes. In 1911 he, like his brother Vladimir, appears to be working in a primitivist style, but without Larionov's inventive exploration of motifs from peasant arts. His *Horses* (possibly exhibited as *The Stable*, cat. 145, Russian Museum) suggests this, while also betraying a knowledge of German Expressionism – especially the work of Marc. Burlyuk, who had been studying in Odessa for the past year, probably met Kandinsky there when he arrived for the first Izdebskii Salon. From 1910 the Burlyuks contributed to the exhibitions of the *Neue Künstlervereinigung* and *Der Blaue Reiter*, while artists from the Munich and Berlin groups took part in the Izdebskii Salons and the first two shows of the Knave of Diamonds. The paint of Burlyuk's *Horses* is layered and impasted; pure, unnatural and non-descriptive colours form large random areas of the composition; the horses are red and defined only by a heavy black contour; the stiff angularity of one horse is that of a wooden toy. Generally, there is a raw quality in the expressive brushwork and use of colour regardless of light, closer to Jawlensky and Shmidt-Rottluff than Marc, yet imbuing the work with some of the emotional force of the latter's *Red Horses* (1911).

The majority of Vladimir Burlyuk's exhibits were portraits and land-scapes which had been shown at the Knave of Diamonds. The former, like those he contributed to *A Trap for Judges* (1910), were simple black and white silhouettes. The following description indicates why the critics were so unimpressed:

> Vladimir Burlyuk has exhibited *Portrait of a Poet* [cat. 131]. A negro has been painted, but not such a negro as we would imagine: to paint him, a fine technique is needed in order to express the way the light shines on dark skin. Mr Burlyuk does it more simply: he draws an ugly silhouette in black and puts this daubing in a frame. This is impossible to comprehend as a poet. Maybe it's a negro poet? Next to it is exhibited the *Portrait of the the Poet Khlebnikov* [cat. 132], probably also of the young generation? What has been drawn is the equine profile of some freak, helped by straight lines and angles. In children's maga-zines there are such problems: to create Napoleon's silhouette out of matches. All of Burlyuk's work possesses this same quality.[84]

Neo-Primitivism was most strikingly present in Malevich's work. Kazimir Severinovich Malevich (1878–1935) had been exhibiting his work in Moscow for some years, but had never before appeared at a Petersburg show. He was, therefore, happy to find a platform for his art in Petersburg and with this exhibition began, together with his colleague Aleksei

Alekseevich Morgunov (1884–1935), an association with the Union of Youth that was to last until its final show.

Malevich's exhibits included *Man in a Pointed Hat*, *Lady and Masseur in the Baths*, all of which had previously been at the Moscow Salon in February 1911. *Masseur in the Baths* (cat. 171) may have been the well-known *Chiropodist in the Baths* (Stedelijk Museum, Amsterdam) based on the composition of Cézanne's *Card Players*. Here, Malevich changed the subject matter to a scene common to the public baths all over Russia and crudified the means of representation: the brushstroke is broad; outlines are heavy; colour is occasionally saturated; space is ambiguous; features are simplified; and full-face eyes appear in profile heads.

Malevich's *Man with Toothache* and *Seed-Beds (Bringing Earth)* (cat. 172) were new. The latter depicts two cumbersome peasants pushing a cart of turf. The clumsy, monolithic figures that fill most of the picture space are flattened and distorted. Space is not articulated, foliage is stylised, and the tiny wheelbarrow and spade above the second peasant recall the lack of perspective and modelling of *lubki*. Here Malevich's Neo-Primitivism is close to Goncharova. Both frequently used the peasant motif for their experiments and exploited the structure of indigenous Russian folk art. Malevich's brightly coloured, heavy, cumbersome forms antagonised the Petersburg critics:

> Imagine the foulest, badly-stuffed sawdust dummy of the most ill-made doll, thickly painted here in blue and there in green. And this dummy has no spine, arms or legs. We'll guess that it is the latter that lie on the bench, and, like the dummy itself, are an outrage. Similarly you can guess that all around are soapsuds.[85]

On this occasion both Larionov and Goncharova chose works that had previously been shown at the Knave of Diamonds or Moscow Salon. Larionov's five exhibits, including his *Self-Portrait* (cat. 166, Tretyakov Gallery), transferred compositional devices from the *lubok* – employing saturated colour, flat ground, heavily outlined form, a monoplanar depiction of the subject and written script. In *Bread* (cat. 164, Tretyakov Gallery), as Bowlt has pointed out,[86] the focus is on the contrasts in mass, producing an effect of weight and objectness similar to that of the static, primitive Russian baker's signboards. While indebted to Western developments, and the interest in primitive art in Paris and Munich, Larionov, unlike the Burlyuks, was concerned with identifying his work with the cultural character of Russia.

Goncharova's primitivist works also looked to Russia, and occasionally used peasant artefacts; one critic discerning a suggestion of 'the painting on lacquered country items'.[87] However, others, such as *Religious Triptych*, *Religious Composition* and *In Church* (cat. 161, Tretyakov Gallery) transferred techniques from icon-painting rather than the secular forms of

folk art that were apparent in Larionov. *In Church* depicts a fashionable lady in blue, with rings on her fingers, holding a basket, against (there is no sense of scale or space) a huge and dominating icon of an almond-eyed Madonna. The contrast between the two figures is emphasised by the different styles used and is that of the physical and spiritual world. This echoes the two areas of Gauguin's *The Vision after the Sermon* (1888), where the division between the supernatural and material realms is indicated by the black and red colour ground. Goncharova's lady takes the place of Gauguin's Breton women, whose vision of the struggle between Tobias and the angel is depicted on the red ground beside them.

Goncharova's art was also inspired by peasant motifs. *The Woodcutter* (cat. 162, Krasnodar Art Museum) is a stylised depiction of a peasant chopping wood. Three-dimensional space is denied as the figure is surrounded by appropriately facetted forms that signify the cut timber. Form is delineated by a broad *cloisonné* outline. Colour contrasts are again emphasised in order to express a certain elemental power and intensify expression. The integration of the Russian peasant with his surroundings, while suggestive of a new awareness of Cubism, also recalls Marc's identification of animals with their environment (for example, *Tiger*, 1912). Goncharova may have been aware of Marc through Burlyuk or Kandinsky, and she did show *The Woodcutter* at the *Der Blaue Reiter* Munich exhibition in February 1912. And while she has chosen a Russian motif her purpose seems akin to Marc's – namely the expression of a pure, underlying organic rhythm, with which animals and peasants are instinctively in touch.

Vladimir Evgrafovich Tatlin (1885–1953) made a modest debut with the Union of Youth, his twelve exhibits – which mostly consisted of drawings – being all but ignored by the critics. Only Rostislavov noted that his *Female Model* (cat. 182) was 'well conceived and original in colour'. Already on friendly terms with Larionov when he moved to Moscow in 1910, Tatlin then came into contact with many of the avant-garde painters, including the Burlyuks and Aleksandr Vesnin. He concentrated on motifs concerned with sailors and fishermen, as in *Naval Uniforms* (Bakhrushin Museum, Moscow). This watercolour depicts a figure holding a roll of blue material. In the top right-hand corner a sign proclaims 'Naval Uniforms', with *Flotskiya* [Naval] deliberately misspelt, echoing the graffiti in Larionov's *Self-Portrait*. Despite the retention of these figurative elements, the handling of the material is also much in evidence. The composition is broken down into broad interpenetrating planes in which there is no coherent system of perspective and the image of the uniform seller blends with the loose, sweeping brushwork. This structure recalls Goncharova's *The Woodcutter*, as the interplay of line, colour and form becomes as significant as the subject itself.

Essentially, then, an interest in folk art was common to both the Petersburg and Moscow contingents at the Union of Youth's exhibition of April 1911, although the means of its exploitation appear to have differed. Although the Petersburgers were concerned with primitivism after their production of *Khoromnyya Deistva*, it was not a dominant or consistent trend and perhaps only evident in Baudouin de Courtenay, Sagaidachnyi, Baller and Shleifer. Many of the artists appear to have retained a metaphysical symbolism in their work (for example Shkol'nik, Spandikov and Filonov), and, together with those who concentrated on expressive techniques (Nagubnikov, L'vov), still ignored native Russian folk motifs. In contrast, the Moscow artists were more easily identifiable by their Neo-Primitivism. While their work remained Western in many respects, copying Parisian Fauve handling and the resonant colour of the Munich Expressionists (as in the case of the Burlyuk brothers), they had also begun to combine this with an exploration of distinctly Russian cultural conventions.

## References

1 See I. Grabar, *Pis'ma 1891–1917*, Moscow, 1974, p. 423, concerning the World of Art's rejection of the newly elected members such as Vasilii Kuznetsov, Larionov and Serebryakova.

2 See E. Kovtun, *Pavel Filonov*, Leningrad, 1988, p. 12. It was also reported (*Golos moskvy*, 16 January 1911, p. 5) that they visited Sweden with similar aims.

3 There is no appropriate translation due to the peculiarly Russian sense of '*khoromyi*' from which '*khoromnyya*' comes. It can either be a big wooden house, usually constructed from separate buildings joined by vestibules and passages, or simply a rich, large house with spacious apartments. By 1911, its use was anachronistic and ironic. '*Deistva*' is an archaic word meaning 'acts' or 'plays'. Thus translating '*Khoromnyya Deistva*' as 'Mansion Plays', for example, is inadequate.

4 M. Etkind, 'Soyuz molodezhi i ego stsenograficheskie eksperimenty', *Sovetskie khudozhniki teatra i kino (79)*, Moscow, 1981, p. 248.

5 A. Rostislavov, 'Levoe khudozhestvo'.

6 N. Breshko-Breshkovskii, 'Soyuz molodezhi', *Birzhevye vedomosti*, No.11612, 13 March 1910, p. 6.

7 For example, J. Bowlt, 'The St Petersburg Ambience', p. 121.

8 S. Auslander, 'Vecher Soyuza molodezhi', *Russkaya khudozhestvennaya letopis'*, No.4, 1911, p. 60.

9 Zguta, *Russian Minstrels*, p. 111. Tsar Maksimilian and Tsar Maksem'yan, the title used by the Union of Youth for its production of the play at *Khoromnyya Deistva* refer to the same folk drama.

10 These and other designs relating to 'Khoromnyya Deistva' were donated by Zheverzheev to the Leningrad (Petersburg) Theatrical Museum, where they remain today.

11 Evreinov wrote his monodrama 'The Performance of Love' (see Chapter 1) with the intention of putting it on at The Crooked Mirror. His conception of monodrama as 'a kind of dramatic representation which attempts to communicate as fully as possible to the spectator the inner state of the protagonist, and presents the world around him as he perceives it at any one moment' (Evreinov, 'Vvedenie v monodramu', *Studiya impressionistov*, p. 52) involved a kind of non-sequential, intimate fusion of emotional action and reaction, not dissimilar to that evoked by *Khoromnyya Deistva*.

**12** The Russian puppet theatre had its origins in the shows of the *skomorokhi*. Blok's play was based on an earlier poem, where the puppet theatre is openly portrayed.

**13** Later, in 1917, Remizov even wrote his own version of *Tsar Maksimilian*.

**14** *Protiv techeniya*, 24 December 1910, p. 4.

**15** See *Obozrenie teatrov*, 26 January 1911, p. 14. 'V. Spektorskii' was probably a pseudonym. Concerning the publication of nineteen variants, see A. Remizov, *Tsar Maksimilian. Teatr*, Petrograd, 1920, pp. 123–6. (Reprinted, Berkeley Slavic Specialities, 1988).

**16** See Elizabeth A. Warner, *The Russian Folk Theatre*, The Hague, 1977, pp. 167–207.

**17** Remizov, *Tsar Maksimilian. Teatr*, p. 114.

**18** *Ibid.*, p. 112.

**19** P'er-O, 'Khoromnyya deistva Soyuza molodezhi', *Birzhevye vedomosti*, No.12146, 28 January 1911, p. 6.

**20** *Ibid.*

**21** A. Rostislavov, 'Khoromnyya deistva', *Teatr i iskusstvo*, 6 February 1911, pp. 127–8.

**22** L. Kamyshnikov, 'Khoromnyya deistva. Spektakl' Soyuza molodezhi', *Obozrenie teatrov*, 29 January 1911, pp. 10–11.

**23** P. M. [Panna Malishevskaya], 'V Soyuze molodezhi', *Peterburgskii listok*, 28 January 1911, p. 4.

**24** Warner, *The Russian Folk Theatre*, pp. 197-198.

**25** *Ibid.*, p. 159

**26** Kamyshnikov, 'Khoromnyya deistva'.

**27** Gita, 'Khoromnyya deistva'. Soyuz molodezhi', *S-Peterburgskiya vedomosti*, 29 January 1911, p. 7. The Easter cake (*'Paskha'*), was made from sweet cream-cheese in the form of a four-sided pyramid.

**28** An example of the cock's vigilante role is seen in Rimskii-Korsakov's opera *The Golden Cockerel*, based on Pushkin's Tale about the *Golden Cock*.

**29** See cast list, *Obozrenie teatrov*, 18 February 1911, p. 28.

**30** Gita, 'Khoromnyya deistva'.

**31** Warner, *The Russian Folk Theatre*, p. 167.

**32** *Ibid.*

**33** Le-Dantyu's article on 'Active Performance' (TsGALI) is cited in Larissa Jadova, 'Des Commencements sans Fins', *Europe, Revue Littéraire mensuelle 53 année*, April 1975, p. 126.

**34** The *poteshny* were a regiment of boy soldiers formed by Peter the Great.

**35** Warner, *The Russian Folk Theatre*, p. 207.

**36** Besides beginning with the sounds of horns, drums and the cock, Gita also noted that 'the whole play was interspersed by choruses and music which was both gracious and original, and which was scored by the composer M. Rechkunov.'

**37** P. M., 'V Soyuze molodezhi'.

**38** V. Ir., 'Khoromnyya deistva', *Sovremennoe slovo*, 29 January 1911, p. 4.

**39** P'er-O, 'Khoromnyya deistva'.

**40** P. M., 'V Soyuze molodezhi'.

**41** Gita, 'Khoromnyya deistva'.

**42** P'er-O, 'Khoromnyya deistva'.

**43** Gita, 'Khoromnyya deistva'.

**44** See *Obozrenie teatrov*, 22 January 1911, p. 15.

**45** Kamyshnikov, 'Khoromnyya deistva'. Adrian Grigor'evich Shaposhnikov (1888–1967) graduated from the Petersburg conservatory in 1913.

**46** Kamyshnikov, 'Khoromnyya deistva'.

**47** *Obozrenie teatrov*, 2 February 1911, p. 17.

**48** *Ibid*, p. 18.

**49** *Obozrenie teatrov*, 6 February 1911, and see *Obozrenie teatrov*, 18 February 1911, p. 28, for a list of the persons involved in the production.

**50** *Rech'*, 20 February 1911, p. 5. A further production was planned for 20 April but did not take place due to Bonch-Tomashevskii's failure to get the costumes to the theatre in time (*Obozrenie teatrov*, 20 April 1911).

**51** A. Rostislavov, 'Vtoraya vystavka Soyuza molodezhi', *Rech'*, 31 December 1910, p. 4; *Golos moskvy*, 16 January 1911, p. 5.

**52** V. Bubnova, 'Moi vospominaniya', (unpaginated).

**55** *Katalog 2-i vystavka kartin obshchestva khudozhnikov 'Soyuz molodezhi' 1911*, St Petersburg (Russian Museum copy).

**56** *Ibid.*

**57** On the corner at Vosnesenskii Prospekt. Breshko-Breshkovskii ('Vystavka Soyuza molodezhi', *Birzhevye vedomosti*, No.12266, 12 April 1911, p. 6) describes the difficulties the group had finding a venue and that they only succeeded in doing so six days before the Easter holiday. They then had to work night and day on Princess Baryatinksaya's 'empty apartment' in order to make it ready for the exhibition to open on the second day of Easter.

**58** They also sold photos of Vrubel's later 'crazy' works (Veg., 'Soyuz Molodezhi', *Rossiya*, 22 April 1911, p. 4).

**59** Bazankur, 'Soyuz Molodezhi', *S-Peterburgskiya vedomosti*, 19 April 1911, p. 2.

**60** Olga Vladimirovna Rozanova (1886–1918), who had studied art at the Bolshakov and Stroganov schools in Moscow (1904–10), made a modest debut with the Union of Youth, contributing just one still-life and *The Restaurant*. Chagall, who, by the beginning of 1911, had moved from Petersburg to Paris, showed two portraits and two works entitled *At the Table*. The portraits, called *Portrait in Red* and *Portrait in White* (see Bazankur, 'Soyuz Molodezhi'), consisted of 'very coherent and emotional painting' (A. Rostislavov, 'Vystavka Soyuza molodezhi', *Rech'*, 24 April 1911, p. 5). Bazankur was impressed by the modulation and power of colour, comparing the intensity of feeling to Filonov's.

**61** Kirill Mikhailovich Zdanevich (1892–1970). Brother of Il'ya Zdanevich. Together with Le-Dantyu, the Zdanevich brothers discovered Niko Pirosmanashvili, the Georgian primitive painter, in the summer of 1912. Zdanevich appears to have first shown his work at the Donkey's Tail exhibition.

**62** On 30 April 1911, while the Union of Youth exhibition was still in progress (it closed on 10 May), the press announced that a group of artists were leaving the newly formed 'Moscow Salon' in order to organise their own exhibition under the name 'Donkey's Tail' (*Obozrenie teatrov*, 30 April 1911, p. 11). Although no names were given it transpired that the leaders were Larionov, Goncharova and Bart. The Moscow Salon had followed Kul'bin in attempting to represent 'all directions of the art groups that exist at the present' (*Golos moskvy*, 11 February 1911, p. 4). Artists who appeared in its first show (10 February – March 1911), included Konchalovskii, Mashkov, Sar'yan, Malevich, Larionov, Goncharova, Sergei Gerasimov, Kharlamov, the sculptors Krakht and Golubkina, and the architects the Vesnin brothers. The 'Donkey's Tail' was not, strictly speaking, breaking away from the Knave of Diamonds, as the latter was not yet an art society, simply an exhibition organised by Lentulov and funded by the businessman S. A. Lobachev at the end of 1910. Thus, contrary to popular belief, Donkey's Tail existed as a definite, if unregistered, group with identified aims, earlier than the Knave of Diamonds.

**63** Khardzhiev, *K istorii*, p. 34.

**64** M. Le-Dantyu, 'Stat'i o zhivopisi', TsGALI, cited in L. Dyakonitsyn, *Ideinye protivorechiya v estetike russkoi zhivopisis kontsa 19-nachala 20vv.*, Perm, 1966, p. 207.

**65** Rostislavov, 'Vystavka Soyuza molodezhi'.

**66** V. Milashevskii, *Vchera, pozavchera... Vospominaniya khudozhnika*, Moscow, 1989, p. 66.

**67** N. Breshko-Breshkovskii, 'Vystavka soyuza molodezhi', *Birzhevye vedomosti*, No.12268, 13 April 1911, p. 6.

**68** Milashevskii, *Vchera, pozavchera*, p. 69.

69 Breshko-Breshkovskii, 'Vystavka soyuza'.

70 Le Fauconnier, 'Proizvedenie iskusstva', *Soyuz molodezhi*, June 1912, pp. 36–7.

71 [anon.] 'Vtoraya vystavka Soyuza molodezhi v S. Peterburge', *Ogonek*, 23 April 1911 (unpaginated). Subsequently, Mamontov noted a successful reference, in their small size and bold execution, to Steinlen ('Oslinyi khvost', *Russkoe slovo*, 13 March 1912, p. 6).

72 Breshko-Breshkovskii, 'Vystavka soyuza'.

73 Van Dongen's *Red Dancer* had even appeared on the catalogue cover for the second Golden Fleece salon. His four works at the Izdebskii Salon included *Pink Woman on a Red Background* and *Woman with a Mirror*. It is also worth noting that Elie Faure's foreword, 'Kees Van Dongen' and 'From Van Dongen's Letters' from the catalogue to Van Dongen's exhibition at the Bernheim-Jeune Gallery, Paris (6–24 June 1911) was translated in *Soyuz molodezhi*, June 1912, pp. 38–42.

74 The *Ogonek* critic referred to the work as *Painting without Title*, while Rostislavov was aware that it was entitled *Nightmare*.

75 E. Glebova, 'Vospominaniya o brate', *Neva*, No. 10, 1986, p. 151.

76 'Autobiography' in Kovtun (ed.), *Pavel Filonov*, p. 105.

77 Bazankur, 'Soyuz Molodezhi'.

78 Kuns was an Academy student from Estonia. Bubnova recalled his 'unusually bright tones' ('Moi vospominaniya'), his reputation for walking 'twenty kilometres' in the summer in order to paint the sky, and that the bodies of his models were depicted as soft as the morning clouds (Kozhevnikova, *Varvara Bubnova*, p. 25). It is worth noting here that the Union of Youth also recognised the value of children's art: Rostislavov found 'a feeling for painting, sometimes with bold solutions of painterly problems [in] the child's work of a little girl'. and pencilled in the Russian Museum *Katalog* is: '209. Children's drawings. Vimi and Lida.'

79 Breshko-Breshkovskii 'Vystavka soyuza'.

80 Concerning *Horses* see *Katalog* (Russian Museum) where it was priced at 300 roubles, double the price of the most expensive of Baudouin de Courtenay's other exhibits. Four of her works had previously been shown at the Knave of Diamonds exhibition, Moscow.

81 The Gozzoli in mind is probably the *Procession of the Magi* fresco, Palazzo Medici, Florence.

82 Rostislavov, 'Vystavka Soyuza molodezhi'.

83 [Anon.] 'Na vystavke Soyuza Molodezhi', *Sinii zhurnal*, 23 April 1911, p. 13.

84 Veg., 'Soyuz Molodezhi', *Rossiya*, 22 April 1911, p. 4.

85 Breshko-Breshkovskii, 'Vystavka Soyuza molodezhi', 13 April.

86 J. Bowlt, 'Neo-Primitivism and Russian Painting', *The Burlington Magazine*, March 1974, pp. 133–140.

87 B. Shuiskii, 'Krainie', *Protiv techeniya*, 17 December 1910, p. 2.

# Act I Scene iii, And the Donkey's Tail

## The fourth Union of Youth exhibition

The Union of Youth's fourth, and smallest, exhibition opened on 4 January 1912. It was organised jointly with the Donkey's Tail group. One critic found only one factor common to the various participants: 'The exhibition... has united the most diverse elements. The link is the age of the participants.'[1] Most took the view that the exhibits were united by their dullness and immaturity, interpreting coarseness as an attempt to shock that was already outdated.[2] Only Rostislavov, Shuiskii and Breshko-Breshkovskii gave the exhibition serious consideration. Rostislavov tried to align it with the new purist theory expounded by Bobrov, noting the genuine study of folk traditions, especially in the Donkey's Tail and the comparative lack of self-possession and integrity in the Union of Youth.[3] Breshko-Breshkovskii found that the Union of Youth had 'become more to the left this year... But everything in the world is relative. Its leftishness fades in comparison with the extremities of the Moscow Donkey's Tail.'[4]

On 24 December 1911 it was announced that a Donkey's Tail exhibition was to open two days later in the 'unsuitable venue of the former State Printing House'.[5] The opening failed to take place. The reason given was that not all the 'Tails' had arrived.[6] No mention was made of combining forces with the Union of Youth, nor of any dissent among Donkey's Tail members.

Instead, thirty-five works by eight Donkey's Tail artists (compared to over 300 works by nineteen exhibitors at the Moscow Donkey's Tail show two months later) were displayed at the Union of Youth's show. A letter from Larionov to Bart, of early November 1911, thanks him for inviting Le-Dantyu and Sagaidachnyi to participate in the Donkey's Tail first show.[7] However, Le-Dantyu, Sagaidachnyi, Bart and Zdanevich, did not appear at the Petersburg show. All four, upon learning that this was to be part of the Union of Youth's exhibition, refused to contribute works. At the beginning of 1912 Le-Dantyu expressed his opinion to Bart:

> I write because I'm filled with bewilderment. Today I heard from Zheverzheev that there has occurred a kind of friendly union between them and Donkey's Tail, in a word, 'one favour deserves another'. Imagine Spandikov, Shkol'nik, Shleifer etc. at the Donkey's Tail show?!! Truly then the exhibition deserves its name in its most literal sense in front of the bourgeoisie and artists... I would

never have believed it if I hadn't seen Larionov's letter in Shkol'nik's hands. As for the Union of Youth show on now, I heard the following opinion from disinterested people, even non-artists: 'Shame on 'Donkey's Tail' for getting entangled with any of these Petersburgers' – this is worse than a 'compromise'... Will it really be the same in Moscow?!'[10]

By the time the Moscow exhibition opened, the four dissenting artists compromised and displayed their works, aided by the premises possessing an upper gallery where it was possible to hang the entire Union of Youth section separately.

On 25 December, just ten days before the opening, the Union of Youth announced that it was accepting works from exhibitors for its show at Apartment 1, No. 2 Inzhenernaya Street.[11] There was no mention of collaboration with the Donkey's Tail, although the premises were those where the Donkey's Tail exhibition was supposed to be opening on 26 December.[12] The venue was owned by the Academy of Arts who hired it out for exhibitions at 'fleecing' rates.[13] One way for young artists to cope with such a financial burden was to share the cost. This, undoubtedly, was one of the prime motivations for the Union of Youth/Donkey's Tail joint enterprise.

Opening on 4 January, the exhibition was timed to coincide with the final day of the All Russian Congress of Artists, held at the St Petersburg Academy of Arts. The Russian capital was packed with people concerned with the arts and the Union of Youth took the opportunity to invite members of the Congress to the private view through a notice in the Congress's bulletin, even offering them half-price entrance on any days thereafter.[14]

The Congress had attracted patrons from all over Russia as well as members of the aristocracy, royal family and government. It was divided into eight working sections concerned with various questions of art (ranging from architecture, antiquity, theatre and applied art to artistic education, technique and aesthetics).[15] Those invited to participate included Union of Youth associates, such as Baller, Zheverzheev, Sagaidachnyi, Le-Dantyu and Morgunov as well as other avant-gardists (for example Kul'bin, Jawlensky, Yakulov, Matyushin, Kalmakov, Mashkov, Petrov-Vodkin). The majority, however, came from the establishment – the Academy of Arts and other art institutions.[16]

The first section, 'Questions of Aesthetics and the History of Art', contained the most controversial lectures and debates, as well as the most original new ideas: Kul'bin spoke on 'Harmony, Dissonance and Close Combinations in Art and Life', 'New Trends in Art' and read Kandinsky's text 'On the Spiritual in Art'; Nikolai Verkhoturov spoke on the place of art in primitive and modern life; and Sergei Bobrov, representing the Donkey's Tail, read a lecture entitled 'The Bases of New Russian Painting'.[17]

Bobrov's lecture was one of the first theoretical statements issued on **105**

behalf of the Donkey's Tail and as such helps to define the position of the group relative to the Union of Youth. He declared that the 'Russian purists' (i.e. the Donkey's Tail artists), concentrated on formal problems because this enabled them to penetrate to the essence of an object. Simultaneously, however, he identifies 'purism' with many of the tenets of Neo-Primitivism and 'idealistic' symbolism. He argued that discarding the laws of nature or visual appearances allowed painting to be 'schematic and simple'. Under the guidance of the first 'purists' of the modern day, Cézanne and Gauguin, as well as the 'purism' of ancient civilisations, the Donkey's Tail conception of purism was that it: 'reflected its object, its living individuality, its painterly ideals… and gives a metaphysical painterly essence to things'.

The artist was to have a heightened awareness, like that of a clairvoyant for whom 'physical mass is no obstacle to the insight of the higher essence… art is a different knowledge, an intuitive concept, and if symbolist painting was illusionism then we should be right to call purism oracularness'.[18] The purists could overcome the chaos of nature through creating works that were complete in themselves. Indeed, objects and nature are almost unnecessary because a work of art was to be a 'painterly transcription of visual impressions or a chain of impressions reworked by the artist'.

Technically, the purists adopted economy of means: 'the purist always tries to cover the largest plane with the least amount of paint'. In 'inserting planes into a painting they do not forget that painting is concerned with two dimensions' and thus every object could be divided into 'little planes that run into one another'. Geometrical forms were felt to impart the greatest harmony to a painting due to their simplicity. They derived from various sources: 'The purists started to study the work of primitives, folk art, artists of the antique world, where natural forms are virtually absent, and came to the conclusion that in these there is considerably more beauty and vital, inner force than in works that are more approximate to nature.' However, in contrast to the French artists the Russians observed the artistic and universal, truths expressed in 'icons… *lubki*, northern embroidery, stone *babas*, bas-reliefs on communion breads, on crosses and our old signboards.'

Bobrov noted that the Russian 'purists' did not paint objectless works but still-lifes and portraits, as well as 'religious, genre and historical compositions'. In this he recalls Matvejs' use for nature as a 'departure point'. He concluded that the basis of 'purism' lay in 'Russian archaism' and that it 'united the painting of pure planes with vital themes'.

As one of the first defences of Larionov's and Goncharova's Neo-Primitivism, Bobrov's lecture, with its sense of symbolism, aligns closely with Kul'bin and Matvejs. Yet when Bobrov gave the same lecture at the Troitskii Theatre a few days later, differences between the ideas of the

Donkey's Tail and Union of Youth were brought into the open. The succeeding quarrels between these groups, as well as the Knave of Diamonds, seem, in part, to stem from this occasion. Livshits claimed that David Burlyuk 'strengthened Bobrov's weak argument', noting that 'the attempt to depict the elements constituting the object had replaced the depiction of the object itself'.[19] On the other hand, Larionov complained to Shkol'nik that he found it 'a great pity that Bobrov did not read the lecture as he had wanted and that you (that is the Union of Youth), in his words, hindered him in this respect'.[20] As if in reply, Eduard Spandikov, in his brief review of the lecture, 'About Bobrov's Paper "Russian Purism"', regretted the speaker's lack of detail concerning formal means. He also felt David Burlyuk's attempts to address this question lacked the necessary precision and objectivity. Spandikov concentrated on the issues that could more simply be equated with his own interests in art – namely the psychological and social basis for formal changes:

> When a remarkable new change occurs in the technique of painting, it does so as a result of a crisis in the psyche, and a new psyche needs new representational means... thus Russian art (after the 1905 crisis in social life) found itself faced with the necessity to follow that shift which had occurred. The focus of artistic creativity had been lost and a condition of passive creativity set in. The object became broader than the subject and the creativity of the genius began – life in its boundless space. In this condition of primeval, unconscious passivity the creative strings of man begin to sound with elemental strength, searching for new paths to consciousness. That is why questions about new representational means for the expression of inner emotions come to the fore.[21]

Spandikov's words highlight an idea common among the Union of Youth – namely that an omnipotent and mystical, natural power governs the form of art. The closer a person is to nature the greater their ability to select and develop means for creative expression. Likewise, Bobrov respected the primitive feelings of man and demanded an altered consciousness in modern man so that he may feel and express the essence of things. Such ideas were to be proclaimed with increasing frequency and specificity in the final two years of the Union of Youth's existence.

Overall, the art shown at the fourth Union of Youth exhibition broadly reflected Spandikov's and Bobrov's comparative attitudes to nature. Generally, the Petersburg exhibits still relied on a sensually perceived reality, while the Donkey's Tail were freer in their abstraction from nature. Both, however, paid tribute to Gauguin and Cézanne as the initiators of their formal approaches, and both acknowledged a metaphysical element.

Of the eighteen Union of Youth artists present, six were new: Yasenskii, Pangalutsi, Potipaka, Novodvorskaya, Kurchaninova and Kuz'mina-Karavaeva.[22] The core of the group remained Spandikov, Shkol'nik and Shleifer. L'vov and Zel'manova contributed several works, and Rozanova

and Filonov were also represented. A significant amount of wall space was taken up by thirty sketches for the previous January's *Tsar Maksem'yan* production.

Given that the Union of Youth advertised that they were accepting work for the exhibition just ten days before it opened, and gave potential exhibitors only three days to bring their work to the galleries, it is not surprising that contributions were few. Nor is it surprising that, although a primitivist tendency dominated, the feeling of direction and consistency was less evident than that of the Donkey's Tail.

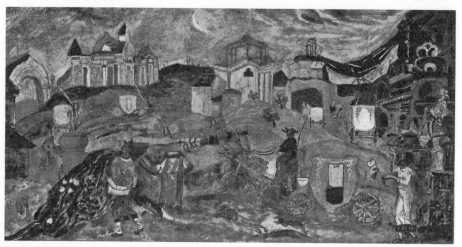

11 P. Potipaka, *Earth*

Bazankur noted the distortions of Kurchaninova's work, which continued those seen earlier in Baudouin de Courtenay and Rozanova:

> L. N. Kurchaninova's *Still Life* [Cat. 18]: a little black round table upon which is a bottle of red-whortleberry pink colour, a bright blue lamb, three coffee-coloured eggs, apparently hen's, and two vessels of some sort, in cherry and bright yellow; all this is set against a background of a bright green curtain, – everything is distorted, slanting, falling from the table....[23]

Another newcomer, Vera Novodvorskaya, exhibited *Picking Fruit* (cat. 46), which showed similarities to Gauguin's *Picking Fruit* (1899), then in Shchukin's collection. Both works depict a tropical scene of semi-naked peasants amidst palm trees. Form is simplified, generalised and heavily delineated. Three-dimensional space is little acknowledged and the figures are depicted in classical, statue-like poses.[24]

The imitative quality in the Novodvorskaya was also evident in P. D. Potipaka. Rostislavov sensed 'many varied influences, from Vrubel to Stelletskii in the nice works [of Potipaka]'. His titles (for example *Allegory*,

*Head of a Prophet*, *Paradise*, *Revelation and Love*) imply paintings full of religious symbolism. Mamontov's suggestion that his love for Vrubel had found him successfully catching the deceased's spirit 'without falling into blind imitation'[25] hints at originality. For Breshko-Breshkovskii: 'Potipaka is talented and possesses a feeling for colour. His *George the Victor* is painted in the spirit of a Byzantine icon. In its colouring this is a rather pleasant work. I didn't begrudge Potipaka's bright and festive colours for the dragon that cringes under the horses hooves....'

Potipaka's *Earth* (cat. 53, Plate 11) is a stylised frieze-like scene in which a procession of horse-drawn coaches drives over hills, past Byzantine churches, to an ancient citadel. A childlike effect is gained from the crudely drawn figures, ambiguities in the treatment of space and generalized forms. Thus the coaches are either seen directly from behind or the side and their size does not relate consistently with their position. Nor is the medievalism of the picture always coherent, although it does suggest, in accordance with the ideas and symbols expressed in *Khoromnyya Deistva*, a return to earlier epochs and values, in order to re-evaluate the present. The ecclesiastical buildings, symbols by which man aspires to transcend his earthly boundaries, suggest that *Earth* may have been part of a series, with *Revelation* and *Paradise*, that examined human worldliness and spirituality.

If Potipaka's primitivist work was rather overburdened with symbolism this was not the case with Zel'manova, another consistent contributor to the Union of Youth. On this occasion she showed ten works, mostly landscapes and portraits. The latter were acclaimed for their 'beauty' and 'interest',[26] with *Portrait of Miss D* (cat. 13) marked out as 'simplified but competent'[27] by the otherwise highly negative Shuiskii. Such simplification is evident in *Margueritte* where a young girl, facing directly out of the canvas, holds two little flowers in her clenched hands. The bold line, lack of modelling and unadorned background recall Matisse's *Marguerite* (seen at his Bernheim-Jeune show in February 1910). The *Ogonek* critic summed up the extent of Zel'manova's innovation and talent: 'In her timid exploration of form and colour a natural gift is evident.' However, her landscapes may have had Impressionistic elements, since Breshko-Breshkovskii felt them to 'almost belong to the Levitan school' and regarded the vast amount of blue water in '*Lake Geneva*' (*Lake Leman*, cat.9?) and the abundance of snow in the Swiss Alpine landscapes, as daunting.

L'vov's sixteen works (which included *Tobolsk* (Plate 4), *The Cry*, *The Garden* and three portraits) showed little change from previous years. Although Zorkii found damp weather in his *Drought* and no hint of smoke in his *In the Smoke*, Breshko-Breshkovskii noted that

the most backward place must be ceded to L'vov. This L'vov could go to any exhibition, from the moderates to those of the Petersburg Society of Artists

inclusive. His stylisation is insignificant. His form is strict. Eyes, ears and bones – all features are in their rightful place. He yields to mood more in the land-scapes, which are more sketch- like. His portraits are documentary and dry.[28]

Very few of the remaining Union of Youth exhibits have survived or can be identified. Nothing is known, for instance, of Dydyshko's three studies, Mitel'man's *Landscape* and sketch, or Nagubnikov's *Still-Life*. Spandikov's four works (two landscapes, *Sleep Walkers* and *Vase*) are also lost, al-though a comparison with Malevich's distortions and fragmentations was made,[29] together with, exceptionally, a muting of colour.[30] In addition, Rozanova only contributed a *Still-Life* and a *Portrait*, neither of which was noted by the press. However, it was quite possibly the latter, its colour and form dissociated from visual appearances, that was described in a review of the Donkey's Tail exhibition: 'rather weak... Rozanova's incomprehensi-ble portrait depicts some sort of man with a bright blue head of hair and the same coloured eyelashes, eyebrows and moustache'.[31]

For the next year at least, Shkol'nik followed a path remarkably close to that of Rozanova. Concentrating on still-lifes and landscapes, both artists reduced symbolist and literary content as they became preoccupied with colour and form. By early 1912 Shkol'nik's 'pleasant landscapes' had given way to scenes that were 'schematic, primitive and painted by a childish hand'.[32] Rostislavov noted that these landscapes, especially *Study of Bakhchisarai, Coffee-House of Menadji Baya, Coffee-House of Mulla Said Ogla, The Terrace*, as well as a still-life, marked a substantial change in the artist's painting. Describing them as 'beautiful impressionistic works', the critic concluded that Shkol'nik had drawn closer to the Mos-cow artists, indeed, that he was the closest of all the Petersburg artists.

Filonov remained the most radical of the Petersburg artists. His three works, catalogued as sketches, appear lost. One was certainly the second *Heads*, painted in the autumn of 1910, which, according to Glebova, had been rejected by the Union of Youth the previous year for being too avant-garde.[33] However, Breshko-Breshkovskii's description closely relates it to that seen in 1911:

> ... he [Filonov] is as terribly enigmatic and charismatic as last year. There are those same heads born of a sick feverish fantasy with extraordinary eyes and features that don't exist in nature, but which are seen at the moment of a frightful dream. Some heads are untouched, others are eaten away by slow decomposition... And here is some kind of irridescent amphibian stretched out separately. You look at it and it is as if you are looking at cerebral matter... But the place is surprisingly beautiful in its colour tones, these soft opals and pearls intersecting one another in a play that is brightened, here and there, by the colours of the rainbow.[34]

Evidently, the complex interplay of formal experimentation and symbol-ism was still present in Filonov and this is reiterated by a sketch of early

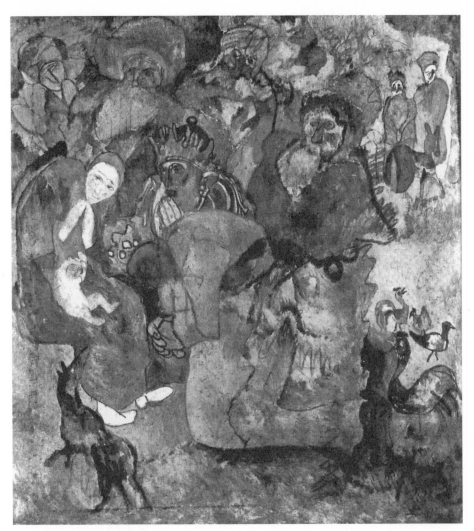

**12** P. Filonov, *Sketch* (Adoration of the Magi)

1912 (Plate 12). This work, given the title of *The Adoration of the Magi* by Kovtun,[35] does not have the concentrated effect of *Heads*, yet it is filled with eclectic stylistic and symbolic references. In this it relates to Potipaka's *Earth*, as well as Kandinsky's *Compositions* of 1910. Filonov's pictorial solution of a religious subject is intricate and tells of a profound interest in painterly texture. The flow of colour and line, disguising the motif, recalls Kandinsky's *Composition No. 2* (Guggenheim Museum), shown in Russia at the Izdebskii Salon of February 1911, while remaining more figurative. The figures are integrated into one fluid mass which creates an ambiguous spatial structure. Some figures, such as the central

111

king with his crown and clasped hands, and the chickens to the right, are enclosed by a dark outline. Others, such as the figures behind and to the right of the king, merge into their surroundings because their contours are broken. The Virgin Mary is a twisted, hunched-up figure holding the infant Jesus on her lap precariously. The donkey in the more brightly-lit right side of the picture is inspired by the rigid forms of Russian folk toys and whistles.

Even from this brief survey it is clear that the Union of Youth was, in 1912, more open to radical experiment than previously. This is also suggested by the group's rejection of portraits by Sergei Gorodetskii, on the grounds that they were too realistic.[36] The following statement concerning the necessary formal attributes of an exhibit was ascribed to the Union of Youth by Breshko-Breshkovskii, and it indicates how far it had moved, since early 1910, towards the sought-after crystallisation of direction: 'If it is realistic, let it be an extraordinary delight of colour, then we will take it as an exception. We do not like or want to meddle with the harmonious unity [of the exhibition].'[37]

The Muscovites were represented as an independent 'Donkey's Tail' section in both the catalogue and the show. The exceptions were Kuprin and Mashkov who showed a small number of still-lifes and portraits first seen at the Knave of Diamonds in 1910 (including Mashkov's shocking *Self-Portrait with the Portrait of Petr Konchalovskii*, cat. 37). Notably absent were the Burlyuks. This demarcation presaged the public break between the Donkey's Tail and Knave of Diamonds at the debate organised by the latter on 12 February 1912.[38] Mashkov's copying of Cézannist technique and adherence to academic rules meant that he had been regarded as conservative during his year with the Donkey's Tail group from April 1911. This caused him to leave the group and subsequently found the Knave of Diamonds society, calling it after the exhibition of the same name of the previous winter.[39]

In many ways the Neo-Primitivist exhibits of the Donkey's Tail artists represented a climax in the development of the trend. Henceforth, new ideas were to adulterate the original system and lead the artists, especially Larionov and Goncharova, quickly into other styles. This change first began to be apparent at the Donkey's Tail exhibition in Moscow two months later.

Goncharova contributed nine Neo-Primitivist works, including *Peasants collecting Apples, Reapers, Womenfolk with Rakes, Larionov and his Platoon Leader* and *The Pond*. The majority of these seem to have been completed in 1911 or earlier and several had been previously exhibited elsewhere. *The Pond* was described by Shuiskii:

> In order to paint such a work it is necessary to attentively and lovingly observe the forms of primitive folk art for a long time. I don't mean to say that this painting pleases the eye, but then it is not intended for a salon. But if you look at

it intently you get a sense of a genuine primitive. This is not a copy, not simply an imitation nor a periphrasis of a *lubok*. It is painted by a person capable of entering into the spirit of the ancient, possessing the primitive point of view.
The angled lines and colours are similar to those in other works by Goncharova. But the harmony of these tones, given meaning, expresses the light and warmth of summer. The figures are full of movement and when you cease to follow the crooked legs you really feel 'how' they take in the sweep net. A few figures, the patch of rough water, the tree framing it – all this has been squeezed, as if deliberately, into the close frames and the painting seems inspired by its rich content.[40]

Goncharova's *Portrait of Larionov and his Platoon Leader* (cat. 111, Russian Museum) displays similar decorative techniques to *The Pond*. Here a youthful, shaven-headed Larionov and his leader, both in grey greatcoats, dominate the surface plane. Both men stand in profile, like figures transferred from a *lubok* or simple Russian gingerbreads. The distorted, free form of the latter is also found in the disproportionately huge hand of the platoon leader. The faces of the men are flat and mask-like. Behind them, separated by an area of unarticulated space, is a series of two-dimensional white, triangular tents and two small figures. The schematic foliage designs in *lubki* are transplanted to the canvas in the stylised sapling which rises from the ground to the right of the men with unnatural symmetry.

Other, perhaps slightly later, works depict peasants filling the picture space with their clumsy, monumental forms (for example *The Reapers*, cat. 112, reproduced in Eganbyuri). Figures are flat, generalised blocks of form and colour, with faces that are either in profile or full-face and over-large hands. There is a new linear dynamism. This forceful combination of the dynamic and monumental, often encouraged by the use of highlighting taken from the icon, fills the works with a feeling of the spirit of the subject – which is both the peasants and the painting process.

In comparison with Goncharova, Bazankur considered Larionov a 'Wanderer' due to his 'strange but comparatively well depicted' genre and landscape paintings. He showed six works, including *Autumn*, *The Baker*, *Peacock* and *Head of a Soldier*, some of which had been shown at his one-day exhibition in Moscow a month earlier (8 December 1911). Breshko-Breshkovskii described *Study of a Head* (cat. 121) as depicting a man eaten away by leprosy, with half his face painted crimson and the other half left as a clean canvas.[41] This 'putrefied' effect was condemned by the critics as the height of bad taste,[42] yet Breshko-Breshkovskii also suggests an attempt, in accordance with Bobrov's theory of 'purism', to go no further than pictorially hinting at a subject.

Of the remaining Donkey's Tail exhibitors, Tatlin and Malevich were to join and influence the future direction of the Union of Youth more than any others.[43] Tatlin showed two works entitled *Fishmonger* and twenty-four

designs for Bonch-Tomashevskii's Moscow production of *Tsar Maksem'yan*.[44] *Fishmonger* (1911, Tretyakov Gallery) reiterates the exploration of structure seen in *Naval Uniforms*. There is none of the monumentality or cumbersome form, nor the brilliance of colour, seen in Goncharova's and Malevich's peasants, yet the artists are united by the resort to local tradition and an awareness of the process of making the object. Tatlin's handling of the paint is calligraphic and both the picture space and imagery are composed from planes defined by intersecting curves. There is a dynamic flattening of space as the line of the horizon is absent and the foreground, dominated by the head of the fishmonger and his work bench, is tipped up, iterating iconic device. The dominance of the icon in Russian art until the eighteenth century meant that Russia had no indigenous tradition of depicting space according to systems of perspective. This, aligned with the icon's structural control and emphasis on materials, made it a perfect object of study for the Russian Neo-Primitivists. Milner, referring to *Fishmonger*, has indicated its relevance:

> For Tatlin, becoming aware of the breakdown in the West of the credibility of illusionistic picture space, the icon painters provided an experienced and proven source of enquiry... painting had become primarily a structure, rhythmically organized, into which the features of familiar experience were insinuated. Circular curves subdivide the canvas and come to contain imagery only after their rhythmic and proportional relationship is established.[45]

Malevich contributed four works. Like Larionov, Tatlin and Goncharova, he utilised subjects from daily life and his vocabulary remained Neo-Primitivist without showing any sign of the impending impact of Cubism. Two gouaches, *On the Boulevard* (cat.125, 1911, Stedelijk Museum, Amsterdam) and *Argentine Polka* (cat.123, 1911, Aberbach Collection, New York) depict clumsy, monumental figures drawn in broad black outline and filling much of the picture space. Bright colour contrasts dominate. In *On the Boulevard* the artificiality of the work is expressed by its colour saturation; a disproportionately small, black figure in the top left corner; ambiguous space; and the highly stylised shrubs (as in the *lubok*). Furthermore, his composition is square (a format used by icon painters) and he emphasises the geometric construction of his work by the strong vertical of the monumental figure and the broad horizontal of the bench.

His colours are more subdued in *Argentine Polka*, although the figures obtain the same static, doll-like quality as *On the Boulevard*. The couple's red faces, one in profile the other full-face, are reduced to stylisations with lozenge-shaped eyes. The female figure even has a full-face eye in a profile face, a consistent primitivist feature in Malevich's work, but also a characteristic of early proto-Cubism, e.g. *Demoiselles d'Avignon*. Malevich uses the most popular dance of the day as his subject, transferring the couple and the written title at the foot of the painting, as Strigalev has pointed out,

from a photograph published a few weeks earlier in *Ogonek*.[46] Despite similar proportions, the painting deliberately contrasts with the photo. From a small black and white photo the subject has been enlarged to a metre high; given a background of crude orange and yellow shading; and the elegant figures have turned into a dumpy, clumsy couple. Although Malevich's brushwork is Cézannist, his use of primitivist elements in the depiction of this latest urban craze not only drew attention to the peculiarities of the painted image but also served to parody and shock. This conjunction of aims shows that Malevich shared Larionov's emphasis on the contemporary and urban, and also felt an allegiance with his open ridicule of convention and society.

## The Donkey's Tail exhibition

Larionov informed Shkol'nik, in late January or early February 1912, that the joint exhibition of their groups in Moscow was to be postponed until Easter. He explained that there was no spare exhibiting space in the city: 'nine exhibitions have opened... and at the venue which we had arranged and received permission for, the Society of Art Lovers, the society has decided to prolong its own exhibition'.[47] He also wrote that the group preferred not to exhibit in a flat, and so had decided to hire the halls of the new School of Painting building where the excellent light could pay tribute to his new experiments. Simultaneously, a notice appeared in *Golos Moskvy* stating that the opening of the Donkey's Tail exhibition, set for 29 January, was being delayed.[48]

In his letter, Larionov dismissed the Petersburg gossip that the Donkey's Tail and the Knave of Diamonds (which had opened its first exhibition as a society on 25 January), were to fuse. He asserted that he had no time for artists like Burlyuk who dashed from one group to another. He made his feelings public on 12 February at the first Knave of Diamonds debate, to which Burlyuk contributed. Because the opening of the Donkey's Tail had been postponed, it opened two weeks after the Knave of Diamonds closed. This was advantageous to the Donkey's Tail. Not only did it mean that the joint exhibition with the Union of Youth in Petersburg could continue until 12 February, but it also gave the artists extra time to complete new canvases – making the work more 'modern' than that of the rival Knave of Diamonds. It also emphasised the distinction between the two groups and allowed the public to end the season with the Donkey's Tail most fresh in its mind.

Even so, the Knave of Diamonds became more popular during its exhibition, mainly because of the arrival of the French works two weeks after the opening: two Picassos from Vollard's collection, six Camoins, two Zherebtsovas and five Van Dongens.[49] The infamous intervention of **115**

Larionov and Goncharova at the debate on 12 February also brought attention, though whether there was any complicity between the two factions is doubtful.

The new premises for the Donkey's Tail exhibition gave the organisers an excellent way of dividing themselves from the Union of Youth – the latter, denying Larionov's proposed display of old and modern *lubki*,[50] being located in the upper balcony of the hall. Public interest and financial success, both of utmost importance to the groups, proved great: over 7000 visitors and paintings sold to a value of 10,000 roubles (Zheverzheev proving the most valuable patron, with his purchase of twenty-seven works).[51]

The Union of Youth added little that was new or previously unshown, and as a result their fifth exhibition continued the consistent mixture of trends seen earlier, with symbolist, Post-Impressionist and Fauvist elements most apparent. The *Ranee Utro* reviewer noted a unifying approach: 'The Muscovites have a broader range of artistic gifts. They have extremes. But on the other hand, the Petersburgers are more even. As theatrical critics would say "they are an ensemble"'.[52]

In all, sixteen Union of Youth exhibitors contributed just over one hundred works, a few more than in Petersburg. The changes consisted of the following: absent were Kuz'mina-Karavaeva and Pangalutsi, and, not unsurprisingly, Mashkov and Kuprin; Matvejs reappeared with *In the Garden*, *A Spiritual Point of View* and *Dissonance*; Bubnova showed several works, including *Picking Pears*, *The Prayer*, *People and Horses* and *In the Mines*, which were praised for their simplicity and effective colour combinations;[53] Filonov appeared, ex-catalogue, with two *Heads* and some sketches;[54] Rozanova added two still-lifes, a self-portrait, another *Restaurant* and a sketch; Spandikov mostly chose work from the 1911 show; Zel'manova added a couple of new portraits and a landscape; and Shkol'nik introduced *Jugs* and the Fauvist *Winter*.

The nineteen Donkey's Tail artists included Bart, Bobrov, Goncharova, Zdanevich, the Larionov brothers, Le-Dantyu, Malevich, Morgunov, Sagaidachnyi, Tatlin, Fon-Vizin and Shevchenko. They exhibited a total of 307 works. The overriding tendency was still Neo-Primitivist, though Futurist elements also began to appear. Tatlin contributed the *Tsar Maksem'yan* designs and *Fishmongers* seen in Petersburg, but added numerous other marine subjects (as well as *In Turkestan* and four still-life and landscape studies from 1909): 'his canvases are impregnated with tar, sun and the salty freshness of the green wave of life in Eastern ports – views of Tripoli, Alexandria, Beirut, haggling over rope, dark harbour dens, etc'.[55] With these motifs the mood of Tatlin's work was distinctly non-European, in keeping with Larionov's desire for his group's art to be distinguishable

from that of the West (see Chapter 5).

Tatlin's use of Byzantine rules of pictorial construction in his exhibits, as well as his interest in sea life, was by no means unique. Sagaidachnyi is also reported to have studied ancient forms, and with a 'beautiful colouring and confident line',[56] in his *Triptych*. Furthermore, his other works were dominated by the East and the sea, e.g. *Constantinople*, *Wharf*, and *Turks on Boats*. Similarly, Zdanevich was noted for 'much distance, air and sun in his *Port* and atmosphere in his *Town*',[57] while Nikolai Rogovin's work was dominated by an 'archaic' tendency.[58]

Of the other minor artists, Ivan Larionov's exhibits were described as 'primitive sentimental landscapes'[59] and Fon-Vizin's fifteen works as imbued with 'mysticism'.[60] In addition, Bart retained literary and symbolist content in his illustrations to Pushkin and Sologub, as well as evidence of his academic training: 'Bart has shown himself an excellent graphic artist. The bold line of his drawings, the ease of his work and his fine taste speaks for itself in all his sketches: *Dancers*, *Pipe Player*, *Soldier* and many others....'[61]

Malevich's continued interest in primitive forms and peasant subjects was much in evidence in his twenty-four exhibits. It is difficult to support fully Douglas's assertion that the 'most striking aspect of these... is Malevich's newly subdued palette'[62] since the works, most of which can be identified, consisted primarily of 'irrepressibly furious red and yellow colours'.[63] An example is the Fauvist gouache *Man with a Sack* (cat. 153, Stedelijk Museum) – a composition of bright yellow, red and light blue in which a clumsy figure with flattened feet walks up a yellow and orange street. Neither do the critics' sparse comments suggest that he had started using cylindrical and metallic forms, although the foremost figures in his oil *Peasant Women in Church* (cat. 151, Stedelijk Museum) have a rounded shape that presages this. In addition, while continuing to employ brilliantly contrasting colour highlights, this work uses steel-greys, matt browns and dull greens, and there is a static, fused mass of repeated gesture and expression unseen in the gouaches. Furthermore, the mask-like faces suggest a new awareness of Picasso's proto-Cubist period (*Seated Woman* and *The Three Women* were then in Shchukin's collection).

The artist with whom Malevich had most in common was Goncharova. Her fifty-four catalogued works consisted primarily of Neo-Primitivist canvases with peasant motifs, though a new adulteration of the style was also in evidence. This was amply illustrated by five works representing 'artistic possibilities apropos the peacock' which pertained to show their subject in Chinese, Futurist, Egyptian, Cubist and Russian embroidery styles. Here a single subject was exploited in order to draw attention to the image-making process. She used a square format, like Malevich, but the interpretation of the styles described in the titles was extremely loose, and without any attempt to emulate or imitate.

A concentration on the process of painting and its detachment from visual appearances often combined with a certain spiritual content in Goncharova's work of this period. Thus her isolation of particular artistic devices could be accompanied by a contemplative mood, as in her four *Evangelists* (Russian Museum). While using the forms of medieval frescoes, the figures of the Apostles are distinguished primarily by colour (for example Luke is grey and John is green), rather than particular individual charactistics. The brushwork is bold and undisguised. Features are crudely depicted and the figures are squashed into the picture space. These and four other religious compositions were censored, presumably because they were regarded as blasphemous.[64]

The majority of Larionov's forty-three canvases were also Neo-Primitivist (including numerous pictures from his *Soldiers* series), adding to the overall impression of the Donkey's Tail show as 'an inventory of Neo-Primitivist achievements'.[65] However, his palette had now become muted, Filograf noting that he 'painted in cold, dull tones'. Furthermore, occurring just a few weeks after the famous 'Exhibition of Italian Futurists' in Paris, Larionov (and Goncharova) introduced Futurist elements, making the exhibition most remarkable as a turning point away from Neo-Primitivism:

> ... in his latest works he is trying to find a new style of movement (Futurism), characterising the seething modern life, and he is not afraid to call his canvases, covered with many- legged twisted little figures, crazy trams and falling cabs – 'photographic studies from nature' or 'monumental photos'.[66]

### The Union of Youth Nos. 1 and 2 (April and June 1912)

Very shortly after the Donkey's Tail exhibition closed, the Union of Youth produced its first publication – a small anthology of articles by its members with six black and white reproductions of predominantly Eastern works of art (the only European work was Michelangelo's *Holy Family*). This contrasted with the second issue of the journal which contained only one original article by a Union of Youth member – Markov's [Matvejs] continuation of 'The Principles of the New Art', the introduction to which had been placed in the first journal. Other items were translations of declarations and manifestoes from catalogues of recent exhibitions in Paris and Munich: the Bernheim-Jeune Exhibition of Italian Futurists (Paris, February 1912); Van Dongen's exhibition (Bernheim-Jeune, 6–24 June 1911); and the Second *Neue Künstlervereinigung* (Moderne Galerie, Munich 1–14 September 1910). These articles were accompanied by reproductions of paintings by Union of Youth members. The idea of the journal was simple: the Union of Youth, that is Zheverzheev, Spandikov, Shkol'nik and Markov in particular, wanted 'to acquaint the public with all trends in

modern painting'[67] and to define the areas of art which they considered significant.

The publication of *The Union of Youth* marked a new phase in the Union of Youth's history. Hitherto its public activity had been dominated by exhibitions. Henceforth it was to be as active as a publishing house and organiser of debates as it was as an exhibiting society and theatrical sponsor. This change reflected a new maturity and confidence in the group's artistic output. It also placed the group at the forefront of avant-garde aesthetics in Russia. No other society championed the cause of the avant-garde as early as the Union of Youth. In fact, the publications emerged as the result of two years self-examination and heralded the subsequent changes in style and personnel that characterised the Union of Youth during its final eighteen months. Here, the content of the journals is briefly outlined, leaving analysis of their specific relevance to subsequent developments in the Union of Youth to the following chapters.

The publication of two declarations by the Italian Futurist painters in *The Union of Youth* was significant since it acquainted the Russian public with previously untranslated texts outlining the artists' principles.[68] The Technical Manifesto, first published in Milan in April 1910, set the tone for a series of manifestos and proclamations made by the Russian avant-garde – not least those issued at the Union of Youth's debates, including the group's own *Credo*. The Italians' denunciations of the past, art critics, imitation and their abandonment of the illusion of three-dimensional space for the representation of dynamic sensation was also to find reflection in Russian art.

The Technical Manifesto and 'Exhibitors to the Public' are generalised statements of theory, which do not enter into specific details concerning the means of expression. Yet they do mention the use of Divisionism and multiple forms, deny Greek principles of anatomical representation in favour of individual intuitive expression and call for a 'synthesis of what one remembers and what one sees'.[69] What should be painted was 'the particular rhythm of each object, its inclination, movement, or, more exactly its interior force' – sentiments which closely concur with Markov's 'The Principles of the New Art'. The concept of force-lines, 'the beginnings or the prolongations of the rhythms impressed upon our sensibility' by the object, introduced a psychological aspect to European modern art akin to that which was already present in Russia (as seen in Kul'bin's early statements). Unsurprisingly, the Russian youth (including Larionov, the Burlyuks and Kul'bin) upon hearing of Italian Futurism, were henceforth to display a propensity towards its ideas.

Markov's influence on these first two issues of *The Union of Youth* was immense. Not only did his own article take up much space but he also worked on the translations of the Chinese poems with Vyacheslav Egor'ev,[70] and persuaded Bubnova to write a note on Persian art (a theme **119**

he chose himself) and translate the Futurist manifesto from the French.[71] Even the reproductions in the first number appeared essentially as illustrations to his and Bubnova's articles and reflected his interests: 'at that time Markov bought Münsterberg's richly illustrated book on Chinese art... the reproduction of the Buddhist sculpture was probably taken from Münsterberg'.[72]

The first two numbers of *The Union of Youth* were similar in format and were produced in runs of 500 copies. The cover of the first reproduced *A Young Lady Reading* by the seventeenth-century Persian artist, Rizā Abāssi. Above the miniature the name of the group was printed in black letters on violet-coloured textured paper. Inside violet and green pages combined with the sepia reproductions to give the journal a rather refined appearance. Most of the reproductions were of Persian and Indian miniatures, at least two of which, were by Rizā Abāssi.[73]

Bubnova's article, 'Persian Art', published under the pseudonym D. Varvarova, echoed the current interest in stylistic device and the East. She examined the Persian miniaturist's freedom from visual representation; the lack, or reduction, of modelling; the graphic qualities of the planes; and the flattening of forms. These elements, together with a conventional strength of colour, were found to imbue the work with 'regal tranquility'.[74] She concluded that the European striving for realism prevents such attainments, her remarks coinciding with Markov's theory: 'Without contemplating the expression of real life he [the Persian] uses exclusively plastic means, a singular passion for abstracted form and line outside of time and space, to create a fragrenced life.'

The first *Union of Youth* also contained Spandikov's note about Bobrov's lecture at the Troitskii Theatre in January, an article by Shkol'nik entitled 'The Museum of Modern Russian Painting' and a brief chronicle. The latter stated that the group was establishing a library of art books which already contained publications about Japanese, Chinese and European artists and which was to be supplemented during the next year by a series of books brought from Western Europe. It also claimed that the Union of Youth was presently organising a 'special museum of photographs', which included pictures of 'frescoes, architectural monuments, miniatures, mosaics and paintings of past and present artists, both Russian and European'.

The chronicle also announced that Spandikov was editing a translation of Worringer's *Abstraction and Empathy* [*Abstraktion und Einfühlung,*] (1908) which, though it never appeared, was due out in late 1912. This is especially significant since it indicates that the group gave considerable attention to, and placed considerable value on, developments in Germany (lending some weight to Le-Dantyu's criticisms). Indeed, Worringer was an acquaintance of Kandinsky and a leading supporter and propagandist of the Expressionist

painters. His theory was derived from Lipps' idea of empathy – the specta-
tor's identification with a work of art as the basis for aesthetic appreciation –
which suggested that colours, lines, forms and spaces have specific emotive
qualities. This, together with Worringer's notion that modern art had to
respond to an inner calling for the selective organization or abstraction of
nature, has much common ground with Markov's ideas.[75]

Both Spandikov and Markov could have worked on the translation since
they were fluent German speakers. Markov's notion of 'non-constructive'
art (see below) closely relates to Worringer's abstract art – as a manifesta-
tion of an internal drive to transcend attachment, as well as the contingen-
cies and limitations of the phenomenal realm. By 1910, both recognised the
insufficiency of the perceptible and were attracted to geometric, crystalline
forms (as seen in Egyptian, Gothic and Oriental art). However, Markov
allows a synthesis of representation and abstraction that, unlike Worringer,
recognises empathic qualities as inherent in abstraction.

Shkol'nik's article supplemented the chronicle by observing that the
Union of Youth was trying to found a museum of new Russian painting.[76]
He began with a scathing diatribe against the ignorant critics of modernism
and foresaw the time when the currently stigmatised art would find its
rightful place in the history of Russian art. He went on to criticise museums
for conservatism and wasting 'endless money daily on the same thing'.
Russian museums, he complained, were full of 'huge canvases in gold
frames... armies of copyists of the most familiar images colouring in
photographs of the paintings of Shishkin, Repin and Makovskii'. He
claimed that it was 'often useless to wander' among such works because
there was almost nothing for the young artist to see and absolutely nothing
to learn. Such a polemic was the most strongly worded public statement by
a representative of the Union of Youth to date, going further in its attacks
on the art establishment and society than Matvejs' critical, but more
programmatical, 'Russian Secession' of 1910.

Shkol'nik saw the awaited acceptance of the new art as signifying a
great rebirth and his words are scattered with renaissance metaphors con-
cerning this new cognition and new life

> when, from the gloom of the dark night is reborn the new morning of a splendid
> dawn, when the marvellous meadow of future creativity breaks into blossom
> and from the nightmarish lines and wild colours are reborn new and beautiful
> images, then Russian life will want to see those paths which have taken Russian
> art here. But much, much will be lost in the dust of our philistines and it will be
> difficult to see those particles which, through their searches, drove painting to
> the splendid uprising.[77]

Without speculating on the content of the new art, other than to assert that it
represented the experiences of the time, Shkol'nik felt the solution to
popular incomprehension was to create a museum 'which in the future

would present a general picture of the gradual development of Russian painting of our times'.

Although Skhol'nik's words imply the ability of the new artists to see the world around them with different eyes, there is no mention of altered consciousness or an overtly mystical sense in his remarks. The nearest he gets is by admitting that their search is inspired by 'something delightful and charming, that, without knowing the bounds of its fantasy, goes beyond the limits of ordinary life and creates a broad and beautiful art'. These hints at the extra-sensibility of the young artists coincide with the increasing influence in their circles, of Uspenskii's ideas about higher states of consciousness and the fourth dimension. Indeed, Shkol'nik's vision, while less apocalyptic, presages that of the *The Victory over the Sun*, the Futurist *zaum* opera staged by the Union of Youth in 1913. Yet, he abstained from positing any psychological theory for the new art, restricting his comments about its many-sided appearance to observations of the following components: 'wild forms, strange compositions and incomprehensible colours, a passion for theory and mathematics'; and dividing the young Russian modernists into 'Futurists, Cubists and Purists'.

Such a proclamation by one of the foremost members of the Union of Youth acts as one of the earliest confirmations of the prevalent tendencies within the group and its interpretation of the current artistic situation. It throws light upon his influences and confirms the rapid assimilation of Western trends by the Russian avant-garde. Indeed, news of the Italian Futurists' February exhibition in Paris had quickly reached Russia, and the term 'Futurist' was part of the vocabulary of the modernists from the Donkey's Tail exhibition onwards. Still, despite his support of modernism, Shkol'nik refrained from substantiating his own, or his group's, actual position among the trends.

Markov's article, although entitled 'The Principles of the New Art',[78] only discussed two principles – that of beauty and that of free creativity. Others, such as texture, weight, plane, dynamism and consonance were due to follow in subsequent essays. These did not appear, although Markov expanded his discussion of texture into an essay which was subsequently published as a separate booklet, *Faktura*. Therefore, the two parts of the article published in *The Union of Youth* must be considered only as an introduction to the principles which the author deemed fundamental to the new art. The remaining principles were examined *en passant* in his published analyses of various primitive and exotic arts (for example Chinese poetry, the art of Easter Island, African art) but were not explored in separate essays.

The first part of the essay was published in the last week of April and coincides almost to the day with the publication of the *Der Blaue Reiter* almanac in Munich (indeed, not only were *lubki* reproduced in the latter but

seven of the twelve contributors, including Burlyuk and Kul'bin, were Russian). This highlights the parallel development of artistic ideas in Russia and Germany. Markov himself was in direct contact with Munich artists in the summer of 1912, as he tried to collect works for the proposed Union of Youth museum and library. In a letter to Markov of 3 August 1912 Marc outlines his schedule as a guide to when and where the two may meet. He also states incidentally, that Macke was in Moscow in Spring 1912, where he met Burlyuk, Larionov and Goncharova.[79] Whatever the extent of Markov's acquaintance with the ideas of the *Blaue Reiter* when he wrote 'The Principles of the New Art', there are striking points for comparison.

Bubnova wrote that Markov's aim was 'to disclose and establish those eternal and fundamental principles which constitute the specific character of plastic arts of all times and all peoples, and the basic and unchanging elements of that 'how' of art, the existence of which is indeed recognised both aurally and literally.'[80] Thus the 'Principles of the New Art' concerned not new aesthetic principles but the rediscovery of the essential artistic truths. The new would emanate from this rediscovery. Hence Markov's lengthy discussion of art that was neither new nor Russian, and his international primitivism. Indeed, in the second part of the essay which concentrated on the 'Principle of Free Creativity', he referred to Chinese and other ancient art forms, determining that 'even the freest art is based on plagiarism... because old, beloved forms instilled in the soul unconsciously repeat themselves'.

Markov himself borrowed terms and themes from Kul'bin, Kandinsky and Worringer. In his 'Modern Painting' lecture of 31 March 1912, Kul'bin discussed: 'the great significance of the "free creativity" trend [here – Kandinsky], where there is the striving away from reality to the fabulous, away from photography and the forms of nature to a full painterly fantasy'.[81] Such a sense of abstraction, of art as a symbolic essence abstracted from nature, was common also to Kul'bin and Markov.

On 30 December 1911 in his lecture 'Harmony, Dissonance and Close Combinations in Life and Art', Kul'bin argued that only 'new art' ever existed. To talk of old or ancient art was to talk of that which contained the new and he went so far as to find 'the justification for modern art precisely in the art of the past'.[82] Markov's conception of 'the new art' is identical to this, and this explains the title of his essay together with his examination of the ancient.

Without questioning the need of art to search for beauty, Markov began his article with a discussion of beauty's qualities: 'Universal beauty, created from the earliest times by various peoples of both hemispheres, is the reflection and expression of the Divine as far as it has hitherto revealed itself to the people.' The perception and expression of beauty was, there-

fore, conditioned by experience. Thus art is an act of plastic principles, whether conscious or not, and modern art should be 'a development of those bequeathed to us by the past'. Such a development needed care, because the most worthless principles could easily be mistakenly adopted. Here Markov posited two opposing conceptions: constructiveness and non-constructiveness. He concentrated on the latter, for it was in this that he discerned art's greatest potential. Influenced by Worringer's discussion of mimetic art in the Classical and Oriental world, he considered the principle of constructiveness, as seen in Greek art and European art generally since the Renaissance, as that where 'everything is logical, rational and scientifically grounded. Gradations and transitions are clearly expressed in everything as subordinations to the main. In a word everything is constructive.'

Markov contrasted this severe doctrine of logic with the beauty of the illogical, or 'non-constructiveness' that was to be found in primitive and Eastern art. To illustrate his argument, he discussed Michelangelo's *Doni Tondo* (The Holy Family), a detail of which was reproduced in the journal, and noted that the arms of each figure possess identical anatomical correctness, their outer lines being a synthesis of all inner anatomical necessities. He complained that there was no need for such a studied response: 'imagine that you free these external lines from the strict accord with scientific anatomy'. Buddhist art, as illustrated by an early-seventh-century Japanese sculpture of Kannon, was free from such an oppressive service to science. Here the vast ears, wafer thin body and thick neck 'submit to other, latent needs of beauty'. In such religious art the divine was perceived by the artist through the dissonance of forms, the play of heavy with light, and the linear rhythms. Such an idealisation denied the necessity of adhering to the laws of nature. Markov interpreted this freedom as justification for modern artists to concentrate on formal properties in order to open up a whole new world of possibilities for the beautiful. But he did not deny that the principle of constructiveness could be penetrated with beauty. Rather, he saw its potential as limited, its approach restricted to 'this world'. Art could be freer. It could be an expression of 'feeling, love and dream', that is, it could be the symbol of the self rather than mimetic of nature.

However, such a principle of free creativity was far from simple, for it required modern Europeans to reject conventions established for centuries. Thus Markov examined the role of the principle of chance in art. The Chinese had long used chance, not as the sole principle for artistic creation but as one among several. Through such an approach, where, for example, the ringing of hundreds of tiny pagoda bells by gusts of wind constitutes music, many 'wonders' could be discovered: 'Chance opens up whole worlds and begets wonders. Many marvellous and unique harmonies and scales, and the enchanting tonality common to Chinese and Japanese pictures, owe their existence only to the fact that they arose by chance,

were appreciated by a sensitive eye and were crystallised.' Modern artists who employed chance as a stimulus for specific purposes were still operating with European constructive principles, using chance as 'a means of stimulation, a departure point for logical thought', rather than allowing the principle of chance to be 'the consequence of completely blind, extrinsic influences'. Further:

> I know many artists who daub their canvas God knows how and then just snatch from the chaos what they think is most successful and, depending on their powers of imagination, subject everything to their desires. Those who devise scales, harmonies and decorative motifs are especially inclined towards this. Others search for more amusing ways of painting – by blobs and *pointillés*. Some stick paper onto the work before it has dried and then when they tear it off the next day find chance, and sometimes beautiful, patches, which they then try to use.[83]

Markov likened the principle of free creativity to play, where a direct or utilitarian purpose is forgotten and the 'I' is expressed more spontaneously: 'we… emerge no longer as the masters of forces hidden within us, but as their slaves'. Art is a manifestation of the self and as such has a character that can be identified either as individual or national. Questions of refinement and crudity lose their relevance because the quality of the work of art is determined by the sincerity with which it was made. Moreover, any expression of the pure self, however sincere in intention, is complicated by certain external influences. Such factors are inevitably corrupting. Markov listed them as follows:

1  the outer function of the hands and the body in general which transmit the rhythm of the soul at the moment of creation;
2  the state of the will;
3  the wealth of imagination, memory and reflexibility;
4  associations;
5  experience of life creeping into the process of creation, subordinating it to its canons, laws, tastes, and habits, and manipulating it with a hand which finds it very pleasant to repeat stereotyped methods; reducing it to the level of handicraft which has built itself such a warm and safe nest in our time;
6  the state of the psyche during creation; the interchange of emotions, joy, hope, suffering, failure etc;
7  the struggle with the material;
8  the appearance of 'empathy', the desire to create style, symbol, allegory and illusion;
9  the appearance of criteria and thought etc.[84]

Only in rare moments of pure inspiration, which may be like religious ecstasy, is the influence of the above factors diminished and the self, be it conscious or subconscious, is free to be intuitively expressed. Free creativity seeks, through persistent inner work, to acknowledge the undesirable elements even if it is powerless to be rid of them.

The form of art created by the principle of free creativity was often a synthesis of both self-analysis and sensual perceptions. In this duality the creators' experiences of both the inner and outer world were expressed. Art forms become '"the swans of other worlds" as the Chinese sing', as artists, breaking down the barriers between themselves and external reality, penetrate the outer appearances of objects to reveal their inner 'rhythm'. The forms were most effective when they represented 'the apogee in economy of resources and the least outlay of technical means' but essentially they should be free, that is crude or refined, absurd or sensible; and not pinned to nature or doctrine. This was Markov's way of the Tao.

Markov concerned himself with a kind of spiritual primitivism – a cause increasingly advocated in *The Golden Fleece* during 1908 and 1909, its final two years of publication. In Toporkov's 'On Creative and Contemplative Aestheticism', the author attempted to define the new aims of artists such as Goncharova, Larionov and Sar'yan.[85] He concluded that with their primitivism they sought a synthesis of objective and subjective reality in order 'to find that magic point where the art of the "creator" becomes the art of the "spectator".' Such empathy was clearly implicit in Markov's words when he stressed the expression of the essence of objects external to the artist through internal investigation. As such he was one of the first to formulate the creative processes involved in Russian Neo-Primitivism.

Markov was undoubtedly also aware of Bely's aesthetic ideas. Although opposed to the impracticality of Bely's idea of the artist having to perfect himself in order to create an art of universal appeal, the two have several principles in common. The notion that art was to be for the whole of mankind, advanced by Bely at his lecture 'Art of the Future' (15 January 1908),[86] coincided with Markov's belief that art was to express the fundamentals of worldly existence. Bely believed that the artist himself was his artistic form and that from his perfection came national perfection. Without being such an idealist Markov's words echo this call for inner stringency. Both recognised man's striving for other worlds. Bely's theosophical stance made the art of the future the religion of mankind but in this he saw, as did Markov in his 'religion of beauty', that the divine would be glimpsed. Finally, Bely argued that the art of the future must 'unite the world of nature and the world of cognition in one complete creative symbol', a synthesis in keeping with Markov's aesthetics.

Prior to Markov's publications, other apologies for the Russian avant-garde were few. Burlyuk had made some propagandist proclamations for the new art at exhibitions since 1908, but his arguments lacked depth and cohesion. Likewise, Izdebskii, a member of the *Neue Künstlervereinigung*, had lectured and written brief appraisals of the new movement to accompany his salons. In accordance with Markov, he did not totally dismiss classical principles, but found them inappropriate to modern painting:

'Greece did not know colour… Colour denies form its geometric concreteness and makes form indistinct… Since the age of the Renaissance, painting has fastened onto problems alien to it – the grasp of the plastic world rather than that of colour.'[87] While Markov did not deny painting the right to deal with plastic problems (on the contrary, he saw it very much as a plastic art), he certainly agreed with Izdebskii's tenet that its attention should be focused on the formal problem of colour and that this should be free from relation to naturalistic imitation.

Izdebskii had an apocalyptic vision of art. Mankind passing through 'the purgatory of the modern capitalist monster-city' would come to a new life and new revelations. At the same time this would be a return to 'Pan, to a joyous rebirth'. Using the term 'impressionism' in the sense employed by Kul'bin and Burlyuk, he felt that it demanded not only a 'painterly mood' but also to 'express the depths of the self, to give painting the feeling and grasp of the wondrous world of colour and line'. It was to achieve this through a profound synthesis of intuitivism and symbolism – almost exactly what Markov demanded with his examination of the self in art. For Markov, intuitive solutions, despite their spontaneity and indefinable origins, were inevitably shaped by circumstantial factors. This marked the individuality of works of art of a single culture.

Kul'bin's intuitive impressionism was similar to Izdebskii's, but his argument differed from Markov's through its use of science. Although Markov did not reject science *per se*, he regarded it as strictly 'constructive' and thereby limited in its application and possible solutions. The scientific basis he saw in European art since Hellenic times was symptomatic of Europe's 'rigid doctrines, its orthodox realism' which 'corrodes national art, evens it out and paralyses its development'. Further, Markov differentiated his purpose from that of the psychologist: 'It is not my task to analyse our "I" in all its diversity… that is the province of psychology.' Kul'bin, on the other hand, aware of recent developments in science, expanded its scope, felt free to dabble in psychology and created a theory of art using scientific principles.

Despite such differences, the two theorists had much in common. Indeed, there was much that was non-constructive in Kul'bin's use of science. The 'rhythm' that Markov sought beyond the world of appearances and that he considered absent 'in objects constructed by the mind on principles of pure proportion and practical truth', was identical with Kul'bin's 'energy… to which physics has recently reduced everything'.[88] Kul'bin accepted that art went beyond the world of visual reality but that in his free expression of inner worlds the artist was reflecting, or at least hinting at, scientific laws of nature. The expression of the 'I', whether in harmony or dissonant with external reality, was an expression of the nature of things at any one time, for the freedom of the creator was itself part of a natural order. In other words, art, as

Markov suggested, was always conditioned.

That both Markov and Kul'bin ultimately advocated the unlimited expression of the essence of reality is indicative of their symbolist heritage. Both artists accepted that the forms of art (unconsciously or consciously) were representative of a divine beauty, and were the result of both sensual perception and inner searching. Markov claimed: 'Forms attained by the application of the principle of free creativity are sometimes a synthesis of complex analyses and sensations; they are the only forms capable of expressing and embodying the creator's intentions *vis-à-vis* nature and the inner world of his "I".' In fact, he appears to be the greater idealist of the two, for he puts art above nature while accepting man's inability to express pure truth because of interference factors. Kul'bin, on the contrary, does not differentiate between man and nature – the fact that man can create art, 'the flowers of culture',[89] be free in colour and form, express the psyche, sound, movement and so on, does not mean he is free from scientific law. Indeed, art is to be a reflection of an empathy with the variety in nature. Ultimately then, both sought the divine in art but Kul'bin saw the divine in nature while Markov saw it, like Worringer, beyond nature.

Kul'bin and Markov applied their principles to art generally, seeking to establish a way for the intuition, through psychological training, in all fields of art. Both were essentially practical in their approach, indicating the hinderances to pure expression and using plentiful examples to illustrate their theory (both discussed folk art, folk toys, children's games and music). Both saw value in the crude, the absurd and the non-sequential.

Markov's 'The Principles of the New Art' developed the ideas he had first announced in 'The Russian Secession', where he had concentrated on the colour, form and line of modern Russian painting, but suggested through his examples (Buddhist art, Greek architecture and so on) that his interest went beyond the principles of painting. His argument had changed little: in 1910 he had sought non-mimetic colour, free from 'materially-related phenomena and ideas', blamed Greece for forcing out the mystical, demanded a painterly art, advocated the use of art of the past and the primitive as models for modern creative work and denied truth to visual reality. By 1912 there was a shift towards determining the factors involved in creating new art, and Markov's argument was less rhetorical. Yet his conception of the world of nature and the right of the artist to distort that world remained identical.

Markov's relationship to Kandinsky also reveals that the artists addressed similar problems and arrived at similar conclusions. In the year after October 1909 Kandinsky had published five 'Letters from Munich' in Makovskii's symbolist monthly *Apollo*. Here, for instance, he appraised Eastern art (and in particular Persian miniatures), announced his opposition to academic art and declared the struggle of the modern artist to heed inner

experiences while abandoning the interference factors of nature. Subsequently he published 'Content and Form' in the second Izdebskii Salon catalogue (early 1911) and had 'On the Spiritual in Art' read to the Congress of Artists at the end of 1911.

In 'Content and Form' Kandinsky, more than either Markov or Kul'bin, established a 'constructive' approach from 'non-constructive' principles.[90] Thus he regarded form as determined by content. Content, however, was not that of external reality, but inner feeling: 'Form is the material expression of abstract content.' His 'principle of inner necessity' was close to Markov's 'principle of free creativity' and enjoyed a similar pragmatism. Both recognised that artists themselves could be the only true critics of their work and that the correspondence of form to inner content (in Markov's terms, the manifestation of 'I') was bound to be flawed. Markov went further in his demands to ignore the spectator's wishes, while couching his principle in terms reminiscent of Kandinsky: '... let me create according to my own inner impulses and criteria'.

Kandinsky, concentrating on colour and line, established the following rules: 'Painting is the combination of coloured tones determined by inner necessity... Drawing is the combination of linear planes determined by inner necessity.' The whole of Markov's 'The Principles of the New Art' elaborated on this theme without once contradicting it. Similarly, the more restricted discussion of 'The Russian Secession' had focused on colour and line as the primary elements of painting, and called for them to be 'the expression of temperament' free from any subjection to material phenomena. Kandinsky echoed this in 'On the Spiritual in Art': 'Feeling is everything, especially at the beginning... true results can never be attained through cerebral activity or through deductive calculation.'[91]

The parallels between all these artists points to the development of a new aesthetic in Russia. Kul'bin had been partly responsible for its inception in 1908; first with his *Modern Trends* exhibition and then with his lectures and articles. The new aesthetic may best be described as 'post-symbolist', since the symbolist heritage is clearly felt, although developed further. Many tenets of Markov's theory are applicable to Neo-Primitivism, although his argument allows a broader interpretation of creative principles. Certainly, the application of his theory to all art was in keeping with the Neo-Primitivists' determination to find common factors in primitive and ancient art of all kinds. As an elucidation of these plastic principles Markov's work has clear limitations. But the article was not intended as an isolated essay and its publication gave some foundation to the methods and techniques of the very latest Russian art. In this respect, Markov gave the move to abstraction then taking place its meaning.

## References

1 [anon.] 'Vystavka kartin obshchestva khudozhnikov "Soyuz molodezhi"', *Ogonek*, 21 January 1912, unpaginated.

2 For example, Zorkii, 'Zhivopis' Soyuza molodezhi', *Vechernee vremya*, 14 January 1912, p. 3; V. Ya [Yanchevetskii], 'Khudozhestvennaya khronika', *Rossiya*, 17 January 1912, p. 5; O. Bazankur, 'Po vystavkam', *Sankt-Peterburgskiya vedomosti*, 25 January 1912, p. 2; 'Vystavka Soyuza molodezhi', *Golos sovremennika*, St Petersburg, 22 January 1912, p. 3.

3 A. Rostislavov, 'Vystavka Soyuza molodezhi', *Rech'*, 24 January 1912, p. 3. Concerning Sergei Bobrov, see below.

4 N. Breshko-Breshkovskii, 'Vystavka Soyuza molodezhi', *Birzhevye vedomosti*, No. 12719, 4 January 1912, p. 6.

5 [anon.] 'Vystavki – 'Oslinago kvosta' i "obshchestva peterburgskikh khudozhnikov"', *Vechernee vremya*, 24 December 1911, p. 3.

6 *Vechernee vremya*, 27 December 1911, p. 5.

7 Cited in N. Khardzhiev, *K istorii*, p. 33. Letter in Khardzhiev's possession.

10 Cited in Khardzhiev, *K istorii*, p. 35. Letter in Khardzhiev's possession.

11 '3-ya vystavka kartin obshchestva khudozhnikov 'Soyuza molodezhi"', *Rech'*, 25 December 1911, p. 1.

12 Letters of mid-December 1911 indicate that the two groups were already discussing collaboration then. At first it seems to have been agreed that the Union of Youth would participate in the Donkey's Tail Petersburg show, though distinguished by a separate title (see Shkol'nik, letter to Zheverzheev, 14 December 1911, cited in Khardzhiev, *K istorii*, p. 34).

13 Breshko-Breshkovskii, 'Vystavka'. He adds that the Petersburg Society of Artists, whose exhibition opened in the same building on 27 December 1911, paid 2000 roubles for six weeks, and the Union of Youth paid a 'fleecing' 500 roubles for a 'tiny little apartment'.

14 *Vestnik Vserossiiskogo s'ezda khudozhnikov*, St Petersburg, 4 January 1912, p. 27.

15 See *Trudy Vserossiiskago s'ezda khudozhnikov*, Petrograd, I, 1914, p. XII.

16 Concerning the participants see, for example, *Vestnik Vserossiiskogo s'ezda*, July–August 1911, pp. 43ff.

17 See S. P. Bobrov, 'Osnovy novoi russkoi zhivopisi' *Trudy*, I, pp. 42–7. Sergei Pavlovich Bobrov (1889–1971) read the lecture on 31 December 1911, repeated it on 2 January 1912 in the third section and on 7 January 1912 in the Troitskii Theatre (an occasion almost certainly organised by the Union of Youth).

18 Such a view was important to the development of Rayism by Larionov. Also, Goncharova showed works marked 'direct perception' at the Donkey's Tail in March. 'Oracularness' is translated from *vizionerstvo* which has no precise English equivalent.

19 B. Livshits, *The One and a Half Eyed Archer*, Newtonville, 1977, p. 78.

20 Larionov, undated letter to Shkol'nik, Russian Museum.

21 E. Spandikov 'Po povodu referata S. Bobrova 'Russkii purizm', Soyuz molodezhi, No. 1, April 1912, pp. 21–2.

22 Elizaveta Yurievna Kuz'mina-Karavaeva (1891–1945), a symbolist poet, showed *The Dragon Gorynych* (a winged dragon with a body of a serpent – an incarnation of evil and violence – in Russian folklore).

23 Bazankur, 'Po vystavkam'.

24 *Picking Fruit* was reproduced, together with Bobrov's *Cyclops* and Zel'manova's *Margueritte*, in the *Ogonek* review. Vera Dmitrievna Novodvorskaya (1884–1942) also exhibited *Illustrations to a Story by Barbey d'Aurevilly*, indicating that literary content had not been abandoned altogether.

25 S. Mamontov, 'Oslinyi Khvost'.

26 Mamontov, 'Oslinyi Khvost'; Filograf, 'Oslinyi khvost', *Golos moskvy*, 13 March 1912, p. 5.

27 B. Shuiskii, 'Oslinyi khvost i Soyuz molodezhi', *Stolichnaya molva*, 12 March 1912, p. 4.

28 Breshko-Breshkovskii, 'Vystavka'.

29 B. Shuiskii, 'Vystavka Soyuza molodezhi', *Protiv techeniya*, 28 January 1912, pp. 2–3.

30 Breshko-Breshkovskii, 'Vystavka'.

31 Filograf, 'Oslinyi khvost'.

32 Breshko-Breshkovskii, 'Vystavka'.

33 Glebova, 'Vospominaniya', p. 151. '101. Heads (2nd)' is pencilled in *Katalog vystavki kartin obshchestva khudozhnikov 'Soyuz molodezhi'*, St Petersburg, 1912 (Russian Museum).

34 Breshko-Breshkovskii, 'Vystavka'.

35 E. Kovtun, 'Iz istorii russkogo avangarda (P. N. Filonov)', *Ezhegodnik rukopisnogo otdela pushkinskogo doma na 1977 goda*, Leningrad, 1979, p. 217.

36 See Breshko-Breshkovskii, 'Vystavka'.

37 *Ibid.*

38 Donkey's Tail members also failed to participate in the Knave of Diamonds exhibition that opened on 25 January 1912.

39 See Breshko-Breshkovskii, 'Vystavka 'Soyuza molodezhi'', which provides a rare contemporary view of the founding of the Knave of Diamonds.

40 This description indicates common features with *Fishing* (Hutton Gallery, New York) and *Fishing* (Tretyakov Gallery). For a detailed discussion of Goncharova's and Larionov's work of this period, see G. Pospelov, *Bubnovyi Valet*, Moscow, 1990, pp. 26–97.

41 Breshko-Breshkovskii, 'Vystavka'.

42 See, for example, Zorkii, 'Zhivopis' ''Soyuza molodezhi'''.

43 Other Donkey's Tail artists included Fon-Vizin, Shevchenko, Morgunov and Bobrov. It is interesting to note that Bobrov utilised Homeric mythology for his formal experiments in *Cyclops* (cat. 113). The clumsy, massive naked figure of Polyphemus guards the entrance of the dwarfed cave in which stands the tiny stick figure of Odysseus, near three grazing sheep. Also, Breshko-Breshkovskii found that the cave 'looks like a carpeted tent' and identified an indigenous folk source for the form of the Cyclops: 'a clay whistle from a Little Russian [i.e. Ukrainian] fair'.

44 According to the catalogue these sketches were already owned by Zheverzheev. Concerning the production and for reproductions of Tatlin's work, see F. Syrkina, 'Tatlin's theatre' in L. Zhadova, ed., *Tatlin*, London, 1988, pp. 155–6, and *ibid.* p. 181.

45 J. Milner, *Vladimir Tatlin and the Russian Avant-Garde*, London, 1984, p. 26.

46 'Argentinskaya pol'ka', *Ogonek*, 12 November 1911, unpaginated, see A. Strigalev ''Krest'yanskoe', 'gorodskoe' i 'vselenskoe' u Malevicha', *Tvorchestvo*, Moscow, April 1989.

47 Larionov, letter to Shkol'nik, Russian Museum.

48 *Golos moskvy*, 29 January 1912, p. 5.

49 See 'Bubnovyi Valet', *Golos moskvy*, 12 February 1912, p. 4. The works expected from Derain and Delaunay were still absent.

50 [anon.] 'Soyuz molodezhi', *Golos moskvy*, 8 March 1912, p. 5. This exhibition opened the following year.

51 See *Golos moskvy*, 8 April 1912, p. 4.

52 Yu. B., 'Oslinyi khvost' i Soyuz molodezhi', *Ranee utro*, 13 March 1912, p. 5.

53 See, for example, Shuiskii, 'Oslinyi khvost'; Yu. B., 'Oslinyi khvost'.

54 See, for example, Yu. B., 'Oslinyi khvost'.

55 [anon.] 'Oslinyi khvost', *Golos moskvy*, 7 March 1912, p. 4.

56 A. K., 'Oslinyi khvost', *Utro rossii*, 13 March, p. 5.

57 Yu. B., 'Oslinyi khvost'. *Town* was described as 'Cubist' by Parkin [Il'ya Zdanevich], *Oslinyi khvost i Mishen*, 1913, p. 66.

58 A. K., 'Oslinyi khvost'.

59 [anon.] 'Oslinyi khvost', *Golos moskvy*, 7 March 1912.

60 *Ibid.*

61 Filograf 'Oslinyi khvost'. However, Bart also contributed'a series of compositions representing light and shade in which everything is illuminated by light from unknowable sources.' ([anon.] 'Oslinyi khvost' *Golos moskvy*).

62 C. Douglas, *Swans of other Worlds*, p. 23.

63 [anon.] 'Oslinyi khvost', *Golos moskvy*.

64 The eight religious compositions by Goncharova were censored the day before the exhibition opened, together with a religious composition by Rogovin and Filonov's *Study of a Female Model*, see 'Tsenzura i Oslinyi khvost', *Golos moskvy*, 11 March 1912, p. 5. Concerning the showing of Goncharova's four *Evangelists*, which were not identified in the catalogue, see Parkin, 'Oslinyi khvost', p. 58 and [anon.] 'Oslinyi khvost', *Golos moskvy*, 7 March 1912 (a review written before the censorship).

65 J. Bowlt, *Russian Art 1875–1975: A Collection of Essays*, New York, 1976, p. 105.

66 [anon.] 'Oslinyi khvost' *Golos moskvy*. These 'photographic studies' appear to contrast with Malevich's 'static' use of the photograph in *Argentine Polka*, although both artists were actually concerned with expressing the painterly nature of their art.

67 *Soyuz molodezhi*, St Petersburg, No. 2, 1912, p. 23.

68 Paolo Buzzi, ('Pis'mo iz Italii. Zhivopis'', ('Khronika'), *Apollon*, July–August 1910, pp. 16–18) had paraphrased the 'Futurist Painting: Technical Manifesto', translated in *Soyuz Molodezhi*, but this, together with Marinetti's twice translated 'Manifesto of Futurism', appears to have gone largely unnoticed (concerning the latter see, for instance, E. Sem-v., 'Futurizm (Literaturnyi manifest)', *Nasha gazeta*, 6 March 1909, p. 4).

69 'Obrashchenie k publike', *Soyuz molodezhi*, No. 2, p. 31.

70 The translations published in *The Union of Youth* reappeared with many others and an essay by Markov, in *The Chinese Flute* [*Svirel' kitaya*], published by the Union of Youth in 1914.

71 V. Bubnova, 'Moi vospominaniya'.

72 *Ibid.* Bubnova is correct: the reproduction, discussed with reference to Markov's article below, was taken from Oskar Münsterberg, *Chinesische Kunstgeschichte*, Esslingen, 1910, I, p. 143. It was an early-seventh-century bronze of Kannon (Chinese – Kwan-Yin), the female aspect of Boddhisattva Avalokitesvara, from the Horiuji temple in Nara, Japan.

73 There is a misprint in the numbering of the six reproductions – the fifth and sixth, indicated as Indian and Persian respectively, should be vice versa.

74 D. Varvarova, 'Persidkoe iskusstvo', *Soyuz molodezhi*, No. 1, 1912, p. 22. Besides the Abāssi miniature of a horseman, where the graphic qualities and abstract forms of nature are evident, the journal contains a reproduction of a miniature depicting Khusrau, the Sasanian monarch observing the bath of his loved one Shīrīn. This was a favourite scene with the Persian miniaturists from the romantic poem of Nīzāmi.

75 There appears to have been no pre-Revolutionary translation of Worringer's work into Russian. The idea to translate it at this time shows how close the Union of Youth was to the *Blaue Reiter* artists: in February 1912 Marc wrote to Kandinsky: 'I am just reading Worringer's *Abstraction and Empathy*, a good mind, whom we need very much.' (Cited in K. Lankheit ed., *The Blaue Reiter Almanac*, London, 1974, p. 30). By this time R. Piper, the publisher of *Der Blaue Reiter*, had already published two editions of the book (Munich, 1908 and 1911).

76 I. Shkol'nik, 'Musei sovremennoi russkoi zhivopisi', *Soyuz molodezhi*, No. 1, p. 18.

77 *Ibid.*

78 Vladimir Markov [V. Matvejs], 'Printsipy novogo iskusstva', *Soyuz molodezhi*, No. 1, pp. 5-14 and 'Printsipy novogo iskusstva (prod.)', *Soyuz molodezhi*, No. 2, pp. 5-18.

79 Marc, letter to Markov, Russian Museum. It is a curious coincidence that Matvejs chose the pseudonym Markov ('of Mark') in April 1912 at the same time as Marc published *Der Blaue Reiter*. It is worth noting that, like Markov, Marc's family also originated from the Baltic provinces, and that he had relations in Moscow (see Kandinsky letter to Kul'bin, 19 July 1911, in Kovtun, 'Pis'ma V. V. Kandinskogo', p. 404).

80 Bubnova, 'Moi vospominaniya'.

81 Rostislavov, 'Vecher khudozhestvenno-artisticheskoi assotsiatsii', *Rech'*, 4 April 1912, p. 4.

82 N. Kul'bin, 'Garmoniya, dissonans i tesnyya sochetaniya v iskusstve i zhizni' *Trudy*, I, p. 36.

83 Markov, 'Printsipy', *Soyuz Molodezhi*, No. 2, pp. 13–14.

84 Here Markov most clearly shows the impracticality of pure abstraction – the virtual impossibility of transcending the material realm, however desirable. Thus mimetic images of some sort are almost inevitable. This suggests a synthetic – rather than antinomic as in Worringer's case – interpretation of abstraction and empathy. It is interesting to note that Markov employs the word '*vchustvovanie*' (empathy), and in quotation marks, to describe one of the negative external factors corrupting the pure work of art. This suggests a borrowing from Worringer, especially as the word (a direct translation from *einfühlung*) was not then in common usage in Russia.

85 A. Toporkov, 'O tvorcheskom i sozertsatel'nom estetizme', *Zolotoe runo*, No. 11–12, 1909, pp. 69–74.

86 See [anon.] 'Iskusstvo budushchago', *Rus'*, 17 January 1908, p. 3.

87 A. I., 'Sovremennoe iskusstvo i gorod' (Lektsiya skul'ptora V. Izdebskago)', *Kievskaya mysl'*, 23 February 1910, p. 5.

88 Kul'bin, 'Garmoniya', p. 35.

89 Kul'bin, 'Treugol'nik', *Salon 2*, p. 19.

90 See Kandinsky, 'Content and Form', translated in Bowlt, *Russian Art of the Avant-Garde*, pp. 17–23.

91 See J. Bowlt and R. Washton-Long (ed.), *The Life of Vasilii Kandinsky in Russian Art: A Study of On the Spiritual in Art*, Newtonville, 1980, p. 81.

# Act I Scene iv, What is Cubism?

## 'What is Cubism?': The Union of Youth debate, 20 November 1912

After the June publication of *The Union of Youth*, the group began its summer recess. Markov (as Matvejs was now known) spent the summer in France and Germany, perhaps even setting off in time to see the Italian Futurists' exhibition at *Der Sturm* in May. Certainly he had been charged by the Union of Youth to make arrangements on the group's behalf. To this end he noted in a letter to Zheverzheev that he had talked with Herwarth Walden of *Der Sturm*, about bringing the Futurist show to St Petersburg some time after August 1913 and taking a Union of Youth show to Berlin; that he had agreed to exchange *Der Sturm* and *The Union of Youth* journals; and that he had talked with a Cologne gallery concerning an exhibition of the Russian avant-garde in 1914. He added: 'In order to get to the heart of German decadence I had to prolong my stay in Berlin, go to Hamburg and Hagen and visit Cologne.'[1]

In another letter, of 26 July 1912, Markov indicated that his responsibilities went beyond the organisation of exhibitions to the purchase of pictures and books for the proposed museum of modern art and library. Writing from Paris, he outlined his activities and aims thus:

> Could you please inform me whether premises for our museum are available? ... I really don't want to dupe such people as Walden and Kandinsky by taking pictures when no museum exists ... I am buying some things for the museum, but have found more things that are suitable for the journal. I wander around endless amounts of bookshops... I badly need a camera... I must write about the principles of the new art and there is material here. What wonderful African and Polynesian sculpture one can buy... it's lucky you gave me so little money for I wouldn't have been able to stop myself. Even so my soul trembles at the thought. I can only buy rubbish – works by the Futurists and Picasso – rubbish compared with the sculptures. But I can't not buy Picasso – they'd kill me in Petersburg... So I've reserved eight Picassos at four francs each...[2]

These letters provide the clearest evidence of where the Union of Youth's interests lay and the contacts they sought in 1912, i.e. with the promoters of German Expressionism, Picasso's art and primitive sculpture. The very fact that Markov was sent to Europe indicates that, unlike Larionov's Neo-Primitivist groups, the Union of Youth actively sought a liaison with the West, and considered themselves part of the modern European movement, with its blend of symbolism, primitivism, Cubism and Futurism. Indeed, at

the same time as writing this letter, Markov wrote to Kandinsky and Marc with requests to contribute works to the Union of Youth, and asking for information about a new book on Cubism that he was having trouble finding.[3]

When Union of Youth members were reunited in the autumn of 1912 there began two final seasons of intense activity. The first public event to be organised was a lecture evening on 20 November. The speakers were

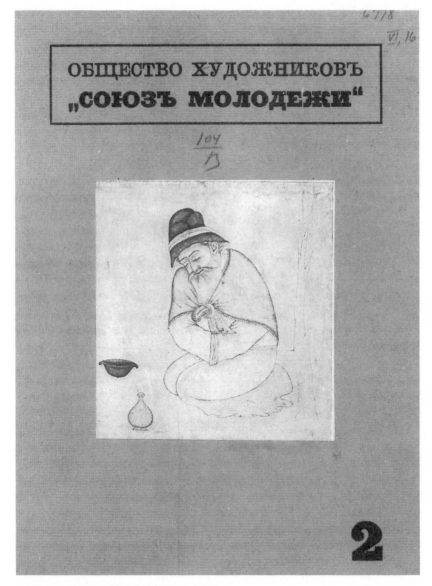

13 Cover of *Soyuz Molodezhi*, No. 2, 1912

David Burlyuk and Vladimir Mayakovsky. Two weeks later, the sixth, and penultimate, Union of Youth show opened. It was the first in Russia to be recognised as 'Cubist' (as well as 'Futurist') by the critics.[4]

In June, as Markov set off for Europe, Burlyuk returned from two months in France and Germany. During his trip he had met Kandinsky in Munich and almost certainly seen the Italian Futurists' Exhibition in Berlin in April.[5] He returned much inspired and energetically went about putting his ideas and plans into action. On 27 October Shkol'nik wrote to Zheverzheev: 'Yesterday I received a letter from D. D. Burlyuk with the suggestion that our society organise a lecture or debate... He offers forty to fifty magic lantern slides... and to talk about Futurists, French and Russian, old and new. He offers to do all this free of charge.'[6]

The fact that the lecture took place on 20 November 1912 indicates the swiftness of the Union of Youth's reaction and its readiness to accommodate Burlyuk. Within days he wrote again with a rough outline of his programme.[7] He headed it 'In Defence of Art', mentioned that there would be more than sixty slides of nineteenth- and twentieth-century paintings and entitled his lecture 'What is Cubism? (the Question of a Dilletante)'. He recommended inviting the following as opponents: Mayakovsky (as well as suggesting him as a second speaker), Kul'bin, Nikolai Burlyuk and the Kievan poet Vladimir El'sner.

Burlyuk also mentioned that he would be delivering the lecture 'Evolution of the Concept of Beauty in Painting' ('without the polemical element'), that he had previously read at the Knave of Diamonds 24 February debate, at an evening organised by the Arts Association. This eventually took place on 10 December. As if hinting that he should like to create a stir in Petersburg only at the Union of Youth's evening, he added: 'With you I shall try to settle old scores with the Peterburgers. I hope that I'll speak well. I've written many articles but don't like 'to read' them.'[8]

Three days prior to Union of Youth's evening Burlyuk and Mayakovsky, together with Nikolai Burlyuk, received their first platform in Petersburg at the Stray Dog club. Burlyuk gave a short speech, apparently restricted to the new poetry, in which he promoted developments in Moscow as opposed to those in Petersburg. He also read his and Khlebnikov's latest poems. Only Kul'bin supported him. However, Mayakovsky, who seems only to have read his poetry, was appreciated to a greater extent and the Union of Youth displayed its continued conciliatory approach. The following report described the evening:

> From the retorts of both sides, i.e. the representatives of Moscow and Petersburg circles of poets, it was apparent that these are two rival camps which are unlikely to be reconciled. Even so, one of the members of the Petersburg Union of Youth announced that attempts are now under way to amalgamate the two camps.[9]

Such collaboration may have been begun at Mayakovsky's first meeting with Union of Youth members four days earlier. On 13 November Shkol'nik wrote to Zheverzheev:

> A young poet and artist who has relations with the Knave of Diamonds and is a friend of Burlyuk has arrived from Moscow. He also wishes to make an independent lecture on the 20th (Tuesday) and offers his services free. In order to succeed in doing something we must speak and listen to him today. I ask you, if you can, to come to Spandikov's at 7 this evening. I'll be there with Mayakovsky and probably Matvejs.[10]

The same day, unless there is an error in the date of either document, the programme of Mayakovsky's lecture was printed with the permission of the town governor.[11] These details provide crucial information about the foundation of the new poetry group called Hylaea, together with its links with the Union of Youth. In addition, they indicate the extent to which Shkol'nik, Spandikov, Zheverzheev and Markov were the decision makers of the group at this time. The tolerant and non-dogmatic leadership of these four enabled the Union of Youth to be a dynamic forum for ideas in 1912 and 1913. Thus the evening of 20 November 1912 was given over not only to Burlyuk's lecture but also to Mayakovsky who gave a talk on 'The Newest Russian Poetry'.[12]

Burlyuk's repetition in Petersburg of two lectures previously given in Moscow is indicative of his desire to spread his reputation between the capitals. Thus he attempted to resume his place as Russia's leading protagonist of modern art usurped by Larionov and Goncharova earlier in the year. The Union of Youth was the perfect foil for his devices. Progressive in leadership, with a mood of enquiry into the latest movements, it was also, despite its short existence, something of an established organisation capable of bearing influence and attracting serious attention.

Burlyuk's appearances in Petersburg followed the same pattern as those earlier in the year in Moscow. The first, at the Union of Youth's event, was full of declamatory mocking of his opponents, while the second, at the Arts Association, was considerably more reasoned and calm. Still, he issued a programme for the first talk and it appears that he followed it to an extent. Essentially, the two talks followed similar loose themes concerning the new movements in art. Thus, when it appeared that the slides could not be shown at the Union of Youth's evening they were found equally applicable to the Association's.[13]

Curiously, Burlyuk seems to have ignored Futurism, even though in one notice for 10 December the talk was given the title of 'Cubism and Futurism'.[14] Such an omission is odd, considering that Futurism was arousing interest in Petersburg at this time, and the fact that Burlyuk himself had originally proposed to talk about 'Futurists, French and Russian, old and new'.[15] News of the Futurists had reached Russia after their exhibitions in

western Europe earlier in the year, and reproductions of works such as Boccioni's *The Laugh*, Carrà's *Funeral of the Anarchist Galli* and Severini's *The Boulevard* had been carried in the press.[16] However, Burlyuk did not restrict his discussion to Cubist principles, and used the occasion of 20 November for an espousal of various ideas on the nature of modern art that were closely akin to those published a month later in *A Slap in the Face of Public Taste [Poshchechina obshchestvennomu vkusu]*.[17]

Burlyuk's lecture programme consists of replies to various hypothetical questions posited by visitors to modernist exhibitions in Russia. These are contrasted to the denial of answers to '"art" critics', such as Benois. As an introduction, he summarised the contemporary situation in Paris, Petersburg and Moscow, and included in this the relations of the critics to the modern artists in Russia. This was followed by a short outline of the history of nineteenth century art in France culminating in the 'abstract essence of Neo-Impressionism – Gauguin, Van Gogh, Cézanne, Matisse and Rousseau'. The programme then included a discussion on whether such art existed in Russia or not, and an outline of his 'canons of the new painting'. Finally, he looked forward to unspecified 'new horizons'.

Reviews of the evening suggest that far from being didactic, Burlyuk revelled in slinging mud at his opponents, ignored rational argument, and preferred to whip up emotions in the crowded hall:

> He talked long and slowly about how painterly art had begun to be painterly only with the twentieth century. And how everything done previously, from Raphael, Leonardo, Titian and Velázquez, right up to Serov, Levitan and Vrubel, is just rubbish – one colour photograph and nothing more. Proclaiming the canons of the new painting, which necessarily consist of colour, texture, line and surface, Burlyuk announced that the artist has the inalienable right to be the arbiter of public taste and that the public must unquestioningly believe the artist.[18]

His canons consisted of the following:

> New painting is constructed on concepts diametrically opposed to old concepts, that is on disproportion, disharmony and asymmetry. Painting must work out the problems that cannot be subjected to other arts. Its charm is in its component elements: line, plane, colour and texture. The new painting is scientific and the modern artist must, like a theoretician, proceed from a special study of the world. In nature line, colour, texture and surface are the fixed elements on which the material world is constructed. Previously there was an unconscious relation to nature; the modern artist must be inspired by a feeling of beauty that is fundamental and yet mysterious. Cubism is a plane interpretation of the world where everything is like a chart of geometric bodies. The fathers of the new interpretation of painting are Van Gogh, Gauguin and Cézanne.[19]

Although this description of Burlyuk's new ideas is superficial, perhaps because his talk avoided serious analysis, his programme outlines a number of important sources for the modern artist in the 'barbaric arts', i.e.

Russian folk art, Russian signboards (he called for a Museum of Sign-boards to be established in the Hermitage) and Russian folk songs. Thus he emphasised his Neo-Primitivist heritage.

The four elements of Burlyuk's canons concentrated on individual constructive elements: he drew attention to Kandinsky's concept of line, his own research into painterly texture,[20] the shifting and 'supplementary secant' planes of the French Cubists and a variety of uses of colour. In the last category he considered the 'dissonance of Mashkov and Konchalovskii, the colour ponderability of Konchalovskii, Larionov's Minor and Major,[21] the colour sequence of Lentulov and Vladimir Burlyuk, the flowing colouring of David Burlyuk and the colour displacement of Léger'.[22]

Despite this systematic approach, the furthest Burlyuk seems to have gone in his lectures, and then only in the Arts Association speech, was to recognise the modern artist's need to express: 'the sensation of visual ponderability, show thickness and volume (as Léger does when depicting severed figures), to represent nature from several points of view, like ancient artists and children who present things full-face and in profile simultaneously.'[23] Undoubtedly the force of his argument at the Union of Youth evening was taken away by the unexpected lack of illustrations and this added to the general impression of lack of substance.[24]

The sharpness of Burlyuk's words against critics and artists alike did little to substantiate his argument: he likened Levitan and Repin to 'a chocolate factory'[25] and described Vrubel as one 'ungifted, who takes trouble only with the subject'.[26] Yet, underlying his rhetoric, there is evidence of an approach that relates to his Russian avant-garde colleagues. Thus he complements Matyushin's, Kul'bin's and Kandinsky's scientific-mystical interpretation of the world and coincides with Markov's and Larionov's concentration on the painting as a made object. Burlyuk called for the artist to select freely and arrange elements – according to his 'soul and unsullied by experience or schools'[27] – in a clear echo of the abstractionist tendencies of his colleagues. He described an apparently non-mimetic art (the only model to be used was that of primitive art), yet, as for most of the Russian avant-garde, his study of the process of making the object that is his painting, also involved a vaguely expressed broadening of man's visual sensation of nature.[28]

Determining the extent of Burlyuk's knowledge of Cubism is difficult, given the limitations of the reports about his lecture. Certainly he knew more than Benois gave him credit for: 'promising to acquaint the Petersburg public with the tenets of Cubism, he only succeeded in eloquently proving that he has understood nothing of Cubism himself and that he has no right to represent the interests of Cubism in Russia'.[29] His 1912 trip to Europe, which included a stay in Paris, had occurred when Cubist ideas were being intensely discussed among artistic circles and in the **139**

press.[30] Indeed, he may have arrived in time to see the *Salon des Indépendants*, since it apparently only closed on 27 May 1912.[31] Thus, even if Burlyuk did not get to see the latest work of Picasso or Braque, he could have become aware of the ideas of the construction of a painting in terms of a linear grid, multiple viewpoints and the fragmentation of the objects into planes and their fusion, in the work of Le Fauconnier, Delaunay, Léger, Gleizes or Metzinger.

Burlyuk's grappling with the definition and meaning of Cubism was undoubtedly hindered by two major factors. First, the itinerary and speed of his European trip gave him little time to absorb the latest developments properly. Second, Cubism could still not be identified as a homogeneous movement based on definite principles.[32] Burlyuk's interpretation extrapolated various elements, such as the diminishing part played by natural appearances, the intellectual or conceptual approach leading to a selection of simple geometric forms, and the virtual denial of the subject. Even so, his demand that the artist 'proceed from a special study of the world' and a 'feeling of beauty that is… mysterious'[33] outlines a subjective approach in which the object still exists. Such ideas appear to coincide primarily with those expressed by Gleizes and Metzinger in *Du Cubisme* (1912): 'painting is… the art of… giving a pictorial expression to our intuitions… we must admit that reminiscences of natural forms cannot be absolutely banished'.[34]

To a limited extent, this combination of expressive, plastic and formal tenets, so typical of the Russian avant-garde, found expression in Burlyuk's art as well (see below). His limitations were reflected in his ability to digest the art of the recent past without truly being able to look forward and use those forms in an innovative way. His part was that of a propagator, rather than instigator, of revolutionary ideas, without a vision of where they could lead.

Mayakovsky followed Burlyuk at the Troitskii Theatre with 'The Newest Russian Poetry', a talk in which he discussed poetry and art in almost identical terms to Burlyuk's. He mocked the narrative nature of poetry and the fear of individualism. He called for a free poetry based on myth, impulse and the rebirth of the primeval role of the word. Closer to Markov than Burlyuk, he echoed Worringer's division of the world of art and life into two separate realms. The first was that of direct intuition, the second of mathematical logic.[35] The distinctive character of Mayakovsky's speech lay in its shocking terms. Thus he proclaimed that in painting it was necessary to be like a 'cobbler' and that the 'word demands spermitization'.[36] Here, rather than in any depth of theory, was the verve of the new wave. It was expressed most forcefully, and presaged, more than Burlyuk's ramblings, the next stage in Russian art. The analogous path for the modern arts seen by Mayakovsky was soon to be expressed in the Union of Youth's union with Hylaea.

### The 'Cubist' and 'Futurist' Show 4 December – 10 January 1912/13

The Union of Youth's sixth exhibition opened on 4 December 1912 at 73, Nevskii Prospekt. Here early Russian experiments in Cubism and Futurism, and Larionov's Rayism, were shown to the Petersburg public for the first time, uniting with the persistent primitivism and symbolism of previous exhibitions. The press was almost universal in its criticism: the show was not to be taken seriously, but should be regarded as somewhere bright, colourful and humorous to go on a grey winter's day in Petersburg.[37] Benois, the object of Burlyuk's scorn, was one of the few critics to try to find meaning in the work, and to welcome the search for novelty with discerning, if patronising, judgement. He summed up his overall impression of the exhibition: 'it is small, and cramped in a humble apartment but it makes up for it with full passion, self-assertion and daring rushes at innovation "at all costs"'.[38]

Exhibits numbered only just over one hundred. The catalogue named twenty-two exhibitors, eight of whom were from Moscow. The latter were not separated in the catalogue or the show. Although Markov and Bubnova were again absent, the founding members Matyushin (who had rejoined the group in November 1912), Mostova and Voinov showed with the Union of Youth for the first time, and Baller and the Burlyuk brothers returned. The Donkey's Tail was represented by Larionov, Goncharova, Malevich, Tatlin and Shevchenko. Of the regular contributors only Filonov, Zel'manova and L'vov failed to show works.[39] During its six weeks the exhibition attracted more than 6000 visitors and numerous works were sold – including those by Rozanova (Plate 15), Malevich, Shkol'nik, Shleifer and Potipaka.[40] This success led to a proposal for the show to travel to Helsingfors (Helsinki), though there is no evidence that this happened.[41]

Benois divided the exhibitors into three: those who practise Cubism and 'with all their strength try to be angular, decisive in their "leit-lines" and distinctive in those geometric bodies to which they reduce the visible world'; those who practise 'greater colourism and floridity, their ideals being Matisse, Cézanne or Gauguin'; and those who 'follow Stelletskii and even... glance at the reminiscences of Dobuzhinskii'.[42] Most Union of Youth members belonged to the second and third categories. For example, Nagubnikov, in keeping with his earlier exhibits, showed three 'attractive' still-lifes (one a bouquet of roses) in which he displayed his 'love for Paul Cézanne'.[43] Also, Potipaka, who earlier in the year had been compared to Stelletskii and Vrubel, retained his stylisation, combining symbolism (*Angels, My Dream* and *Lyric Poetry*) with decoration (e.g. *Motif of a Tapestry*) and Eastern themes (*From Memories about Siberia, Something Eastern*). Shuiskii outlined the formal qualities of his work:

**141**

P. Potipaka presents himself as the most serious and promising participant in the show. I speak only of the sketch *Women* (No. 58). Here there is linear ability and interesting, though far from balanced or harmonic, colour. His other works are less distinctive: there is something from Rerikh, some deliberate stylisation taken from the *lubok*, everything, but no artist.[44]

Shleifer and Shkol'nik were colourists. On this occasion it was Shkol'nik, exhibiting seventeen works (far more than any other participant), who attracted most attention. The reviews do not indicate any striking new developments, although the effect of having a hall to himself, together with the unified character of the canvases, provoked greater appreciation. Benois found him, with his 'attractive series of paintings... apparently pretending to the still vacant and most honourable place of "the Petersburg Matisse"'.[45] In fact, his work was dominated by colourful studies of flowers. Only a series of four pictures, depicting the seasons of summer and autumn, and *Twilight* (familiar themes for Shkol'nik since 1908), appear to have had other subjects. This concentration on exploring the compositional possibilities of a single subject attained highly decorative results:

14  O. Rozanova, *Seated Lady*

The last room where the colourful sketches and studies of I. Shkol'nik are hung – the flower beds, flowers, sunflowers, cannas and nasturtiums, and still lifes – is very bright and joyous. Everything is expressed in bright colour combinations with dominating patches of blue, orange, red and yellow. Only the sharp accentuation of the angular design is excessive, to the extent that it damages the generally beautiful impression of his canvases.[46]

Shkol'nik's choice of flowers is indicative of his study of colour and form: tropical cannas, with their irregular shape and bright yellows and reds, sunflowers, Michaelmas daisies and nasturtiums are all marked by extremely varied forms and exotic colours

It is possible that Shkol'nik may have employed cylindrical, metallic-coloured forms similar to those Malevich now borrowed from Léger (see below), as one critic noted his use of 'thick honey, copper-pipe colours'.[47] More certain is the lack of modelling and perspective similar to Goncharova's *Harvest* series (1911) and derived from Matisse in *Harmony in Red*. This is most evident in *Still-Life with Vases* (Russian Museum) where Shkol'nik concentrates on the use of colour. The composition is divided between those flat elements 'floating' on the surface (two vases with flowers and a bowl with three green pears), and those behind (drapery and a black lacquered tray – a Russian folk source for Neo-Primitivist technique). Pictorial space is flattened and patterned, setting up a tense equilibrium between the horizontal and vertical planes. A black tablecloth and lilac-pink drapery combine with a patterned wall in one vivid surface of colour. However, the overlap and intersection of forms, such as the drapery covering the bottom edge of the tray, create spatial ambiguity and recall paper collage. The work, with its deliberate artificiality, is a play of 'minor' colour tones – violet, orange, lilac-pink, and pale green. These combine with the varied shapes and patterns of the still-life to make it a highly ornamental work.

In late 1912, Shkol'nik was closer than any other Union of Youth member to Rozanova.[48] She, exhibiting more works than on any previous occasion (eleven canvases), displayed still-lifes, urban landscapes and a portrait. The overriding character of these was Fauvist. *Portrait of Alevtina Rozanova* (cat. 73, Sverdlovsk Art Museum, Plate 15 ) serves to elucidate her approach and study of *faktura*.[49] The flattened, schematic rendition of the model, *chaise-longue* and flowers, with its bold outline combines with some spatial ambiguity to indicate the limited extent of Rozanova's departure from convention. However, the portrait bears intriguing relations with a lithograph (Plate 14). While the figure reclines in the same position, wearing a similar hat and dress, this should not be taken for a study for the portrait. On the contrary, it may have been the painting that served as the study. In the lithograph the figurative components are reduced to bold strokes of broken black line. There is no attempt at modelling or descrip-

tion. Only the minimum of outline remains to hint at visual appearances. By comparison with the lithograph and the 1913 series to which it belongs (which indicated a new analysis of constructive elements), in late 1912 Rozanova's concentration on abstract principles in art appears little developed.

Matyushin contributed four landscapes and *Sculpture of Knotted Wood (Composition)*. In his unpublished autobiography, he noted that the sculpture was made from a root and that it 'revealed the idea of movement'.[50] Photographs of his root sculptures show little thin and delicate, twisted figures, stretching in contorted movement that is at once human and organically natural.[51] Most of these are reminiscent of extended and emaciated human torsos and limbs. Matyushin allows the shapes of the root to dictate the dynamic of the composition. Thus, rather than copying visual nature Matyushin presented natural forms in such a way as to express nature's underlying rhythms. The use of the root was ideal for this – its growth, largely underground, goes on continually and yet invisibly. As such, it is symbolic of the universal movement in nature.

Matyushin believed, like Kul'bin, that such movement, subject as it is to natural laws, was scientifically established and consequently perceivable by analysis. Accordingly, he sought to determine the unison of outer form and inner structure in a single tensile work. Such an exploration of the substance of matter used nature not only as 'the departure point for art', but also as the essence of art. His concentration on observation of nature led him to the belief that human perception, i.e. visual apprehension of reality, could be extended. He felt able to perceive the universal motion. Thus, like many others associated with the Union of Youth (the Burlyuks, Markov, Larionov, Spandikov and later Malevich), he sought a heightened awareness for the artist in order to express a perceived essence. The root sculpture and, no doubt, the landscapes were the expression of such a broadened perception. Although the exact identity of the landscapes he showed is impossible to ascertain, Shuiskii noted: 'M. Matyushin, with his landscapes (especially cat. 44 and 47) in gentle feminine colours, should be singled out from all the exhibitors.'[52] Elsewhere he described them as 'ingenuous'.[53] During 1911 and 1912 Matyushin created many tempera studies of the shore of the Gulf of Finland and the trees that surround that shore. *The Sea* (Russian Museum), for example, is as an abstract study of the shoreline. Dominated by gently curving horizontal lines, the composition is comprised of pale blues and greens, and soft yellows and creams. Similarly, *Two Pines* (Russian Museum), with trunks depicted close to the picture surface and neither treetop nor root, is a study of the curved lines and planes of nature. Through these lines nature reveals its true essence. Matyushin thus brings the Russian avant-garde back to the lessons of Monet's Impressionism. Here the high horizon leads to a pale sky. Below is the sea divided from the land by another horizontal – a pale green line.

144

### Выставка „Союза молодежи" („Кубистовъ") въ Петербургѣ.

Со снимковъ по порученію «Огонька» К. К. Булла.

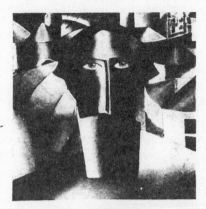

К. С. Малевичъ.—«Портретъ Ивана Васильевича Клюнкова».

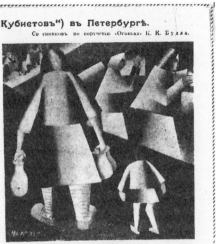

К. С. Малевичъ.—«Въ полѣ».

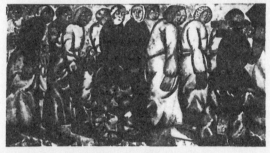

К. С. Малевичъ.—«Крестьянскія похороны».

Э. К. Спандиковъ.—«Дама съ гитарой».

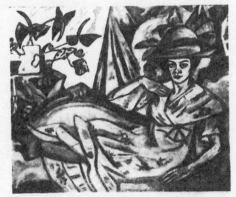

С. В. Розанова.—«Портретъ А. В. Розановой».

15 'Vystavka "Soyuza molodezhi" ("Kubistov") v Peterburge', *Ogonek,* 6 January 1913. From top left: K. Malevich, *Portrait of Ivan Vasil'evich Klyunkov, In the Fields, Peasant Funeral*; E. Spandikov, *Lady with Guitar*; O. Rozanova, *Portrait of Alevtina Rozanova.*

The tree trunks are heavy verticals that change from reddish blue to brown. Such works, as representations of organic life, anticipate Matyushin's theory of spatial realism, based on a perception of the world transformed by persistent observation and analysis.[54]

## The Muscovites

At the sixth exhibition, perhaps more than any other, the Union of Youth members were distinguishable from their Moscow colleagues. The distinction was based upon a shift in artistic values seen in the Muscovites' contributions. However, this did not affect all of the exhibitors, nor by any means the majority of works. Indeed, as previously, the mood was primarily Neo-Primitivist. The only exceptions were a few works by Malevich, Goncharova, Larionov and the Burlyuks. This, though, was enough to mark the start of a new stage that was to alter profoundly the appearance of the Union of Youth for the final year of its existence.

David Burlyuk's four contributions received much attention in the press, if primarily for their titles: *Moments of the Decomposition of a Plane with Elements of Wind and Evening introduced into a Maritime Landscape (Odessa) represented from Four Points of View; 'Young Lady', Free Drawing (Colour Instrumentation: Colour Hyperbolism); 'Portrait of a Student' (Turkish Style, Colour Hyperbolism); and Leit-Line conceived according to the Assyrian Method and the Principle of Flowing Colouring.* The pretentiousness of such titles, similar to ones used earlier in the year at the Knave of Diamonds show, was deliberate. According to Livshits, Burlyuk's intention was to shock the public and scoff at the pomposity of European scientific jargon for which there was no Russian equivalent.[55] Nevertheless, the use of these terms to express simple concepts was related to Burlyuk's new concentration on, and analysis of, the formal qualities of painting.

Unfortunately, despite the attention the paintings attracted, few critics took them seriously, and most ignored their content and structure. One critic noted the mocking use of words ('Bottom of the painting'), near the 'lower' edge of one work.[56] Lazarevskii claimed that 'some kind of small insect' is represented 'against a background of frenzied coloured ravings'[57] in *Leit-Line* (cat. 10). Mirskii described a combination of arbitrary elements that suggests a relationship with Malevich's ensuing trans-rationalism: 'A circle, two little sticks, one eye, two squares and a moustache'.[58] If the composition related to the caricature that accompanied Mirskii's article it consisted of abstract intersecting geometrical figures (triangles). The realistic elements of the moustache and eye act as a counterpoint to the decomposition of forms, but the overall impression is one of movement. Such a defraction of compositional elements is opposed to Cubism's retention of the subject as the point of pictorial construction despite its fragmentation.

146

Similarly, *Maritime Landscape* (cat. 7), which Benois described as 'pseudo-Cubist nonsense',[59] appears to have been at once a play with the geometric forms and multiple viewpoint of Cubism and an alogical composition of a variety of visually-perceived elements.[60] From one angle there appears a yacht comprised of simple planes in the bottom left corner and triangular sail-like drapery with shaded creases dominating the right side. Turned clockwise through ninety degrees, there appears at the bottom, apparently bent against the wind, the primitive figure of an orthodox Jew – a symbol for the large Jewish population of Odessa. Thus the 'elements of wind and evening introduced into a maritime landscape (Odessa)' are identifiable. A further ninety degrees and walls and roofs become recognisable. Other objects include feather-like squirls and facetted blocks. This conglomeration, apparently created with all the colours of the palette,[61] creates an impression of chaotic disorder. The ambiguous concoction of representation and abstraction, three-dimensional and two-dimensional space, with its collage-like effect, is indicative that Burlyuk was toying with the *faktura* of painting rather than analysing the broadened vision of man. It is not a Cubist work, since the disparate subject is not an object fragmented into planes and constructed on the basis of a linear grid. In addition, the movement is not round the subject but with it. In this sense the work appears closer to Futurist principles in the depiction of a temporal space.

Vladimir Burlyuk's work was hung with his brother's at one end of the exhibition premises and this contributed to the critics' confusion of the two. Like David, Vladimir's work appears not to have been new: two of his three exhibits, *Geotropism* and *Portrait of the Poet Benedikt Livshits*, had previously been shown at the Knave of Diamonds exhibition in January. The third, *Portrait of Nikolai Burlyuk* (cat. 6), contained formal elements similar to the first two: '[Burlyuk] tries to pass off as a portrait of his brother a brightly coloured icositetrahedron.'[62] The critic S. P-n. described the gravitational movement of *Geotropism* (cat. 4), represented by 'wedge-shaped dull coloured shards', as follows:

> The vertical line does not have direction but one could draw on one end a sharp arrow-shape and on the other a plume and no-one would doubt where the arrow was flying to. In the same way the black colour is heavier than the light. Consequently, with the general pointedness of the lines directed towards earth and the general colour weight – in a word with means of universal conventionality, that is with generally recognised symbolism, it is possible to attain on the canvas a definite directed movement of line and colour. The whole canvas appears to turn into an index finger.[63]

Thus the composition fails to question man's conventional conception of geotropic motion and space. Still, *Geotropism* coincides with the current of new ideas concerning the nature of space then circulating among Burlyuk's  **147**

colleagues. The work used flat abstract colour forms to depict a concept of movement, without reference to any conventionally representative form. Space thereby becomes real and tangible. As such, it bears relation to the Italian Futurists' desire to depict motion. Although not concerned with the exploration of new dimensions, Burlyuk's subject has become objectless spatial motion, and his embodiment of this in painterly form was new.

Rayist painting was seen in Petersburg for the first time at this show. On 20 September 1912 Larionov had written to Zheverzheev offering an independent Donkey's Tail exhibition in Petersburg and, coincidentally, 'an article on Rayism – a new trend in painting founded by me', for the next edition of the group's journal.[64] Neither offer materialised. Instead, Larionov, Goncharova, Tatlin, Malevich and Shevchenko were included in the Union of Youth's show.

Shevchenko and Tatlin had changed only subtly from their previous appearances. The three works by Shevchenko (*Sleeping Man, Boy* and *Urban and Suburban Carriage Park*) continued his decorative study of primitive forms, though with increasing Cubist facetting of geometricised planes. Tatlin's eight works again focused on maritime subjects with curvilinear forms. His well-known *Sailor* (cat. 84, Russian Museum), shown for the first time, continued his earlier calligraphic examination of pictorial construction with an emphatic highlighting that confirms his study of icon painting.

Malevich, like Tatlin, exhibited at the 'Modern Painting' exhibition which opened on 27 December 1912 in Moscow. His works there and at the Union of Youth had similar titles, motifs and pictorial solutions (e.g. *The Mower, In the Fields, Harvest*). Also like Tatlin, he remained attached to a figurative art, utilising icon techniques and format. However, Malevich preferred rural scenes to maritime ones, and his constructive form was marked by its straight contours and illusion of volume. He exhibited six paintings and six sketches. *Harvest* and *Peasant Funeral* (Plate 15), already seen at the Donkey's Tail, retained the vulgarised, heavily delineated forms of his 'orthodox' Neo-Primitivism.[65] Elsewhere the use of the peasant motif continued, but the concentration on pictorial device which Neo-Primitivism had introduced was now radically altered. Glagol' described the change:

> Malevich's compositions from pieces of tin canisters are worthy of the public's attention… If you want to be a Cubist then take a few dozen Gromov herring tins, painted in the colours of the rainbow, and make from them an image of some human figures, mowers, reapers, etc. Then copy them all onto the canvas.[66]

*In the Fields* (cat.35, Plate 14), like the similar *Taking in the Rye* (Stedelijk Museum, Amsterdam) shown at the concurrent 'Modern Painting' exhibition, was almost certainly painted in the summer/autumn of 1912.[67] This gave Malevich time to absorb and interpret, without accusa-

tions of pastiche, the French work he had seen at the second Knave of Diamonds show, and in particular Le Fauconnier's sketch to *Abundance* and Léger's *Essay for Three Portraits*.[68] He uses conical and tubular forms, derived from Léger, to provide a dense but shallow picture space and construct the figures. The material is disguised by metallic tones created by shifting gradations of colour within a plane. Outline is now all but the edge of a volume. The world is dehumanised to an even greater degree than the earlier primitivist works. This is attained by the implantation of the material of the industrial, modern world on a rural subject. Though this is also the case with *Portrait of Ivan Vasil'evich Klyunkov* (cat. 36, Plate 15), the cylindrical forms of the background showing stylised houses and fields on a curved plane, the icon-like simplicity of the face and the iconic object in the top right corner, ensure that the observer does not feel such a sense of detachment or dehumanisation. Further, this indicates that Malevich still persisted in imparting an essential social and spiritual sense to his 1912 works.

Malevich's selection, like that at 'Modern Painting', reflected the development in his work during 1912. Much confusion has recently existed over the exact dating of many of his works, and consequently a number of both Cubo-Futurist works and works from the later peasant series, have been attributed earlier dates than they should.[69] In late 1912 Malevich was working almost exclusively in the style seen in *In the Fields*. That is he was revising and rejecting earlier primitivist experiments without yet developing the examination of space through facetted form seen in his Cubo-Futurist work. There exists no evidence that this later style was created prior to mid-1913.

Goncharova's six works (including two fragments of her 'Grape Harvest' series (*The Bull* and *Wine Drinkers*) and *The Woodcutters*) also remained predominantly Neo-Primitivist. The only example of a new style was a single Rayist work, *City at Night* (cat. 16) which was described as similar to Larionov's *Rayist Sausage and Mackerel* 'but more interesting in its graphic decorativeness and coloring'.[70] Here, Goncharova depicted a confused conglomeration of windows, walls and roofs, lacking all sense of monumentality and   occasionally interspersed by fine rays. The latter remain small and of little pictorial significance. The chaotic order of the objects and their fragmentation shows a new awareness of both Delaunay (his 1911 *City* series, for example) and of the Italian Futurists. Indeed, Delaunay's *Cities*, which become increasingly abstract and difficult to read, have a sense of light and movement similar to Goncharova, and are likewise composed of a series of small, flat or tilted, interlocking planes.

Shuiskii sensed that Goncharova's work was closer to Larionov's than previously.[71] This was indicative of their intensified collaboration in 1912. At this time Goncharova moved away from an overtly decorative primitivism towards the disintegration of forms. This move towards an art that was **149**

primarily concerned to express immaterial objects in space deprived the artists of their distinctly non-European subjects. Even so, Rayism was an early embodiment of the trend in Russia to discern and express the intangible in nature, though it now added a scientific emphasis. As such it predates Malevich's and Tatlin's exploration of the nature of space, though these two artists had already shown that besides their concern with the material quality of painting, they were interested in the painting of the immaterial. Furthermore, despite the extremity of its pictorial solution, Rayism does have factors in common with primitivism.

The first Rayist works exhibited were Larionov's *Glass (Rayist Method)* and *Rayist Study*, shown at the World of Art's Moscow autumn exhibition.[72] This exhibition opened on 13 November 1912, three weeks earlier than the Union of Youth. At the latter Larionov's seven exhibits revealed the climax of his primitivism and the introduction of Rayism. Both styles showed a snubbing of both pictorial and social convention. This lack of convention identifies a similar concern – to establish new laws for painting. *Spring* (cat. 22, Tretyakov Gallery), from a series of primitivist works depicting the seasons, shows a flat, childishly deformed head and shoulders of a naked hermaphroditic prostitute. As in previous work a pig strolls across the background, though here its eye is huge and lozenge-shaped. Uneven writing of 'Spring 1912' across the canvas is indicative, like David Burlyuk's 'Bottom of the painting' and Malevich's 'Argentine Polka', of a desire to incorporate extraneous literary elements into the content.

Larionov's Rayism marked a move to the representation of objectless reality. Although he eventually expounded his theory in the booklet *Rayism* [*Luchizm*], published in April 1913 (and in subsequent articles), earlier conceptions of what the style meant to him are more persuasive as appropriate to the art exhibited at the end of 1912. In October 1912, having interviewed Larionov on his new painting, the critic V. Mak reported: 'Rayism... is to generalise everything on one plane... As in Cubism objects are broken down into planes, in Rayism they are turned into a play of lines. The Rayist painting is an infinite series of coloured stripes and rays from which form dimly and gradually arises.'[73] Such a description makes Rayism an art of realism. Larionov, clearly influenced by the Italian Futurists' 'force-lines', tried to differentiate his forms in space from the temporal forms of the Futurists, claiming that Rayism was indigenous to Russia.

Mak described four works completed by October 1912, two of which, the landscape (cat. 23) and *Portrait of a Fool* (cat. 21), were exhibited at the Union's show:

> The Rayist landscape: all the trees stretch to the sun and the sun to them, from the roofs of the houses come light rays, the tops of the bushes burn like flares, everything is radiant and shines in a play of light. The triptych entitled *Farm* is

curious… The first canvas is a straw-chewing *Portrait of a Bull*, despite the fact that the bull closely resembles a thoughtful man with a yellow face and yellow moustache; the second is *Portrait of a Fool* and in it nothing is possible to make out despite the artist's explanation; the third part is called *Cocks and Hens* and is comprised of a very beautiful combination of yellow and red colours. The first impression is one of chaos but look attentively and you see how, from the light that emanates from the haze, in the changing colours of the radiant surfaces of the lines, there arises in this canvas the fantastic spectre of a gigantic gleaming bird.[74]

In three of the four works described some semblance of the visual appearance of the object survived. In an interview published in January 1913, Larionov spoke of his new style as that of the sum of impressions possible from a given object.[75] Using the optical theory that claims that all we see is light rays either direct from their source or reflected by the edges of the objects they strike, Larionov stated that he sought to paint the web of intersecting and interweaving rays that thereby existed. Nature could thus be represented more fully than previously: 'By using the principles of Rayism I can attain a universality in the representation of this or that object'.

Larionov gave the artist a new visual form to depict. In his notes for a lecture on Rayism that he intended to give for the Union of Youth in March 1913, he wrote of the 'denial of form as existing for painting besides the image in the eye'.[76] Furthermore, in his article 'Rayist Painting', he noted a debt to Cézanne whose *passage* between planes occurred because he possessed the 'keenness of sight… to notice the reflex rubbing, as it were, of a small part of one object against the reflected rays of another'.[77] Larionov's form was spatial, arising from the intersection of rays selected according to the artist's will. It could be the 'representation of all previously existing forms… the expression of sensation and the extratemporal',[78] and hence it gained a spiritual quality that Larionov likened to the fourth dimension. He preferred not to elaborate on this, however, perhaps fearing to fall into the traps of symbolism and mysticism, while attempting to keep his theory, with its scientific basis, purely formal and relative to painting.

*Portrait of a Fool* (Tserchinsky Collection, Paris) shows Rayism as a mass of coloured lines filling the picture surface without dissecting it. These virtually obliterate the references to a face which appear to underlie them. All attempt to express volume is neglected. The geometric principles employed by Malevich are denied, although the lines remain straight, and apparently revolving, in a plethora of triangles around a central axis. Objects are more readily perceptible in *Rayist Sausage and Mackerel* (cat. 26, Ludwig Collection, Cologne), which, despite its tangle of intersecting colour lines, belongs to Larionov's 'realist Rayism'. In the midst of the lines are several blue mackerel fish, lying parallel in an orange-brown tin in the centre of the canvas. To the left and right of them, at a variety of angles, are the cut forms of the sausage. These objects give the work a shallow

depth. Here, the significance of the coloured lines and painterly texture, counterpointed by the figurative objects, is more evident. These were the fundamental painterly laws to which Larionov tried to adhere in Rayism, and as such are close to Tatlin's evocation of the essential expressive means in his fishermen series. Indeed, Larionov's formless *Portrait of a Fool* almost echoes, despite its lack of curves, Tatlin's circular rhythms.

Evidently, the Union of Youth's sixth exhibition marked a turning point in the group's history, as the Muscovites, while still reliant on primitivist techniques and motifs, introduced new principles of pictorial composition, derived from a knowledge of Cubist and Futurist developments, but marked by distinct qualities (for example, Malevich's, Goncharova's and Tatlin's use of the icon and peasant themes, and Larionov's specific notion of rays), that set them apart from the West Europeans. The style of the Petersburg members appears to have become more decorative, but with only seven of the fourteen artists exhibiting more than three works, any underlying shift in values and styles is difficult to substantiate. However, Rozanova's new prominence, with a series of Fauvist landscapes and still-lifes, combined with similar interests seen in Shkol'nik's and Shleifer's work to indicate a new concentration on colour and space.

## References

1 Markov [V. Matvejs], letter to Zheverzheev, (undated), TsGALI, Fond 769, op. 1, ed. khr. 438, l. 1. Due to the closure of the Union of Youth in early 1914, the proposed exhibitions did not have a chance to take place.

2 The Bakhrushin Central State Theatrical Museum, Moscow, Fond 99, op. 1, ed. khr. 59, l. 1. Enigmatically, Markov ends his letter: 'It is a pity Gaush isn't here, otherwise I'd have got him enthusing, just like I enticed Shchukin.'

3 Concerning Markov's invitation to Marc, see Marc letter to Markov, 3 August 1912, Russian Museum, Fond 121, op. 1, ed. khr. 42. Concerning Markov's correspondence with Kandinsky, including mention of Picasso, African art and a book on Cubism ('It should be published in Paris this summer'), see Kandinsky letter to Markov, 29 July 1912, Russian Museum, Fond 121, op. 1, ed. khr. 31, cited in E. Kovtun, 'V. Markov i otrkytie afrikanskogo iskusstva', *Pamyatniki kul'tury. Novye otkrytiya 1980*, 1981, pp. 413–14. The book referred to is almost certainly Gleizes and Metzinger's *Du Cubisme*, as this had been advertised as appearing in March 1912, though in fact it was only published in the second half of the year (see E. Fry, *Cubism*, London, 1978, pp. 111 and 196).

4 See, for example, [anon.] 'Vystavka Soyuza molodezhi ('Kubistov') v Peterburge', *Ogonek*, 6 January 1913, unpaginated. Boris Mirskii, 'Veselaya vystavka', *Sinii zhurnal*', 4 January 1913, p. 7 (among others), referred to it as 'Futurist'.

5 See, C. Douglas, *Swans of Other Worlds*, pp. 20 and 89.

6 Cited in Khardzhiev, *K istorii*, p. 13.

7 Burlyuk, 'V zashchitu iskusstva!!!', Russian Museum, Fond 121, op. 1, ed. khr. 13, l. 9–10.

8 *Ibid*. He also noted that he would leave Moscow on 15 November and that Mayakovsky had just left for Petersburg where he was to stay with Nikolai Burlyuk.

9 Z., 'Konflikt poetov v Brodyachei sobake', *Obozrenie teatrov*, 19 November 1912. This amalgamation bore first fruit in Union of Youth, No. 3, in which the new group Hylaea participated.

10 Cited in Khardzhiev, *K istorii*, p. 14.
11 V. Mayakovskii, 'O noveishei russkoi poezii', Russian Museum, Fond 121, op. 1, ed. khr. 13, l. 12.
12 *Ibid.*
13 The slides included works by Raphael, Courbet, Monet, Cézanne, Matisse, Gauguin, Van Gogh, Léger, Picasso, Rousseau, Larionov, Mashkov, Lentulov, Konchalovskii and Kandinsky.
14 See *Rech'*, 4 December 1912, p. 6.
15 Khardzhiev, *K istorii*, p. 13. It is curious that Burlyuk refers to 'French' rather than 'Italian' Futurists. However, his list of slides does not include any Italian Futurists, and he may have originally thought to discuss the works of Léger and Delaunay with reference to Futurism.
16 See N. Shebuev, 'Kubisty. Novyya veyaniya v zhivopisi', *Solntse rossii*, June 1912, pp. 10–11. See also, [anon.] 'Khudozhniki futuristov', *Ves' mir*, May 1912, p. 30; Vip., 'Na vystavke futuristov (Pis'mo iz Bryussele), *Moskovskaya gazeta*, 28 May 1912, p. 2; A. Koiranskii, 'Itogi futurizma', *Obozrenie teatrov*, 4 August 1912, pp. 8–9; and N. N., 'Futuristy', *Voskresnaya vechernyaya gazeta*, 26 August 1912, p. 4. There was also talk about Petersburg Futurists – e.g. I. Yasinskii, 'Zhivopis' budushchago (O poyavlenie Peterburgskikh futuristov)', *Rech'*, 18 August 1912, pp. 3–4.
17 See the declaration, signed by Burlyuk, Kruchenykh, Mayakovsky and Khlebnikov, *Poshchechina obshchestvennomu vkusu*, Moscow, 1913, pp. 3–4 and dated December 1912. See also Burlyuk's articles 'Kubizm' and 'Faktura', *ibid.*, pp. 95–101 and 102–10.
18 Lazarevskii, 'Disput o kubizme', *Vechernee vremya*, 21 November 1912, p. 3.
19 A. Rostislavov, 'Vecher Soyuza molodezhi', *Rech'*, 23 November, p. 5.
20 He published this in 'Faktura', *Poshchechina*.
21 Larionov exhibited two still-lifes (from 1909–10) that were marked as 'major' and 'minor' at his one-day exhibition on 8 December 1911. These musical terms may have been used to signify colour combinations based on primary and non-primary colours.
22 See Burlyuk, 'Chto takoe Kubizm', Russian Museum Fond, op. 1, ed. khr. 13, l. 7–8, 11–12.
23 A. Rostislavov, 'O vecher khudozhestvenno-artisticheskaya assotsiatsiya', *Rech'*, 14 December 1912, p. 7.
24 See Lazarevskii, for example, 'Disput o kubizme'.
25 Burlyuk, 'Chto takoe Kubizm'.
26 Rostislavov, 'Vecher Soyuza molodezhi'.
27 Rostislavov, 'O vecher assotsiatsiya'.
28 Burlyuk talked of the broadening of man's visual sensation of nature in 'Kubizm', *Poschechina*, p. 97.
29 A. Benois, 'Kubizm ili kukishizm', *Rech'*, 23 November 1912, p. 3.
30 Concerning articles on Cubist painting published at this time, see Fry, *Cubism*, p. 178 and J. Golding, *Cubism: A History and an Analysis 1907–1914*, London, 1988, p. 17. In March an article on Cubism, sent from Paris, and which paid special attention to Gleizes' work, was published in Petersburg: E. Dmitriev, 'Chto takoe kubizm', *Birzhevye vedomosti*, No.12834, 13 March 1912, p. 6.
31 See D. Gordon, *Modern Art Exhibitions*, I, Munich, 1974, p. 87.
32 Concerning the separation of Picasso and Braque from the other Cubists, as well as Delaunay's development of Orphism, see Golding, *Cubism: A History*, pp. 9-21.
33 Rostislavov, 'Vecher Soyuza molodezhi', and see Burlyuk, 'Kubizm'.
34 A. Gleizes and J. Metzinger, *Du Cubisme*, Paris, 1912, pp. 9 and 17. Translated by Golding in *Cubism: A History*, p. 18.
35 See Mayakovskii, 'O noveishei russkoi poezii'.
36 Khardzhiev, *K istorii*, p. 15.
37 See, for example, I. Yasinskii, 'Veselaya vystavka', *Birzhevye vedomosti*, No.13287, 7 December 1912, p. 5.

38  A. Benois, 'Vystavka Soyuza molodezhi', *Rech'*, 21 December 1912, p. 3.

39  Filonov spent the second half of 1912 in Italy and France, having set off with 200 roubles gained from Zheverzheev's purchase of one of his Heads; L'vov transferred to the New Society of Artists' exhibition (January 1913) with his Siberian landscapes.

40  See *Russkaya molva*, 13 January 1913, p. 6.

41  See *Protiv techeniya*, 19 January 1913, p. 4.

42  Benois, 'Vystavka Soyuza molodezhi'. Dmitrii Semenovich Stelletskii (1875-1947), exhibited mainly with the New Society of Artists, Union of Russian Artists and World of Art. His work, like that of Rerikh and Bilibin, was heavily influenced by the study of ancient Russian art.

Of the minor contributors, Nadezhda Vladimirovna Lermontova (1885–1921), a student at the Zvantseva School, and Mostova attracted the attention of Benois. He claimed that Lermontova had all that her daring colleagues had *plus pompier* and described her *Workers* and *Study for a Portrait* as 'Cubist and classical'. On the other hand, he noted that Mostova, who was heavily influenced by Dobuzhinskii at this time, was making good use of colour but lacked graphic skills. Unfortunately, no description of Baller's work *Self-study, Grapes at the Market* and *Harvest*, Dydyshko's *Sketch for a Decorative Panel (Spain)*, Lyubavina's still-lifes or Voinov's *Portrait of A. P. Eisner* (plaster), *Portrait* and *Sketch*, survives. Likewise Spandikov's five untitled exhibits went unreviewed, although one was reproduced in *Ogonek* as *Lady with Guitar* (Plate 15). It depicted a stylised semi-nude figure in the centre of a flowing mass of dematerialised colour. It is also worth noting that Ivan Al'bertovich Puni (1894–1956), taking part in his first exhibition in Russia, showed *Breakfast*, which Matyushin described as 'a large... strong work – an expressive, volumetric and ponderous figure of a woman' (Khardzhiev, *K istorii*, p. 146).

43  Aleksandr A., 'Soyuz molodezhi', *Teatr*, 14 December 1912, p. 2.

44  B. Shuiskii, 'Soyuz molodezhi', *Den'*, 7 December 1912, p. 5. The *Ogonek* critic ('Vystavka') added that one of Potipaka's studies of *Women* (he showed two) depicted the figure against a plain green ground.

45  Benois, 'Vystavka Soyuza molodezhi'.

46  Aleksandr A., 'Soyuz molodezhi'.

47  S. P-n., 'Ne smeshnoe. Na vernissazhe vystavki Soyuza molodezhi', *Den'*, 10 December 1912, p. 5

48  *The Union of Youth*, No. 3, published the following March, not only featured Shkol'nik's and Rozanova's drawings together, but also announced that an almanac of their graphic work was to be published. This never occurred. However, from mid-1913 Rozanova began to illustrate Futurist booklets.

49  This oil is also known as *Portrait of A. Rozanova (Woman in a Pink Dress)* and *Lady in Conversation*. Alevtina Vladimirovna Rozanova was the artist's sister.

50  Matyushin, Unpublished Autobiography, 1920, TsGALI, Fond 134, ed. khr. 2, l. 23.

51  TsGALI, Fond 134, ed. khr. 2, l. 28 and 29. These were taken at the 1919 First State Free Exhibition of Works of Art.

52  Shuiskii, 'Soyuz molodezhi', *Den'*.

53  Shuiskii, 'Soyuz molodezhi', *Protiv techeniya*, 8 December 1912, p. 5.

54  Concerning Matyushin's subsequently published theory of 'SEE-KNOW' (Sight and cognition), in which vision could be extended first to 180°, then to 360°, see A. Povelikhina, 'Matyushin's Spatial System', *The Structurist*, Saskatoon, 1975–6, pp. 64–71.

55  B. Livshits, One and a Half-Eyed Archer, p. 63.

56  See S. P-n., 'Ne smeshnoe'.

57  [anon. (Lazarevskii)] 'Vystavka kartin soyuza molodezhi', *Vechernee vremya*, 5 December 1912, p. 3. Concerning Lazarevskii's authorship of this article, see *Vechernee vremya*, 11 December 1912, p. 4.

58  B. Mirskii, 'Veselaya Vystavka'.

59  Benois, 'Vystavka Soyuza molodezhi'.

60  The painting is taken to be that which Livshits calls *Landscape from 4 Points of View* (*One and a Half Eyed Archer*, p. 47).

61  See I. Yasinskii, 'Veselaya vystavka'.

62  Shuiskii, 'Soyuz molodezhi', *Den'*.

63  S. P-n., 'Ne smeshnoe'.

64  Cited in Khardzhiev, *K istorii*, p. 39.

65  See Benois, 'Vystavka Soyuza molodezhi'.

66  S. Glagol' [S. Gouloshev], 'Kartinnyya vystavki', *Stolichnaya molva*, 2 January 1913, p. 3.

67  See *ibid.* Malevich distributed his work carefully between the two exhibitions – showing the development of his Neo-Primitivism at both. At the Moscow show he displayed the earlier *Mower*, the stone *baba*-inspired *Woman with Buckets and a Child*, together with examples of his new style – *Reaper, Harvest* (now known as *Taking in the Rye*) and *Head of a Peasant* (the latter closely relating to his *Portrait of Ivan Klyunkov* – see below).

68  [anon.] 'Bubnovyi valet', *Stolichnaya molva*, 27 February 1912, provides another possible, and intriguing, source for Malevich's development in 1912. It states that 'a monograph about the Cubist painters and others, and reproductions of the pictures at the exhibition sold very briskly'. The book referred to is hard to identify since neither Gleizes and Metzinger, Salmon, or Apollinaire, had yet published their books on Cubism in France. Indeed, of these only Gleizes and Metzinger's book was written at this time.

69  This has occurred in, for example, E. Kovtun, 'The Beginning of Suprematism', *Von der Fläche zum Raum* [Exhibition Catalogue, Galerie Gmurzynska], Cologne, 1974, pp. 32–49; J. Bowlt, 'Malevich's journey into the non-objective world', *Art News*, New York, December 1973, pp. 16–22; E. Kovtun, 'Kazimir Malevich', Art Journal, Fall 1981; and D. Sarabianov, 'Kazimir Malevich and his Art 1900–30' in W. Beeren, J. Joosten (eds.), *Kazimir Malevich* [exhibition catalogue] Amsterdam, 1989, p. 68. The problem is discussed in C. Douglas, 'Malevich's Painting – Some Problems of Chronology', *Soviet Union*, No. 2, 1978, pp. 301–9.

70  Aleksandr A., 'Soyuz molodezhi'. For a reproduction of *City at Night*, see Eganbyuri, *Larionov and Goncharova,* Moscow, 1913.

71  Shuiskii, 'Soyuz molodezhi', *Den'*.

72  As with Malevich's work much confusion has recently existed over the first exhibiting of Larionov's Rayism (see Gray, *The Russian Experiment*; M. Dabrowski, 'The Formation and Development of Rayonism', *Art Journal*, Spring 1975, pp. 200–7, for example). A study of the relevant exhibition catalogues, contemporary reviews and interviews with Larionov, reveals that Rayism only appeared after the Donkey's Tail exhibition.

73  V. Mak., 'Luchizm', *Golos moskvy*, 14 October 1912, p. 5.

74  *Ibid.* The description of *Cock and Hens* fits with the *Cock (Rayist study)* (1912, Tretyakov Gallery).

75  F. M., 'Luchisty (v masterskoi Larionova i Goncharovoi)', *Moskovskaya gazeta*, 7 January 1913, p. 2.

76  M. Larionov, 'Doklad Larionova', Russian Museum, Fond 121, op. 1, ed. khr. 13, l. 2.

77  Larionov, 'Luchistaya Zhivopis'', *Oslinyi khvost i mishen*, p. 97.

78  M. Larionov, 'Doklad Larionova'.

# Act II Scene i,
# Becoming declamatory

The sixth Union of Youth exhibition closed on 10 January 1913. The same month a series of meetings took place, starting with a general meeting on 3 January to discuss membership.[1] Bubnova, Tatlin, Malevich, Morgunov, David Burlyuk and Matyushin were elected as official members, while Lermontova, Puni and Lyubavina failed to get the number of votes required. Such a procedure highlights an increased sense of direction (including a leaning towards the Moscow-based artists) and certain criteria for aesthetic judgement. A new committee of the Union of Youth was also elected (Shkol'nik, Zheverzheev, Matyushin, Baller and Rozanova).[2] It was further decided to send Spandikov, Rozanova, Potipaka, Matyushin, Shkol'nik and Nagubnikov to Moscow. Leaving on 11 January, they were to arrange a 'highly desirable' meeting with Target and the Knave of Diamonds.[3] The intention was to set up joint exhibitions in Moscow and Petersburg. Simultaneously it was announced that the Union of Youth's unifying ambitions went further: 'steps have already been made for an even broader union with Finnish and Swedish artists in order to arrange an exhibition of the new trends in Northern art'.[4]

Little was realised. The trip to Moscow went ahead but the results were inconclusive. At first, both Larionov and Burlyuk agreed to participate in a Union of Youth debate at the end of February.[5] However, Larionov remained uncommitted about a joint exhibition. He had so many independent plans that a union was not only unnecessary but, as far as most of the Target group were concerned, also unwelcome. Furthermore, the 'Union of Youth' representation at the Knave of Diamonds third exhibition, which opened on 7 February 1913, consisted solely of its new Moscow contingent, i.e. Burlyuk, Tatlin, Malevich and Morgunov. Thus the Union of Youth failed in their objectives of bringing together the groups representing the modern trends in Russia.

During late January and early February the committee turned its attention to arranging debates and publishing the third edition of its journal. By 5 February it was decided that the debates would concentrate on two themes – new literature and new art.[6] Matyushin now became one of the group's most active members again. Among his many activities he sought the publication of a separate translation of Gleizes and Metzinger's *Du*

*Cubisme* and was in contact with Larionov and Burlyuk concerning their appearances at the debates. But it was as editor of the independently published second edition *A Trap for Judges*[7] that he succeeded in bringing Burlyuk and Larionov together on a project for what was to be the last time. Larionov's worsening relations with Burlyuk, indicated in letters to Matyushin,[8] prevented all future mutual collaboration with the Union of Youth. However, early in February both were expected to appear at the group's debates, which were timetabled for 27 February and 1 March.[9] Thus, in an undated letter, probably of the second half of January, Larionov wrote to Matyushin about his participation in the 'New Russian Painting' evening, without mentioning any disagreement with Burlyuk:

> Yesterday Mayakovsky was here and asked me to send either you or Shkol'nik the programme of my lecture about Rayism. Apparently this is necessary for the city governor. I'm sending you this programme. Read it and please be kind enough to pass it on to Shkol'nik. It is a synopsis. Everything that is mentioned here I'd like you to print in full on the poster. Thus the public can be better informed and anyway the more detailed the programme the more attractive it is. The slides for the lantern I'll send later with the others, i.e. with Burlyuk and Mayakovsky, as they'll do as illustrations for the literary evening. Its very nice that *A Trap for Judges* will have a bigger format than before...'[10]

However, at the 7 February opening of the Knave of Diamonds exhibition, both Burlyuk and his brother Vladimir appeared with works whose pretentious titles bore open references to optics, multiple viewpoints and the 'movement of light masses and coloured shifts'. These had obvious Rayist connotations, so that Larionov would have been entitled to believe them a slap in his face. Indeed, the following day, quite possibly after having seen the exhibition or its catalogue, he wrote to Matyushin distancing himself from Burlyuk (and implicitly referring to the Moscow meeting of the artistic groups):

> Either I or someone else will read the lecture which I shall write in full and bring with me. There is no common ground between D. D. Burlyuk and me, and what D. D. has said will not be included, as Rayism is totally new and belongs to me alone at the moment. We can have a talk about the introduction but it seems to me it also contains no common ground with Burlyuk. Furthermore, I'd like to ask that my appearance be ascribed to the end of the last debate, so as to coincide with the order of developments and appearance of modern trends in art.[11]

This desire to distinguish himself from Burlyuk was undoubtedly a factor in Larionov's eventual non-participation in the debate. However, in mid-February he was still expected to appear and even after the debates were postponed until 23 and 24 March, Shkol'nik travelled to Moscow and apparently obtained his agreement to participate.[12] Yet in an undated letter to Matyushin (presumably written around the end of February) Larionov excused himself from the debate:

David Davidovich [Burlyuk] has told me that your debates have been postponed four weeks – I'll probably be in Moscow at that time as I expect to go to the south… In Moscow two debates are proposed with my participation, but I doubt that I'll appear – as I'm sick of all this, especially after the chewed straw of the Knave of Diamonds.[13]

In the event Larionov was in Moscow and did participate, indeed scandalously so, in the Target debate on 23 March, the same day as the Union of Youth's 'Modern Painting' debate.[14] The Target evening was entitled 'The East, National Character and the West', and besides gaining Larionov's lecture on Rayism from the Union of Youth, included talks from Il'ya Zdanevich on 'Marinetti's Futurism' and Shevchenko on 'Russian National Art'.[15]

At this time Larionov was busy arranging an exhibition of *lubki*, which opened in the second half of February, and Target's show, which was set to open on 24 March. After the postponement of the Union of Youth debate, Larionov's patience with the group seems to have snapped, and at last he began to adopt the policy of non-cooperation encouraged earlier by other members of Donkey's Tail. He wrote to Le-Dantyu expressing a dramatic change of mind and new attitude towards the Petersburg group:

I have declined from the debate and the lecture on Rayism, but I most humbly implore you to be at the debate and if discussion of this arises then let them at first talk about Rayism and then correct them as you see fit. Tell Il'ya Mikhailovich [Zdanevich]. He knows almost everything about Rayism, as I've explained it to him, and he can brilliantly formulate some idea… I shall never read my lecture for them. And hereby declare war. I most humbly ask you to start the action at the first Union of Youth debate.[16]

True to his word, Larionov never participated with the Union of Youth again – neither in debates or exhibitions; the letter signalled his final break with the group. It is not known whether Le-Dantyu was present at the Union of Youth debate since Rayism is not mentioned in the reports, suggesting that it was not discussed. However, soon afterwards Zdanevich was able to speak up for Larionov, and against the 'feeble attempts [at Futurism] of our home-grown Futurists, the authors of *A Slap in the Face of Public Taste* and the organisers of the recent debates in the Troitskii Theatre', during his lecture 'On Futurism'.[17] This event, held on 7 April and organised by the Arts Association, was also supposed to be a debate, but was banned as such by the police. Although Larionov did not appear, the lantern slides he had previously promised the Union of Youth (including work by himself, Goncharova, Boccioni and Picasso), were shown.

Larionov's break with the Union of Youth was put far more diplomatically in a letter to Shkol'nik, where he also declines from contributing to the fourth edition of *The Union of Youth* and outlines the separate plans of his group. No war is declared[18] and no final break is intimated. Even so, Larionov's coolness towards any future co-operation is unmistakable and

the divergence of paths henceforth made clear. The letter, presumably written around the end of March, represents the last real contact between Larionov and the Union of Youth. It suggests the reasons for Larionov's sudden break with the group. As a declaration of intent, the letter is crucial to understanding the movement of Larionov's group away from the Union of Youth. Until 1913 Larionov had enjoyed the use of the exhibition platform the Union of Youth had given both him and his group. In March 1913, with new financial backing, Larionov no longer needed that platform. As already stated, the collaboration of the groups was based as much on economic necessity as on mutual respect, and with Larionov's newly found 'Persian prince' (see below), the ties could be broken. This independence, brought about by Larionov's championing not only of Russia but the East in general, though still reliant on sponsorship, meant that he could free himself totally of the other Russian groups. It did not mean, however, that he suddenly sought confrontation with the Union of Youth, as he led Le-Dantyu to believe. Indeed, as the letter shows, he desired to remain on friendly terms with its members:

> With regard to the drawings for the Union of Youth almanac I must inform you… that we are publishing a very extensive almanac *Donkey's Tail and Target*, where everything on the art and literarure of Petersburg in the last two years will be included – literature of young poets still unknown to you, Persian, Georgian and Armenian Rayists and Futurists; about another ten booklets with illustrations are also coming out. Due to the publication of our almanac with my illustrations, at the moment there is no possibility of participating in your fourth journal. Moreover, we have been commissioned by the publishers and the whole group unanimously decided only to issue our own almanac and books.
>
> As to the Knave my advice is to spit on them, not to write anything to them, not to speak to them and not to respond to them.
>
> With regard to your exhibition in Moscow. I don't know how well off you are at the moment, but if you've got money, and indeed you have after the debates, then it wouldn't be bad to organise a show in Moscow. It's true that there are up to thirty shows in Moscow every year and three special exhibition halls. Our group is organising at least three exhibitions in the next year. There will be no outlay as I've already paid for them – the first will be in the autumn and will be exclusively Rayist painting. The second will be together with the Eastern artists. Both will be in Petersburg as well. Our sponsor is not interested in money but only the practice in life of the principles proposed by us. We renounce the West and only together with Eastern artists create and establish our ideas – our sponsor is a Persian prince who received his education in the Paris 'Majlis Sultany'. The third of our shows will only be in Moscow. This is an exhibition of Pneumo-Rayism. For Petersburg with its red-tape and immobility this is too incomprehensible.
>
> Send back my books as quickly as you can. We are selling them at twice the indicated price. *Antique Love*, where there are two of my drawings, sells at a rouble per copy.

> For now I shake your hand. Give my regards to Levkii Ivanovich [Zheverzheev] and the members of the Union. From Natal'ya Sergeevna too. M. Larionov.[19]

Meanwhile, Burlyuk had appeared at both Knave of Diamonds debates of 1913 (7 and 24 February), creating a scandal in the first by his uncompromising condemnation of Repin's *Ivan the Terrible* which had recently been damaged by a vandal. At the second, he spoke on his familiar theme of 'New Art in Russia and the Art Critics' Attitude towards It'.[20] On this occasion it was left to Mayakovsky to provoke the scandal with his demands 'to blow up all museums with dynamite'.[21] His Futurist pretensions appear more radical than Burlyuk's, for on 25 February Burlyuk published an article in which he called for the establishment of a national museum of 'cottage arts', where special place would be given to traditional, provincial signboards, and where 'the charm of the national (and not international) folk spirit will live'.[22] However, Mayakovsky, who was critical of the conservative tendency in the Knave of Diamonds, seems to have influenced Burlyuk, for the Burlyuk brothers both withdrew contributions from the group's exhibition due to open in Petersburg on 3 April, and did not participate with it again until 1916.

The timing of the two Union of Youth debates (23 and 24 March 1913) at the Troitskii Miniature Theatre coincided with the publication of the third issue of *The Union of Youth*, and of the group's *Credo*, as well as with an official association with the newly formed literary group Hylaea.

David Burlyuk had originally intended to talk on 'Painterly Counterpoint'[23] at the first debate, but appeared with a speech entitled 'The Art of Innovators and Academic Art in the Nineteenth and Twentieth Century'. This brought it closer to the talks he had given at the Knave of Diamonds in February. Shkol'nik's visit to Moscow around 6 March resulted in Malevich eventually replacing Larionov. Malevich gave his own talk and read 'The Report of the Group of Russian Futurists'. It was the latter, together with the reading of the Union of Youth's newly written *Credo*, which opened proceedings, and which, as it is now clear, held most significance.

Neither Burlyuk nor Malevich appeared as representatives of the Union of Youth, despite the fact that they had both recently joined the group. Yet at the Union of Youth's committee meeting of 4 March members' participation in such evenings had been discussed, with the resolution that it was 'highly desirable and indeed necessary'[24] that they took part in the debate.

Burlyuk's lecture repeated, contrary to the advertised programme, his Moscow berating of Repin's *Ivan the Terrible*. Much of his argument was taken up with the faults of the painting from the academic point of view. He highlighted the latter in an attempt to show Repin's unworthiness, even as a realist. His words about the recent trends in art seem to have been limited to

wrathful denouncements of the critics, and, as usual, in particular, Benois.[25]

Malevich's appearance at the debate was more controversial and more provocative than Burlyuk's, not least because he was now a member both of Target[26] and the Union of Youth. Indeed, despite a new divergence in their paths, in some respects Malevich seems to have acted as Larionov's envoy. He grasped the opportunity, with new confidence in his own creative ideas, to make a public appearance as a speaker for the first time.[27] In fact, he sought to investigate the state of modern art in Russia, as if he had taken over the latter part of Burlyuk's lecture programme and given it his own interpretation. Speaking hurriedly, he tried to characterise the Knave of Diamonds as the offspring of Cézanne and Gauguin, and to promote the Donkey's Tail, which he recognised had now turned into Target, as the followers of national aims.

Although the full extent of Malevich's declamatory statements issued under the title of 'The Report of the group of Russian Futurists' is not known, the following points have been recorded:

> Art cannot travel in gigs it must rush along in cars!…Our dim-headed press is reminiscent of stupid firemen who put out the fire of everything that is new and unknown. At the head of these firemen stands their talentless chief, Repin…Old art consists totally of talentlessness. Take for example Serov, the talentless master, who has immortalised the talentless face of voiceless bawler Shalyapin.[28]

While these hardly amount to a positive programme for the future of art, and served primarily to whip up feeling among the audience (the ensuing noise threatened to have the evening closed down), they at least indicate that Malevich was now ready to speak out against the establishment using essentially Futurist rhetoric. Thus, four years after the literary manifesto of the Italian Futurists had been published in Russia, a group of Russian painters, through Malevich, announced that they too were Futurists.[29]

The Union of Youth's *Credo*[30], read 'in an expressionless voice by a tall, dishevelled Futurist with a long, uncovered neck',[31] was less specific in its attacks than Malevich's speech, but similarly energetic in its defence of the new. As the first concrete statement of policy by the group since Matvejs' 'Russian Secession' three years earlier, it bears comparison with that previous declaration. It also has clear associations with his 'The Principles of the New Art' and with Rozanova's 'The Bases of the New Creative Work and the Reasons for it not being Understood'.[32]

Rather than echoing the spirit of the Italian Futurist proclamations published in *The Union of Youth*, the *Credo*, announced as an 'artistic battle Credo'[33], more closely resembles the epithets of challenge contained in the original 'Manifesto of the Futurist Painters', published as a leaflet in Milan in February 1910. However, unlike the Italians (whose painting lagged behind their declamations), the Union of Youth's leaflet disclosed

that it considered the group's 'technical Credo' already established by its exhibitions and theoretical works. In this respect it is largely complementary to the 'Russian Secession', which, despite its polemical elements, consisted mainly of reasoned argument for the freeing of art from imitation of observable nature. In the *Credo*, argument is replaced by unsupported declarations of protest. Inevitably these concentrate on the Russian art establishment and critics. Significantly, considering Larionov's advice 'to spit on them', the Knave of Diamonds is also criticised for being lulled by the 'stuffy... atmosphere' of 'that general dormitory in which the Wanderers, the World of Art and the Union of Russian Artists heavily slumber'. Such criticism seems to refute the purpose of the earlier approaches made by the Union of Youth to the Knave of Diamonds. And despite a common terminology, even Kul'bin did not escape some slight, though he remained unnamed: 'We declare war on all the imprisoners of the Free Art of Painting, who shackle it in the chains of daily life: politics, literature and the nightmare of psychological effects.'

It is this declamatory tone of protest that most strikingly recalls the first 'Manifesto of the Futurist Painters' (1910), albeit in milder language:

> We declare that the painter may speak only the language of painterly creative experience...
> We declare war on all self-loving Narcissi who cultivate the sentimentality of personal experiences and for whom nothing is dear besides their own, constantly reflected, face...We declare war on the Corner Creation of the World of Art, who look at the world through one window...
> That free creativity is the first condition of Originality!
> From this it follows that in Art there are many paths!...
> This is our slogan: 'In continuous renewal is the Future of Art'...
> There is no honour for us to turn to a... ridiculous spectre of the past, to the fruitless invention of that which has already ceased to be....

This can be compared with the Italians claims to:

> 1 Destroy the cult of the past, the obsession with the ancients, pedantry and academic formalism...
> 2 Totally invalidate all kinds of imitation.
> 3 Elevate all attempts at originality, however daring, however violent...
> 5 Regard all art critics as useless...[34]

Despite similar demands for continual renewal,[35] there are differences between the Russians and Italians in their attitude to the everyday, and this hints at the more mystical approach (inherited from symbolism), that gave Russian Futurism its peculiar identity. In contrast to the Russians' dismissal of routine daily life, the Italians 'Support and glory in our everyday world, a world which is going to be continually and splendidly transformed by victorious Science.' Indeed, as if underlining their independence from the Italians, the Russians proclaimed: 'We despise the word "Glory", that

reduces the artist to a stupid animal who obstinately refuses to step forward even when he is driven by the whip.'

It is also worth comparing Target's principles, published in their exhibition catalogue at the same time as the *Credo*. Written by Larionov, the points made, while in part agreeing with those of the Union of Youth, also act as a counterpoint. Thus, the Union of Youth declared that it was intent on retaining its previous forms of public appearance, describing them as a 'practical path' which 'in the future will broaden and deepen... more and more', and Larionov viewed his group's appearances as developmental, that 'each exhibition has advanced new artistic problems'.[36] Similarly, Larionov sought to exhibit work of artists 'not belonging to some defined direction and creating, for the most part, works distinct from the manifestation of their personalities'. This echoes the Union of Youth's protest against the Narcissus cult in painting and their acceptance of all new paths to the new.

However, Larionov was closer to Markov than the *Credo*, in that he did not reject the past so categorically, nor condemn imitation. Thus he recognised 'a copy as an independent work of art' and 'all styles which have gone before us', and announced that Target 'proclaims every possible combination and merging of styles'. Such sentiments resemble Markov's idea in 'The Principles of the New Art' where he calls even the freest art plagiarism and cites the Chinese value of imitation and free copying. Like Markov, Larionov develops his principles in support of the East and in opposition to the West, and this contrasts with the Union of Youth's *Credo*, which fails to differentiate.

While Larionov regarded the Union of Youth, like all art societies, as inevitably doomed 'only to stagnation', his relations with Markov continued to be marked by a distinct attitude (as late as January 1913 Markov was considered a participant in Target).[37] However, Larionov went further in asserting the universal character of painting: 'We consider that the whole world can be expressed entirely in painterly forms – life, poetry, music, philosophy etc.'

Despite its comparative limitations, the publication of the Union of Youth's *Credo* in such a proclamatory form could not have been envisaged even a year previously. Its disrespect for all past art announced a new vitriolic attitude. This new assertiveness may well have derived from an awareness of the dynamic developments in Western Europe. The Union of Youth now considered themselves the Russian representatives of Futurism, although they stopped short of attaching any such label to themselves, perhaps fearing the inevitable limitations that a label implies.

The 'Public Debate on Modern Painting' ended with a discussion about the way ahead for new art in which Baller, Red'ko and Burlyuk took part. While Baller reiterated sentiments about the fall of the old Apollo ex-    **163**

pressed in the new issue of *The Union of Youth* (see below), Burlyuk admitted that new art was heading for the abyss in which old art already sat, and confounded this apocalypsism with a final 'worn phrase about the burning fire of "eternal truth and eternal beauty"'.[38] Their statements were interspersed by Kruchenykh's surprisingly 'conciliatory and explanatory'[39] remarks about the significance of Cubism and the declamations of 'a Futurist from the Don', who read his twelve syllable poem in which he demonstrated his 'theory' of the reduction of whole phrases to single words:

'Ba, ba-ba, ba-ba,
Goden buba, buba, ba!'[40]

The participation of Kruchenykh and 'the Futurist from the Don' highlights an overlap with the Public Debate on New Russian Literature, which occurred the following day. This relationship between the arts was simultaneously demonstrated by Hylaea's participation in the Union of Youth's third journal.

On 17 February David Burlyuk had written to Matyushin recommending the 'absolutely vital'[41] participation of Kruchenykh in the literature debate then set for 27 February. However, a programme for the debate after it was first postponed until 1 March omits Kruchenykh (Nikolai and David Burlyuk and Mayakovsky are given as the speakers), though it does list various readings from *A Trap for Judges* and *A Slap in the Face of Public Taste*, including Livshits' 'People in a Landscape', Nikolai Burlyuk's 'Lady Rider', Kandinsky's 'To See', Nizen's 'Spots', Guro's 'Newspaper Notice' and various poems by David Burlyuk, Mayakovsky, Kruchenykh and Khlebnikov.[42]

With the further postponement of the debate, the programme changed and when it was eventually published the readings had vanished in favour of Kruchenykh's lecture 'The Unmasking of the New Art'.[43] By this time the Union of Youth had concluded its formal alliance with Hylaea, accepting, at the committee meeting of 6 March, its autonomous participation in Union of Youth activities.[44] It was thus, and largely through the energetic intermediary work of Matyushin, that Nikolai and David Burlyuk, Livshits, Kruchenykh, Khlebnikov and Guro, who had just gone to press with the second *A Trap for Judges*, were published in the third *Union of Youth*.

The published programme for the lectures of 24 March indicates that the evening turned into an espousal of the principles of the latest literature, reminiscent of the proclamations made in *A Slap in the Face of Public Taste* and *A Trap for Judges*.[45] Nikolai Burlyuk's speech, 'Fairy Tale – Myth', looked at the characteristics of the fairy tale as the use of the word to its highest degree. His structural approach included an examination of fairy tales' use of sounds in speech rather than words; their themes of

incarnation and immortality; and aesthetic values that deny reason – 'as a victory over logic'.

Mayakovsky's talk, 'The One that Came by Himself', continued the new concentration on the function and character of the word devoid of such extraneous conditions, such as 'content... language (literary and academic)... rhythm (musical and conventional)... metre... syntax... etymology'. As Burlyuk and Malevich in the debate on painting, Mayakovsky denounced all that had gone before: 'Our poetry has no precursors.' He talked about the 'rebirth of the true role of the word', looked at Cubism and Futurism in the word and his group's relations to the Ego-Futurists and critics. Apparently Mayakovsky did not hide his Futurism: 'From Sologub the grave-digger, from Andreev the father of suicide, we call you to modernity. To live in the turbulent life of the city, of screeching rails, to melt in the breath of the fields, to jump, to laugh.'[46] His words most closely resemble the declaration of *A Slap in the Face of Public Taste* and continue his November argument, in which he had concentrated on the essence of words, demanding a 'rebirth of the original role of the word' and comparing the Futurists' use with that of myth.[47]

The search for essence through the concentration on primary formal elements, which has clear foundations in the approach of Neo-Primitivism and symbolism, has obvious parallels with the painterly demands of the artists. This is further in evidence in David Burlyuk's speech 'The Graphic Elements of Russian Phonetics', which was based on the principles outlined in the new *A Trap for Judges*. Burlyuk, now a painter-poet, announced that the modern poets had 'shaken loose the syntax of Russian speech... have begun to impart content to words according to their written form and phonetic traits... forgotten about spelling to please the occasion... destroyed punctuation marks... We describe nouns by all parts of speech.' While this was undeniably inherited from Marinetti's 'Technical Manifesto of Literature' (May 1912),[48] Burlyuk goes further than Marinetti in his search for the formal properties of the word. The leader of the Italian Futurists had called for free words – which necessarily involved the destruction of syntax and the suppression of adjectives, verbs and punctuation. But he had used analogy as associative imagery, retaining an overtly symbolic content for the word. Burlyuk on the other hand searches within words, and with neologisms, for their attributes – creating a theory about the function of vowels and consonants and emphasising the visual appearance of letters. He proclaimed that consonants are the 'bearers of colour and the notions of faktura', while vowels represent 'time, space and the motion of the plane'. This expressiveness of individual letters took further Marinetti's idea about the 'naked' purity and 'essential colour' of nouns, which, when used in analogy chains, were able to 'embrace the life of matter'.[49]

Burlyuk's conceptual approach was illustrated by examples of 'descriptive' and 'graphic' poetry, as well as by Kruchenykh's 'The Unmasking of the New Art'. The programme shows that the latter consisted of non-sequential, neologistic aphorisms ('In the Cage and behind the Cage', 'The World from the End or the End without the World', 'Transcendental Irony or the Metaphysics of the Pot', for example). Such a reduction of poetry and prose to their formal elements, with its rejection of the constructive nature of European rationalism and its emphasis on individual essential components, relates to Markov's 'Principles', where the search within for the pure 'swans of other worlds' was applied to both painting and poetry. Furthermore, the quest for the true nature of existence through new art also recalls Kandinsky's theory about the nature of painting as 'the combination of coloured tones determined by inner necessity'.[50] This highlights the coincidence of the theories and ideals of the new Russian poets (as enunciated at the Union of Youth debate), and the new technical approaches and aspirations of the painters – announced simultaneously by Rozanova (see below). For both poets and painters the process of making the object that is their art has become central to their art, rather than observation of the surrounding world.

The debate on modern Russian literature was not only a theoretical affair. During Kruchenykh's 'speech', the speaker, together with Nikolai Burlyuk and Mayakovsky, donned human masks with humorous, tragical and evil faces. They announced, one after the other: 'Trepetva', 'Dyshva', 'Pomirva', 'Pleshchva',[51] congratulated each other and themselves most of all, and left the stage. With the introduction of this element of farce, comedy and grotesque, involving the combination of the visual and verbal arts, Kruchenykh presaged the Futurist opera, *Victory over the Sun*, which he was soon to write in collaboration with Matyushin, Malevich and Khlebnikov, and which the Union of Youth were to stage at the end of the year.

Despite a rowdiness at the literature debate, it was less scandalous than earlier, similar occasions. Of the opponents, only Vasilisk Gnedov[52] seems to have taken the Futurists seriously enough to shout his disbelief in them and proclaim himself, and two other Petersburg poets associated with the Ego-Futurists – Shirikov and Ignat'ev – as the poets of modern Russia. The furthest extreme seems to have been that of an anonymous 'Rondist' with a grey beard, who cried: 'I too shall found my own school of Rondists, of round dolts and round idiots. I shall not paint with paints but with street dirt, not with a brush but with my open palm. I shall compose my own alphabet. I shall not speak but moo like a cow: "Mur, kur, pur" – this is my new poem.'[53] Whether this was said by one of Burlyuk's troupe or one of their mockers is uncertain. In either case, it points, through its allusions to crude and primeval technique, to the avant-garde's attempts to find a new and essentially pure form of art – where the burden of traditional extrane-

ous factors which usually corrupt the work of art (such as empathy and experience) is, if not totally negated, transformed. Thus the Futurist literati became more radical than Markov who felt such a denial, however desirable, impossible to achieve due to the irrepressibility of the complex psyche and personality in art.

### The Third Union of Youth Journal

The third issue of *The Union of Youth*, which was published on 22 March 1913, was the last. It was also the most assertive issue, and, in contrast to the second, all the contributions, including the illustrations, were by Union of Youth or Hylaea members. Indeed, only the articles by Baller and Matyushin discussed developments in Europe, and then in relation to the situation in Russia. Most revealing with regard to the latest trends, was Rozanova's article on the principles of the new art and her parallel illustrations. These revealed a new interpretation of Cubism and Futurism, unseen in the work she had displayed at the Union of Youth's recent exhibition.

The question of the publication of Nizen's translation of Gleizes and Metzinger's *Du Cubisme*, which had been edited by Matyushin, had arisen almost as soon as the latter had rejoined the Union of Youth at the beginning of January.[54] On 8 March it was decided to include a study of *Du Cubisme* by Matyushin, rather than the translation, in *The Union of Youth*.[55] Just four days earlier the other articles for publication had been read to the committee and accepted for entry.[56] Thus, together with the inclusion of work by the Hylaea poets, the journal's final form was hurriedly agreed. Despite this haste, a surprisingly unified sense of direction is evident in the third issue.

Matyushin first met Mayakovsky and Kruchenykh around the end of November 1912, when preparations were under way for the Union of Youth's autumn debate and exhibition. An alliance had immediately sprung up with the first result being the second *A Trap for Judges* almanac, published by Matyushin's independent press, 'The Crane', in the first week of March 1913. The alliance gained the name Hylaea, which in turn united with the Union of Youth. The foreword to the third *Union of Youth*, a statement by Hylaea, the 'autonomous poetry section' of the Union of Youth, propounded its principles and reasons for unification.[57] Coincidentally it stated the current position of the Union of Youth.

'The Russian Secession' had declared that 'We search only for beauty' and hinted at the problems involved in finding and manifesting it. Hylaea's declaration continued this attitude, advising that it was not to be found in 'automatism' or 'the temporary' and that it was seeking a 'definition of the philosophy of the beautiful'. Hylaea also acknowledged the difficulty of dealing with beauty, recognising that it could be appreciated 'beyond the

bounds of consciousness' and allowing that enquiry into the nature of human cognition could provide the grounds for such an appreciation. Such an expansion of human perception had been implicit in Markov's 'The Principles of the New Art', where the author recognised that inner work could produce the most important results concerning the reflection of divine beauty.

The overall impression gained from both the theoretical and creative parts of the third number of *The Union of Youth* is of a journey through Russian artistic modernism. The group's previously unestablished position with regard to Cubist and Futurist principles is set out. As will be shown, this is most vividly embodied in the graphic art of Shkol'nik and Rozanova which, rather than evoking identical ends, displays the variety of experiment with expressive means then being utilized in Russia.

Such a journey is also evident in the accompanying prose and poetry by six Hylaea poets (Mayakovsky was conspicuously absent). Like the Union of Youth articles and illustrations, this shows a limited variety of modernist trends – from impressionism and symbolism to Futurism. Thus Guro included her short, impressionistic prose sketch 'The Chirp of Spring', David Burlyuk two examples of symbolist verse ('The Hermit' and 'The Lover of Night') and Kruchenykh his typographical poem 'THE HORSES ARE PULLED' and 'GO OSNEG KAID', 'written in a language of my own invention'.[58] The neologistic examination of the structure of the word was foremost in Khlebnikov's 'War is Death'. Khlebnikov, especially in 'Teacher and pupil. About words, cities and peoples'[59] and 'Conversation between two individuals', also developed the relationship between the word and number. Here, modern literature is set off against Russian song: the first sees the horror in life and advocates death, while the second sees beauty and advocates life; the first blames war as senseless slaughter, while the second glorifies military feats.

Avgust Baller's two small articles, 'The everyday Apollo and the black Apollo'[60] and 'On the chromotherapy already taken',[61] outlined his view of the evolution of art. 'The everyday Apollo' looks at the constructive nature of art since the Greeks. Baller concludes, like Worringer, that the spreading of the Hellenic ideals has undermined the art and culture of other civilizations and that its rationalised base is as worthless as the 'hopeless phosphates' given to the old and sick. He points out that these phosphates and salts end up drinking the sick and are joined in doing so by the trees in the cemetery. Bakst's work *Terror Antiquus*, the journal *Apollo*, Golovin's designs for the production of *Elektra*, are all criticised by Baller for being touched by the contagious spirit of Apollo. Yet in the last 'twenty or thirty years' Apollo has been 'beaten by sharp blows on the head' and is 'surgically wounded'. The wounds have been inflicted by the Fauves, the Cubists and the Futurists. The old Apollo 'cracks and falls' and a new one is born

with 'curved legs', colour reminiscent of the 'Nubian night and French polish, and a head of steel-bronze' which the 'future Futurists will not break through'.

Baller's argument coincides with the current thinking among members of the Union of Youth that the modern artists are creating a new era and a new dimension for art, in which the discovered beauty is essential and eternal. However, his support for the modern, with references to its inheritance of technical principles from African art, goes little beyond being a statement of rejection of the Greek inheritance. He welcomes its downfall but does not stipulate the means by which it is to be replaced, or with what purpose.

'On the chromotherapy already taken' takes the rejection of 'The everyday Apollo' further, briefly examining, by means of medical analogy, the steps already taken in rejection of academic laws. The medicine taken to rid the artist of his academic illness is traced back over fifty years to the emergence of Impressionism. The prescription was 'more sun, light and air'. This gradually changed 'from light to colour' and with that arrived 'the chromotherapy' evident from the 'impressionable Monet to the Fauve Matisse'. But while this therapy healed many, it also ran its course. Thus Baller was able to accuse Petrov-Vodkin's *Bathing of the Red Horse* (1912) of being a 'red anachronism' and Gauguin's colourism of being *passé*. All this had been replaced by Picasso, who had: 'originated from Spain and as you know the Moors came to Spain. They came from Africa… Oh the great black gods of the Nubia!' Baller went no further in his explication of Picasso's principles but his recognition of the artist as the leader of modern art confirms his position *vis-à-vis* modern trends.

Spandikov's article, 'The labyrinth of art,'[62] consisted of short symbolistic aphorisms on art. 'The tangled strands of creativity' are encountered by inner searching. Only in this limited way can eternity be sensed and its mystery slightly unravelled. The way forward is to 'move away from space time to find the number' – as if Spandikov is calling for the artist to abandon the magnitudes of the fourth dimension for the more abstract notion of mathematical space, in order to sense the eternal more realistically. He predicts a new era for art – 'a wave of art that will unsparingly spill over everyone and everything and will ruthlessly break up many creations and human lives'. The coming of the new art is apocalyptic, as in so many predictions of the Russian modernists:

> … a new, bright life radiates and other spirits, other beauties are made to shine and sound in peoples' chords… drops of poison burst out laughing and tears of the stars have fallen into the rainbow… red and yellow threads have struggled with blue and green… it was so hot and cold that a ray, piercing the earth, smiled at the moon… a rocket of flesh struck against the sky and broke into myriads of radiant, sparkling lines…

**169**

Spandikov's vision of art, with its preponderance of fantastic visual imagery, is based on a complete upheaval of established norms, and although he refrains from introducing any technical or formal directives, it is in keeping with Markov's and Kul'bin's concerns. Where Spandikov goes further is in his description of the sensation of the eternal, the essential universal beauty. Markov and Kul'bin described methods to sense the eternal in art but they did not describe that sensation in their essays. Spandikov bridges this gap with a compilation of images that recalls the effects of hallucinogenic drugs (in this it may be related to the evocative chaotic order of Filonov's Heads), and the vivid visual effects of Larionov's Rayist canvases.

By way of contrast with Spandikov, Nikolai Burlyuk's article, 'Vladimir Davidovich Burlyuk',[63] is an attempt to give his brother's painting, and that of the Russian 'Cubists' in general, a scientific basis. It starts from the premise that art is created from 'reflectiveness and advocacy of the materialization of ideas'. The combination of the painting and its creator, as embodied in the work, is regarded as the essence of art. As such, every work links the local and temporary (i.e. the person) with the ideal permanent. This urge to abstraction subjects art to definite laws. Beauty, instead of responding to some individual psychological demands, is 'now confined to the creation of certain permanent systems of plane geometry'. Vladimir Burlyuk used plane combinations in 'two, three and curved dimensions'. His representation of constructions in nature in two dimensions required renunciation of knowledge of the third dimension and hence the flatness of some works. He determined to show through visual expression the dynamics and/or material of a section of space-time. Thus the lines and surfaces depicted on the canvas could be distinguished as temporal, spatial and interactive. A canvas could thereby be given direction, weight, instability or equilibrium and was no longer reliant on the singularly subjective visual sense. Such abstract qualities had been reflected in recent works like *Heliotropism* and *Geotropism*. Colour became identified with energy and 'with every work of art we find new relations between the person and the world'. This allows for the lack of movement around an object in Burlyuk's art and his denial of volume – there is no interpenetration of his facetted planes, only a superficial interaction. This structural simplicity and geometry coincides with Worringer's notion of abstraction.[64]

Burlyuk's painting, his brother claimed, sought to embody his personality in relation to the fundamental abstract qualities of existence. In trying to depict movement, for example, in time and space, the artist involved himself with the fourth dimension. However, Burlyuk made no claims about the necessity of a higher consciousness for the perception of the fourth dimension and did not enter into metaphysical argument. His claim that such notions could be depicted neglected all mention of the means of their perception or the decisions involved in the embodiment of a non-

material quality in a material media. Such matters were taken for granted by the appearance of the work itself. It remained for Matyushin and Rozanova to enter into the argument for a higher consciousness.

Rozanova's 'The Bases of the New Creative Work and the Reasons for it not being Understood',[65] synthesises the preceeding essays, together with ideas from Markov, Kul'bin and the Union of Youth's *Credo*. To these she adds a technical approach. Still, much of the article is taken up with attacks on the establishment in general, and on Benois in particular. This is done in defence of a 'new creative world view' which included the Burlyuks' 'titles of paintings expressed in technical language (leit-line, colour instrumentation etc.)'. She claimed that the public needed awakening from its slumbers,[66] and especially from the conception of beauty based on copies of nature and terms of 'Familiar and Intelligible'. The critics and 'pseudo-artists' who 'depreciate its [new art's] significance', only confound the problem by their failure to analyse the meaning of the new art.

While asserting that a transient epoch was only that of 'Senility and Imitation', Rozanova admitted that each new era, which works out a new code of artistic practice in part reliant on cultivated experience, inevitably experiences in the course of time a 'slackening in creative energy'. This allies with the call in the *Credo* for 'continual renewal' in art and can be associated with Spandikov's likening of culture ('the spirit of nations') to a flower hovering over the universe and scattering its petals at different times and in different 'secret corners'.[67] She added that when an era seeks to cultivate the codes of a previous era, artistic technique is developed to 'an improbable level of refinement which is reduced to a cold prestidigitation of the paintbrush'.[68]

Having criticised the 'Corner creative work' of the World of Art and Union of Russian Artists, as in the *Credo*, Rozanova then follows Baller in her evocation of the means, since the Impressionists, to overcome the reliance on the visible in art and to instigate problems of a purely painterly nature. She outlines the process of modern art as 'a series of independent theses', from the Impressionists' 'stipulation of an atmosphere of air and light in a painting, and colour analysis' through Van Gogh's and Cézanne's experiments, to those of the Futurists and Cubists. She concludes with a call for 'eternal renewal' in art. This coincides with Uspenskii's suggestion that forms of consciousness and the means of their expression continually evolve, and that as a result 'besides forms already known to us new forms must arise'.[69] Rozanova reiterates her objection to the 'continual rehashing' and 'laziness' of the 'art critics and veterans of the old art' who trade on their 'immutable face'. Her criticisms add little that is new to the position of the avant-garde in Petersburg. They do, however, voice the argument against the its opponents with a forceful cogency and reason that is only paralleled in Markov.

The most remarkable qualities of Rozanova's article lay in her original exposition of the principles of the new art. She begins with a description of the function of painting that is very close to that outlined by Burlyuk:

> The art of Painting is the decomposition of nature's ready-made images into the distinctive properties of the common material found within them and the creation of different images by means of the interrelation of these properties; this interrelation is established by the Creator's individual attitude... The desire to penetrate the World and, in reflecting it, to reflect oneself.[70]

Art is taken as the 'active aspiration to express the World' and this is made possible by three creative elements: '1. The intuitive basis. 2. Individual transformation of the visible and 3. Abstract creative work.' This is comparable with Uspenskii's 'units of psychological life – sensation, representation and the concept, and the fourth which is beginning to arise – higher Intuition'.[71] Rozanova's new awareness is apparently less mystically inspired than Uspenskii's, though the selection of the theme of the work is seen as made by the intuitive impulse of the creator.

Rozanova chose not to explore the intuitive aspect or the factors involved, yet it is clear that for her it meant a visual sensation as it acts on the psyche. She avoided the psychological enquiry imposed by Kul'bin, and implied a spontaneous, involuntary and individual reaction to stimuli, ruling out the possibility of chance in art. The subject was causally selected, though the cause remained unexplained. However, once the intuitive impulse had been identified, it was transformed by the personality of the artist into an abstract conception – a painting: 'He will reveal the properties of the World and erect from them a New World – the World of the Painting, and by renouncing repetition of the visible, he will inevitably create different images; in turning to their practical realisation on the canvas he will be forced to reckon with them.' She continued: 'The abstract embraces the conception of creative Calculation and of expedient relations to the painterly task.' This notion of calculation describes the process of abstracting the elements of nature within one's field of experience, especially for their representation on the canvas. The process of orderly selection and representation differs from that of past art, where the artist, 'riveted to nature, forgot about the painting as an important phenomenon'. Rozanova contrasts this 'fruit of logic, with its immutable, non-aesthetic characteristics' with her intuitive abstraction and in so doing is very close to Markov's definition of rationalised and non-rationalised art. She allows, like Markov, that the work of certain ancient epochs, the young and the primitive included a transformation rather than imitation of nature and that this could be the result of 'unconscious qualities'.

Rozanova insisted on a conscious process for the new art, and like Markov saw modern art as a conglomeration of factors working *on* and *within* the artist.[72] However, she demanded that the result was a scientifi-

cally reasoned work of 'constructive processing'. Only then could the self-sufficiency of the painting be realised. Markov ignored this, defining art as an expression of the self and through this the world as it is perceivable. Rozanova's definition of art as an abstract expression of the world, allowed the artist to concentrate on such principles as: 'pictorial dynamism, volume and equilibrium, weight and weightlessness, linear and plane displacement, rhythm as a legitimate division of space, design, planar and surface dimension, texture, colour correlations and many others'. This allies her with the work of the Burlyuks and helps explain her own abstract illustrations reproduced in the journal.

Six lithographs each by Rozanova and Shkol'nik were included. Although randomly distributed throughout the journal, most of the works relate to one another in some order – illustrating a gradual reduction of pictorial form to its basic linear characteristics. This is especially visible with Shkol'nik, who moves from the relatively descriptive *Petersburg. The Wash-House Bridge* (Plate 16),[73] to the abstract geometric planes and broken lines of the journal cover (Plate 17). The first is a Fauvist depiction of an urban river scene that recalls the decorative image in Derain's *Pool of London* (1906), possibly one of the London views he showed at the first Golden Fleece salon. In Shkol'nik's work poles bend on the embankment in the foreground; boats rest on the water; a train crosses the bridge; and houses frame the river edge. Despite being flattened the clearly identifiable figurative elements are stable and respond to the spatial recession of the picture. Hatching distinguishes light from shade.

The source of light is ignored in Shkol'nik's *Two Vases* (1913) where the subject, depicted by heavy, straight lines, is flattened, static and highly stylised. This compares with the picture of two boats, trees and houses (Plate 18) where the touch is laconic and calligraphic. Here linear perspective is retained by the converging diagonals and depth is confirmed by the scale of the houses against the bending trees of the foreground. However, in the next work with a similar subject (Plate 19) foreground and background are fused into a medley of spherical movement that comprises the trees, houses and sun. The subject is further distanced from visual appearances in the following work (Plate 20), where the image is more urban and mechanical than previously. Buildings are turned into flat blocks of irregular rectangular form, distinguishable only by the uneven black spots that indicate windows. The thick lines that intermittently cross and surround the buildings suggest the arches of a bridge without truly identifying it. This reduction of form is continued in the illustration for the cover (Plate 17), which comprises a simple, structured abstract composition. Only by reference to the previous work could it be suggested that this is an urban scene reduced to an abstract entity. The subject is now the compositional elements themselves. The contrast of black and white, line and block, ques- **173**

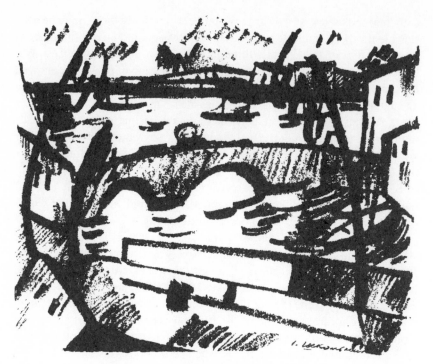

I. Shkol'nik  **16** *Wash-House Bridge, Petersburg*
**17** cover for *Soyuz Molodezhi*, 1913

СОЮЗЪ МОЛОДЕЖИ

3

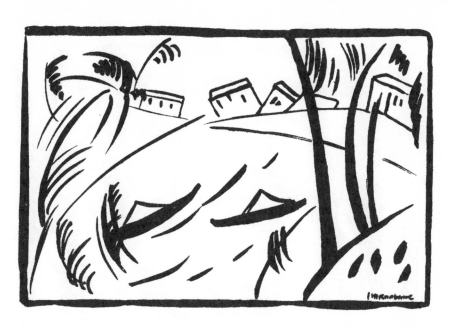

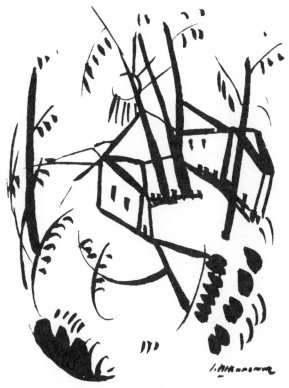

**18, 19** I. Shkol'nik, lithographs

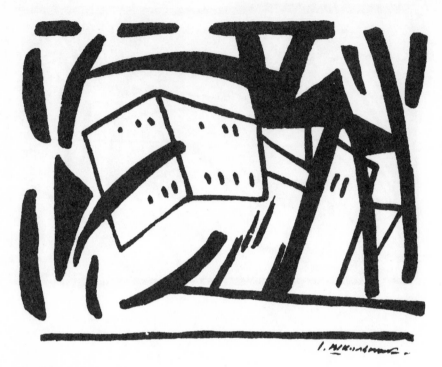

**20** I. Shkol'nik, lithograph

tions the nature of space as solid becomes indistinguishable from non-solid.

Rozanova's work also gradually reduces form to its constructive elements. Although a reduction was seen earlier with reference to *Portrait of Alevtina Rozanova* (see Plates 14 and 15), it progressed beyond that to a more radical and Futurist rejection of decorative aims. This is seen, for instance, in the depiction of a chaotic street scene (Plate 21) where fragments of buildings collide and slide into telegraph poles, the arch of a bridge, the street and part of a wheel. This fusion of representational elements evokes the turbulent motion of the city and recalls the spirit of Boccioni's *The Street enters the House* (1911).

Rozanova's and Shkol'nik's works, while acting as illustrations to Rozanova's theory (and thereby indicative of recent developments in the art of the Union of Youth), were distributed about the journal, apparently independent of the text surrounding them. Thus they are devoid of any specific correlation with the works by Hylaea. This divorces them from the integrated nature of the visual art and poetry of some of the Russian Futurist booklets, the first of which had been created by Larionov, Goncharova, Khlebnikov and Kruchenykh in the autumn 1912.[74] Even so, Rozanova's contribution lays the foundations for her collaboration with

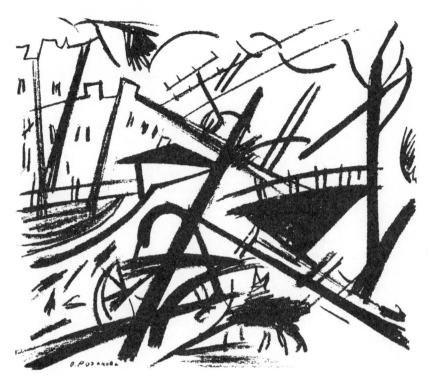

**21** O. Rozanova, lithograph

Malevich and Kruchenykh on their jointly produced booklets later in 1913.[75]

Matyushin continued the general tone of the journal about the dawning of a new age in art, with his introduction to, and editing of, *Du Cubisme*:

> we feel the coming regal moment of the transition of our consciousness to a new phase of dimensions from the third measure to fourth. Artists have always been knights, poets and prophets of space, at all times they have sacrificed everything and perishing they have opened the eyes and taught the masses to see that great beauty of the world hidden from them. So it is now – Cubism has raised the banner of the New Measure – the new doctine about the merging of time and space.[76]

Whereas other contributors stopped short of analysing the consciousness required for the perception and expression of the invisible world, Matyushin brought such an analysis to the surface. He juxtaposed carefully selected and edited paragraphs from *Du Cubisme* with correlatory passages from Uspenskii's *Tertium Organum* (1911), asserting that the latter 'to a great extent supports many tenets of the new phase in art – of Cubism and the definition of the fourth dimension'. Thus he developed the vaguely mystical quality of Gleizes and Metzinger's essentially technical brochure (they had obscurely referred to 'non-Euclidean' geometry and claimed that **177**

a Cubist painting 'harmonises with things in their entirety, with the universe; it is an organism').[77] In so doing, Matyushin implicitly allied the work with his own ideas about the expansion of consciousness and perception.

*Du Cubisme*, undoubtedly a source of much of the new Russian thinking, like both Baller's and Rozanova's articles, had outlined the deficiences of the 'modern' art from Courbet onwards. The Impressionists' dependence on the eye rather than its combination with the mind, necessarily limited their work, due to the eye's restricted capabilities. Matyushin, closely paralleling Rozanova's theory, quoted the Cubists' praise for Cézanne, that 'deep realist', who had 'despised the appearance of objects, penetrating into the common essence', so that painting became 'a revelation of the plastic consciousness of our instincts'. This too could be united with the notion of the fourth dimension as a field of new consciousness: Uspenskii had taught that the essence of things, that is their inner qualities, is not in our space, but that of higher space and hence subject to further dimensions.

In detecting the underlying presence of the fourth dimension in *Du Cubisme*, Matyushin made a distinctly parapsychological interpretation of the new art. Such an interpretation, which made extrasensory perception an attainable higher awareness, had hitherto been explored in Russia by Kul'bin alone. Kul'bin, having introduced his notion of the fourth dimension into the arts in 1910, had, as recently as 19 February 1913, talked not only about the fourth dimension but also about the the sixth and seventh, as well as 'annulled time' and 'annulled space'.[78] Matyushin applied Uspenskii's words about the clairvoyancy of artists to the Cubists' declaration that paintings should be: 'the expression of all the traits of depth, weight and duration… [which] allows by a corresponding rhythm in a very limited space, the genuine cohesion and merging of objects'. Such a correspondence of ideas between the Cubists and Uspenskii went further when applied to the concept of perspective, for both suggested the abandonment of this in favour of a perception of an object from all sides at once. Thus with a heightened sensitivity the artist could depict line, surface and volume as elements capable of revealing an integral whole. Space could be eliminated, as Kul'bin had intimated, if, between the 'sculpturally expressed reliefs' of the Cubists were depicted forms perceived by the suggestions of the subconsciousness.

Matyushin's article is an important indication of the Russian attitude towards the apprehension and representation of the world. It reinforces Larionov's Rayist painting and theory which sought the depiction of matter (rays) between objects. It also implies the difference between the French Cubists and the Russians. The technical concerns of the French are of secondary importance to Matyushin, who prefers to illuminate the correspondence of ideas with those of recent psychology. The French felt that

the fourth dimension could be attained by movement around the object – creating a synthesis of simultaneous multiple views in space. The Russian interpretation, as seen in the theoretical works of Matyushin, Markov, Kul'bin, Rozanova and Larionov, was based first on the artist acquiring a higher consciousness. This change in consciousness would allow a fourth dimensional view of space (i.e. a view of space where the notion of time was included).

Evoking the fourth dimension in art implied that the artists came closer to depicting the true nature of reality than they had previously. The French judgement that this could be induced by the straightforward regard for certain natural laws was not totally antipathetic to the Russian idea that the essence of the world could be penetrated and represented by working on the development of the human psyche. Both sides ultimately were in agreement about the unity of matter and the suitability of the forms and constituents of this matter as subjects for painting.

The energetic activity of the first three months of 1913 did not immediately abate after the March debates, even though the art season was drawing to an end. The Union of Youth held several general meetings in quick succession.[79] At these the debates and journal were discussed and plans laid for the future. Among the latter was Malevich's suggestion to set up a Moscow committee of the Union of Youth; the design for the society's official stamp; the fourth journal; and a lecture by Aleksei Grishchenko, an exhibitor with the Knave of Diamonds.[80] Originally, material for the fourth issue of the journal was given the submission deadline of 12 April but this was subsequently put back and the publication postponed until the autumn.[81] In fact this postponement, possibly influenced by the failing health of Guro, and her subsequent death on 23 April, was to prove not temporary but permanent. Guro's gentle, pervading influence was felt by many members, not only of Hylaea, but of the Union of Youth as a whole. Without doubt her death shook the group which she had co-founded. Its activity of the spring of 1913 became sharply curtailed, only Grishchenko's talk going ahead.

Besides Shkol'nik's unsuccessful approach to Larionov for an article on Rayism, little is known about the proposed contributions to the fourth journal. One possibility was an article on the Ukrainian sculptor Archipenko.[82] As one of the first sculptors to utilise Cubist principles (his 1912 work included the opening up of voids within the mass of a figure, thereby rejecting the traditional concept of sculpture as solid surrounded by space), he would undoubtedly have interested the Union of Youth. Also, the Hylaean section, with the addition of Mayakovsky, would almost certainly have contributed once more;[83] there may have been an article on Tatlin, since he wrote to Shkol'nik in April 1913 reminding him that '*The Female Model* or *The Boy with Fish*' should be used as illustrations;[84]    **179**

Matyushin could have submitted the article he had written in 1912 on the fourth dimension;[85] and the Union of Youth's *Credo* may have been included.

It is known that Rozanova submitted a short article entitled 'The Resurrected Rocambole'.[86] This concerned a lecture by B. N. Kurdinovskii organised by the Arts Association on 3 March 1913. The lecture, 'Repin and his Creative Work' was intended by the Association to counteract Burlyuk's and Kul'bin's recent lectures for the group. In the event, the evening was closed by the police after the public, feeling insulted by the first opponent, 'a not unknown member of the Black Hundreds, Mr Zlotnikov', had become agitated in their protests.[87] The closure inevitably led the subsequent discussion of the evening in the press to focus on the scandal rather than the contents of the lecture itself.

In fact, Kurdinovskii's lecture had been both an apology for Repin's work and an anti-modernist proclamation and, as Rozanova indicates, it was this that incited her to attack it. Thus from the generalities of 'The Bases of the New Creative Work' she utilises a particular occasion to express the same sentiments. Essentially, she compared the speech, with its 'belated cult of Wandererism', to Ponson du Terrail's tales about Rocambole, a character who could die in one adventure and be resurrected in the next.[88] But she broadened her attack by seeing Kurdinovskii as a servile 'blind instrument of fate', a predictable characteristic of the 'Rocambole effect' on society, created by the slashing of Repin's *Ivan the Terrible*. She described the current situation that could lead to such a phenomenon. An attitude of passivity to art was the sole explanation for such excitement. The Russian public had only 'mechanically perceived' the recent trends, unaware of the necessity for an 'active study of art'. Thus it had been sufficient for some external reason (i.e. the abusing of the Repin) to awaken the public's 'active attention to that which did not need it: the everyday world of the Wanderers'.

The final act of the Union of Youth's season was Grishchenko's lecture, 'Russian Painting and its Connexion with Byzantium and the West', which took place at the Troitskii Theatre on 2 May 1913, the day after the Knave of Diamonds' Petersburg exhibition closed.[89] The talk took its theme from Grishchenko's simultaneously published book of the same title, where the development of Russian painting is traced from the thirteenth to the twentieth century.[90] His idea was to establish the definition of a national art, claiming that the painterly idea had continually been present in Russian art from the ancient icons, through the Petrine period to the innovations of the present day. He examined the influence of foreign art on Russian in all periods, concluding that 'the originality of the national painter is never lost in the presence of foreign influences'.[91] But he attacked the World of Art, whose essence lay in 'retrospectivism, aestheticism and graphic arts',[92] and like Burlyuk and Rozanova before him, he rejected the art and criticism of

Serov, Vrubel and Benois, calling for 'free painting and the complete freedom of individualism'.[93]

Grishchenko's book provides one of the first serious Russian studies of Picasso's creative principles, but this seems to have been considerably reduced in the lecture. Instead he included a section based on the Knave of Diamonds.[94] Although he had participated with the Knave of Diamonds at its two 1913 shows, he was sharply critical of its approach which failed to 'escape from the Wanderers'.[95] He claimed that 'Konchalovskii, Mashkov, Lentulov, Ekster and Falk do not have the principles of easel painting, but a nationalism reduced to the representation of national objects.'[96] In other words they were entirely reliant on the pale imitation of Cézanne, French Cubism and Italian Futurism, lacking their European mentors' 'logical development and... natural growth'.[97] Such a notion was in keeping with the Union of Youth's newly critical attitude towards the Knave of Diamonds and as such it summed up the recent factionalizing, rather than unifying, tendency in the group.

The lecture passed off peacefully. The stuttering Grishchenko was a far less charismatic or phlegmatic orator than Burlyuk or Mayakovsky, and his argument covered much ground already known to the Petersburgers. Still, he reinforced their ideas about the state of modern Russian art and was soon invited back to deliver a lecture at the autumn debates. Furthermore, he contributed to the final Union of Youth exhibition in the autumn, having given up collaborating with the Knave of Diamonds. His May lecture signalled an end to the Union of Youth's 1912–3 season, and although individual members collaborated over the summer, it was only with the arrival of autumn that the group became fully active once more.

## References

1 See 'Protokol Obshchago Sobraniya chlenov Obshchestva khudozhnikov Soyuza molodezhi', 3 January 1913, Russian Museum, Fond 121, op. 1, ed. khr. 1, l. 10.
2 Spandikov, Matvejs and Dydyshko stood down.
3 See 'Protokol Obshchago Sobraniya', 9 January 1913, Russian Museum, Fond 121, op. 1, ed. khr. 1, l. 14. Target was the new name for Larionov's Donkey's Tail group. It was adopted to symbolise the antipathetic attitude of the public, critics and other artists to the group: 'As to a target, towards us fly the gibes and abuse of those who cannot raise themselves up to us, who cannot look at the problems of art with our eyes' (F. M., 'Luchisty', *Moskovskaya gazeta*, 7 January 1913, p. 2).
4 *Rech'*, 15 January 1913, p. 6. As noted above, until 19 January 1913 it was reported that the exhibition would travel to Helsingfors (See *Russkaya molva*, 13 January 1913, p. 6 and *Protiv techeniya*, 19 January 1913, p. 4).
5 See 'Doklady-disputy', *Rech'*, 17 February 1913, p. 6.
6 'Protokol', 5 February 1913, Russian Museum, Fond 121, op. 1, ed. khr. 1, l. 17.
7 *Sadok Sudei II* (March 1913) included four Rayist drawings by Larionov and Goncharova. It was dominated by the 'Hylaea' poets – Khlebnikov, David and Nikolai Burlyuk, Mayakovsky, Kruchenykh, Guro, Nizen and Livshits. David Burlyuk contributed several drawings of geometricised horses depicted from 'four points of view'. Also

two works by Vladimir Burlyuk were included that consisted of flat geometricised and facetted planes, reminiscent of tribal masks. These subsequently appeared on the poster for the Union of Youth's March debates.

8 Cited in Khardzhiev, *K istorii*, pp. 39-41.

9 See various programmes, Russian Museum, Fond 121, op. 1, ed. khr. 13, l. 13–6.

10 Cited in Khardzhiev, *K istorii*, p. 39.

11 *Ibid.*, p. 40.

12 Recorded in 'Protokol', 4 March and 6 March 1913, Russian Museum, Fond 121, op. 1, ed. khr. 1, l. 19 and l. 21 (Committee Meeting Minutes of 4 March and 6 March 1913). See also Rech', 15 March 1913, p. 5.

13 Cited in Khardzhiev, *K istorii*, p. 41.

14 See Khardzhiev, 'Mayakovskii i zhivopis'', in V. Pertsov, M. Serebryanskii (eds.), Mayakovskii; materialy i issledovaniya, Moscow, 1940, p. 371. Concerning Larionov's scandalous behaviour, see G. Pospelov, *Bubnovyi Valet*, pp. 110 and 237.

15 *Ibid.*

16 Cited in Khardzhiev, *K istorii*, p. 41.

17 Senior, 'O futurizme: Doklad I. M. Zdanevicha', *Russkaya molva*, 9 April 1913, p. 5. Zdanevich even went so far as to claim 'Futurism does not exist either in the Knave of Diamonds or the Union of Youth' (Rostislavov, 'Doklad o futurizme', Rech', 9 April 1913, p. 4).

18 In Target's manifesto 'Rayists and Futurists' [Luchisty i Budushchniki], (*Oslinyi khvost i mishen*, Moscow, 1913, p. 9), the group claimed 'We declare no war whatsoever, for where could we find opponents who are our equals!?'.

19 Larionov letter to Shkol'nik, undated, Russian Museum, Fond 121, op. 1, ed. khr. 39, l. 1. By this time Larionov and Goncharova had published (with Khlebnikov and Kruchenykh) six booklets: *A Game in Hell, Antique Love, The World From the End, Hermits, Half-Alive* and *Pomade*. Besides the second *A Trap for Judges*, no 'Futurist' booklets had yet appeared in Petersburg.

20 Burlyuk published *The Noisy 'benois' and the New Russian National Art [Galdyashchie 'benua' i novoe russkoe natsionalnoe iskusstvo]* in Petersburg in the summer of 1913. This booklet also included an advertisement for Union of Youth publications – among the proposals was Markov's *Chinese Flute* and *Faktura*, Burger's *Cézanne and Hodler*, Shkol'nik and Rozanova's *Almanac of Drawings*, a Union of Youth translation of Gleizes and Metzinger's *Du Cubisme* and *The Union of Youth* (No. 4) – the latter given the date of September 1913 for publication. Burlyuk's long-running argument with Benois stemmed from the latter's criticism of certain modernist artists at the Union of Russian Artists' 1910 exhibition.

21 'Bubnovye valety', *Russkoe slovo*, 26 February 1913, p. 7.

22 David Burlyuk, 'Kustarnoe iskusstvo', *Moskovskaya gazeta*, 25 February 1913, p. 2.

23 See 'Doklady-disputy', *Rech'*, 17 February 1913, p. 6.

24 'Protokol', 4 March 1913, Russian Museum, Fond 121, op. 1, ed. khr. 1, l. 19.

25 '... almost half the talk' was taken up with this according to A. Rostislavov, 'Disput o zhivopisi', *Rech'*, 26 March 1913, p. 5.

26 Malevich showed some of his most radical works to date, including *The Knife Grinder*, at the Target exhibition which opened the following day in Moscow.

27 Malevich introduced his talk thus: 'Ladies and Gentlemen, I hope you will try to restrain the raptures provoked in you by my interesting lecture.' (S. Timofeev, 'Disput o sovremennoi zhivopisi', *Den'*, 24 March 1913, p. 3).

28 *Ibid.* Viktor Shklovsky (*Mayakovsky and his Circle*, London, 1974, pp. 51–2) has added the following: 'Before the lecture, Malevich exhibited a picture: on a red ground, women in black and white, shaped like truncated cones. This was a powerful work, not an accidental find. Malevich did not intend to shock anyone, he simply wanted to explain what it was all about. The audience felt like laughing. Malevich spoke quietly: 'Serov that mediocre dauber...' The audience began to clamour joyfully. Malevich looked up

and calmly said: "I was not teasing anyone, that is what I believe." He continued his lecture.'

29 For Marinetti's literary manifesto, see E. Sem-v., 'Futurizm (literaturnyi manifest)', *Nasha gazeta*, 6 March 1909, p. 4.

30 'The Union of Youth', *Credo*, St. Petersburg, 23 March 1913, Russian Museum, Fond 121, op. 1, ed. khr. 13, l. 17.

31 Timofeev, 'Disput o sovremennoi zhivopisi'.

32 O. Rozanova, 'Osnovy novogo tvorchestva i prichiny ego neponimaniya', *Soyuz molodezhi*, No. 3, March 1913, pp. 14-22.

33 'The Union of Youth', *Credo*.

34 'Manifesto of the Futurist Painters', 1910, cited from U. Apollonio, *Futurist Manifestos*, London, 1973, p. 26.

35 It is worth noting that Bergson's *Creative Evolution* was published in Russian translation as *Tvorcheskii Evolyutsiya*, Moscow, 1909.

36 Larionov, 'Predislovie', *Mishen*, [exhibition catalogue], Moscow, 1913, pp. 5-6.

37 See F. M., 'Luchisty'.

38 Rostislavov, 'Disput of zhivopisi'.

39 *Ibid.*

40 Timofeev, 'Disput of sovremennoi zhivopisi'.

41 Khardzhiev, 'Mayakovskii i zhivopis'', p. 362.

42 'Sokrashchennaya programma', Russian Museum, Fond 121, op. 1, ed. khr. 13, l. 13.

43 'I disput publichnyi 'O noveishei russkoi literature', Russian Museum, Fond 121, op. 1, ed. khr. 13, l. 28–9.

44 'Protokol', 6 March 1913, Russian Museum, Fond 121, op. 1, ed. khr. 1, l. 21, and see Khardzhiev, 'Mayakovskii i zhivopis'', p. 363.

45 For a full examination of the literary side of Russian Futurism see V. Markov, *Russian Futurism – A History*, London, 1969. See also V. Barooshian, *Russian Cubo-Futurism 1910–30*, The Hague/Paris, 1974.

46 Tan., 'Kubisty i kruglisty', *Rech'*, 26 March 1913, p. 2.

47 See Mayakovskii, 'O noveishei russkoi poezii'.

48 Published in F. Marinetti, *Zang tumb tumb*, Milan, 11 May 1912. See Marianne W. Martin, *Futurist Art and Theory 1909–15*, Oxford, 1968, p. 128.

49 Martin, *Futurist Art*, p. 128.

50 V. Kandinskii, 'Soderzhanie i forma', *Salon 2*, p. 16.

51 Tan., 'Kubisty i kruglisty'. These are nonsense words.

52 Vasilisk [Vasilii Ivanovich] Gnedov (b. 1890). His most famous work is a cycle of poems, *Smert iskusstva* (Petersburg, 1913) in which the last poem is a blank page.

53 Tan., 'Kubisty i kruglisty'.

54 See 'Protokol', 9 January 1913.

55 See 'Protokol', 8 March 1913, Russian Museum, Fond 121, op. 1, ed. khr. 1, l. 22. However, the Union of Youth still intended to publish the translation of *Du Cubisme* separately.

56 See 'Protokol', 4 March 1913, Russian Museum, Fond 121, op. 1, ed. khr. 1, l. 19.

57 *Soyuz molodezhi*, No. 3, 1913, p. 5.

58 A. Kruchenykh, 'GO OSNEG KAID', *Soyuz molodezhi*, No. 3, p. 72.

59 This had originally appeared as a seperate booklet: V. Khlebnikov, *Uchitel' i uchenik. O slovakh, gorodakh i narodakh*, St. Petersburg, 1912.

60 A. Baller, 'Apollon budnichnyi i Apollon chernyavyi', *Soyuz molodezhi*, No. 3, 1913, pp. 11–13.

61 A. Baller, 'O khromoterapii uzhe ispol'zovannoi', *Soyuz molodezhi*, No. 3, 1913, pp. 23-24.

62 E. Spandikov, 'Labarint iskusstva', *Soyuz molodezhi*, No. 3, pp. 6–10.

63 N. Burlyuk, 'Vladimir Davidovich Burlyuk', *Soyuz molodezhi*, No. 3, 1913, pp. 35–8.

64 See W. Worringer, *Abstraction and Empathy*, New York, 1980, pp. 21–2.

65  O. Rozanova, 'Osnovy novogo tvorchestva i prichiny ego neponimaniya', *Soyuz molodezhi*, No. 3, 1913, pp. 14–22.

66  In the *Credo* the metaphor of sleep was used several times with reference to the establishment, suggesting Rozanova's contribution.

67  Spandikov, 'Labarint iskuustva', pp. 6–7.

68  Rozanova, 'Osnovy', p. 19. Cf. Matvejs: 'the deft brushstrokes of Zorn or Sorolla are no more than *salto mortale*, cheap effects... We deny acrobatics in painting.' ('Russkii Setsession').

69  Petr Uspenskii, *Tertium Organum*, Petersburg, 1911, p. 60, cited from M. Matyushin, 'O knige Gleizes i Metzinger *Du Cubisme*', *Soyuz Molodezhi*, No. 3, 1913, p. 26. Matyushin's comparison of *Tertium Organum*'s tenets with those of Cubism, as expressed in Gleizes and Metzinger's *Du Cubisme*, suggests that such a relation was current among members of the Union of Youth.

70  Rozanova, 'Osnovy', p. 14.

71  Cited from Matyushin, 'O knige', p. 26.

72  Rozanova wrote, as if anticipating Matyushin's 'SEE-KNOW' theory, that modern art was: 'what the artist sees + what he knows + what he remembers etc.'.

73  This title is taken from J. Kowtun, *Die Wiedergeburt der künstlerischen Druckgraphik*, Dresden, 1984, p. 84.

74  *Starinnaya Lyubov, Mirskontsa and Igra v adu*, Moscow, 1912.

75  During the second half of 1913 they published *Bukh Lesinnyi, Vzroval', Vozropshchem, Porosyata, Slovo kak takovoe, Chort i rechetvortsyi, Ryav! Pertchatki!* and *Utinoe Gnezdyshkov... durnykh slov*. See Compton, *The World Backwards*, pp. 125–6.

76  M. Matyushin, 'O knige Gleizes i Metzinger *Du Cubisme*', *Soyuz Molodezhi*, No. 3, 1913, pp. 25–34. Matyushin himself published the separate edition of *Du Cubisme*, translated by his sister-in-law Ekaterina Nizen (St Petersburg, 1913), which the Union of Youth had originally discussed publishing. Also in 1913 a translation by M. V. [Maksimilian Voloshin] appeared in Moscow, and excerpts from the book were translated in *Russkaya molva*, 21 January 1913, p. 3.

77  Gleizes and Metzinger, *Du Cubisme*, Paris, 1912, p. 11. Fry has observed that, despite talk of the fourth dimension by some Cubist critics, 'the authors' [Gleizes and Metzinger] metaphorical reference to non-Euclidean geometry, of which they knew hardly anything at all, is only a restatement of the similarly poetic reference to the 'Fourth Dimension', which originated with Apollinaire in 1911 [*Gil Blas*, Paris, 26 November 1911].' (E. Fry, *Cubism*, London, 1978, pp. 111–12).

78  See A. Parnis, P. Timenchik, 'Programmy Brodyachei sobaki', *Pamyatniki Kul'tury 1983*, Leningrad, 1985, p. 208.

79  See 'Protokol', Russian Museum, Fond 121, op. 1, ed. khr. 1, l. 23-28.

80  Aleksei Vasil'evich Grishchenko (1883–1977) had studied painting in the Moscow studios of Yuon (1910) and Mashkov (1911).

81  See 'Protokol', 19 April 1913, Russian Museum, Fond 121, op. 1, ed. khr. 1, l. 28.

82  See A. Nakov, 'Notes from an Unpublished Catalogue', *Studio International*, London, 1973, XII, p. 223.

83  By this time Mayakovsky had already written 'Painting of the Modern Day', which was published in 1914: V. Mayakovskii, 'Zhivopis' segodnyashnego dnya', *Novaya zhizn'*, Moscow, May 1914.

84  Tatlin, postcard to Shkol'nik, 30 April 1913, Russian Museum, Fond 121, op. 1, ed. khr. 67.

85  Mention of this article, 'The Sense of the Fourth Dimension' is made, for example, in S. Compton, 'Malevich's Suprematism – The Higher Intuition', *The Burlington Magazine*, August 1976, p. 579.

86  O. Rozanova, 'Voskreshnii Rokhombol'', Russian Museum, Fond 121, op. 1, ed. khr. 82, l. 1–2.

87  'Skandal na lektsii', *Rech'*, 4 March 1913, p. 2. See also *Russkaya molva*, 4 March 1913,

p. 4. In fact it was this event, which led the Union of Youth to be extra-cautionary at its debates later in the month. Zlotnikov was an anti-revolutionary artist whose cartoons illustrated the Black Hundreds papers.

**88** One of Ponson du Terrail's tales was entitled *La resurrection de Rocambole* (Paris 1866). Concerning Terrail's influence on the Knave of Diamonds, see Pospelov, *Bubnovyi Valet*, pp. 100–2.

**89** It had been reported at the end of 1912 ('Bubnovyi valet', *Teatr*, 23 December 1912, p. 3) that a Knave of Diamonds almanac, with the following articles, would be published within a few days: Kandinsky, 'Posvyashchenie (vvedenie k teorii novago zhivopisnago iskusstva)' [Dedication (An introduction to the theory of new painterly art)]; D. Burlyuk, 'Kubizm i zhivopisnyi kontrapunkt' [Cubism and painterly counterpoint]; Le Fauconnier, 'Sovremennaya vospriimchivost' i kartiny' [Modern receptiveness and paintings]; and Apollinaire, 'Ferdinand Léger'. In the event only the last two articles were included with Aksenov's 'K voprosu o sovremennom sostoyanii russkoi zhivopisi' [On the question of the modern situation of Russian painting] (the theme of his lecture at the Knave of Diamonds debate on 24 February 1913); and two exhibition reviews.

**90** A. Grishchenko, *O svyazyakh russkoi zhivopisi s Vizantiei i Zapadom XIII-XX vv. Mysli zhivopistsa*, Moscow, 1913.

**91** A. Rostislavov, 'Doklad v Troitskom teatre', *Rech'*, 4 May 1913, p. 4.

**92** *Ibid.*

**93** *Ibid.*

**94** This section compares with his article on the group: A. Grishchenko, 'Bubnovyi valet', *Apollon*, No. 6, 1913, pp. 31–8.

**95** Rostislavov, 'Doklad v Troitskom teatre'.

**96** *Ibid.*

**97** 'Doklad A. V. Grishchenko', Russian Museum, Fond 121, op. 1, ed. khr. 13, l. 35–6.

# Act II Scene ii, The final curtain

The Union of Youth's seventh exhibition turned out to be its last. It was also one of its most remarkable, not least because of the radical new work by Malevich, Filonov and Rozanova. Having opened early in the exhibiting season, on 10 November, the show continued for a full two months until 12 January 1914. The venue, 73 Nevskii Prospekt, was the same as the previous year.

As expected, Larionov, Goncharova and Shevchenko were absent. However, they had, upon their request, been sent invitations to participate. This appears to have been a ruse to create antagonism, for the Moscow artists informed Shkol'nik, through Malevich, that their request had only been a joke.[1] Malevich himself did take part, as did Tatlin, Morgunov and the Burlyuk brothers, and they brought with them from Moscow Shekhtel', Khodasevich, Podgaevskii, Sinyakova, Labunskaya and Klyun. Other new artists included Al'tman, Bezhentsev and Lasson-Spirova,[2] while Filonov, Zel'manova and Ekster returned after absences. Besides the 165 catalogue entries, a posthumous exhibition of Guro's work was also held – the only time she showed with the group she helped found.

Though Guro's exhibition was given a separate room it was largely passed over by the critics, who concentrated on the more sensational work of the other halls. As Rostislavov had earlier noticed in his obituary of Guro, the reason for the general silence about her was that she had given the critics no food for irony or ridicule.[3] In fact her art, just as her prose and poetry, was always distinguishable from that of her colleagues by its intimate love for the impressionistic appearance of nature. This nature, essentially the Finnish landscape, she seemed to feel rather than see. Her watercolours and ink drawings often catch fragments of roots and stones, branches of pine trees or a path. The feeling of an intuitive awareness of organic growth is evoked. Volume and perspective are ignored. Guro seems to not only have penetrated other worlds but had them penetrate her.

The brief notices that Guro did receive give a sense of how representative her posthumous exhibition was. Denisov remarked: 'There are many graphic and illustrative qualities, as well as symbolism, in the works of the recently deceased E. Guro – a delicate talent that is more poetic than painterly. The most successful of her drawings is the Japonist sketch of a snow-covered tree and two or three pencil landscapes';[4] and Rostislavov

noted 'There is a quite delicate realism in the very attractive, very schematic and generalised work of the late E. Guro. She feels nature so subtly. Many of her small works, book decorations etc. are very good.'[5]

Guro's impressionism appears unique at the exhibition, her empathy with nature only comparable to Matyushin. The new concentration on pictorial construction outlined by Rozanova in her recent essay, and a continuation of the coloristic concerns already stated in the work of Shkol'nik and Shleifer, dominate. Most striking is the adaptation of Neo-Primitivism to the new ideas concerning the expression of the basic elements of painterly art. A Cubist fragmentation of form and a Futurist interest in dynamism and urban subject matter are much in evidence for the first time.

Rostislavov and Denisov were the only critics to seek meaning in the work. The latter found it essentially superficial, but explained this by the lack of a genuine school of painting in Russia, and welcomed the attempt to start afresh. However, he found unfortunate traces of the 'uncreative' World of Art in:

> the general... absence of strict demarcation between the principles of easel painting and stage decoration; the ornamental complexity and crampedness of composition instead of a wise simplicity; the often ungrounded colouring (in some cases colour alone comprises the painting); the bluntness of the tube paint, which has not been transformed into strong and restrained tones; and finally in the lack of a manipulated painterly texture – a satisfaction with the easy and superficial means of painting.

Rostislavov was more enthusiastic, recognising the painters' right to try to paint not only 'that which you see... but also that which you know, not only the static, but also the dynamic'. His general impression of the exhibition was of 'a union, not on the grounds of a universal, definite aim, but on the grounds of novelty, and, principally, of isolated individuality. Here a fair amount is already old, but I would add that in the majority of the good painting, the old has been renewed with some sauce of novelties.'

Malevich's work was the most sensational at the show. While his output of 1913 has been the subject of much recent analysis,[6] there has been little attempt to study its context with regard to the Union of Youth, and hence this aspect is stressed here. Indeed, since early 1913 Malevich had been one of the Union of Youth's most active members. His meeting with Matyushin the previous winter was crucial. It resulted in a friendship and working relationship that led to his non-objectivity and, more immediately, to 'transrationalism'. Thus in June 1913 he was able to write to Matyushin: 'We have come as far as the rejection of reason so that another kind of reason can grow in us, which in comparison to what we have rejected, can be called beyond-reason, which also has law and construction and sense, only by knowing this will we have work based on the law of the truly new, the beyond-reason.'[7]

Malevich's arrival at this conception of an alternative order of things is comprehensible given the circles in which he now moved: it relates to both Filonov's and Rozanova's analytical and intuitive principles, as well as to Matyushin's Uspenskian interpretation of *Du Cubisme*, and Markov's call for the abandonment of causally created art. Inevitably, a symbolist legacy is felt.

In the same letter, Malevich developed his means of using 'beyond-reason' (that is *zaum*) in art:

> This reason [*zaum*] has found Cubism for the means of expressing a thing... I don't know whether you agree with me or not but I am beginning to understand that in this beyond-reason there is also a strict law that gives pictures their right to exist. And not one line should be drawn without the consciousness of its law; only then are we alive.[8]

Malevich's awareness of this law was to be reflected in his Union of Youth exhibits. These he divided into two groups: '*zaum* realist' works, all of which were created in 1912, thereby predating his *zaum* ideas; and 'Cubo-Futurist realist'. His letters to Shkol'nik of late October and early November 1913 indicate how laboriously he organised the Moscow contributions to the show and how much his new works, with their new sense of research and discovery, meant to him. He described his depression at sending off the works upon which he had spent so much recent time, and which had surrounded him in his apartment. In addition, he wrote of his poverty and the need to sell the paintings at any cost. This was reflected in the prices pencilled in the administrative copy of the catalogue,[9] which range from a very meagre twenty-five roubles for the Cubo-Futurist *Paraffin Stove* to a mere 100 roubles for *The Samovar* (by contrast Filonov asked 2,400 roubles for *Feast of Kings*).

Between 1912 and 1913 Malevich experimented with a variety of modern styles from Neo-Primitivism to a Cubist geometricisation. He had used the peasant as a motif to represent the eternal. As seen above, his peasant changed from a clumsy bestial character into a primitive machine being. Benois had noted this swing at the previous Union of Youth exhibition but had found it a hesitant oscillation, spoiling what he considered Malevich's otherwise attractive work. He concluded: 'In previous times, it was very likely that a man was praised for "searching" and "not standing still". But truly now what is demanded from an artist is "firm groundedness" and "inviolable conviction"'.[10] Malevich requested (in vain) that the following reply be printed in the exhibition catalogue above his entries: '"But truly now what is demanded from an artist is inviolable conviction..."' (Benois, 21.12.1912). But I say that the inviolable will be destroyed tomorrow and the only one who lives is he who destroys his convictions of yesterday.'[11] Thus he allowed himself to assimilate and interpret a number of styles in quick succession. This even permitted, as seen many years later in his

return to the peasant motif and figurative art, the possibility of utilising styles already tried and abandoned, without fear of contradicting 'modern' tendencies.

Malevich's description of his works as realist indicates he regarded them as the result of perception. His six examples of *'zaum* realism' included some (for example, *Morning after the Blizzard in the Village* and *The Knife Grinder*) shown in the Spring at the Target show. In fact, the catalogue labelling of Malevich's work as *'zaum'* and 'Cubo-Futurist' realist is misleading, not least because the former were supposedly created when the idea of *zaum* had not yet crystallised in his thinking. Furthermore, the notion of Cubo-Futurism was also very new and ill-defined at this stage.

However, the works belonging to the *'zaum* realist' group do constitute a recognisable group and almost certainly belong to a period between the end of 1912 and the middle of 1913. They continue the use of peasant motif seen in 1912 but with an increasing fusion of subject matter and environment. This, in turn, shows a growing mastery of Cubist and Futurist principles.[12] The decorative canvases *Morning after the Blizzard in the Village, Peasant Woman with Buckets,* and *The Knife Grinder*, start from the same heavy, volumetric, geometricised figures as *Taking in the Rye*, but end with multiple viewpoints and a new analytical and dynamic form.

*The Knife Grinder* (cat. 66, Yale University) could be described as a Futurist depiction of movement, though, as Compton has pointed out, it 'illustrates a complex reaction… to stimuli borrowed from the European avant-garde'.[13] Thus the circular movement of the grinding tool creates reverberations throughout the composition. The figure is seen in profile and full-face, and the legs and feet are repeated. The stairs recall Duchamp's *Nude Descending a Staircase* (reproduced in Gleizes and Metzinger's *Du Cubisme*). Furthermore, a debt to Léger is felt: the mechanised world and fragmentation of matter, lacking a systematic grid, is highly suggestive of Léger's *Woman in Blue*, which had been shown in a Moscow exhibition of French art in January 1913 and reproduced in a Russian journal as early as October 1912;[14] and the stylisation of the hands appears to have been borrowed from Léger's *Essay for Three Portraits*, shown at the Knave of Diamonds 1912 exhibition.

Despite the *zaum* appearance of the staircase and balustrade in *The Knife Grinder*, and the saw blades and the objects in the place of the subject's left eye in *The Completed Portrait of Ivan Klyun* (cat. 65, Russian Museum), only the latter represents a clear shift towards the representation of Malevich's new transrational world of four dimensions. Here the interpenetration of planes and the alogical association of elements begin to dominate. The metallic surfaces are cut open and the reassemblage, with its broken contours, only loosely resembles a head. The right eye is split and

the space of the left eye, crowded with objects, creates an ambiguous representation of volume. This deliberate distortion of the eyes suggests their function is more than optical. It states that the eye is knowing and can perceive a new spatial reality. Such a visual statement prepares the way for the higher reality perceived by 'Cubo-Futurist realism'. Thus *The Completed Portrait of Ivan Klyun*, while linked to the *Portrait of Ivan Klyun* shown previously, shows a transition to the study of volumes and hyperspace seen in the decorations Malevich made for Kruchenykh's *zaum* opera *Victory over the Sun*.

The '*zaum* realist' works are united by their withdrawal from the ordinarily visible world to a world of unified colour planes. The subject, related to the title, is still clearly identifiable despite the fragmentation of formal elements. However, Malevich added an independent sense of vitality and mystery to his exploitation of Parisian developments. Recorded in the catalogue as 1913 examples of 'Cubo-Futurist realism' are six works: *The Reapers, The Paraffin Stove, The Wall Clocks, The Lamp, The Samovar* and *Portrait of a Landlady*. These are less well known than the '*zaum* realist', but relate closely to Malevich's new graphic work in Kruchenykh's Futurist booklets.[15] Contemporary descriptions help create an impression of their appearance, e.g. '*Wall Clocks* is a painting in which he [Malevich] has broken up into parts not only the casing with the time and pendulum but also the very amplitude of the pendulum and the hour striker with its wheezing sound, as well as the measured definition of the sound etc., the knowable and non-knowable, the existing and the implied...'[16] Such a fragmentation resembles that seen in *The Completed Portrait of Ivan Klyun*. However, Rostislavov hints that the formal elements have become more of a processed 'hodge-podge', rather than retaining the integrity of the works in the other section. This is also suggested by the description of *Portrait of a Landlady* (cat. 72) as a 'formless pile of little cubes and cylinders' – which apparently contained no visual reference to the subject of the title.[17]

Malevich's Cubo-Futurism represented the new order of things. It acted as a progression from '*zaum* realism', which perceived the new order from the point of view of the old order. Inevitably, a new consciousness had to be attained to be able to represent the new, fourth-dimensional order. To this end, nature, and consequently the peasant, had to be abandoned. As a result, Malevich changed his motifs as well as his style, but did not limit himself to the Italian Futurists' devotion to the machine. His titles suggest man-made, domestic objects, symbols of home-life in the city.

Where the object is indicated in 'Cubo-Futurist realism', it is fragmented almost to the point of non-recognition. Malevich makes use of Braque's and Picasso's Cubist painting of 1910–12, basing the composition, as in *Samovar* (cat. 71),[18] on a systematic grid, fragmenting forms,

muting colours for the first time, and divorcing the planes from representational function. Dynamism is created by the oblique turning of the squares to form diamonds. The viewpoint is no longer relevant – the artist has gone within: 'the world did not exist from below, from above, from the side of from behind: we merely formed conjectures about it... We began to regard the world differently and discovered its many-sided movement and were thus faced with the problem of how to convey it fully.'[19]

In *Musical Instrument/Lamp* (cat. 70?, Stedelijk Museum, Amsterdam), which is closely related to his designs for *Victory over the Sun*, Malevich borrowed ideas from Picasso's new work in Shchukin's collection, e.g. *Violin and Guitar* (1913). Yet, his colours are not so entirely subservient to form, as he uses purple to create a shallow depth to the construction, without binding it to its surroundings. In addition, and in keeping with the *zaum* ideas of *Victory over the Sun*, the work seems to relate, through its underlying geometrical structure, to a diagram of a tessaract (i.e. a four-dimensional solid as it passes through three-dimensional space, generated from a three-dimensional cube) from Charles Howard Hinton's book *The Fourth Dimension* (1904).[20] Here then Malevich appears to have found an original and vital pictorial solution to the representation of the 'fourth dimension'.

Like Malevich, Filonov was particularly active in Union of Youth circles in 1913. The group even planned and announced a lecture on him by Nikolai Burlyuk.[21] Entitled 'P. N. Filonov: The Crowner of Psychological Intimism', it was to look at all aspects of Filonov's work: his sources of inspiration (from Goya, Poe, Hoffman, Bosch, Leonardo to the Russian *lubok*, miniatures, the primitive art of Africa and Asia and ideography), formal qualities and context.[22] As Malevich, Markov, Matyushin and Guro, Filonov felt able to penetrate the exterior world to an essential core and to this end employed styles from previous epochs, while concerning himself with the inner analysis required for the expression of essential universal qualities. However, he differed in his selection of sources and his compositional analysis, with its skeletal figures and atom-like forms.

At this time Filonov was working on his theory of 'made paintings' and rejecting Cubism for its limited dependence on the visible qualities of an object (i.e. its colour and form). He called instead for the use of a 'knowing eye' rather than just a seeing one.[23] Understanding as a prerequesite for sensing and expressing the eternal could only be achieved through intense and dedicated work. The natural result of such work was a painting or drawing made according to its own organic and evolutionary requirements, with its own inner forces as well those of its creator.

None of Filonov's exhibits were given descriptive titles, referring instead to the type of composition, i.e. *Painting, Half a Painting*,[24] *Six Coloured Drawings (Principle of the painting), Design of a Lubok Picture,*    **191**

*Drawing* and *Sketch*. Only in the inventory catalogue were references to subjects pencilled in, e.g. *Painting* (cat. 133) became 'Russia after 1905' and *Design of a Lubok Picture* (cat. 135) 'Man and Woman'. Painting (cat. 131), has since received the title *Feast of Kings*. Filonov valued this work far higher than any other, its marked price being 2,400 roubles, more than ten times the average cost of exhibits (Shkol'nik, for instance, asked only 100 roubles for his pictures). His title, *Painting*, indicates that he considered this one of the most worked out and complete compositions.

Surprisingly, considering Filonov's fantastic imagery, his work attracted little attention. As a consequence *Feast of Kings* (1913, Russian Museum) is the only exhibit that can be identified with certainty. The nightmarish images of *Heads* recur with similar blood-red tones and a dark, heavy atmosphere. Here, however, the naked and sometimes fleshless figures are far more orderly, sculptural and primitive. Despite their lack of relations with one another they partake in a common ritual. The canvas is filled with their oppressive, dehumanised solemnity – a feeling that is enhanced by the distortions of the figures. The multiple symbolic references to various art forms bear witness to Filonov's unique interpretation of areas of interest to his contemporaries. Thus the influence of stone *baba* sculptures is evident, especially in the face of the highlighted female figure second from the left at the back; reference is made to Bosch's grotesque figures; and the arm gestures, the rich red and gold colour tones and the order of the line of figures behind the table can be related to Russian icons. Filonov sought a realism (like Malevich), as he himself called it,[25] that was essentially cerebral. Reference to the visual world, as earlier, was to be primarily artificial in order to emphasise the distinctly creative process of art.

Although the identity of the *Half Paintings* is no longer known, one critic described them as populated by 'an infinite number of figures of various sizes, which have no connections of any sort between one another',[26] in keeping with the tendency expressed in *Heads* and *The Feast of Kings*. Similar concerns are evident in *Man and Woman* (cat. 135?, Russian Museum). Here Filonov has adapted another sort of primitive art to his own – the *lubok*. This is evident, for example, in a disproportionately small row of primitive figures along the bottom edge of the composition. The differences in scale and sizes are not accompanied by any attempt to accommodate them within spatial recession. The rural peasant order of the lower line of figures, who are led away by some top-hatted urban figures, contrasts with the towering, artificial and chaotic city world above. Figures and buildings are stacked up on each other. A barred window represents the imprisonment such a world creates for the human psyche. Figures are emaciated and deformed. Multiple viewpoints create an interplay of ambiguous spatial relations and light. Colour is softened to light blues, sandy buff and muted reds. While the two figures floating on the picture surface

appear as smoothly carved ivory, the king and throne to the right are marked by a facetted linearity. Both the country and city order evoked are lands of fools. In this way Filonov retains his sense of symbolism.

Rozanova's seventeen exhibits showed, as did her illustrations to *The Union of Youth* and Kruchenykh's Futurist booklets, a gradual abandonment of the Fauvist Neo-Primitivism seen earlier. Some new works were grouped together as 'Ways and Characters of Psychical Movements (Experiment in the Analysis of My Own Creative Work)', indicating the process of interiorisation that she had discussed in 'The Bases of the New Creative Work'. Her titles varied from abstract and semi-abstract notions, e.g. *Dissonance, Landscape-Inertia*, to more specific references to external reality, e.g. *Construction of a House, Embankment*, and *Portrait of Kruchenykh*.

In *Construction of a House* (cat. 102) figures were created from flat, boldly delineated, curvilinear planes, the horses and cart at the bottom being cut off by the edge of the canvas. To this is added a new disregard for geometric perspective as the picture is packed with a sense of vertical growth similar to Filonov's *Man and Woman*. Like the Filonov, the degradation and alienation of city life for workers and animals alike is stressed. The figures are faceless and attain a primitive monotony of repeated movement.

While still evoking Rozanova's concern for the dehumanising effects of the city, *Man in the Street* (cat. 105, Thyssen-Bornemisza Collection) is more dynamic and Futurist. In this, and other urban landscapes of the period, her palette is subdued – greys, browns and black dominate, as if evocative of the primary impression left by such landscapes. The figure is fragmented into a series of disjointed colour planes, apparently inspired by Carrà's *Plastic Transcendences* (1912, shown at *Der Sturm* in September 1913). The planes intersect at all angles, giving a sense of the street entering the man. This fusion of the subject with his surroundings is further encouraged by the repetition of parts of the figure and a multiple viewpoint. Thus his left arm appears at once by his side and behind him; his nose is in profile; while his face has disappeared altogether. Elements of writing, steps and buildings surround and penetrate the figure. This retention of visual elements appears to be a response to Le Fauconnier's call, published in *The Union of Youth*, for a work of art to retain just enough reference to visual reality as the artist feels necessary.[27] Such a reference could then act as a link between the artist's spirit and the material.

While the final Union of Youth show was dominated by the innovations of the previous three artists, the appearance of their work was not totally isolated.[28] Tatlin contributed four works: three 'laconic, in the Japonist fashion, and masterly'[29] ink drawings and *Composition Analysis (Oil)* (cat. 127). These appear not to reflect the extent of his exploration into mixed

**193**

**22** M. Sinyakova, untitled work

media construction, which had commenced after his European travels and visit to Picasso earlier in 1913.[30] However, a pencil and gouache sketch known as *Composition Analysis* (Kapitsa Collection, Moscow), quite possibly a study for the oil at the Union of Youth, reduces form to a set of carefully selected and proportioned planes. As Zhadova has pointed out,[31] what is depicted is the constructive basis for a Madonna and Infant composition. Whether Tatlin used as his model an icon or a Cranach *Madonna*, is questionable since the angle of the line, the inclination of the heads and the position of the infant's legs are suggestive of both. Indeed, Zhadova has proposed that Tatlin synthesised the two:

> Tatlin, aware of the tenets of Cubism, has brought into his own composition the 'open' rhythm of spatial tension, creating a new unity based on the principle of dynamic balance... Tatlin laid bare the classical method of creating a picture, at the same time reinterpreting it and giving it new constructive essence... The symbiosis of the refined rhythmics of icon painting and the stereoscopic effect of mathematically exact Renaissance compositional techniques, created in Tatlin's art 'genes' from which it was possible later for 'material culture', Tatlin's organic constructivism, to evolve.[32]

This suggests that *Composition Analysis* marked a turning point in Tatlin's art and was one of the most remarkable works at the show. Indeed, the constructive distribution of the pictorial elements in Tatlin's painting, while far more rationalised than Malevich's or Rozanova's compositions, indicates a heightened sensitivity to the material and retains a symbolic and spiritual strength, in keeping with his artistic milieu.

The Burlyuks continued along much the same lines as the previous year, indicating a concern with compositional principles and folk art but lapsing into decoration rather than analysis. Yasinskii described Vladimir Burlyuk's

'minimalist' *Self-Portrait from Two Points of View (the Revelation of Orange and Blue Colours)* (cat. 4) thus: 'If you look at a man and see nothing except orange and blue stripes, then with two brushes you dip one into orange paint the other into blue and you draw on the canvas two oblique stripes – then you get the portrait of Burlyuk.'[33] David Burlyuk contributed just three works including *Running Horse (Primitive) and Image from Three Points of View*. The third work, *Conductor of the Moscow Bolshoi Theatre (the opera 'Lakme')* (cat. 8, reproduced in *Ogonek*) used a Futurist fragmentation of forms into small facetted planes. There are also, as in Rozanova's exhibits, a few visual reminders of the subject (two huge black arms at the top right of the canvas, a pair of eyes in the centre, a treble clef, instrument strings).

Morgunov exhibited *The Aviator's Study* (cat. 85, formerly Costakis Collection), a small gouache consisting of planar forms painted in subdued browns and greys on a geometricised linear grid. Within the abstract planes are identifiable objects, including two faces, papers and a ball. These are crossed, with collage effect, by a simple model plane and a hatchet. The word 'Polski' is added in the top left corner. Two decorated black boxes stand out from the composition like labels. The theme of aviation, a perfect symbol for the rejection of the old world order, was of increasing interest to the Cubo-Futurists. Indeed, in June 1913 Malevich had published, possibly the first Cubo-Futurist drawing, *Simultaneous Death of a Man in an Aeroplane and on the Railway,* in Kruchenykh's *Explodity* [*Vzorval'*], which has much in common with Morgunov's use of the subject.

The works of the aforementioned artists represent the most original aspect of the exhibition. As has been shown, they are intimately linked by a new study and interpretation of developments in Cubism and Futurism. Although symbolism is still present in this, it represented a considerable break with the group's previous Neo-Primitivism. But it is essential to remember that to a large extent these artists were not Union of Youth members, or if they were, they had only recently joined. Many were still living in Moscow. Although the public identity of the Union of Youth was inextricably altered by these artists, they did not represent the main core of the group. Thus it is worth examining the work of the remaining Petersburg artists in order to get a fuller impression of the group.

Potipaka was compared to Filonov for the complexity of his composition[34] and did have titles that suggested an interest in similar themes to the more avant-garde exhibitors (e.g. *Fools, Grinders*). In all he showed nine works, including *Zarathustra, Firing at the Target* and *Beautiful Idea*, which paid tribute to his 'great reserves of fantasy'.[35] Yet Rostislavov again found cause for comparison with Stelletskii and Vrubel in the stylisations of *Youths, Fools*, and *The Grinders*, and also noted their 'confident and skilfully composed figures which still speak of the old canons'. **195**

Similarly, Spandikov also seems to have in part touched on the avant-garde's concerns. First, his lost *About Landscape* and *About Colour*, suggest an analysis of painterly form. Second, his other paintings used inexplicable, *zaum*-like symbols to convey their objects. Thus *Time* (cat. 122): 'He has depicted time in the form of a naked female figure whose stomach has the appearance of a spurting fountain. Why is this time?'.[36] Such an apparently alogical association of form and subject matter is reiterated in *Easter* (cat. 121): 'A huge blue egg, perhaps that of an ostrich, is set in the middle of a huge canvas on a yellowish tendril.'[37] That painted eggs were an Easter tradition is the only link of the composition and its title. The 'yellowish tendril' was described by another critic as 'a gramophone trumpet'[38] and it was perhaps from this that Yasinskii speculated about the musical qualities of the work. In any case, Spandikov continued the sketch-like quality in both his drawings and paintings, leading Rostislavov to call his style 'non-composed realism'.

A Fauvist primitivism was retained by Shleifer and Shkol'nik. Both contributed several provincial scenes. An interest in primitive art is suggested by Shleifer's 'very original' *Smith's Signboard* (cat. 160).[39] However, a tendency to decoration was evident in *Bakhchisarai* and *Still-Life*, the latter being marked by its 'over-sweet Sudeikin or Anisfel'd colours'.[40] In Shkol'nik's *The Provinces* (Plate 23) the flattened buildings and spatial ambiguity appear essentially as a play with stylistic device rather than the

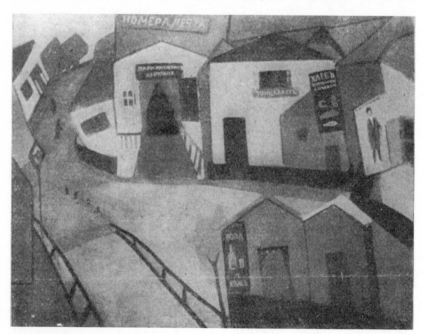

**23** I. Shkol'nik, *The Provinces*

analysis of structure seen in his lithographs for *The Union of Youth*. However, he does display a concern with signboard art, and this is emphasised by the prominence of the various shop signs: ''The Dream' Guest-House', 'Barber-Leech', 'Dance Class', 'Bread and Fish', 'Tailor' and 'Water and *Kvass*'. Here the provinciality is evoked by the use of old, local words such as 'tsirul'nya' for barber-leech and the use of 'o' instead of 'a' in the spelling of dance-class ('tontsklass' rather than 'tantsklass'), which recalls the misspelling in Tatlin's *Naval Uniforms*.

Zel'manova also retained an interest in primitivism. Of her many exhibits, that which found most admiration, *Golgotha (Imitation of the Siena School)* (cat. 46), indicated a study of medieval principles. Denisov found the work too encumbered by graphic and decorative qualities, but other critics admired both its painterliness and the originality of its use of Italian primitive sources.[41] The majority of her exhibits were landscape studies, described by Rostislavov as 'well generalised' and following the 'latest aims'. She also contributed a number of single-figure compositions, including a 'green *Female Model* and a blue *Self-Portrait*'[42] (Plate 24), which showed little change from *Margueritte*, shown at the start of 1912.

Rostislavov found Dydyshko an 'extremely cultured artist'. Having graduated from the Academy in November 1912, he now felt freer to exhibit and less inclined to compromise. He had been drawn to Impressionist landscape since his early days as a student in Tbilisi, and this persuasion, suppressed during his period of study, first under Ažbé in Munich, then under Kardovskii in Petersburg, remained a continual interest for him. Virtually all of his exhibits at the Union of Youth were landscapes, painted in a variety of styles. Yasinskii described the new Dydyshko:

> I don't know what is guiding such a leading artist as Dydyshko, whose brushes can make colours sing and sound like gold, and sparkle like gems. I don't know what guides him to horrifically simplify his palette with an abundance of grey-muddy colours and to fracture the perspective in the fog of Cubism that is completely alien to the Russian soul.
>
> Undoubtedly Dydyshko... searches intensively and with agonising anguish for that 'something' about which Corot spoke. But maybe he's searching like the man who looked for his gauntlets when all the time they were under his belt. The lack of taste, the artificiality and the lack of imagination in Dydyshko's landscapes... Of course painting is not photography... But what can one say about painting that lies? Does the artist really have the right to depict a pine tree in the shape of algae with circular fronds.[43]

Although such a description suggests that Dydyshko was experimenting with Cubist principles, surviving reproductions of his work, while indicative of an abandonment of his Impressionistic open-air painting and a new limited colouring, give little indication of this.[44] For example, *Sheds* (1913, Cat. 27? Plate 25), where the whole composition is subjugated to the loose undulating rhythms of the fields and trees, relates more to the final years **197**

(1906–7) of Braque's Fauve period, when his debt to Cézanne and Gauguin was giving way to a more structural kind of work, than to his Cubist work.[45]

Matyushin's exhibits consisted of two 'musical' works, *Red Peal* and *Pardon Peal*. V. A., the *Ogonek* critic, found them an exception to the rest of the exhibition. Rather than being a manifestation of some idea, he regarded them as a reflection of 'genuine mood'. Rostislavov was more specific about the second work: 'Matyushin's musical painting of pink and yellow windings encircled by blue, strangely conveys the impression of the "Pardon peal"'. According to Bowlt this and *Red Peal* were painted at Old Peterhof in the summer of 1913 under the impression of the bells from a nearby monastery.[46] The descriptions imply that Matyushin had already moved towards his later non-objective *Painterly-Musical Constructions*. His theory concerning the extension of vision allowed him to materialise sound and the *Peals* were perhaps the first fruits of such a process. The description of his work and the nature of his ideas in 1913 show a marked similarity with those of František Kupka in his *Disks of Newton*. Both artists combined reference to music and the non-objective study of colour with mystical associations. However, given the atmosphere of creative enquiry that enveloped both Paris and Petersburg, it remains possible that Matyushin and Kupka reached their painterly solutions for similar problems independently.[47]

The Union of Youth's seventh exhibition can be seen as the last general showing of the state of the group. More can be learned about its identity than from any other event in which it was involved during its final season. It comprised a new and volatile mixture of styles, from Fauvism and primitivism, to Cubism, Futurism, and possibly even Orphism. This cocktail proved too much to contain and led swiftly to the group's disbandment (see below). Although the group had now disassociated itself from the Knave of Diamonds and Larionov's Target, it lost none of its previous variety and, with Malevich and Tatlin reaching climaxes in their experiments, none of its vitality. The new emphasis on compositional structure, i.e. the process of making the object that is the painting, did little to diminish the symbolism that had imbued the group's art from the start.

The Union of Youth's last exhibition signified an energy and purpose within the group that led it to organise several final ventures at the end of 1913. These provided an opportunity for a further public showing of the developments in members' art and theory. However, active participants were relatively few, and therefore these events were unrepresentative of the group's general persuasions. This is especially important to remember given the disproportionate, though justifiable, amount of study that one of the events, *Victory over the Sun*, has stimulated.

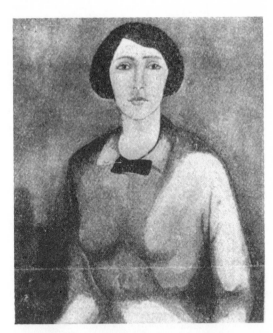

**24** A Zel'manova, *Self-Portrait*

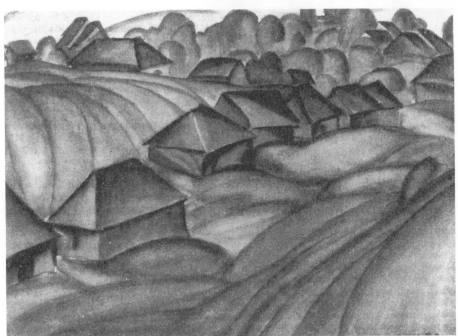

**25** K. Dydyshko, S*heds*, 1913

On 1 November the group announced that a series of lectures and discussions would take place at the exhibition.[48] These were to include **199**

readings by Markov, and Burlyuk's talk on Filonov. Also Grishchenko was to give a lecture on Picasso at the Troitskii Theatre on 20 November. A series of Futurist theatre performances was advertised, including Vladimir Mayakovsky's *A Tragedy*, Kruchenykh's *Victory over the Sun* and plays by Guro, Khlebnikov and Nikolai Burlyuk. In the event, the Union of Youth's final activities consisted of an evening of 'Futurist Poets' (Burlyuk, Kruchenykh and Mayakovsky) on 20 November; two performances each of *Vladimir Mayakovsky: A Tragedy* and *Victory over the Sun*; and the publishing of Markov's essays *Faktura, The Chinese Flute* and *The Art of Easter Island*.

During the autumn and winter of 1913–14 many evenings dedicated to Futurism and avant-garde art were organised in Petersburg. They, rather than exhibitions, dominated the season and stimulated public debate. Chukovskii's lecture, 'Art of the Days to Come', on 5 October had done much to initiate the discussion. Kruchenykh and Mayakovsky had both appeared: Kruchenykh with a carrot in his buttonhole and Mayakovsky in a yellow jacket. A series of similar evenings followed, where Kul'bin, David Burlyuk, Pyast, Yakulov, Shklovskii, Le-Dantyu and Zdanevich appeared to champion their own interpretations of the latest trends in modern art. Also, poetry evenings were held by Severyanin and the Hylaean poets. The mood at these events was one of excitement and tension, as if a new energy was being found and released. The idea of Futurist drama began to circulate. In Moscow Bolshakov's non-sequential drama depicting city night life, 'The Dance of the Streets', with Larionov's decorations and Arkhangelskii's music, opened on 6 October. Two weeks later, on 19 October, the 'Pink Lantern' Futurist cabaret opened in Moscow, based on the idea of the 'Futu' theatre discussed by Larionov in early September.[49]

The first Union of Youth evening of the season was originally marked for Grishchenko's talk on Picasso. It was then proposed that Grishchenko be accompanied by Burlyuk ('On the Selling and Buying of Paintings'), Kruchenykh and Mayakovsky, in an evening dedicated to both painting and poetry.[50] Ultimately, Grishchenko pulled out and 20 November at the Troitskii Theatre was advertised as 'On the Latest Russian Literature. The Futurist Poets (On Yesterday, Today and Tomorrow)'.[51] It therefore ended up differing little from other Futurist gatherings of the day. Indeed, a very similar meeting, entitled 'Evening of Futurists-Speechcreators' had been held on 13 October in Moscow; Burlyuk had read his lecture 'Pushkin and Khlebnikov' in Petersburg on 3 November; and the Cubo-Futurist poets were to appear again in Petersburg on 29 November.[52]

The evening indicates the Union of Youth's continuing support for new literature, and in particular, its close relationship with the Hylaean poets. Yet the majority of the group's members, including Spandikov, Shleifer, Dydyshko, Zel'manova, Potipaka and Morgunov, still participated little in

spheres other than easel painting. Thus it would be a mistake to consider the desire for a synthesis of the arts, let alone a synthesis on Futurist principles, to be universal within the group. Nevertheless, its most prominent artists, Rozanova, Malevich, Filonov and Shkol'nik, freely moved into Futurist theatrical and book design; David Burlyuk took up Futurist poetry and Markov analysed poetic principles.

The Futurist poets, readily available and practised orators, were capable of attracting large crowds and thereby bringing in money. The Union of Youth for their part, were happy to oblige the poets with a platform, while at the same time perpetrating their desire to propagate new art. Sympathy with the poets was high and the evening also served as an opportunity to advertise another Union of Youth sponsored event – the forthcoming 'Futurist Spectacle' at the Luna Park Theatre (banners adorned the stage and posters the foyer).

The evening, like previous Union of Youth public meetings, was something of a disappointment. The audience, who by now were primed for scandal by earlier Futurist antics, found themselves being amusingly entertained – as if the Futurist poets had become something of an alternative comedy act. Any substance and depth to their words was lost due to the deliberate lack of rationalised thought and analysis.

The essence of the evening appears to have been the following: Mayakovsky appeared in his yellow and black striped jacket, denounced those who discussed the Futurists, proclaimed the necessity of the city in poetry and pronounced a few neologistic phrases. Kruchenykh, 'with indescribable familiarity, bordering on impudence, pronounced incoherent nonsense about the meeting of creative work and science'.[53] He also 'convinced the public that "irregularities decorate correct speech like spit decorates the road."'[54] He talked about the rhyming of 'korova' with 'teatr' and the abbreviation of words, according to the American principle that time is money (thus 'nravitsya' becomes 'nra' and 'chelovek' 'cheek').[55] He ended by looking at the clock and running from the stage without finishing his words. Then David Burlyuk appeared with his usual condemnations of the critics and, on this occasion, praise for Khlebnikov, who sat on the stage and bowed to the public. His speech differed little from one he had given on 3 November. One further device that these Futurists used, that was also employed by Larionov and Goncharova in Moscow, was the painting of the face – a symbol of their precocious desire to extend the bounds of visual and literary art: 'Among the public paced a Futurist looking like a tattooed Indian: on one of his cheeks was drawn an arrow and on the other an anchor.'[56]

More novel for the Petersburg public was the Union of Youth's production of *Victory over the Sun* and *Vladimir Mayakovsky: A Tragedy* two weeks later. While bringing together various artists and poets connected

with the group on a single project, neither was conceived by the Union of Youth in the integral way that *Khoromnyya Deistva* had been. Rather, individuals, even if they had been introduced to one another by the group and were now the mainstays of its progressive direction, met outside of the group to create their respective dramas. Only later was the Union of Youth brought in to obtain the theatre and advertise the show as 'The First Performance of Futurist Theatre in the World'. Still, in many respects the performances can be seen as the climactic event in the history of the Union of Youth. Certainly, with their call for the establishment of a new era with new values, they seem aptly to predict a radical change in the group, if not its subsequent sudden dissolution. It is also possible to see them as an avant-garde progression from *Khoromnyya Deistva*, reflecting a sustained interest in uniting the arts, if not artists, as well as a shift to the more radically modern.

Very valuable scholarly work has already been done on the significance of the occasion, especially with regard to the combination of Kruchenykh's *zaum* text, Malevich's ingenious designs and the concept of four-dimensional space.[57] In order not to repeat much of what has already been said, the emphasis here is switched to the role of the Union of Youth in making the production possible. This has seldom been examined. Writers generally assume that *Victory over the Sun* marks a definitive outlook by the group, without considering that the Union of Youth was still a heterogeneous collection of individuals searching in a variety of directions. It is more correct to consider it the most striking and innovative example of one of the group's persuasions and, as such, far in advance of much of the group's work. It should be seen, not essentially as a statement by the group, but as an outcome of the Union of Youth's unchanging desire to support new art in whatever way the times dictated appropriate.

The suggestion that the ideas for both *Victory over the Sun* and *Vladimir Mayakovsky* came from outwith the Union of Youth, is upheld by a letter from Malevich to Matyushin after their Uusikirkko 'conference' with Kruchenykh in July 1913: '... Mayakovsky and I have a suggestion for you and I hope that Kruchenykh and you will join us. Thus, we are commissioning you to make a written application on behalf of all our theatrical work to the Union of Youth for backing us in the first show....'[58] Kruchenykh confirms the nature of the Union of Youth's support: 'The Union of Youth seeing the domination of the theatrical veterans and taking into account the extraordinary effect of our evenings, decided to put the work on in grand style and to show the world "the first Futurist theatre".'[59]

Matyushin noted that the idea for the opera emerged during the Uusikirkko conference and that 'the Union of Youth committee finally decided to perform *Victory over the Sun* and the tragedy *Vladimir Mayakovsky: A Tragedy* after many difficulties and discussions.'[60] As with previous events

arrangements appear to have been left until the last moment. However, the problem now largely stemmed from the difficulty in persuading theatre management and workers of their purpose. In the end, Malevich created 'twenty-four large pieces of decor in four days' while 'receiving the most vulgar mockery and idiotic laughter' and then the costumes were not finished according to his desires.[61] The lack of preparation also affected the players – students were brought in just a few days before the first performance and the amateur singers employed had little time to rehearse. Furthermore, finding a pianist to play the 'broken down, out of tune piano' proved a problem.[62]

In 1913 the attempt to challenge and renew the very concepts of beauty and art, that had been a mark of the Union of Youth's approach since its foundation, gained a Futurist orientation in the work of Rozanova and Malevich. The presentation of *Victory over the Sun* (3 and 5 December 1913, Luna Park Theatre), an 'opera' which its author later described as expressing 'the victory of technology over cosmic and biological powers',[63] was a manifestation of the new Futurist tendency within the group. It marked the group's support for Russian Futurist principles in particular. As far as Matyushin, the author of the music, was concerned, *Victory over the Sun* continued his interest, expressed in his editing of *Du Cubisme*, in the expansion of perception: 'The opera has a deep, inner content, mocking at the old romanticism and excessive verbiage… it is a victory over the old, established notion about the sun as "beauty"'.[64]

Rozanova's poster for the event depicted a spirallic vortex.[65] An inward, turning motion is apparent. A lithographic print, it uses three colours – red, green and black, together with bare patches of the off-white paper. Figurative elements such as the letters 'Futu tea' (standing for 'Futurist theatre') are discernible in the centre of the work. They are placed on the breast of a man. In the top left corner a face, two eyes and a top hat, comprised of very few thick and straight black lines, are visible. A hand, apparently holding a bunch of tickets is in the top right corner. So, from the confused medley of abstract planes, a representation of a Futurist theatre ticket-seller or impresario appears. The domination of the new plastic principles, the disfiguration of form and the dynamism of the work, directly relate to the message contained in the two performances – i.e. the forthcoming overthrow of outdated artistic values.

Kruchenykh's libretto was essentially a *zaum* text, written, he claimed, 'imperceptibly'.[66] It is full of alogisms, neologisms, abbreviations, and confused grammar, putting into dramatic practice the new independence of words from meanings already employed by himself and Khlebnikov in their poetry. The monologues of the characters are frequently disconnected and a sequential development through the action is difficult to perceive. Even so there exists a 'plot' of sorts, in which the sun is captured. The sun

**203**

acts as a symbol for such notions as the old beauty, visibility, the illusion of three-dimensional reality and 'Apollo, the god of rationality and clarity, the light of logic'.[67] No longer will man be dependent on these illusive principles. This meaning is conveyed by action and words in which the absurd is clearly controlled. In an interview given a few days before the performance, Matyushin and Malevich gave the following account of the work:

> *Victory over the Sun* is devoid of any developing plot. Its idea is the overthrow of one of the greatest artistic values – the sun in this case. The world has been put in order and the boundaries between separate things and objects fixed. Definite, prescribed human ideas about relations between things exist in peoples' consciousness. The Futurists wish to be free of this world of orderliness, from the process of thought in it. They want to turn this world into chaos: established values are to be broken to pieces and from these pieces they want to create new values, giving new generalisations, opening up new unexpected and invisible relations. So here is the sun – it is a value from earlier times – thus it constrains them and they want to overthrow it. The process of its overthrow is the subject of the opera. It is expressed by the players in words and sounds.[68]

The plot, as far as it exists, and the personages in *Victory over the Sun*[69] show parallels with *Tsar Maksem'yan*. Both, by means of excessive and sometimes unprovoked violence, depict the overthrow of an established and tyrannical order (embodied by the old symbols of beauty, the Sun and Venus respectively). Characters in *Victory over the Sun* include two *budetlyan* strongmen, Nero and Caligula in one person, a traveller, Some Ill-Intentioned One, a Bully, Turkish soldiers, Sportsmen, Gravediggers, the Speaker on the Telephone, the New Ones, the Cowards, a Reciter, a Fat Man, an Old Inhabitant, an Attentive Worker, a Young Man and an Aviator. Of these Nero and Caligula roughly equates to the Tsar; Some Ill-Intentioned One has a function not dissimilar to Anika the Warrior; the gravedigger appears in both dramas; the chorus of Sportsmen recalls the *skomorokhi*; and the Futurist Aviator who comes onto the stage at the end of the opera to cry 'Ha ha ha I am alive' and sing a military song of single syllables is a technological equivalent of the Cock, with its final cock-a-doodle-do announcing the rebirth of dawn and a new life. Primitivism then, is alive and well even in the Union of Youth's most radical appearance.

The essence and non-constructive form of both works, including the 'interlude' activities of the chorus/*skomorokhi* and the gravediggers, appear one and the same. In this respect Bowlt is right in his conclusion that *Victory over the Sun* is 'fully within the *balagan* tradition'.[70] Even Matyushin's discordant music (based on quarter-tone and simultaneous movement of four independent voices in an attempt to 'destroy the old sound, the boring diatonic music')[71] sung by flat voices and played on an untuned piano would have recalled the amateur aspect of the *balagan*, and *Tsar Maksem'yan* in particular. *Victory over the Sun* was a 'Futuristic

jamboree'[72] which, like *Khoromnyya Deistva*, was concerned with displacing the notions of high theatre and entertaining 'more by noise, movement and colour... than by the logic of the plot line.'[73] The action commenced with the tearing up by budetlyan strongmen of the 'conical and spiral' patterned curtain.[74]

Malevich's stage and costume designs have been abundantly examined recently.[75] Through the combination of these, careful use of lighting, the *zaum* text and the discordant music, the creators of *Victory over the Sun* sought an embodiment of Uspenskii's fourth unit of psychic life – 'higher intuition'. This was the 'real' world where people could understand the incompleteness of the three-dimensional world. As it was attained, four-dimensional space would be comprehended, together with a new concept of time and a sensation of infinity. The costumes were highly simplified – to the point sometimes of being plain geometric figures. Yet they convey the essential marks of each character very immediately. In many respects they are dehumanised stereotypes. Although this marks their modernity, it recalls that which had gone before in *Tsar Maksem'yan*. Both spectacles were imbued with a spontaneity, bright colours and a naivety, and both employed cardboard and masks.

For his stage designs Malevich adopted Cubist principles. They have been adequately described by Rudnitsky:

> Malevich painted the backdrops utilising pure geometric forms: his renowned 'black square' appeared for the first time... alongside straight and curved lines, musical notes, signs resembling question marks. There is no concern for top or bottom, no allusion... to any particular place of action: the very concept of 'place' in his scenery is disregarded.[76]

Almost all of the stage designs relate to the structure of a tessaract – they comprise squares within a square and are attached by four diagonals between the corners. Whether the space is receding or advancing is ambiguous. This, together with the simple geometric bodies, refers to the machine age and perception of the fourth dimension. But this too was not without its references to ancient art, for the format of a square within a square directly relates to the icon and hence to the spirituality of the icon image.

During Khlebnikov's prologue, 'Blackcreative Newsettes', read by Kruchenykh, behind the speaker was hung a curtain made of a simple sheet on which were painted 'the "portraits" of Kruchenykh, Malevich and Matyushin themselves'.[77] These probably took the Cubist idiom again, as in Malevich's *Portrait of Matyushin. Author of the Futurist Opera Victory over the Sun* (Tretyakov Gallery).[78] Here Malevich retains recognisable features among a construction of geometric forms – the keyhole, half a forehead, a fragment of a tie and shirt-collar and a line of shortened white piano keys. As Compton has pointed out,[79], the drawer-front with a key-

hole alludes to the Fat Man's words in *Victory over the Sun*: 'Indeed, nothing here is that simple, though it seems to be a chest of drawers – and that's all! But then you roam and roam.'

The performance itself, despite the roving spotlights picking up relief elements of Malevich's set on random occasions, was less Futurist than that proposed by Larionov in September 1913. While the language, music and sets show a sharp break with the past, the action, still on a stage and separated from the audience (unlike *Tsar Maksem'yan*) remained essentially traditional. Larionov's 'Futu' theatre, on the other hand, was to revolutionise the action and audience participation: 'Spectators will be placed according to the action either on a raised platform in the middle of the hall or above it on a mesh net under the ceiling... in order to see the play from above... during the action the stage floor and decorations will be in continual movement.'[80] Cacophonic flute music was to accompany the action and actors were to have other actors in the role of their hats, shoes, trousers etc., creating 'something like a "decorative leitmotif"'.[81]

*Vladimir Mayakovsky: A Tragedy* (2 and 4 December 1913) was written at the same time as *Victory over the Sun,* and while its author, Mayakovsky, was in close contact with Malevich. Again it refers to the *balagan* tradition but modernises the situation and speech. It consists of a prologue, two acts and an epilogue. The main character is Mayakovsky himself, while others, played by students, are only fragments of the poet's self. In this fragmentation of the personality the tragedy relates to Larionov's 'Futu' and Evreinov's monodrama, although in the former the parts are more concerned with the emotional attributes of the player than those of his appearance.

In the short prologue Mayakovsky appears as a prophetic poet in a sad, distorted city. He appeals to the people, saying that he shall give them true happiness and 'reveal our new souls' through a universal language. The first act, 'City. Merrily', finds him in a city during a beggars' holiday. He tries to comfort and entertain the beggars but is interrupted by a thousands-of-years-old man, with dried up black cats, who talks about human suffering. This theme is reinforced by the appearance of the 'Man without an Ear', the 'Man with a Stretched Face', a 'Man without an Eye or Leg' and others. Only a 'Normal Young Man' pleads for reconciliation with all this suffering so that he may lead a peaceful life.

The second act, 'City. Depressing', finds Mayakovsky in a new city dressed as a prince. As in *Victory over the Sun*, where the sun is captured outside of the action on the stage, so here the revolt has occurred unobserved by the audience. People approach Mayakovsky with kisses and bundles that turn out to be tears. He takes their burdens and strides off to throw them to the god of storms. But even this city, free from the tragedy of existence, is sad, for it is dull and boring. Finally in the short epilogue there

is a sense of harlequinade as Mayakovsky sends up the tragedy of the work and patronises the audience: 'I'm sorry I have no breast or I would have fed you like a kind nanny.' He praises himself for having opened up their consciousness to a 'superhuman freedom', compares himself to a Dutch Cock[82] and ends by proclaiming he sometimes likes his own name 'Vladimir Mayakovsky' best of all.

The parallels with *Victory over the Sun* are evident in the discovery of new worlds and the freeing of language from denotative meaning, but unlike Kruchenykh's opera there is greater pessimism. Here, even the opening up of new vistas of human possibility is regarded as purposeless. Perhaps because of this Mayakovsky refrains from abandoning the function of language and grammar to Kruchenykh's extent. Furthermore, the production of *Vladimir Mayakovsky* was less ambitious in regard to stage sets and costume designs than *Victory over the Sun*. Nevertheless, it was the occasion of a unique collaboration between Filonov, Shkol'nik, Rozanova and Mayakovsky. Filonov, on Mayakovsky's request, was responsible for all the costumes and the sets of the prologue and epilogue. Although it is known that Mayakovsky's appearance, in his yellow and black striped jacket, resembled that of a *skomorokh* or fairground buffoon, only descriptions of Filonov's work survive:

> Small panels (or 'screens') placed at the back of the stage near a backdrop covered with rough cloth served as scenery. Throughout the prologue and epilogue there glowed a square panel designed by Pavel Filonov, which was 'painted brightly with various objects: little boats, houses and wooden horses, as if someone had strewn a pile of toys around and children had drawn them.' Yartsev acknowledged that 'it was very cheerful, colourful, warm and merry, reminiscent of Christmas time.' A small flight of steps draped in brown calico stood in front of the footlights. Mayakovsky, making his entrance, ascended these steps as though he were mounting a pedestal.[83]

Kruchenykh considered Filonov's stage designs examples of 'made paintings' and indicates a coincidence with his easel work: 'two huge, to the size of the stage, masterly and thorough, made paintings. I especially remember one: a disturbing, bright city port with many painstakingly drawn boats, people on the shore and then a hundred town buildings each of which was finished to its last little window.'[84] Izmailov added that Filonov's scenery looked like 'some kind of variegated jumble of arms, legs, faces and childrens' toys'.[85] More significantly, Zheverzheev noted in the centre of the '*lubok*-cheerful heap of colour toys, a large and beautiful cock',[86] again relating the work to *Tsar Maksem'yan*.

Zheverzheev also described Filonov's costumes (no sketches were made) as 'extremely complex in their composition and "planar"',[87] and added that they had little to do with Mayakovsky's words. Filonov painted the costumes, in the form of his fantastical images, directly on canvas. This

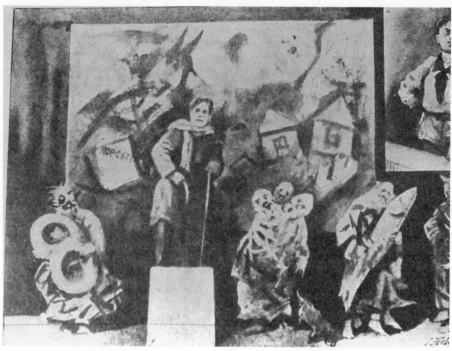

26 *Vladimir Mayakovsky: A Tragedy*, sketch 'from life' by S. V. Zhivotovskii

was then stretched over a large frame, giving it the appearance of card-board. On stage the actors moved the frame in front of themselves. Some actors, representing hawkers just carried outsize folk symbols – an iron herring from a signboard or a *kalach* loaf of bread (Plate 26). They 'move slowly, in straight lines, always facing the public (they cannot turn because there is no cardboard to the back or side of them). They wear white lab coats and line up along the sides of the panels, a little closer to the rough cloth backdrop.'[88] This planar appearance led the players to appear inhu-man, just as the subjects of Filonov's recent paintings, and as Mayakovsky had intended the characters in his tragedy. Their two-dimensionality in a three-dimensional world symbolised the fact of other orders of existence. Besides these players there was a silent 'Female Acquaintance', who stood covered by a sheet on the corner of the stage. When Mayakovsky tore the sheet away from her a five metre high *papier maché* peasant woman was revealed 'with ruddy cheeks and dressed in some kind of rags'.[89] She, the symbol of all the Neo-Primitivism in the work, was then dragged off to be burned.

Shkol'nik designed the sets for the two acts of the play. However, his initial plans, apparently anticipating Constructivist stage design, had to be shelved: 'Shkol'nik's originally conceived three-dimensional designs (with many stairs, bridges and passages) turned out to be unrealisable in

those times and so the artist ran to another extreme – he confined himself just to two painterly backdrops on which he brilliantly painted two urban landscapes.'[90] His urbanism, like that of Filonov, Rozanova and Malevich, matched his experiments in easel painting. His sketch fo Act One depicts a flattened, sliding town, seen from above, as if from an aeroplane. Spatial recession is distorted and volume is altogether lost. The town is far from intimate. Rather it is distant, cold and inhospitable. Yartsev described the actual backdrop as 'a city with roofs, streets and telegraph poles collapsing into one another', which corresponds to Mayakovsky's line 'the city in a web of streets' and recalls the urban works of Shkol'nik's assistant Rozanova, reproduced in *The Union of Youth*.[91] Another sketch, also apparently intended for the first act, uses the collage technique seen in Shkol'nik's *Still-Life with Vases*. Again the houses fall in on one another and are flattened. The overlapping of forms rejects perspectival illusion. Despite the increased chaos, signboards are prominent, as in his *The Provinces* (Plate 22), including 'Fish', 'Bakers' and 'Fashion'. 'Vlad Maya' is added in the bottom left hand corner in reference to the author of the tragedy. Tiny, empty trams travel helter-skelter among the buildings.

Both sketches compare with that for Act Two where again a chaos of primitive several-storeyed houses and roofs is depicted, though this time in 'the pink light of evening out of which arises the green Arctic Ocean'.[92] Dissecting the curve of the ocean are two diverging lines at the top of which is written the word 'North' – the place for which the poet finally sets off to deliver the peoples' tears to 'the dark god of storms at the source of animal faiths'. Shkol'nik's simplifications undoubtedly coincided with the flat costumes of Filonov, though the intricacy of the latter's stage designs appears not to have been repeated. Indeed, Filonov's work, which continued to be seen on the walls during the play, with its 'fish, pretzels, little toy trams overturned in the deserted streets and its upside-down iron frames of pipes',[93] acted simultaneously like a playground and square of a modern city and thereby complemented the distant dehumanised city of the backdrop. From this it becomes clear that the plastic principles, and their distinct Neo-Primitivist heritage, employed by both artists in their painting, were translated effectively to the stage.

### Vladimir Markov's publications

Taken together, the Union of Youth's seventh exhibition, the production of *Victory over the Sun* and *Vladimir Mayakovsky*, and the publication of Markov's essays, emphatically underline the position the group had reached by the end of 1913. In all of these there was a sense of revolution: vestiges of the old order were exposed and visions of a new order announced. Still, the revolution had not completed its course and a new

worldview had not yet been installed. The heritage of symbolism and Neo-Primitivism remained dominant, even in the early phases of Cubo-Futurism that the Union of Youth presented to the world. It was also very much in evidence in Markov's final contributions to the group.

Markov spent every summer from 1910 to 1913 in Europe, gathering material for his creative and theoretical work. In 1910 and 1911 he travelled through Italy; in 1912 he was in Paris, Berlin and Cologne; and in 1913 he visited Sweden, England, Holland, Belgium, France and Germany. He studied the frescoes of Umbria and Abruzzi, the mosaics of Ravenna and the reserves of the ethnographic museums in London, Berlin and Leiden. He made notes, drew sketches and took photographs. All in an attempt to penetrate to the essence of plastic principles in art.

In part the Union of Youth subsidised Markov's journeys of 1912 and 1913. But the money was not as forthcoming or abundant as Shkol'nik had implied. On 23 April 1913 Markov wrote to Shkol'nik stating his desire to receive a grant, indicating by his blunt tone that he regarded such a request as nothing exceptional. However, by 5 June he wrote to Zheverzheev from Sweden saying he had left on his travels after unexpectedly receiving 350 roubles from a Moscow publisher 'for *Faktura*'. This suggests that the Union of Youth were not instrumental in sending Markov abroad. Further, it implies that the committee were not only reticent with money, but that they also only published Markov's works under some pressure. This is confirmed by another letter to Zheverzheev on 10 April 1913:

> With regard to *Faktura*. This affair has already dragged on five months and has started to annoy me. That's why I reckoned that I have a right to start discussions with other publishers ... I would very much like to speak about *faktura*, not only in front of the committee, but to all members, exhibitors and guests. Dydyshko and Filonov know something about my work.[94]

Markov implies a difference of opinion within the committee about the value of *Faktura*, but the problems of publication may have stemmed from financial considerations rather than arguments about the essay's merits as a contribution to the study of modern art.

In any case, following the financial success of the Futurist performances, *Creative Principles in the Plastic Arts: Faktura [Printsipy tvorchestva v plasticheskikh iskusstvakh: Faktura]* was eventually published by the Union of Youth in December 1913.[95] It was followed shortly afterwards by *The Art of Easter Island [Iskusstvo ostrova paskhi]* (January 1914) and the long awaited *The Chinese Flute [Svirel' kitaya]* (late March 1914).[96] These were the last of Markov's works to be published during his lifetime, and the final public acts of the Union of Youth.[97]

*Faktura* and *The Chinese Flute*, both prepared prior to Markov's final European tour of 1913, relate closely to his 'The Principles of the New Art' and the translations of Chinese poetry published in the first two issues of

*The Union of Youth*. The extended length of his study of *faktura* was a primary consideration in its publication as a separate booklet, rather than as an essay in *The Union of Youth*. Still, it continued the discussion begun in 'The Principles of the New Art' by concentrating on the elements essential in the creation of art. Although generally appropriate to primitivism, his argument was applied to all types of art.[98] Primarily his concern was aesthetic – what makes a work of art a work of art, i.e. what is *faktura*. To this end he paid special attention to the material and its manipulation, comparing and contrasting a wide variety of examples. Ultimately, he found *faktura* the combination of material, style and their perception, i.e. the 'sensation' of a work of art. *Faktura*, then, was not a purely physical property, but something which changes with social and historical conditions.

As previously, Markov examined the artist's relationship to nature. In 'The Russian Secession' he had claimed that the artist took only a kind of 'radium' from nature and what he created essentially had 'nothing in common with nature'. In *Faktura* he underlined this claim for abstraction with a comparative analysis of the creative processes of nature and the processes of man. Nature's organic creation was found to be ultimately destructive, returning everything to dust, while man's creation involved techniques to change and preserve materials according to different laws. This coincides with the ideas expressed in *Victory over the Sun*, that the artist must prevail over biological, and even cosmic, powers.

Markov paid special attention to the plastic principles involved in painting, sculpture and architecture. In all three, forms are created according to the conditions of the material, the environment and the artist's psyche. In an elaboration of the ideas of 'The Principles of the New Art', he looked at the varied combination of these conditions which create the transformations known as art. Again he found primitive and ancient art forms the most pertinent to his argument. The 'chance' forms of the material in nature were frequently exploited in such a way that they dominate the work of art, creating an abstract expression of the conceived object. Presaging his subsequent study, Markov cited the example of the wooden sculpture of the Easter Islanders – created in curving arches due to the shape of the wood taken from old boats. The apparently contrasting subjection of material properties to man's treatment, especially evident in man's artificial combination of materials and deliberate accession to the form of the object, was not necessarily any less valid. Indeed, the creation of paint itself involved an unnatural mixing. The combination of elements, as long as it was not for cheap effect or purely decorative purpose, could, whatever the degree of refinement involved, create a work of art. Thus, the elaborate techniques and materials of icons are equally as valid as Easter Islanders' sculpture.

What was essential for the creation of a work of art was a love for    **211**

material. Without attention to material and formal properties the danger existed of lapsing into the weak imitations of visual appearances taught by art schools. Here Markov clearly supports Larionov's Donkey's Tail and Target artists, particularly Tatlin, and their emphasis on the painting as a made object. Although *Faktura* is less declamatory than 'The Principles of the New Art', the attack on the deficiences of the art establishment is unrestrained. Again he regards imitation as unavoidable due to cultural and psychological circumstances, but he urges an abandonment of the internationalism of academic art which threatens to reduce the artist to a technician. A cultural awareness must necessarily combine with technical ability and spiritual consciousness in order that the unique quality of art is attained. Without such a combination the symbols created are empty.

Markov reiterates the deceptive nature of academic realism and notes that since full illusion is impossible art must inevitably be a symbol, an imitation of some perceptible effect rather than outer form. Art then could be mimetic of the idea and of other art, but it was essentially non-mimetic with regard to nature. In trying to describe the virtually ineffable quality of artistic *faktura*, Markov reminds the reader that even imitation of the old is impossible – reconstructions always possess a new *faktura*. Thus he allows the Italian Futurists' discovery of a new beauty and *faktura* in the mechanised world, while recognising that this too is ultimately a slave to nature. But he is reticent to endorse the Futurist sculptors' use of machine-made items due to their lack of attention to the plastic properties of the materials. Still, potentially, the use of either factured or manufactured materials and objects can create a work of art. And indeed their combined use, as in Picasso's collages, could be validated as a conscious expression of a knowledge about, and love for, their properties. Such an expression is capable of creating new fakturas, through the new tensions and sensations it evokes.

*Faktura* for Markov is a combination of inner and outer worlds. The degree and shades of such a combination give rise to a common 'sensation' that in turn give a work its distinguishing quality, or 'tuning fork', as he called it. This 'tuning fork' is conditioned by its creator's characteristics and cultural background. Here he develops his earlier discussion of art as both an expression of the creator's self and national qualities. Thus art, which he likens to handwriting, is environmentally determined. Art is a result of its creator's personality, which in turn is a result of circumstances. He argues his case by examples of the distinctive *scuola locale* in the towns of Umbria. Acknowledging the external factors active in the creation of art, he notes that their denial in the academies is the denial of the individual which results in a monotonous banality. Previously, for example, the availability, composition and size of materials played primary roles in the creation of a 'tuning fork'. Again Markov cites Easter Island art:

We no longer have, or express, a love for the monumental collosus; there are no more huge stone figures; the love for such a tuning fork has vanished. The materials which were used were not just stone, but whole rock faces and parts of slopes (Egypt, Abu-Simbel, Easter Island, China etc.). Large stone images of rulers are hewn directly on the rock face in Easter Island; thus the artists used the naturally-given proportions and chance; the likely result of such a relation with the material is manifested as a love of the colossal. But as soon as you have learned to cast bronze, the large stone figures and the vast dimensions disappear.[99]

While the 'tuning fork' was unconscious for the Easter islanders and the Umbrians, whose assortment of pigment, material and treatment was due to 'chance', that of the modern artist should be conscious. Thus the selection of compositional elements, from the vast variety available, is of utmost importance for the development of art: 'From the thoughtless mixing of all God's given pigments we will never acquire a distinctive tuning fork... working from and copying nature nature never pays attention to the *faktura*, nor to the tuning fork.' Nature then possesses much potential danger for modern artists. To avoid its traps they should turn to the principles employed by artists of other times – in order to obtain a certain 'tuning fork'. If the artists were concerned with the idea of form alone, as, Markov implied, were the realists, then they could employ any material, but if they sought a 'tuning fork', that represented both the self and their relations with the world, then they must be consciously selective in their materials and their use.

While Markov's argument in *Faktura* is occasionally repetitive, generally the expansion of his examination of the principles of art is highly original and incisive. He writes with the same simple style as in his two previous articles and illustrates his points with numerous exotic examples. The significance of the essay, the fullest development of Markov's ideas, is in its exposition of the compositional options facing the modern artist and, hence, also the Union of Youth. His argument is analytical rather than polemical, and it echoes the Union of Youth's initial aim to study art unburdened by any preconceptions about the creative process. Stripping away such preconceptions, he can even talk about the characteristics of the implements and dyes used, the texture of the surface, the notion of framing and methods of preservation. He thereby calls into question many of the accepted notions concerning these elements. While accepting that the artist must learn many techniques in order temporarily to overcome the destructive power of nature, he does not seek a dissonance with nature. Art is of another order to nature, but relations between the orders exist which cannot be overlooked. Ultimately, art is dependent upon its surroundings.

In *Faktura*, Markov remains an apologist for the modern movement but refuses to allow it, just as academic art, the right to practice exercises in unconsiously created form. A neglect of plastic principles and ignoring of **213**

material and non-material qualities denies the value of the creative act. Thus his enquiry supports the formal experiments seen in the most recent work by Union of Youth members such as Tatlin, Rozanova, Filonov and Malevich – and their retention of spirituality. At the same time, other Union of Youth artists, such as Shkol'nik, Shleifer, Zel'manova and the Burlyuks, appear not to have lived up to his stringent demands for a conscious, individual 'tuning fork'

The breadth of Markov's search for creative principles was emphasised by *The Chinese Flute* and *The Art of Easter Island*: one is an examination of Chinese poetry, the other concerns the sculptural art of tiny Easter Island in the Pacific Ocean. There could hardly be two more contrasting art forms. On the one hand were delicate Chinese poems, whose style and complex rules of composition evolved, and were carefully manipulated by successions of ruling dynasties, over many centuries. On the other hand were the crudely worked stone colossi of Easter Island. Yet both, despite their emphatic differences, were constructed according to distinct, established rules that gave them a *faktura* wholly appropriate to their environment. In such art, far from the levelling influence of modern art schools, Markov found and elucidated the principles he considered essential for art. He thus confirmed his position as a leading spokesman for Neo-Primitivism, having imbued the trend with a profound spiritual and symbolist sense in *Faktura*. This trend, begun by Larionov and Goncharova around 1908, and developed through the activities of Donkey's Tail and the Union of Youth, now reached its climax. But in so doing, it laid the foundations for new movements in Russian art – for Cubo-Futurism, Suprematism and Constructivism.

*The Art of Easter Island* suffers from a lack of visual material. This weakens Markov's argument for the creative principles involved and the work fails to be so critically incisive as his other essays – remaining instead essentially ethnographical and classificatory. Much of the essay consists of a historical review of Easter Island civilization. Still, the study of the stone and wooden sculpture as an art form was unprecedented. It owed much to Markov's primitivist interests, akin to those of the Russian avant-garde[100] and inspired by Gauguin's use of Tahitian motifs and Picasso's use of Iberian and African sculpture principles.[101] Although *The Art of Easter Island* does not pursue any claim of relevance to modern art, its exposition of the creative forms and principles of the Easter Islanders is symptomatic of the modern artists' search for simple faith in nature and life outside of the alienating world of industrial society. While others transferred and exploited the instinctive, expressive qualities of primitive art in their own art, Markov attempted to unravel the heritage and significance of its plastic qualities.

In 1913 it had been possible for Markov to see just three stone statues from Easter Island in London and Paris. For his analysis of Easter Island art

he had mostly to rely on the memoirs of missionaries and explorers. Inevitably these paid only passing attention to the form of the art. Still, he constructs a convincing picture of the monumental stone colossi and the smaller wooden sculptures. As in *Faktura*, he looks at methods and implements of construction, reasons for the size, social use and formal qualities. The independence of the forms of the represented images from their appearance in nature is important to Markov, yet he recognises that the use of material is vitally linked with nature. The simple, intuitive and, at the same time conceptual, embodiment of a local 'tuning fork' satisfied his search for a forgotten language of form. Although he speculates as to various sources for Easter Island art, the uniqueness of its stone sculpture among the islands of the south Pacific is highly significant to him. He notes that while Polynesian and Melanesian art occasionally had similar formal characteristics, neither possessed the monumental stone sculpture of Easter Island. This interest in individuality coincides with his attraction to the national cultural pedigree of the Chinese in *The Chinese Flute*.

Markov's exposition of Easter Island sculpture indicated that the crudity of forms and implements used in the art were actually the result of a highly developed ancient culture, which had its own written language and painting. The stone colossi, up to fifteen metres in height, were invariably representations of human figures, often with huge triangular red hats made of volcanic tuff. They were some kind of memorial stones to ancestors or gods and were made, using obsidian knives, in vast workshops on the volcanic slopes of the island. The sculptors, who would create, at most, two complete figures in their lifetime, were highly revered in local society. The statues had much in common with the smaller wooden sculpture created on the island, including the essential pillar-like construction, an ornamentally marked chest and collar-bone, small arms, long ears, short neck, oblong face with a long nose and broad eye sockets. However, the colossi could possess rich ornamentation on their backs, as well as incisions into planes, to stress features.

The unique *faktura* of Easter Island art was intrinsically interesting to Markov. Through his study of the variety of its art forms he is able to identify the relative rise and decline of the culture. Not surprisingly the low point is reached when the sculptures lose their individuality, and incorporate realistic features such as teeth in the mouth and unelongated ears. By that time the workmanship was poor and the object was created for trade rather than worship.

In *Faktura* Markov had admitted that the art object could be nothing but a symbol. In *The Art of Easter Island* and *The Chinese Flute* he explored two very different creations of symbols. That of Chinese poetry was a refined expression of a metaphysical outlook. That of Easter Island art was a cruder response to faith in nature. It is almost as if Markov has taken up

the long-running argument in *The Golden Fleece* concerning 'idealistic symbolism' and 'realistic symbolism', in an attempt to show the validity of both. In neither essay did he propose that the creations of the Easter Islanders and Chinese should be imitated. Rather, his aim appears one of assimilation and regeneration. He puts the principles of Chinese poetry and Easter Island sculpture before the modern reader in order that they may provoke some new perception of the world around. This new awareness of artistic possibilities could then lead to a new formal language free from the 'constructive' language predominant in Europe.

Because of the comparative wealth of material with which he could work, Markov's argument in *The Chinese Flute* is more fully substantiated than that of *The Art of Easter Island*. Of the twenty-two photographic illustrations in *The Art of Easter Island* (all apparently made by himself in European ethnographic museums) only two stone and seven wooden sculptures from Easter Island were shown. In *The Chinese Flute* there are thirty-one poems belonging to numerous Chinese dynasties from the twelfth century bc. to the nineteenth century ad. These are in Russian translation. However, their translator, Vyacheslav Egor'ev, did not translate them directly from the Chinese but from previously published French and German translations.[102]

Though 'The Principles of the New Art' and *Faktura* had been primarily concerned with the visual arts, Markov had also found occasion to turn to Chinese poetry for examples of 'non-constructive' principles of beauty. In *Faktura*, in his discussion about the compiling of materials, Markov had cited Li-Tai-Po, a great eighth-century poet of the Tang dynasty. His poem, 'Staircase in the Moonlight', concerns the sadness of a queen walking in the moonlight. It is devoid of profound philosophical thought, being rather a selection of flickering elements (nephrite stairs, besprinkled dew, the pearl-white curtain of the pavilion, magic stones, the babble of a waterfall, a pearl) upon which the moonlight falls. Such an assemblage of materials creates an especially evocative *faktura*. According to Markov, the modern western craving for logical, sequential construction is, by comparison, the work of mere craftsmen. Without a sensitivity to chance materials there can be no encapsulation of the essential mystical element in life. Poetry, like the visual arts, need not strive to express some concrete idea, but rather a feeling. This feeling could be evoked simply by the combination of materials, whether plastic or literary. In such a way he left the door open for objectless art.

Markov had shown in 'The Principles of the New Art', that Chinese poetry, like Chinese art, could sensitively employ the principle of chance in order to open up whole wondrous worlds: 'The Chinese, for example, sings that the eyebrows of a woman are black and long, like the wings of black swallows in flight. In the tree whose autumn leaves are falling he sees a

harp on whose strings the wind sobs. For him the falling snow is a cloud of white butterflies, dropping to the earth.'[103] These examples of the principle of chance were taken from the three poems ('Of Autumn', 'The Gifts of Love' and 'Snow') which appeared in *The Union of Youth* and which were subsequently published in *The Chinese Flute*.[104] By choosing poems written by three different authors in three different epochs (from the eleventh, thirteenth and nineteenth centuries), Markov emphasised the exploitation of the accidental in Chinese art as well as hinting at the longevity of Chinese creative principles. In his introduction to *The Chinese Flute* he describes how such principles survived for so long, and in this he has a message for modern art:

> It is true that the Huns, Tatars, Mongols and finally the Manchurians cut short a series of national dynasties in the course of the four-thousand-year history of China, but not once did China fall under the influence of its conquerors. On the contrary, there occurred a swift assimilation of the latter and the utter absorption of a foreign element.[105]

He regarded such an assimilation as essential in order to retain an independent art with an identifiable *faktura*. The Chinese leaders had assured this by their spreading of the values of art and literature, together with those of physical labour, throughout the nation, with the aim of furthering the spiritual well-being of the country. Poetry had played an essential role in this process of enlightenment. This could be seen as early as the ninth century bc. in Shi-King's primitive poetry. His content was heterogeneous and his style simple and laconic. Historical narrative was absent yet the poems remain records of the atmosphere and customs of the time. Furthermore, the style, with its subtle linking of different parts, established a tradition, the influence of which was still possible to feel in early twentieth century Chinese poetry.

With a syntax solely dependent on the sequence of events and the growth of a writing system that was essentially a visual language having nothing in common with the aural language, Chinese poetry was able to develop in ways totally alien to those of Europe. The fact that the poetry was perceived independently by the eyes and the ears led to a duality, the special beauty of which was noted by Markov: 'The marked sign in Chinese language, allows, without resorting to sound for help, the spontaneous expression of an idea. And the poets used this advantage to deepen the sense of the word, to strengthen the impression and to attract the attention of the reader.' The combination of painterly and musical elements in poetry was unique and through the adoption of certain rules of composition it was refined to create rare examples of beauty. Markov examined these rules in some detail and found linguistic inflections, caused by the separation of the visual and aural aspects, unencountered in the poetry of other nations.

*The Chinese Flute*, in comparison with *The Art of Easter Island*, is a comprehensive critical study of an ancient art form. Markov's aim was to establish the relevance of Eastern art to contemporary Western art. He did not require that the modern European artist copy the principles employed in China, but rather, as in all his work, wanted to provide examples of genuine ways in which the creative process can be approached. From such studies a rediscovery of the artist's native culture could be made and ultimately art could move forward, still in accordance with the tradition to which it belonged. This need not be a strictly nationalist art for, as the Chinese had proved, external influences could be absorbed to create a new dynamic, without altering the balance of the established art forms. Markov's, and the Union of Youth's, aim, was ultimately to re-establish essential relations, lost in the sterile, alienated world of the Russian art establishment, between modern artists and the world they perceived, experienced and lived in. As I have show, to a remarkable extent, and in innovative ways this aim was realised.

### References

1 See Malevich letter to Shkol'nik, 5 November 1913, Russian Museum, Fond 121, op. 1, ed. khr. 41, 1. 5.

2 Shekhtel', Podgaevskii, Labunskaya and Ekster appeared in both the Union of Youth's exhibition and 'No. 4', the Moscow show organised by Larionov which opened on 23 March 1914. This hints at a greater sympathy of direction between the two parties than Larionov would have liked to admit. M. Bezhentsev, displayed a work that gave a 'completely whole, constrained impression... (cat. 11), something like a motif of a fine pattern (blue, brown and white)' (A. Rostislavov, 'Vystavka Soyuza molodezhi', *Rech'*, 28 November 1913, p. 3). Bezhentsev's concentration on colour and lack of title suggest purely painterly concerns. One critic found his canvases 'really resemble nothing' (R., 'Vystavka Soyuza molodezhi i khudozhniki 'Zaburlyukali'', *Peterburgskaya gazeta*, 11 November 1913, p. 3). E. A. Lasson-Spirova, one of the founders of the ''Made Paintings' Intimate Studio of Painters and Draughtsmen' in January 1914, contributed three untitled works in which she 'found a successful use for Cubism in children's toys' (R., 'Vystavka Soyuza').

3 A. Rostislavov, 'Neotsennaya', *Rech'*, 28 April 1913, p. 3.

4 V. Denisov, 'Soyuz molodezhi', *Den'*, 30 November 1913, p. 5.

5 Rostislavov, 'Vystavka Soyuza'.

6 See, for example, W. Sherwin Simmons, *Kasimir Malevich's Black Square and the Genesis of Suprematism, 1907–1915*, Ph.D. thesis, Johns Hopkins University, Baltimore, 1979, pp. 51–130; and S. Compton, *Kazimir Malevich: A Study of the Paintings, 1910–1935*, Ph.D. thesis, University of London, 1983, pp. 51–96.

7 Cited from E. Kovtun, 'Kazimir Malevich', *Art Journal*, Fall 1981, p. 235. Translated from the Russian by C. Douglas.

8 Cited from C. Douglas, 'Beyond Reason: Malevich, Matiushin, and their Circles', *The Spiritual in Art: Abstract Painting 1890–1985*, [exhibition catalogue], Los Angeles Museum of Art, New York, 1986.

9 *Soyuz molodezhi; katalog vystavki kartin*, St Petersburg, 1913, Russian Museum. For Malevich's letters, see Russian Museum, Fond 121, op. 1, ed. khr. 41, 1. 3–5.

10 Benois, 'Vystavka Soyuza molodezhi', *Rech'*, 21 December 1912.

11 'Spiski proizvedenii', 2 November 1913, Russian Museum, Fond 121, op. 1, ed. khr. 41, 1. 2.

12 For an analysis of the reception of Cubism and Futurism in Russia, see C. Humphreys, *Cubo-Futurism in Russia: The Development of a Painterly Style 1912–1922*, Ph.D. thesis, University of St. Andrews, 1989, pp. 10–101.

13 Compton, *Kazimir Malevich: A Study*, p. 54.

14 *Woman in Blue* was reproduced in *Novoe vremya (prilozhenie)*, 13 October 1912, p. 10. It was shown at the '"Modern Art" Exhibition of French Paintings', together with work by Picasso, Matisse, Marquet, Van Dongen, Gris, Metzinger, Heckel and Kirchner.

15 I.e. *Vzorval', Vozropshchem, Porosyata, Troe and Slovo kak Takovoe* (all St Petersburg, 1913). *Reapers* (cat. 67), for example, was almost certainly based on an illustration to *The Three [Troe]*, opp. p. 50. Much scholarly attention has been given to Malevich's graphic work. See, for example, D. Karshan, *Malevich: The Graphic Work 1913–1930*, [Exhibition Catalogue], Jerusalem Museum, 1975; S. Compton, *The World Backwards*, London, 1978.

16 I. Yasinskii, 'Soyuz molodezhi', *Birzhevye vedomosti*, No.13854, 13 November 1913, pp. 4–5.

17 R., 'Vystavka Soyuza'.

18 There are two *Samovar* variants – one in a private collection in New York, the other in the Rostov Art Museum. The steps and aeroplane wheels in the composition relate to the motifs of *Victory over the Sun*.

19 K. Malevich, *On New Systems in Art*, published in Vitebsk, 1919, translated in T. Andersen (ed.), *Malevich: Essays on Art 1915–1933*, London, 1969, p. 114.

20 For a discussion of Malevich's conception of the fourth dimension and the relationship of his thought with recent theory see L. D. Henderson, *The Fourth Dimension and Non-Euclidean Geometry in Modern Art*, Princeton, 1983.

21 'Na vystavke "Soyuza molodezhi"', *Rech'*, 1 November 1913, p. 5.

22 Nikolai Burlyuk, 'P. N. Filonov', Russian Museum, Fond 121, op. 1, ed. khr. 41, 1. 4.

23 See Filonov, 'Made Paintings' (1914) and 'The Basic Tenets of Analytical Art' (1923?) in Misler and Bowlt, *Pavel Filonov*, pp. 135–54. Despite his rejection of Cubism, Filonov's ideas for a conceptual art still have much in common with it.

24 There were two such works – as evidenced by R., 'Vystavka Soyuza' and 'Spiski proizvedenii'.

25 See Misler and Bowlt, *Filonov*, p. 139.

26 R., 'Vystavka Soyuza'.

27 See Le Fauconnier, 'Proizvedenie iskusstva', *Soyuz Molodezhi*, No. 2, 1912, pp. 36–7.

28 Similar modernist trends were evident in all of the following artists. Ivan Vasil'evich Klyun (also known as Klyunkov and Klyunov, 1873–1943), a friend of Malevich. By 1913 he was working in a Cubist idiom, as seen in *The Jug* (Rostov Art Museum). Furthermore, Ekster's work now reflected a Futurist study of form and space; Grishchenko showed 'highly cultured... integrated and well composed works, *Yard, Piazza*, the still-lifes and the especially beautiful *Jug and Tomatoes* [in which] the definite influence of the newest French artists is felt' (Rostislavov, 'Vystavka Soyuza'); Vera Fedorovna Shekhtel' (1896–1958), a friend of Mayakovsky's and sister of Lev Shekhtel' (Zhegin) exhibited *Orphistic Painting* and *Balalaika*, probably in similar style to her Cubist *Still-Life*, reproduced in the 'No. 4' catalogue; Mariya Mikhailovna Sinyakova (1890–1984), who had studied in Mashkov's studio since 1912, showed two untitled paintings, with a tubular effect that drew comparison with Malevich (Rostislavov, 'Vystavka'). The reproduction of one in *Ogonek* (1 December 1913, Plate 22) seems to show a scene from Futurist theatre.

29 Rostislavov, 'Vystavka Soyuza'.

30 Tatlin's postcard to Shkol'nik, of 30 April 1913 was written at Eropkino railway station as he headed for Paris. He writes that he left Moscow on 26 April.

31 See L. Zhadova, ''Composition-Analysis', or a New Synthesis?', L. Zhadova (ed.),

*Tatlin*, London, 1988, pp. 63–6.

32 *Ibid.*, pp. 65–6.

33 Like Tatlin, one of Burlyuk's exhibits reflected an interest in icon painting technique: *George the Victor (copper) Painterly Bas-Relief*. In 'Spiski proizvedenii' this was subtitled 'copper icon'.

34 Rostislavov, 'Vystavka Soyuza'.

35 R., 'Vystavka Soyuza'.

36 *Ibid.*

37 Yasinskii, 'Soyuz molodezhi'.

38 R., 'Vystavka Soyuza'.

39 Denisov, 'Soyuz molodezhi'.

40 R., 'Vystavka Soyuza molodezhi'.

41 V. A., 'Vystavka kartin Soyuza molodezhi v Peterburge', *Ogonek*, 1 December 1913, p. 7; Rostislavov, 'Vystavka Soyuza'; Yasinskii, 'Soyuz molodezhi'.

42 Rostislavov, 'Vystavka Soyuza'.

43 I. Yasinskii, 'Sovremennoe iskusstvo', *Birzhevye vedomosti*, No. 13780, 1 October 1913, p. 6.

44 See *Novyi Zhurnal dlya vsekh*, No. 10, 1915.

45 Dydyshko was in Paris in the Spring of 1908 and would, for instance, have been able to see Braque's *Calanque*, at the *Salon des Indépendents*. Also, *Le Port de la Ciotat* was shown at the Golden Fleece salon in Moscow a few weeks later.

46 J. Bowlt, 'The St Petersburg Ambience', p. 129.

47 A similarity to the 'pure', 'musical' forms of Delaunay's Orphism may also have been evident in Matyushin's work. Certainly word of Orphism had reached Russia by this time (as indicated by Shektel''s *Orphistic Painting*) – see, for example, the dismissive article 'Orfeisty', *Vestnik teatra*, 31 March 1913, p. 6.

48 'Na vystavke 'Soyuza molodezhi'', *Rech'*, 1 November 1913, p. 5.

49 See [anon.] 'Teatr Futu', *Moskovskaya gazeta*, 9 September 1913, p. 5, and below.

50 See 'Poety futuristy', Russian Museum, Fond 121, op. 1, ed. khr. 13, 1. 39.

51 See, for example, the printed programme, 'O noveishei russkoi literature', Russian Museum, Fond 121, op. 1, ed. khr. 13, 1. 77–8; and *Rech'*, 17 November 1913, p. 1.

52 Concerning these evenings, see V.A. Byalik (ed.), *Russkaya literatura kontsa XIX-nachala XXvv*, II, Moscow, 1972, pp. 560–5.

53 [anon.], 'Vecher futuristov', *Obozrenie teatrov*, 22 November 1913, p. 13.

54 [anon.] 'Vecher futuristov', *Rech'*, 21 November 1913, p. 6. Another version of this, altering the meaning, was reported: 'Rhythms decorate verses like flowers a room and like spit the road' (Evg. Adamov, 'Prosveshchenie ili attraktsion', *Den'*, 22 November 1913, p. 3).

55 [anon.], 'Vecher futuristov', *Rech'*.

56 *Ibid.*

57 E.g. C. Douglas, 'Birth of a 'Royal Infant': Malevich and "Victory over the Sun"', *Art in America*, March–April 1974, pp. 45–51; M. Etkind, 'Soyuz Molodezhi i ego stsenograficheskie eksperimenty'; J.-C. Marcadé, *La Victoire sur le Soleil*, Lausanne, 1976; K. Rudnitsky, *Russian and Soviet Theatre 1905–1932*, London, 1988; L. D. Henderson, 'The Merging of Time and Space: "The Fourth Dimension" in Russia from Ouspensky to Malevich', *The Structurist*, 1975/6, pp. 97–108.

58 Cited from Douglas, *Swans of other Worlds*, p. 36.

59 Cited from B.N. Kapelyush, 'A. E. Kruchenykh. Pis'ma k M. V. Matyushinu', *Ezhegodnik rukopisnogo otdela Pushkinskogo doma na 1974 god*, Leningrad, 1976, p. 174.

60 M. Matyushin, 'Futurizm v Peterburge', *Futuristy: Pervyi Zhurnal russkikh futuristov*, St Petersburg, 1914, p. 155. Zheverzheev mentions these difficulties ('Vospominaniya', V. Azarov and S. Spasskii (ed.), *Mayakovskomu*, Leningrad, 1940, pp. 133–4) adding that only the recent poor takings of the Luna Park Theatre led its management to allow the

Futurist performances for four days. One of the first Russian articles on Italian Futurist theatre appeared in the summer 1913, shortly after the Uusikirkko conference: V. Shaposhnikov, 'Futurizm i teatr (Marinetti, Pratella, Russolo)', *Maski*, Moscow, August 1913, p. 29ff.

61 Matyushin, 'Futurizm v Peterburge', p. 156.
62 *Ibid.* p. 155. See also 'Eskizy i kroki', *Peterburgskaya gazeta*, 29 November 1913, p. 4, about the refusal of one musician.
63 Kruchenykh, 'Pervyya v mire postanovka futuristov' *Nash Vykhod* (unpublished). Cited from J. Kowtun, 'Sieg über die Sonne', *Sieg über die Sonne*, Berlin, 1983, p. 51.
64 Matyushin, ' Tvorcheskii put' khudozhnika', pp. 106–7, cited in L. Jadova, 'Des Commencements sans fins', *Europe, Revue Littéraire mensuelle 53 année*, Paris, April 1975, p. 130.
65 For a colour reproduction of Rozanova's poster, see *Sieg über die Sonne*, p. 26.
66 Cited in Douglas, 'Birth of a Royal Infant', p. 46.
67 *Ibid.*, p. 47.
68 –'., 'Kak budut durachit' publiku (futuristskaya opera)', *Den'*, 1 December 1913, p. 6.
69 The text of *Victory over the Sun* was published as a booklet shortly after the production, at the end of December 1913 (*Pobeda nad solntsem: opera*, St Petersburg, 1913).
70 J. Bowlt, 'When Life was a Cabaret', *Art News*, December 1984, p. 124.
71 Matyushin, 'Futurizm v Peterburge', p. 156.
72 Bowlt, 'When Life was a Cabaret' p. 124.
73 *Ibid.* p. 124.
74 K. Tomashevskii, 'Vladimir Mayakovskii', *Teatr*, No. 4, 1938, cited in E. Bartos, V. Nes Kirby, 'Victory over the Sun', *The Drama Review*, XV, 1971 p. 120.
75 See note 57 above. Most are in the Petersburg Theatrical Museum.
76 Rudnitsky, *Russian and Soviet Theatre*, p. 13.
77 [anon.], 'V Peterburge', *Muzy*, Kiev, 25 December 1913, p. 20.
78 Malevich exhibited *Portrait of Matyushin* two months later at the Knave of Diamonds exhibition.
79 Compton, *Kazimir Malevich: A Study*, p. 93.
80 [anon.] 'Teatr Futu'.
81 *Ibid.*
82 The cock symbol compares with that of *Tsar Maksem'yan*. The text of *Vladimir Mayakovsky* was published as a booklet in March 1914 (*'Vladimir Mayakovskii': tragediya*, Moscow, 1914).
83 Rudnitsky, *Russian and Soviet Theatre*, p. 13. Citation of Yartsev, from 'Teatr futuristov', *Rech'*, 7 December 1913.
84 *Mayakovskii v vospominaniyakh sovremennikov*, Moscow, 1963, p. 625.
85 A. Izmailov, 'Vecher futuristov', *Birzhevye vedomosti*, No.13886, 3 December 1913, p. 2.
86 L. Zheverzheev, 'Kostyum delal P.N. Filonov', Petersburg Theatrical Museum, quoted in Etkind, 'Soyuz Molodezhi', p. 255.
87 Zheverzheev, 'Vospominaniya', p. 135.
88 Yartsev, 'Teatr futuristov', from Rudnitsky, op. cit., p. 13.
89 *Ibid.*, p. 13.
90 Zheverzheev, 'Vospominaniya', p. 135.
91 For a reproduction of a sketch by Rozanova for *Vladimir Mayakovsky* (that closely relates to the works in the journal), see V. N. Terekhina, '"Nachalo zhizni tsvetochno aloi...". O.V. Rozanova (1886-1918)', *Panorama iskusstv 12*, Moscow, 1989, p. 47.
92 Etkind, 'Soyuz Molodezhi', p. 255. The sketch is in the Petersburg Theatrical Museum.
93 M. Davydova, 'Teatral'no-dekoratsionnoe iskusstvo' *Russkaya khudozhestvennaya kul'tura 1908–1917*, Moscow, 1980, p. 218.
94 Markov, letter to Zheverzheev, 10 April 1913, Bakhrushin Theatrical Museum, Moscow, Fond 99, ed. khr. 61, l. 1–2. Markov's letters of 23 April and 5 June 1913 are in the

Russian Museum, Fond 121, op. 1, ed. khr. 46, 1. 2 and ed. khr. 43, 1. 1.

95 The publisher's date is 1914 but in fact the book appears to have been released at the very end of 1913; see advertisement at the end of the book (V. Markov, *Printsipy tvorchestva v plasticheskikh iskusstvakh: Faktura*, St Petersburg, 1914), which states that *The Chinese Flute* 'will come out in the first days of January [1914]'. The translation of the Russian word *faktura* into English is problematic. Its multiple meaning has no English equivalent, as this section shows. Neither 'texture' nor 'facture' adequately convey the sense of the word. Likewise 'feel' is too vague. Thus the word is left untranslated and its meaning for Markov is explained by the enquiry below.

96 When *The Art of Easter Island* appeared (V. Markov, *Iskusstvo ostrova Paskhi*, St Petersburg, 1914), a note at the end stated that *The Chinese Flute*, would be published at the end of January and that *Negro Art* would be published in March 1914. Although *The Chinese Flute* (V. Markov, *Svirel' Kitaya*, St Petersburg, 1914) carried a note saying that it had been printed in January 1914 (p. II), it did not appear in the *Knizhnaya letopis'* until the week of 27 March to 3 April 1914. *The Chinese Flute* had been discussed as early as the Union of Youth committee meeting of 8 March 1913, where Zheverzheev, in Markov's absence, proposed its publication.

97 The Union of Youth's participation in an exhibition in Baku was advertised in the local press – see, for example, 'Vystavka kartin', *Baku*, 25 March 1914. Despite the apparent arrival of the works (*ibid.*), when the show opened on 30 March, though Kul'bin and Grishchenko were present, there was no mention of Union of Youth. Eventually Zheverzheev managed to get *Negro Art* published (V. Markov, *Iskusstvo negrov*, Petrograd, 1919). Among Markov's other works was an unpublished essay concerned with the eskimo sculpture of Northern Asia and an essay about the plastic symbols of Byzantium.

98 A less hybrid apology for Neo-Primitivism, though tinged with Futurist references to the mechanised world, is to be found in Aleksandr Shevchenko's *Neo-Primitivizm (ego teorii, ego vozmozhnosti, ego dostizheniya)*, Moscow, 1913. Published in November 1913 and dated June 1913, the coincidence of ideas with *Faktura*, and more especially Markov's previously published essays, is considerable. Predictably, Shevchenko, who exhibited twice with the Union of Youth in 1912, called for an abandonment of academic tradition and a renewal of primitive (especially Eastern) principles in art.

99 Markov, *Faktura*, pp. 67–8.

100 It is interesting to note that on 28 May 1912 it was reported (*Stolichnaya molva*, p. 4) that Larionov's brother Ivan had just set off for Polynesia in order to study its culture. It is worth recalling that Baller wrote about Javanese puppet theatre in *The Studio of Impressionists* and that Kalmakov used Polynesian ornamentation.

101 As Humphreys has pointed out, Picasso's proto-Cubist period of monumental figure painting dominated Shchukin's collection of his work, and was heavily influential upon the Russian artists. Furthermore, Shchukin displayed African sculpture with his Picasso collection (see Humphreys, *Cubo-Futurism in Russia*, pp. 24–6).

102 Many appear to have been translated from Hans Bethge, *Die Chinesische Flöte*, Leipzig, undated. Six of the poems had been published without commentary in *The Union of Youth* (Nos. 1 and 2). Markov notes (*Svirel' Kitaya*, p. XVI) the unsatisfactoriness of the translations. The translator Egor'ev died on 2 May 1914, one day before Markov.

103 V. Markov, 'Printsipy novago iskusstva', *Soyuz molodezhi*, No. 1, 1913, p. 13. Bowlt alters the meaning of the second example in his translation, *Russian Art of the Avant-Garde*, p. 29.

104 See *Soyuz molodezhi*, No. 1, pp. 15-17 and *Svirel' Kitaya*, pp. 87, 63 and 80.

105 Markov, *Svirel' Kitaya*, p. III.

# Epilogue

With the publication of Markov's essays, the Union of Youth, its death toll sounded by *Victory over the Sun*, ceased to function. Its force, and even *raison d'être*, was spent after the production of the Futurist opera, which can be seen as a statement of the new worldview that the group had encouraged. With the presentation of this worldview, the old order had to be abandoned and, with it, old affiliations and established groups. As if colluding with this, the performance of *Victory over the Sun* occasioned a dispute in the Union of Youth's ranks that ended with the group being wound up. Zheverzheev, who had personally agreed to subsidise the production, was upset by the scandal it created, especially as the public had been charged very high prices for tickets. He argued with Kruchenykh about payment and refused Matyushin's request to return Malevich's designs.[1] These events led several Union of Youth members to seek official curtailment of the group's collaboration with Hylaea in a letter to Zheverzheev of 6 December 1913.[2] The chairman responded by refusing to subsidise future ventures, and as a result only the books by Markov, for whom Zheverzheev always seems to have retained respect, were published. Planned exhibitions and the fourth issue of *The Union of Youth* were cancelled. The Union of Youth had served its purpose. It had brought artists together without dogma or preconditions, but its attempts to unify disparate tendencies, at a time of fierce competition for originality, were bound to fail as new allegiances and factions emerged. By early January 1914, Filonov, for example, already sought to establish his own 'Intimate Studio of Painters and Draughtsmen'. While he sought an alliance with Malevich and Matyushin, he rejected the company of Rozanova and Burlyuk.[3] Simultaneously, Malevich resigned from the Union of Youth and by 21 February he wrote to Rozanova referring to the 'unfortunate Union', asking who else was leaving and confirming his and Morgunov's permanent resignation. Coincidentally he confirmed his intention to participate in an exhibition organised by Kul'bin, adding 'give him my regards and thank him for his attention').[4]

In 1917 Zheverzheev and Shkol'nik tried to resuscitate the Union of Youth. They convened a general meeting of the group on 21 March.[5] It was agreed 'to revive the activity of the Society with respect to exhibitions etc.'. New members were elected and future meetings arranged. The chair-

man remained Zheverzheev and the secretary Shkol'nik. A list of members was drawn up.[6] Previous Union of Youth associates included Spandikov, Shleifer, Rozanova, Dydyshko, Zel'manova, Potipaka, Baudouin de Courtenay, David Burlyuk, Puni, Lyubavina, Lermontova, Al'tman, Chagall, Malevich, Ekster and Tatlin. New members included Annenkov, Karev, Denisov, Turova, Svyatoslav Voinov, Popova, Lentulov, Archipenko, Zadkin, Bruni, Udal'tsova, Miturich and Tyrsa, as well as the Finnish painters Uuno Alanko and Yrjö Ollila. Unsurprisingly, there is no mention of co-operation with the Futurist poets. However, only a few meetings were held before the summer, and with the revolutionary events of the autumn the enterprise failed to get off the ground.[7]

## References

1 See Khardzhiev, *K istorii*, p. 153.
2 *Ibid*. p. 158.
3 See Filonov's letter to Matyushin cited in Misler and Bowlt ed., Filonov, pp.139–43.
4 Malevich, letter to Rozanova, 21 February 1914, Russian Museum, Fond 134, op. 1, ed. khr. 71, l. 1).
5 See 'V obshchem sobranii', 21 March 1917, Russian Museum, Fond 121, op. 1, ed. khr. 1, l. 29).
6 'Spisok chlenov obshchestva khudozhnikov 'Soyuz molodezhi', Russian Museum, Fond 121, op. 1, ed. khr. 6. See also ed. khr. 11, l. 20-3 and 40.
7 Still Al'tman, Puni, Spandikov, Filonov and Shkol'nik appeared as a 'Union of Youth' section at the 'First State Free Exhibition of Works of Art' in 1919.

# Biographical notes

The following short biographical notes, essentially complementing the information in the text are given for the lesser known artists who played important parts in the history of the Union of Youth.

**BALLER, Avgust Ivanovich** [Bal'er] (1879–1962)
Born in Budaki, Bessarabia. First exhibition: 'Blanc et Noir', St Petersburg, 1903. Participated in Triangle and Union of Youth shows. During the late 1900s lived with his wife, the artist Arionesko-Baller, in the Netherlands and graduated from Amsterdam Academy of Arts, 1911. Lived mostly in Petersburg until 1919. Then moved to Kishinev, Moldavia where he lived, teaching at the Kishinev Art Institute, until 1941. Died in Bucharest

**BUBNOVA, Varvara Dmitrievna** (1886–1983)
Born in St Petersburg. From 1903 studied at the Drawing School of the Society for the Encouragement of the Arts, then at St Petersburg Academy of Arts (1907–14). First exhibited at the Union of Youth's Riga exhibition. Moved to Moscow in 1917 and subsequently worked in INKhUK. In 1922 moved to Japan. Returned to Sukhumi in 1958 and St Petersburg in 1979.

**BYSTRENIN, Valentin Ivanovich** (1872–1944)
First studied art under N. I. Murashko at the Kiev Drawing School; then under A. I. Tvorozhnikov and Mate at St Petersburg Academy of Arts (1892–1902), with breaks for poor health. First exhibited at the 'Third Exhibition of the Society of Russian Watercolorists', St Petersburg, 1895; later at Triangle and the Union of Youth shows. Co-founder of the Union of Youth. Worked as stage and costume designer for Troitskii Theatre (1911–12) and Liteinyi Theatre (1912–13). Worked in St Petersburg until 1913. Organised and taught at the Bogorodskoe School of Artistic Wood Carving (1915–37), Moscow Province and taught in the Art Faculty of the Moscow Textile Institute, 1935–41.

**DYDYSHKO, Konstantin Vinkent'evich** (1876–1932)
Born near Kovno [Kaunas], Lithuania. Graduated from the Tiflis [Tbilisi] Infantry Cadet Institute 1904. Studied at Tiflis Art Institute (early 1900s); the Munich studios of von Stück and Ažbé (1905); and the St Petersburg Academy of Arts (1905–12), under Kardovskii and Dubovskoi. Graduated in 1912 and received the title of 'teacher of drawing' in 1916. Travelled much in Europe 1906–13 (including Italy, France, Spain). First exhibited at the Spring Show of the Moscow College of Painting, Sculpture and Architecture (1909). Subsequently a regular contributor to Union of Youth exhibitions and thereafter the World of Art. Lived in Copenhagen from 1929.

**GAUSH, Aleksandr Fedorovich** (1873–1947)
Studied at the Petersburg Academy of Arts 1893–9. Founder member and secretary of the New Society of Artists (1904–7). Participated in Union of Russian Artists' exhibitions. Founder member of the Union of Youth. Member of the World of Art from 1911, and keeper of the Museum of Old Petersburg from 1912.

# Biographical notes

**KUL'BIN, Nikolai Ivanovich** (1868–1917)
Born in Helsingfors (Helsinki). Died in Petrograd. Brought up in Petersburg – entered the Military-Medical Academy in 1887. Graduated (with distinction) as a physician in 1893. Entered the Clinic of Professor F. I. Pasternatskii as a doctorate student. Member of the Society for the Protection of Peoples' Health from 1893. Teacher at the St Petersburg Military-Medical Attendants' School from 1893. Began to study microscopic drawing in 1888 and micro-photography in 1894. Awarded degree of Doctor of Medicine for dissertation on alcoholism in 1895. Published several scientific articles 1896–1907. Made a General and Full State Councillor, 1907. First exhibited at 'Modern Trends in Art' 1908. Subsequently organised and participated in many avant-garde exhibitions in St Petersburg, Moscow, Vilna, Baku, Ekaterinodar. One-man shows – October 1912, June 1918. Lectured on Futurism 1913 – 1914. Main decorator at the Terioki Theatre, summer 1912 and the Queen of Spades Theatre (St Petersburg) December 1913 – January 1914. Founder member and decorator of Stray Dog cabaret cellar; founder of the Ars society (1911) and the 'Spectator' society (1912–13). Published 'Chto est' slovo', *Gramoty i deklaratsii russkikh futuristov*, St Petersburg, 1914; 'Chto takoe kubizm' *Strelets*, Petrograd, 1915 pp. 197–216. His illustrations appeared in many books and almanacs, e.g. N. Evreinov, *Teatr kak takovoi*, St Petersburg, 1913; I. Severyanin, *Tost bezotvetnyi*, Moscow, 1916.

**L'VOV, Petr Ivanovich** (1882–1944)
Born in Tobolsk. First studied in N. P. Ul'yanov's studio (1897–99), then at the Moscow Institute of Painting, Sculpture and Architecture (1900–2) under S. V. Ivanov and S. A. Korovin. Studied at the St Petersburg Academy of Arts (1902–13) under Kardovskii, Tsionglinskii, Rubo and Samokish. Graduated in 1913. First exhibited with the New Society of Artists in 1909. Member of the Union of Youth, the World of Art and later the '4 Arts'. Lived in Khabarovsk 1915-1923. Taught at Moscow Vkhutemas/ Vkhutein 1924-9, and at the Leningrad Institute of Painting, Sculpture and Architecture 1933–41. Died in Perm.

**MATVEJS, Hans Voldemars Yanov** [Vladimir Markov/Matvei] (1877–1914)
The son of a couple who ran a buffet at one of the stations in Riga. His father died while he was still young and he was brought up, with two step-sisters and a brother, by his mother (who died in 1908) and step-father. After leaving school in 1895 he studied at the art school of B. Blum in Riga, graduating in 1902. He taught art in a private school in Tukumas, Latvia and by 1903 had saved enough money to move to Petersburg. Took lessons from Tsionglinskii and in 1906 entered the Academy of Arts, studying under professors Kiselev and Dubovskoi. Due to graduate in the autumn 1914 but died suddenly of peritonitis on 3 May.

**MOSTOVA, Zoya Yakovlevna** (1884–1972)
Also known as Matveeva-Mostova. Born in Perm. Graduated from Kiev Art Institute in 1905. Moved to St Petersburg 1906. Worked as a secretary at the Ministry Commission of the Committee of Finance 1906–9. Took a pedagogical course at the St Petersburg Academy of Arts 1907. Travelled in France and Italy in 1910. First exhibited at 'Modern Trends in Art' 1908. Founder member of the Union of Youth. Exhibited with the World of Art. Worked as a schoolteacher 1910–19. Married the sculptor A. T. Matveev in 1914. Died in Moscow.

**NAGUBNIKOV, Svyatoslav Aleksandrovich** (1886–1914?)
Studied at the St Petersburg Academy of Arts 1910-1914. Apparently died in the First

World War. First exhibited with the Union of Youth, 1910, and contributed to all but one of their shows. Also participated in the shows of the Higher Art Institute at the Academy of Arts (1911-1913) and the World of Art (1913).

**SAGAIDACHNYI, Evgenii Yakovlevich** (1886–1961)
Prior to 1910 studied at the St Petersburg Academy of Arts. Mobilised during the First World War. Subsequently lived in L'viv. Contributed to exhibitions organised by Kul'bin, the Union of Youth and Larionov. First exhibited at the 'Impressionists' 1909.

**SHKOL'NIK, Iosif Solomonovich** (1883–1926)
First studied at the Odessa Art Institute. Student at the St Petersburg Academy of Arts 1905–7. First exhibited at the 'Modern Trends in Art' 1908. Founder member and secretary of the Union of Youth. From 1914 worked as a designer at the Troitskii Theatre. After the 1917 Revolution became commissar of the State Free Art-Scientific Studios in Petrograd and was appointed to the Commission for the purchase of work by modern artists.

**SHLEIFER, Savelii Yakovlevich** (1881– 1942?)
Graduated from the Odessa Art College 1904. Studied at the Parisian Academie des Beaux Arts 1905–8 and the St Petersburg Academy of Arts 1908–9. First worked as a theatrical designer 1907 (Gorky's *Children of the Sun*). First exhibited at the 'Impressionists' 1909. Participated in all the Union of Youth exhibitions. From 1912 worked on commissions for the Troitskii Theatre and in 1915 became a designer at the Liteinyi Theatre.

**SPANDIKOV, Eduard Karlovich** (1875–1929)
Born Kalvaria, Poland (now Lithuania). Pathologist Worked at the Department of Universal Pathology, Institute of Experimental Medicine, St Petersburg. Founder member and legal consultant of the Union of Youth. First exhibition: 'Modern Trends in Art', 1908. Participated in all the Union of Youth exhibitions.

**VOINOV, Rostislav Vladimirovich** (1881–1919)
Studied at the School of Drawing of the Society for the Encouragement of the Arts and in the studio of L. E. Dmitriev-Kavkazskii (late 1890s to early 1900s). Worked as a sculptor and ex-librist in St Petersburg. Founder member of the Union of Youth, contributed to their fifth and last exhibitions. First exhibited at his one-man show, Petersburg 1907. Also participated in the 'Art in the Life of the Young Child Exhibition' 1908. Established his own art-joinery workshop specialising in wooden toys in the 1900s.

# Select bibliography

## Primary sources

**RUSSIAN MUSEUM, St Petersburg**

**Fond 121. The Union of Youth**

ed. khr. 1 Minutes of Union of Youth meetings

ed. khr. 2 Requests to found the Union of Youth

ed. khr. 3 'Pravila vstupleniya v chleny tovarishchestvo khudozhnikov 'Soyuz Molodezhi'

ed. khr. 6 'Spisok chlenov obshchestva khudozhnikov 'Soyuz molodezhi'

ed. khr. 13 'Doklad Larionova'; 'Doklad N.D. Burlyuka – "P.N. Filonov – zavershitel' psikhologicheskago intimizma"'. 'O noveishei russkoi literature'; 'Credo Soyuza molodezhi'; 'Doklad A.V. Grishchenko'

ed. khr. 15 'Proekt ustava'

ed. khr. 39 Larionov letters to Shkol'nik

ed. khr. 41 Malevich letters to Shkol'nik

ed. khr. 42 Marc letter to Markov

ed. khr. 43 Markov letter to Zheverzheev

ed. khr. 44-45. Markov letters

ed. khr. 46 Markov letters to Shkol'nik

ed. khr. 47 Matyushin letters to Zheverzheev

ed. khr. 49 Matyushin letters to Shkol'nik

ed. khr. 67 Tatlin letter to Shkol'nik

ed. khr. 82 Rozanova "Voskreshnii Rokhombol'"

ed. khr. 85 Spandikov notes.

## ST PETERSBURG STATE THEATRICAL MUSEUM

Sketches for *Khoromnyya Deistva*.

Sketches for *Pobeda nad Sol'ntsem* and *Vladimir Mayakovskii: Tragediya*.

## ACADEMY OF ARTS, Riga

Voldemārs Matvejs [V. Markov] file: V. Bubnova 'Moi vospominaniya o V.I. Matvee' 1960

## CENTRAL STATE ARCHIVE OF LITERATURE AND ART [TsGALI], Moscow

**Fond 134,** op.1. ed. khr. 1-19 Guro sketches, notebooks and letters

op.2. ed. khr. 4-11. Guro Sketches and notebooks

op.2. ed. khr. 23 Matyushin 'Avtobiografiya'.

## Exhibition catalogues

*Katalog 1908 vystavka 'Sovremennykh techenii v iskusstve'*, St Petersburg, 1908.
*Katalog kartin vystavki 'Venok' 1908 g.*, St Petersburg, 1908.
*Katalog vystavki kartin gruppy 'Venok stefanos'*, St Petersburg, 1909.
*Katalog vystavki kartin 'Impressionisty' Treugol'nik*, St Petersburg, 1909.
*Katalog vystavki kartin 'Impressionisty' Treugol'nik*, Vil'na, 1909.
*'Treugol'nik'* [exhibition catalogue], St Petersburg, 1910.
*Vystavka kartin obshchestva khudozhnikov 'Soyuz Molodezhi'*, St Petersburg, 1910.
*Soyuz Molodezhi* [Exhibition catalogue], Riga, 1910.
*Katalog vtoroi vystavki kartin obshchestva khudozhnikov 'Soyuz molodezhi'*, St Petersburg, 1911.
*Salon 2: Mezhdunarodnaya khudozhestvennaya vystavka*, Odessa, 1911.
*Katalog vystavki kartin obshchestva khudozhnikov 'Soyuz molodezhi'*, St Petersburg, 1912.
*Katalog vystavki obshchestva khudozhnikov 'Soyuza molodezhi'*, Moscow, 1912.
*Katalog vystavki kartin gruppy khudozhnikov 'Oslinyi khvost'*, Moscow, 1912.
*Soyuz Molodezhi: Katalog vystavki kartin*, St Petersburg, 1912–1913.
*Katalog vystavki kartin gruppy khudozhnikov 'Mishen'*, Moscow, 1913.
*Soyuz Molodezhi: Katalog vystavki kartin*, St Petersburg, 1913–1914.
*No.4: Vystavka kartin futuristy, luchisty, primitiv*, Moscow, 1914.

## General

Andersen, Troels (ed.): *Malevich: Catalogue Raisoné of the Berlin Exhibition 1927*, Stedelijk Museum, Amsterdam, 1970.
Barooshian, V. D.: *Russian Cubo-Futurism 1910–1930: A Study in Avant-Gardism*, Mouton, The Hague/Paris, 1974.
Bowlt, John: 'Russian Formalism and the Visual Arts', *Russian Formalism: 20th Century Studies* (eds. J. Bowlt, S. Bann), Scottish Academic Press, Edinburgh, 1973, pp. 131–46.
'Neo-Primitivism and Russian Painting' *The Burlington Magazine*, March 1974, pp. 133–140.
'The St Petersburg Ambience and the Union of Youth', *Russian Art 1875–1975: A Collection of Essays*, MSS, New York, 1976, pp. 112–129.
*Russian Art of the Avant-Garde. Theory and Criticism 1902–1934*, Viking Press, New York, 1976.
*The Silver Age. Russian Art of the Early Twentieth Century and the World of Art Group*, Oriental Research Partners, Newtonville, Massachusetts, 1979.
Bowlt, John and Washton Long, Rose-Carol (eds.): *The Life of Vasilii Kandinsky in Russian Art. A Study of 'On the Spiritual in Art'*, Oriental Research Partners, Newtonville, Massachusetts, 1984.
Burlyuk, David D.: *Galdyashchie 'benois' i novoe russkoe natsional'noe iskusstvo (Razgovor g. Burlyuka, g. Benois i g. Repins ob iskusstve)*, Knigopechatnya Shmit, St Petersburg, 1913.
Compton, Susan: 'Malevich and the Fourth Dimension', *Studio International*, April 1974, pp. 192–5.
'Malevich's Suprematism – The Higher Intuition', *The Burlington Magazine*, August 1976, pp. 576–85.

# Select bibliography

*The World Backwards. Russian Futurist Books 1912–1916*, British Museum Publications, London, 1978.

Denisov, V. I.: 'Puti zhivopistsa (k rabotam Dydyshko)', *Novyi zhurnal dlya vsekh*, Petrograd 1915, No. 10, pp. 52–9.

*Die Kunstismen in Russland: The Isms of Art in Russia 1907–1930*, Galerie Gmurzynska, Cologne, 1977.

Douglas, Charlotte: 'Colours without Objects: Russian Colour Theories (1908–1932)', *The Structurist*, 1973–4, pp. 30–41.

'Birth of a Royal Infant: Malevich and "Victory over the Sun"', *Art in America*, March-April 1974, pp. 45–51.

'The Universe Inside and Out. New Translations of Matyushin and Filonov', *The Structurist*, 1975–6, pp. 72–9.

*Swans of Other Worlds. Kazimir Malevich and the Origins of Abstraction in Russia*, UMI Research Press, Ann Arbor, Michigan, 1980.

Etkind, Mark: 'Soyuz molodezhi i ego stsenograficheskie eksperimenty', *Sovetskie Khudozhniki i kino '75*, Moscow, 1981, pp. 240–59.

*Futuristy: Vladimir Mayakovskii: Tragediya*, Moscow, 1914.

Henderson, Linda Dalrymple: *The Fourth Dimension and Non-Euclidean Geometry in Modern Art*, Princeton University Press, Princeton, New Jersey, 1983.

Isakov, I. S.: 'K risunkom P. I. L'vova', *Novyi zhurnal dlya vsekh*, Petrograd, 1915, No. 8, pp. 53–5.

Jensen, Kjeld B.: *Russian Futurism, Urbanism and Elena Guro*, Arkona, Aarhus, 1977.

Kamenskii, Vasilii: *Put' entuziasta*, Permskoe knizhnoe izdatel'stvo, Perm, 1968.

Kennedy, Janet: *The 'Mir Iskusstva' Group and Russian Art 1898–1912*, Garland, New York, 1977.

Khardzhiev, N.: 'Mayakovskii i zhivopis'', *Mayakovskii: Materialy i issledovaniya*, (ed. V. O. Pertsov and M. I. Serebryanskii), Nauka, Moscow, 1940, pp. 337–400.

Khardzhiev, N., Malevich, K. and Matyushin, M.: *K istorii russkogo avangarda: The Russian Avant-Garde*, Hylaea Prints, Stockholm, 1976.

Kovtun, E. F.: 'Pis'ma V. V. Kandinskogo k N. I. Kul'binu', 'Vladimir Markov i otkrytie afrikanskogo iskusstva', *Pamyatniki kultury. Novye otkrytiya. Ezhegodnik 1980*, Leningrad, 1981, pp. 399–416.

Kowtun, J. F.: *Die Wiedergeburt der künstlerischen Druckgraphik*, VEB Verlag der Kınst, Dresden, 1984.

Kozhevnikova, I. P.: *Varvara Bubnova. Russkii khudozhnik v Yaponii*, Nauka, Moscow, 1984.

Kul'bin, N. I.: *Svobodnaya Muzyka. Primenenie novi teorii khudozhestvennogo tvorchestva k muzyke*, St Petersburg, 1909.

(ed.): *Studiya Impressionistov*, N. I. Butkovskaya, St Petersburg, 1910.

Livshits, Benedikt: *The One and a Half-Eyed Archer* (ed. and trans. J. E. Bowlt), Oriental Research Partners, Newtonville, Massachusetts, 1977.

Lozovoi, Aleksandr: *Varvara Bubnova*, Sovetskii Khudozhnik, Moscow, 1984.

M. [V. Matvejs]: 'Russkii Setsession' (Po povodu vystavki "Soyuza molodezhi" v Rige)' , *Rizhskaya mysl'*, 11 and 12 August 1910, p. 3.

*Malevich 1878–1935*, Stedelijk Museum, Amsterdam, 1988.

Marcadé, Valentine: *Le Renouveau de l'Art Pictural Russe 1868–1914*, Editions L'Age d'Homme, Lausanne, 1971.

Marcadé, Valentine and Jean-Claude (ed.): *La Victoire sur le Soleil*, Edition bilingue. Théâtre Annés Vingt, L'Age D'Homme, Lausanne, 1976.

Markov, Vladimir: *Manifesty i programmy russkikh futuristov*, Slavische Propylaen Band 27, Wilhelm Fink Verlag, Munich, 1967.

*Russian Futurism. A History*, Macgibbon and Kee, London, 1969.

Markov, Vladimir [V. Matvejs]: *Printsipii tvorchestva v plasticheskikh iskusstvakh: Faktura*, Soyuz Molodezhi, St Petersburg, 1914.

*Iskusstvo ostrova Paskhi*, Soyuz Molodezhi, St Petersburg, 1914.

*Svirel' Kitaya* (poems translated by V. Egor'ev), Soyuz Molodezhi, St Petersburg, 1914.

*Iskusstvo negrov*, (ed. L. I. Zheverzheev), Narkompros, Petrograd, 1919.

Matvei, Voldemar [V. Matvejs]: *Katalog yubileinoi vystavki V. Matveya (90 let so dnya rozhdeniya)*, Riga, 1967.

Milner, John: *Vladimir Tatlin and the Russian Avant-Garde*, Yale University Press, New Haven, Connecticut, and London, 1983.

Misler, Nikoletta and Bowlt, John.: *Pavel Filonov: A Hero and his Fate*, Silvergirl Inc., Austin, Texas, 1983.

Nakov, Andrei: 'Formalisme et Transrationalité: au delà du cubo-futurisme', *Change*, February 1976, pp. 209–38.

*One Hundred Years of Russian Art: From the Private Collections in the USSR*, (eds. D. Elliott and V. Dudakov), Lund Humphries, London, 1989.

*Oslinyi khvost i mishen*, Ts. A. Myunster, Moscow, 1913.

*Pavel Nikolaevich Filonov 1883–1941*, Avrora, Leningrad, 1988.

*Poshchechina obshchestvennomu vkusu*, G. L. Kuzmin, Moscow, 1912.

Pospelov, G. G.: 'M. F. Larionov', *Sovetskoe iskusstvosznanie '79*, Sovetskii khudozhnik, Moscow, 1980, pp. 238–66.

Pospelow, Gleb: *Moderne russische Malerei: Die Kınsterlergruppe Karo-Bube*, Kohlhammer, VEB Verlag der Künst, Dresden, 1985.

Povlekhina, Alla: 'Matiushin's Spatial System', *The Structurist*, 1975–776, pp. 64–70.

Richardson, William: *Zolotoe Runo and Russian Modernism: 1905–1910*, Ardis, Ann Arbor, Michigan, 1986.

*Russian and Soviet Paintings 1900–1930: Selections from the State Tretyakov Gallery, Moscow and the State Russian Museum, Leningrad*, Hirshhorn Museum and Sculpture Garden, Smithsonian Institution, Washington, D.C., 1988.

*Russian Futurism 1910–1916 Poetry and Manifestos: 54 Titles on Colour and Monochrome Microfiche* (ed. Susan Compton), Chadwyck-Healey, Cambridge, 1977.

*Russian Stage Design. Scenic Innovation 1900–1930*, from the Collection of Mr and Mrs Nikita D. Lobanov-Rostovsky (ed. J. Bowlt), Mississippi Museum of Art, Jackson, Mississippi, 1982.

*Russische Avantgarde 1910–1930*, Sammlung Ludwig, Prestel-Verlag, Munich, 1986.

*Russkaya khudozhestvennaya kul'tura kontsa XIX-nachala XX veka (1908–1917)*, Kniga 3, Nauka, Moscow, 1977.

*Russkaya khudozhestvennaya kul'tura kontsa XIX-nachala XX veka (1908–1917)*, Kniga 4, Nauka, Moscow, 1980.

*Russkoe iskusstvo XV-XX vekov iz fondov gosudarstvennogo russkogo muzeya*, Khudozhnik RSFSR, Leningrad, 1989.

Rudnitsky, Konstantin: *Russian and Soviet Theatre: Tradition and the Avant-Garde*, Thames and Hudson, London, 1988.

*Sieg über Die Sonne: Aspekte russischer Künst zu Beginn des 20. Jahrhunderts* Schriftenreihe der Akademie der Künste, Band 15, Fröhlich and Kaufmann, Berlin, 1983.

# Select bibliography

*Soyuz Molodezhi*, St Petersburg, Nos. 1-3, 1912–13.

Sternin, G. Yu.: *Khudozhestvennaya zhizn' Rossii 1900–1910-x godov*, Iskusstvo, Moscow, 1988.

*Ustav obshchestva khudozhnikov 'Soyuz Molodezhi'*, St Petersburg, 1910.

Warner, Elizabeth: *The Russian Folk Theatre*, Mouton, The Hague/Paris, 1977.

Zguta, Russell: *Russian Minstrels. A History of the Skomorokhi*, Clarendon Press, Oxford, 1978.

Zhadova, Larissa: *Malevich. Suprematism and Revolution in Russian Art 1910–1930*, Thames and Hudson, London, 1982.

Zhadova, Larissa (ed.): *Tatlin*, Thames and Hudson, London, 1988.

Zheverzheev, Levkii I.: *Opis' pamyatnikov russkago teatra iz sobraniya L.I. Zheverzheeva*, Petrograd, 1915.

# Index

Page numbers in bold refer to Plates. Page numbers in italic refer to biographical notes

# Index

# Index

# Index

**239**

# Index